ROBERT

INDIANA

ROBERT

CARL J. WEINHARDT, JR.

HARRY N. ABRAMS, INC.,

PUBLISHERS, NEW YORK

INDIANA

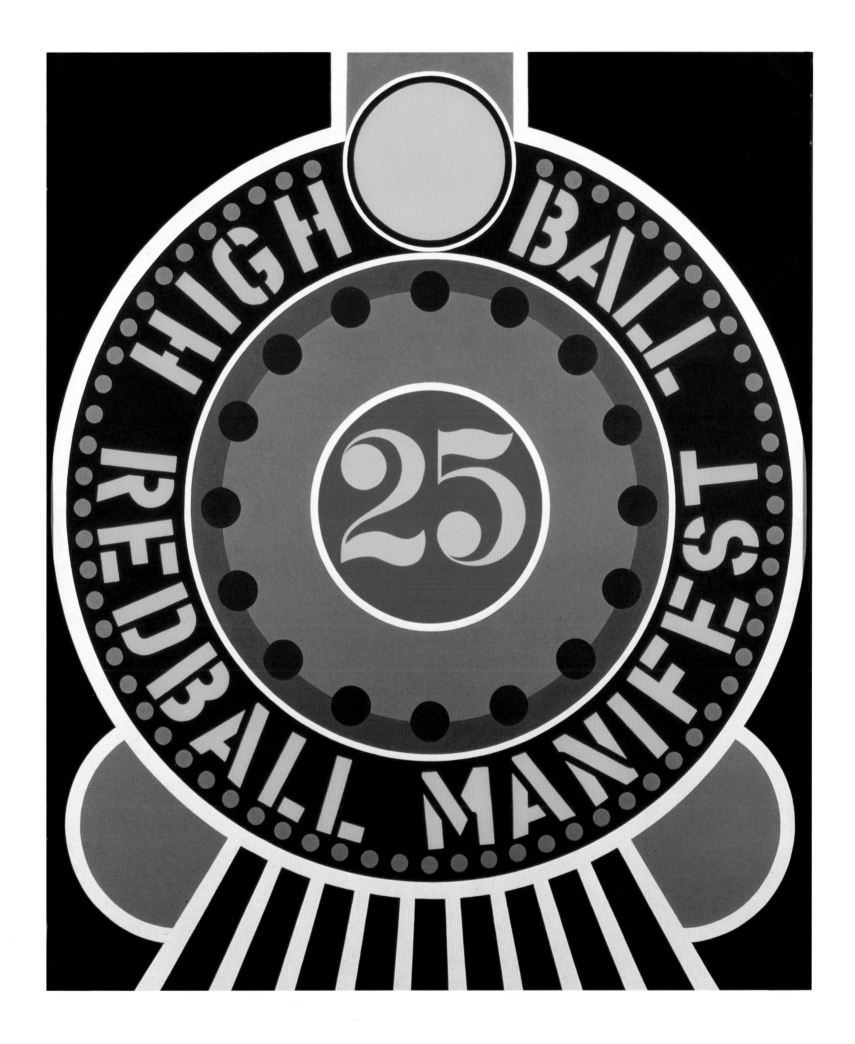

PAGE 3:
HIGHBALL ON THE REDBALL MANIFEST. 1963.
OIL ON CANVAS, 60 × 50″.
UNIVERSITY OF TEXAS AT AUSTIN. THE MICHENER COLLECTION

PROJECT EDITOR: **LORY FRANKEL**
EDITOR: **THERESA BRAKELEY**
DESIGNER: **MARIA MILLER**
PHOTO EDITOR: **BARBARA LYONS**

LIBRARY OF CONGRESS CATALOGING IN PUBLICATION DATA
WEINHARDT, CARL J.
ROBERT INDIANA.
BIBLIOGRAPHY: P.
INCLUDES INDEX.
1. INDIANA, ROBERT, 1928– . I. TITLE.
N6537.I53W44 709′.2′4 82–1778
ISBN 0–8109–1116–7 AACR2

CONTENTS

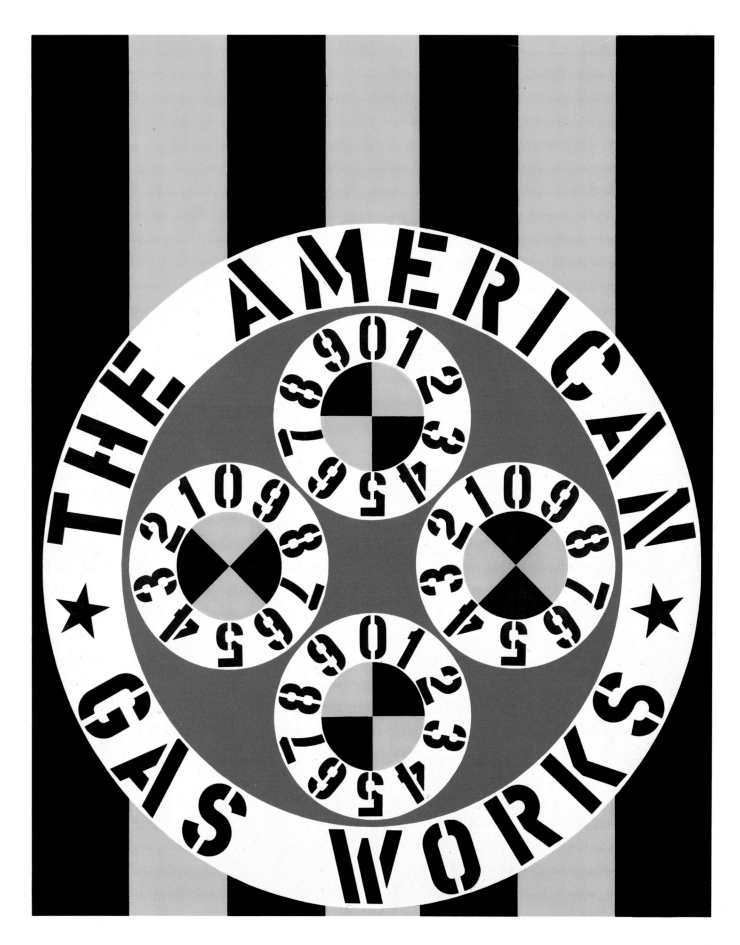

THE AMERICAN GAS WORKS. 1961–62.
OIL ON CANVAS, 60×48″. MUSEUM LUDWIG, COLOGNE, WEST GERMANY

FOR MANY OBSERVERS, THE ART OF ROBERT INDIANA HOLDS AN ELEMENT OF THE MYSTERIOUS, THE ELUSIVE—OF SOMETHING BEYOND THE SEEMINGLY CONCRETE AND STRAIGHTFORWARD IMAGERY THAT FIRST STRIKES THE EYE. "TO KNOW ROBERT INDIANA IS NOT TO KNOW ROBERT INDIANA. TO UNDERSTAND ROBERT INDIANA IS NOT TO UNDERSTAND ROBERT INDIANA."[1] SO CONCLUDES ROBERT L. B. TOBIN, A COLLECTOR AND ANALYST OF THE ARTIST'S WORK. TOBIN SEES THESE PAINTINGS, SCULPTURES, AND GRAPHICS AS "A DELIBERATELY CONSTRUCTED LABYRINTH" INTO WHICH BEHOLDERS ARE CHALLENGED TO ENTER. ONCE INSIDE, THEY ARE PROFFERED MANY CLUES TO THE ARTIST'S CREATIVE PATHWAYS BUT ARE NEVER GIVEN COMPLETE GUIDES.

FOR SOME VIEWERS THIS ENIGMATIC ASPECT IS A PART OF THE FASCINATION AND BEAUTY THEY PERCEIVE IN THE WORK. "BECAUSE I DO NOT UNDERSTAND WHY I LIKE IT SO MUCH . . . **THE AMERICAN DREAM** IS FOR ME . . . SPELLBINDING,"[2] SAID THE LATE ALFRED H. BARR, JR., WHEN THE MUSEUM OF MODERN ART, NEW YORK, ACQUIRED THAT PAINTING IN 1962. AND GENE SWENSON, ONE OF THE NEW YORK CRITICS MOST SYMPATHETIC TO INDIANA'S EARLY OUTPUT, REMARKED ON THE DEVELOPMENT SHOWN BY THE ARTIST'S SECOND SOLO SHOW AT THE STABLE GALLERY IN 1964: "ROBERT INDIANA IS NOT STRAIGHTFORWARD . . . IT IS AS IF THE ARTIST WERE MASKED OR HIDING BEHIND A SCRIM OF PERFECTION AND FLIPPANT IRONY. . . . ONE IS MOVED ALMOST SECRETLY—IN LOOKING AT PRESENT BEAUTY, SURE AND CALM, IN REMEMBERING AN OMINOUS PRESENCE, THE COLD BEAUTY OF A COMELY APPARITION."[3]

ON THE OTHER HAND, THE CRITICAL RESPONSE WAS NOT ALWAYS SO FRIENDLY WHEN THE YOUNG ARTIST'S CONSTRUCTIONS AND PAINTINGS FIRST CAME TO PUBLIC NOTICE IN THE INNOVATIVE CONTEXT OF THE EARLY 1960S. BOTH INDIVIDUALLY AND AS A PARTICIPANT IN GROUP EXHIBITS IN THOSE YEARS, HE ABSORBED HIS SHARE OF VERBAL ABUSE. THE VERY SAME "SPELLBINDING" **AMERICAN DREAM** CAME UNDER A FAR COLDER EYE THAN THAT OF BARR WHEN **ART INTERNATIONAL**

ASSESSED THE SAME MUSEUM SHOW. CALLING INDIANA'S WORK "THE MOST BLA-
TANTLY 'AMERICAN' PAINTING EXHIBITED," THE CRITIC WENT ON, "ITS JUKE BOX
IMAGERY, ITS BUCKEYE PAINT HANDLING, THE OUTRAGEOUSNESS OF ITS DERIVA-
TIONS, AND ITS RHETORICAL FLARE WERE HARD TO IGNORE, IF NOT TO DISLIKE."[4]

SUCH DIATRIBES WERE FREQUENT AT THE TIME, AS DISCONCERTED ART HISTO-
RIANS FACED A BARRAGE OF ICONOCLASTIC YOUNG ARTISTS WHO DEPARTED FROM
ALL ACCEPTED NOTIONS OF "ARTISTIC" MATERIALS, WORKING METHODS, AND
SUBJECTS IN A DISRESPECTFUL OUTPOURING OF EXPERIMENTAL PIECES THAT
DEFIED CLASSIFICATION. AT THE SAME TIME, CURATORIAL INGENUITY STRAINED
TO INVENT BLANKET LABELS FOR ARTISTS SO ESSENTIALLY DIVERSE THAT THEIR
CHIEF CHARACTERISTIC IN COMMON SEEMED TO BE THAT THEY WERE **NOT** AB-
STRACT EXPRESSIONISTS, THE GENERATION OF AMERICAN PAINTERS WHO HAD
DOMINATED THE PRECEDING DECADE. THE NEW CATEGORICAL TAGS RANGED FROM
THE NONCOMMITTAL TO THE FLATLY DISPARAGING. ASSEMBLAGE, POP, OP, NEO-
DADA, SIGN PAINTING, NEW REALISM, NEW VULGARIANS ARE AMONG THE TERMS
DEVISED TO COPE WITH VARIOUS ASPECTS OF MATERIALS, CONTENT, AND VISUAL
EFFECT; ROBERT INDIANA'S WORK WAS SHOWN UNDER SEVERAL OF THOSE
HEADINGS.

THE LABEL THAT STUCK TO HIM LONGEST WAS THAT OF POP ARTIST. AT THE
TIME INDIANA WILLINGLY ACCEPTED IT AND VIGOROUSLY JOINED THE DEBATE
BETWEEN ARTISTS AND CRITICS ABOUT THE SIGNIFICANCE OF THE TERM **POP** AND
THE WORKS IT ENCOMPASSED, THOUGH EVEN THEN HE RESISTED BEING PI-
GEONHOLED. IT SOON BECAME APPARENT THAT THE VARIOUS GROUPINGS WERE
SUPERFICIAL AND IMPERMANENT AND THAT THE ATTEMPTS TO GRAFT THE NEW
WORKS ONTO SOME FAMILY TREE OF EARLIER EUROPEAN ART WERE FUTILE. MOST
OF THE ARTISTS WENT THEIR INDIVIDUAL WAYS TOWARD VISIONS THAT NO LONGER
LINKED THEM, AND THE NAYSAYERS AMONG THE CRITICS BEGAN TO BE ELIMINATED
BY ATTRITION, IF NOT BY CONVERSION.

YET TODAY INDIANA ACKNOWLEDGES THAT THE ASSOCIATION WITH THE POP

MOVEMENT GAVE HIM WIDE EXPOSURE AND A TASTE OF FAME AND LENT HIS ART A PARTICULAR IDENTITY IN THE PUBLIC EYE. THINKING BACK OVER HIS CAREER AS HE PREPARED FOR A RETROSPECTIVE EXHIBITION OF THE WORK HE HAS RETAINED IN HIS OWN COLLECTION, HE RECOGNIZED HIS OWN EVOLUTION FROM THE REBELLIOUS YOUNG ARTIST OF THE POP EXPLOSION. "THIS IS NOT THE WORLD OF THE '60S. . . . MY WORK OF THE '60S WAS A YOUTHFUL REACTION, BUT ONE DOESN'T STAY YOUNG. THE EMOTION OF YOUTH IS SOON SPENT, AND THE SHARP SOCIAL ISSUES THAT I ADDRESSED IN THOSE DAYS ARE NOW BLUNTED."[5] NOWADAYS, POP ART HAS BEEN PRONOUNCED DEAD, BUT INDIANA "IS MINDFUL THAT HE IS IN GOOD COMPANY: ONE WITH OLDENBURG, ROSENQUIST, LICHTENSTEIN, WESSELMANN, AND WARHOL."[6] "THERE HAVE BEEN NO DESERTIONS FROM THE RANKS OF THE SIX, NO RECANTERS, NO SUICIDES. THE SIX OF US GO ON PAINTING OR SCULPTING, BUT WE HAVE ALL GONE ON FROM WHAT WE WERE ORIGINALLY; WE HAVE ALL GROWN IN OUR ART."[7]

HIS OWN OUTPUT HAS BEEN PROLIFIC. AN IMPRESSIVE LIST OF SOLO EXHIBITIONS AND GROUP-SHOW PARTICIPATIONS ATTESTS TO HIS ACTIVITY, AND THE ACQUISITION OF HIS WORK BY MAJOR MUSEUMS AND PRIVATE COLLECTORS IN THE UNITED STATES AND MANY OTHER COUNTRIES INDICATES A HIGH ASSESSMENT OF ITS QUALITY AND SIGNIFICANCE OVER MORE THAN A QUARTER OF A CENTURY.

PAINTER, SCULPTOR, PRINTMAKER, STAGE AND COSTUME DESIGNER, CREATOR OF A PARADE OF POSTERS AND BANNERS, INDIANA HAS EMPLOYED, WITH REMARKABLE VERSATILITY, THE CONCISE AND CONCENTRATED STYLE THAT HE MADE HIS OWN. THE MOST LITERARY OF HIS GENERATION OF AMERICAN ARTISTS, TORN AT FIRST BETWEEN BECOMING A WRITER AND AN ARTIST, HE HAS ISOLATED THE WORD, THE NUMERAL, AND THE GRAPHIC SIGN AS LEGITIMATE AND POWERFUL SUBJECTS FOR ART. HE MAKES NO CLAIM TO BE THE FIRST TO INSERT WORDS INTO HIS PAINTINGS—MANY ARTISTS HAVE DONE AND STILL DO SO—BUT IT WAS HIS PARTICULAR CONTRIBUTION TO MAKE THE WORD A WORK OF ART. WHEN HE CARRIED SOME OF THE WORDS (AND EVENTUALLY THE NUMERALS) THAT OCCUPIED HIM AS A

PAINTER (LOVE, ART) INTO THE SCULPTURAL DIMENSION, HE BECAME LITERALLY A WORDSMITH, FASHIONING THE LOGOS IN METAL.

THOUGH ART WON OUT OVER WRITING AS HIS PRIMARY OCCUPATION, INDIANA HAS CONTINUED TO PRODUCE CRITICISM, AUTOBIOGRAPHY, POETRY, AND A WEALTH OF BACKGROUND CLUES TO THE MEANINGS WOVEN INTO HIS ART. ASIDE FROM SHEER VISUAL DESCRIPTION, MOST OF WHAT HAS BEEN PUBLISHED ABOUT HIS WORK DERIVES FROM HIS OWN STATEMENTS, EITHER WRITTEN OR TRANSCRIBED FROM PERSONAL INTERVIEWS. THAT IS THE CASE IN THIS BOOK AS WELL.

INDIANA MAKES NO SECRET OF THE FACT THAT MUCH OF HIS WORK HAS ITS AUTOBIOGRAPHICAL FOUNDATION, SOMETIMES DOCUMENTED DIRECTLY ON THE CANVAS WITH NAMES AND DATES; BUT WHERE THE ART SEEMS CRYPTIC, THE WRITINGS ARE FRANK, CASUAL, WITTY, SARCASTIC, FAMILIAR. TWO VERSIONS OF HIS "AUTOCHRONOLOGY" HAVE BEEN PRINTED IN EXHIBITION CATALOGUES, ONE OF THEM IN 1968 AND THE OTHER, CONSIDERABLY REVISED AND UPDATED, IN 1977. IT TAKES THE FORM OF ANNUAL NOTES, JOTTINGS, RECORDS OF THE WORK ACCOMPLISHED, THE RECOGNITION RECEIVED, ENCOUNTERS WITH PEOPLE AND IDEAS, AND ALWAYS THE CYCLES OF COINCIDENTAL WORDS, NUMBERS, AND NAMES THAT CAPTURED HIS IMAGINATION. BOTH IN THIS "DIGEST," AS HE CALLS IT, AND IN HIS REVELATIONS OF THE SOURCES OF PARTICULAR PAINTINGS, HE PROJECTS A CYCLICAL RATHER THAN A LINEAR PATTERN ON THE EVENTS OF HIS LIFE AND THE WORKS THEY INSPIRED.

IT IS THIS PATTERN OF COINCIDENCE AND RECURRENCE, THEME AND REFRAIN, THAT SUGGESTED THE ORGANIZATION OF THIS TEXT AROUND KEY STATEMENTS BY THE ARTIST BEARING OUT THAT PERSONAL PHILOSOPHY.

AS FOR THE MYSTERY ASSOCIATED WITH INDIANA'S WORK BY SO MANY OBSERVERS, SOME OF IT MUST REMAIN FOR RESOLUTION IN THE VIEWER'S OWN EYE AND EXPERIENCE. THE ARTIST IS RESPONSIBLE FOR A CERTAIN AMOUNT OF MYSTIFICATION, PARTLY BECAUSE HIS MODE OF VISUAL EXPRESSION IS NOT REPRESENTATIONAL AND NARRATIVE BUT SYMBOLIC, ALLUSIVE, DECENTLY CLOTHING

INTIMATE DETAIL IN OUTWARD FORMALITY. ALSO, AS AN IRONIST, A WIT, HE HAS SOMETIMES, ESPECIALLY IN THE MOCKING POP CLIMATE, VENTURED REMARKS THAT CANNOT ALWAYS BE TAKEN AT FACE VALUE.

EVEN SO, HIS DESIRE TO COMMUNICATE IS EXPLICIT. "IS AN ARTIST TALKING TO HIMSELF, OR IS HE TRYING TO COMMUNICATE WITH OTHER PEOPLE? . . . I REALLY HAVE TRIED TO DO BOTH."[8] THAT AIM, EXPRESSED IN 1977, WAS RE-AFFIRMED IN 1982: "IT IS THE WISH OF EVERY ARTIST TO REACH THE BROADEST POSSIBLE PUBLIC. WHAT COULD BE MORE PLEASING? IT IS THE SCALE AND THE AUDIENCE WHICH ARE THE TWO PRIME FACTORS FOR ARTISTS UNDERTAKING PUB-LIC COMMISSIONS."[9] OF RECENT YEARS, MUCH OF HIS EFFORT HAS BEEN DEVOTED TO SUCH COMMISSIONS.

INDIANA MIGHT WELL AGREE WITH AN OBSERVATION BY JOSEF ALBERS THAT THE AIM OF ART IS "TO REVEAL MYSTERIES ABOUT ONESELF." AND ULTIMATELY THE REVELATION IS IN THE WORK ITSELF AND WHAT IT OFFERS OUTSIDE THE REALM OF LITERARY EXEGESIS.

1. ROBERT L. B. TOBIN, IN UNIVERSITY OF TEXAS AT AUSTIN, **ROBERT INDIANA** (1977), EXHIBITION CATALOGUE, P. 17.
2. ALFRED H. BARR, JR., IN THE MUSEUM OF MODERN ART, NEW YORK, **RECENT ACQUISITIONS: PAINTING AND SCULPTURE, DECEMBER 19, 1961–FEBRUARY 26, 1962.**
3. GENE SWENSON, **ART NEWS** (SUMMER 1964), P. 13.
4. MAX KOZLOFF, "NEW YORK LETTER," **ART INTERNATIONAL** 6, NO. 2 (MARCH 1962), P. 58.
5. IN WILLIAM A. FARNSWORTH LIBRARY AND ART MUSEUM, ROCKLAND, ME., **INDIANA'S INDIANAS** (1982), EXHIBITION CATALOGUE, P. VIII.
6. IBID., P. VII.
7. IBID., P. X.
8. IN UNIVERSITY OF TEXAS AT AUSTIN, **ROBERT INDIANA**, P. 26.
9. IN WILLIAM A. FARNSWORTH LIBRARY AND ART MUSEUM, **INDIANA'S INDIANAS**, P. VII.

BY NATURE I AM A KEEPER. I JUST DON'T DISCARD THINGS. . . . IN A SENSE MY ART IS REALLY A REFLECTION OF THAT.

ROBERT INDIANA WAS BORN IN NEW CASTLE, INDIANA, 13 SEPTEMBER 1928 (9/13/28). BOTH THE NUMBERS AND THE PLACE ARE SIGNIFICANT, FOR DATES FIGURE PROMINENTLY IN THE ARTIST'S WORK, AND EARLY IN HIS CAREER HE TOOK THE STATE'S NAME FOR HIS OWN. ACUTELY SENSITIVE TO THE RELENTLESS PROGRESSION OF NUMBERS, HE PLAYS UPON THEIR RECURRENCE AND COINCIDENCE AS LANDMARKS OR SIGNS OF DESTINY, BOTH IN HIS OWN LIFE AND IN RELATION TO OUTSIDE EVENTS.

"MY FASCINATION WITH NUMBERS," HE HAS WRITTEN, "CAME OUT OF A PECULIAR CIRCUMSTANCE . . . MY MOTHER COULDN'T STAND TO LIVE IN ONE HOUSE FOR MORE THAN ONE YEAR AT A TIME. BY THE TIME I WAS SEVENTEEN . . . I HAD LIVED IN TWENTY-ONE DIFFERENT HOUSES. AND SO IT GOT TO BE A KIND OF THING THAT THIS WAS HOUSE NUMBER 6 AND THIS WAS HOUSE NUMBER 13. I WAS VERY CONCERNED ABOUT IT AS A CHILD AND GOT EVEN MORE INTERESTED IN IT LATER."[2]

AT THE TIME OF THE ARTIST'S BIRTH, NEW CASTLE, INDIANA, WAS VERY CLOSE TO THE POPULATION CENTER OF THE UNITED STATES, WHICH WAS A POINT OF PRIDE FOR HOOSIERS; IN OTHER SENSES, TOO, THE STATE CELEBRATED ITSELF AS THE HEART OF THE COUNTRY. INDIANAPOLIS, IN MIDSTATE, WAS DUBBED "THE CROSSROADS OF AMERICA" BECAUSE OF ITS FOCAL POSITION IN TRANSPORTATION; IT THEN OUTSTRIPPED CHICAGO IN THE NUMBER OF ITS RAILROAD CONVERGENCES AND STOOD ASTRIDE THE EAST-WEST "NATIONAL ROAD," U.S. HIGHWAY 40, WHICH TRAVERSED THE STATE FROM THE OHIO LINE TO TERRE HAUTE AT THE ILLINOIS BORDER.

NATIVE SONS SUCH AS THE POET JAMES WHITCOMB RILEY, THE NOVELIST BOOTH TARKINGTON, AND THE SONGWRITER PAUL DRESSER, BROTHER OF THEODORE DREISER, HAD ENDOWED THE STATE WITH A FOLKSY, BACK-HOME IMAGE (FOR EXAMPLE, IN, RESPECTIVELY, **THE LITTLE ORFANT ANNIE BOOK, PENROD,** "THE BANKS OF THE WABASH"). THE DARKER SIDE OF LIFE IN "THE HEART OF THE HEART OF THE COUNTRY"[3] HAD ALSO BEEN DISCLOSED IN THE REALIST NOVELS OF

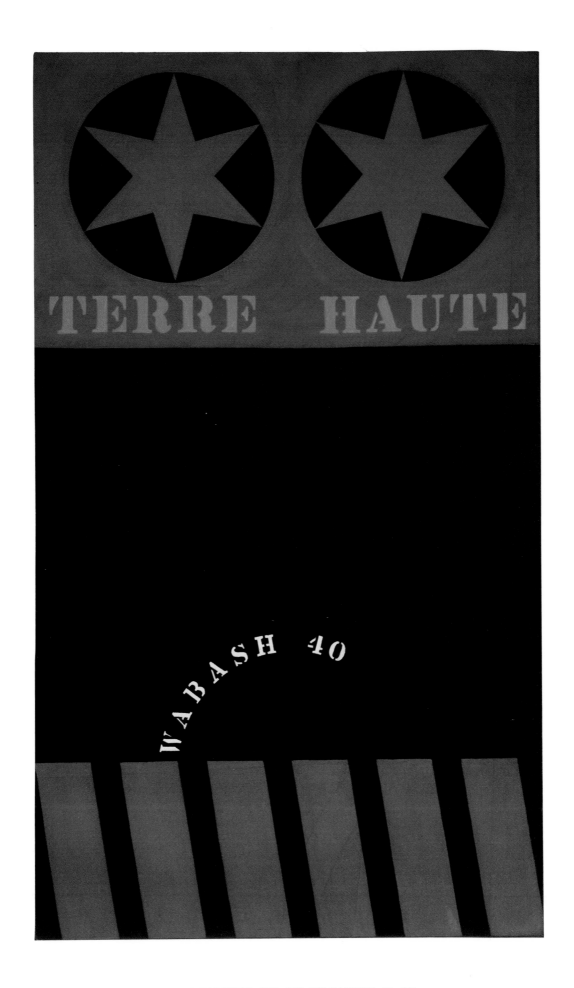

TERRE HAUTE. 1960. OIL ON CANVAS, 60×30″

DREISER, THE SOCIALIST ACTIVISM OF LABOR ADVOCATE EUGENE DEBS, AND THE FLAMBOYANT BANK HEISTS OF JOHN DILLINGER AND HIS GANG.

CULTURALLY, THE STATE SEEMS TO HAVE OFFERED COMPARATIVELY INFERTILE SOIL FOR THE DEVELOPMENT OF VISUAL ARTISTS UP TO THAT POINT, BUT ROBERT INDIANA OFTEN CITES ONE EXEMPLARY FIGURE WHO, HE SAYS, WAS "THE HANS HOFMANN OF HIS DAY"[4]: WILLIAM MERRITT CHASE (1849–1916). CHASE WAS THE MOST INFLUENTIAL TEACHER AROUND THE TURN OF THE CENTURY— BRILLIANT, POLISHED, ELEGANT IN HIS WORK AND IN HIS MANNER OF LIFE. HOWEVER, HE WORKED FAR FROM HIS HOME STATE AND, UNLIKE INDIANA, SELDOM REFERRED BACK TO IT.

INDUSTRIALLY, INDIANAPOLIS WAS THE CENTER OF A THRIVING AUTOMOBILE INDUSTRY, PRODUCING, WITHIN THE STATE, THE LORDLY DUSENBERG, ALONG WITH SOME SIXTY MORE MODEST MODELS AVAILABLE TO SUCH DREAMERS OF "THE AMERICAN DREAM" AS THE PARENTS OF THE FUTURE ARTIST. "CENTERPIECE OF HIS FAMILY'S LIFE," INDIANA RECALLS, THE CAR "WAS MORE STABLE THAN HOME ITSELF. . . ."[5] THE FIRST CAR MENTIONED IN HIS "**AUTO**CHRONOLOGY" (EMPHASIS ADDED), OR AUTOBIOGRAPHICAL JOURNAL, WAS A FLIVVER BEARING AN INDIANA LICENSE PLATE FOR 1927. IT FORMS THE CENTRAL CHARACTER OF HIS **MOTHER** AND **FATHER** DIPTYCH (1963–67; SEE PAGES 118–19), AND THE PAINTER BELIEVES HE MAY HAVE BEEN CONCEIVED IN IT, A CHILD OF THE AUTOMOBILE ERA. ANOTHER CAR THAT HE RECALLS WITH SOME NOSTALGIA AS "THE FAMILY'S FAVORITE POSSESSION" WAS "A PLYMOUTH NAMED BENNY—INCREASINGLY VENERATED AS THE ODOMETER ADVANCES,"[6] WHICH TOOK THEM ON A TRIP TO TEXAS IN 1936.

THAT MOTORCAR INDUSTRY, WHICH SET AMERICANS ON WHEELS (AND ONLY LATER BECAME CENTRALIZED IN DETROIT), PRODUCED AN EVER-SPREADING NETWORK OF HIGHWAYS WITH ALL THE ATTENDANT WAYSIDE STOPS AND SERVICES. ALONG WITH THOSE CAME "THE UBIQUITOUS AMERICAN ROAD SIGN AND PAINTERS OF AMERICAN ROAD SIGNS."[7] AS AN ARTIST WHO HAS DRAWN ON SUCH SIGNS FOR SUBJECT MATTER, INDIANA LATER SPECULATED THAT THE MIDDLE WEST MIGHT

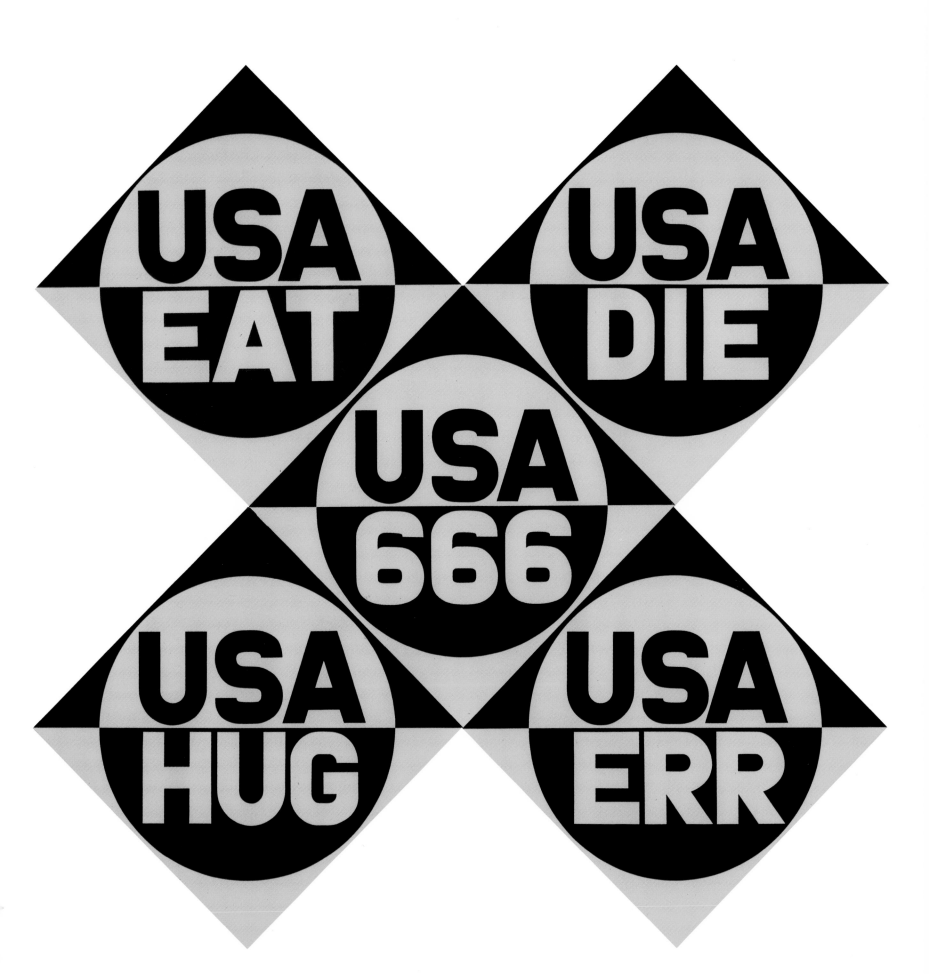

USA 666. 1964–66.

OIL ON CANVAS, 5 PANELS, 8′6″×8′6″

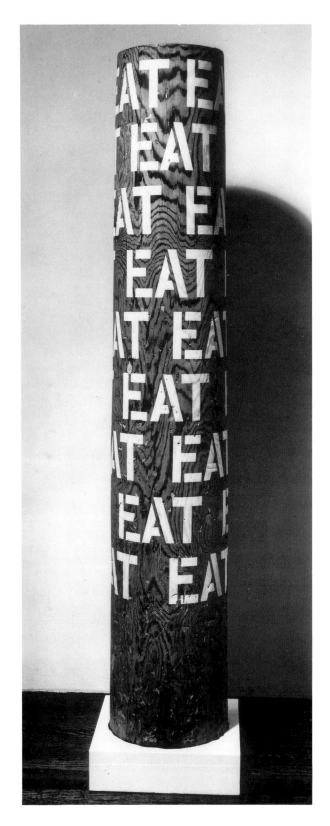

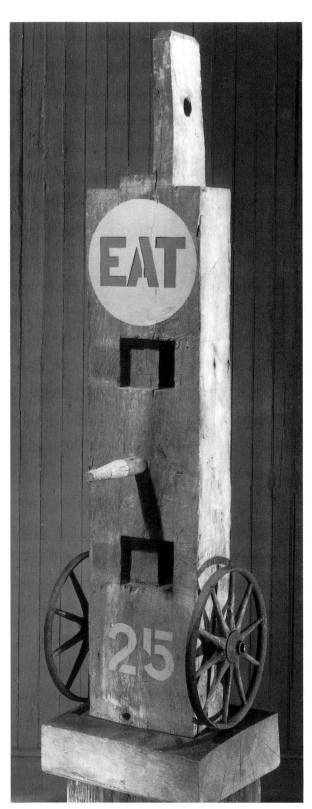

COLUMN: EAT. 1964.

GESSO ON WOOD, HEIGHT 64″ WITH BASE

EAT. 1962.

WOOD AND IRON WITH OIL, HEIGHT 59¾″

HAVE HAD "A LITTLE GREATER PROFUSION OF ROAD LITERATURE"[8] THAN OTHER AREAS OF THE COUNTRY.

IN ANY CASE, HIS PERIPATETIC MIDDLE-WESTERN CHILDHOOD, WHICH WITHIN A FEW MONTHS TOOK HIM FROM NEW CASTLE TO VARIOUS TEMPORARY HOMES IN INDIANAPOLIS AND MOORESVILLE, LEFT HIGHWAYS AND THEIR MARKERS IN-GRAINED UPON HIS MEMORIES. THE FAMILIAR DESIGNATIONS OF ROADS WERE THEIR ROUTE NUMBERS—ROUTES 37, 29, 40, 66—NUMBERS THAT TOOK HIS FATHER, EARL CLARK, TOWARD VISIONS OF FORTUNE: "THE TIME," AS THE ARTIST HAS SAID OF THOSE EARLY YEARS, WAS "CALLED DEPRESSION."[9]

THE NUMBERS AND SIGNS OF THAT TIME TOOK SPECIAL FORMS IN THE WORKS THAT GREW OUT OF INDIANA'S MEMORIES. THE FIGURE 6, IN ITS REPETITIONS AND VARIATIONS IN PAINTINGS AND PRINTS OVER SEVERAL YEARS, "IS, IN FACT, AN HOMAGE TO THE ARTIST'S FATHER BECAUSE OF THE CLOSE IDENTIFICATION OF THAT NUMBER WITH HIM."[10] THE PAINTING (AND PRINT) **USA 666** (1964–66), IN BLACK AND YELLOW, "IS A VARIATION OF A . . . SIMILAR PAINTING [DONE EARLIER] IN RED, BLUE, AND GREEN—THE COLORS OF PHILLIPS 66, AN AMERICAN PETROLEUM FIRM THAT EMPLOYED THE ARTIST'S FATHER FOR 12 (2 \times 6) YEARS,"[11] AND A SIGN SEEN OFTEN BY THE CHILD. "BORN IN THE SIXTH MONTH IN A FAMILY OF SIX CHILDREN," INDIANA'S FATHER "DESERTED HIS FAMILY AND WENT WEST FOR A NEW LIFE VIA ROUTE 66."[12]

MORE CLOSELY ASSOCIATED WITH THE ARTIST'S RECOLLECTIONS OF HIS MOTHER, CARMEN, IS THE SIGN EAT, FREQUENTLY COUPLED WITH THE WORD **DIE** IN HIS WORKS IN MANY MEDIUMS: CONSTRUCTIONS, PAINTINGS, GRAPHICS, AND AN ACTUAL SIGN IN ELECTRIC LIGHTS. DURING HIS DEPRESSION CHILDHOOD, HIS MOTHER "USED TO WORK IN RESTAURANTS AND HAVE RESTAURANTS OF HER OWN," HE HAS SAID.[13] "THE MOST PERSONAL ASPECT [OF THOSE TWO WORDS] WAS THAT . . . 'EAT' WAS THE LAST WORD MY MOTHER SAID BEFORE SHE DIED, WHICH ACCOUNTS FOR THE DIPTYCH **EAT/DIE**."[14]

DYING AND ITS ATTENDANT CEREMONIES WERE EARLY IMPRESSED ON THE

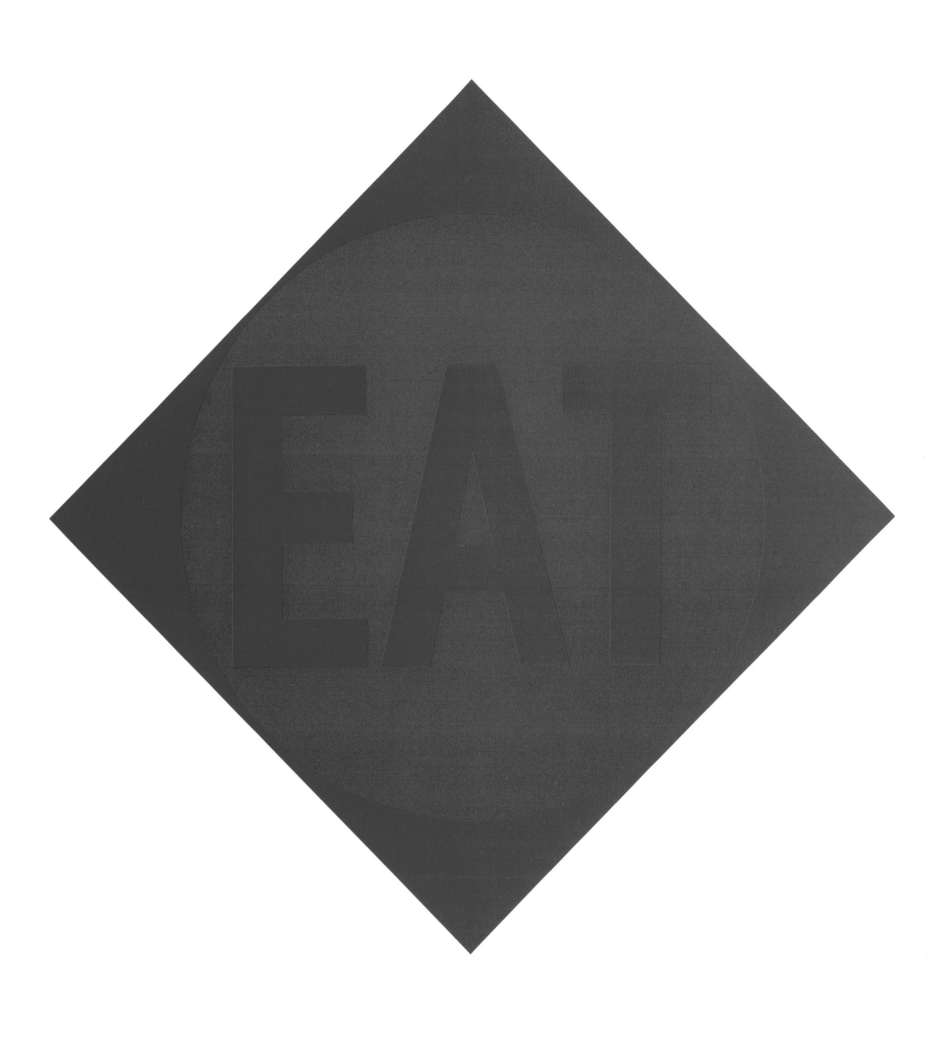

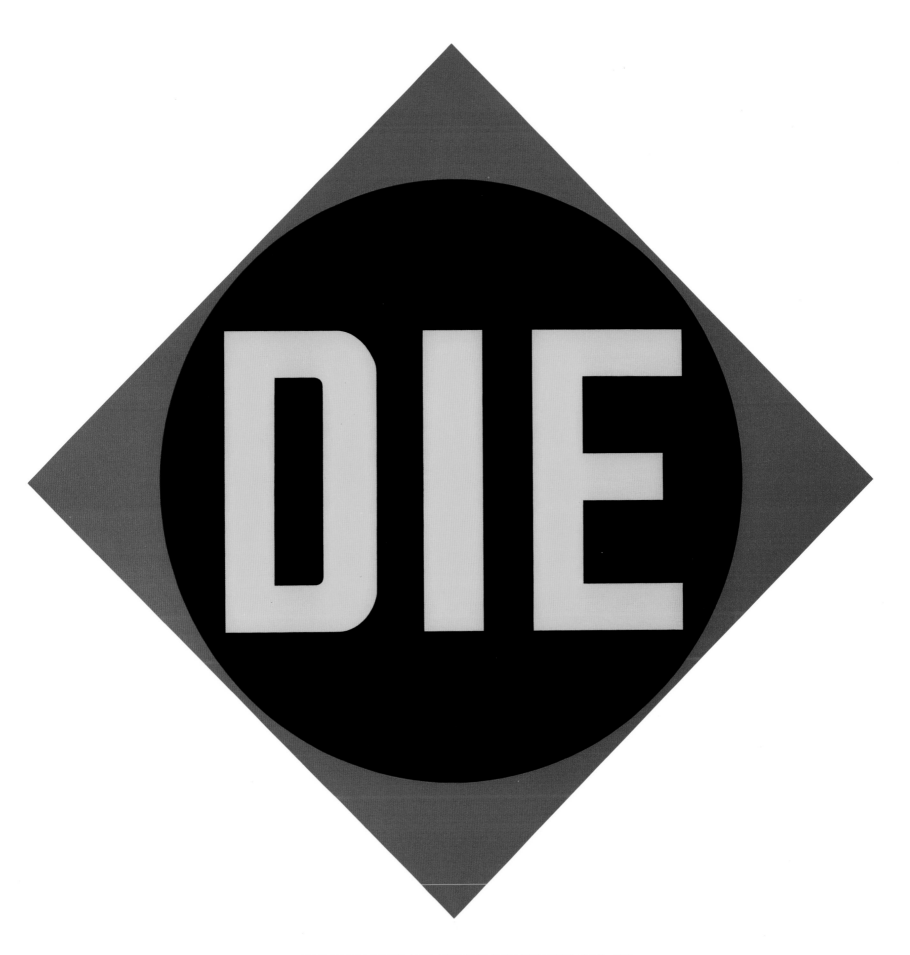

THE GREEN DIAMOND EAT AND **THE RED DIAMOND DIE**. 1962.
OIL ON CANVAS, 2 PANELS, EACH 85×85″. WALKER ART CENTER, MINNEAPOLIS

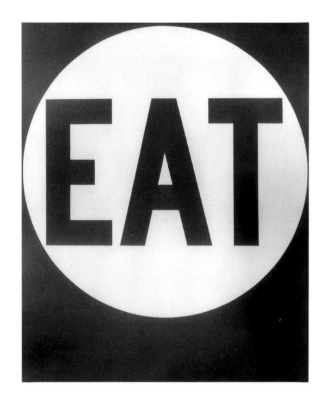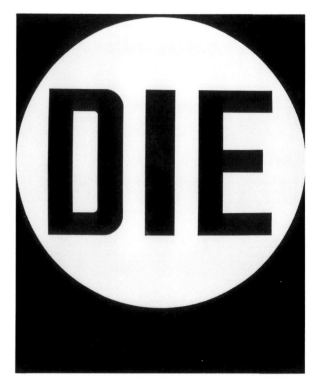

EAT AND **DIE**. 1962. OIL ON CANVAS, 2 PANELS, EACH 72×60″

BOY'S MIND. ONE OR ANOTHER OF HIS FATHER'S LARGE FAMILY OF AUNTS AND UNCLES OR HIS GRANDMOTHERS AND GRANDFATHERS SEEMED ALWAYS TO BE AT DEATH'S DOOR, AND HIS CHILDHOOD, IN RETROSPECT, RESEMBLED ONE LONG FUNERAL PROCESSION. EACH DECORATION DAY, IT WAS HIS MOTHER'S PROJECT TO TRAVEL BY CAR ALONG A PLANNED ROUTE FROM GRAVEYARD TO GRAVEYARD, BEARING TRIBUTES FOR THE TOMBS OF VARIOUS RELATIVES. NOT SURPRISINGLY, SOME OF THE CONSTRUCTIONS THAT THE YOUNG ARTIST LATER MADE OF FOUND MATERIALS TOOK THE FORM OF COMMEMORATIVE MARKERS, WHICH HE THOUGHT OF AS HERMS OR STELES.

THE DEADLY REALITIES OF THE DEPRESSION, HOWEVER, WERE OFFSET BY A DEEPLY ROMANTIC ASPECT OF LIFE IN THE STATE OF INDIANA, AS LYRICALLY EXPRESSED IN THE NOVEL **RAINTREE COUNTY** (1948) BY ROSS LOCKRIDGE, JR., WHO, LIKE INDIANA, WAS BORN IN NEW CASTLE. THE NEW CASTLE THAT LOCK-

RIDGE RECONSTRUCTED UNDER THE NAME OF FREEHAVEN WAS "A PLACE THAT HAD NO BOUNDARIES IN TIME AND SPACE, WHERE LURKED MUSICAL AND STRANGE NAMES AND MYTHICAL AND LOST PEOPLE, AND WHICH WAS ITSELF ONLY A NAME MUSICAL AND STRANGE."[15] A MAP ILLUSTRATION DEPICTING RAINTREE COUNTY (ACTUALLY, HENRY COUNTY) SHOWS PARADISE LAKE, IN THE CENTER, "A POOL OF SHIMMERING GREEN," AND THE OVERALL COLORS "ALL WARM AND GLOWING . . . WITH THE WORDS INSCRIBED ON THE DEEP PAPER . . . DAWNWORDS, EACH ONE DISCLOSING THE ORIGIN AND ESSENCE OF THE THING NAMED."[16]

THAT DESCRIPTION MIGHT ALMOST HAVE BEEN WRITTEN OF SOME OF INDIANA'S WORD PAINTINGS: OF **THE CALUMET** (1961), FOR EXAMPLE, WHICH, QUOTING HENRY WADSWORTH LONGFELLOW'S **HIAWATHA,** SEEMS TO CHANT A LITANY OF INDIAN TRIBAL NAMES CIRCLING IN STAR-FILLED RINGS OF EARTH RED AND YELLOW ABOUT THE CENTRAL SYMBOLIC WORD **PUKWANA,** THE PEACE PIPE. ECHOING THE POET'S PAEAN TO THE VANISHING RED MAN AND HIS EQUALLY DISAPPEARING WORLD OF NATURE, THE PAINTING REPRESENTS IN ITS AUTHOR'S OPINION THE CULMINATION OF HIS MOST LITERARY PERIOD.

THE LOVE OF POETRY, OF WORDS WITH ALL THEIR QUALITIES OF SHAPE AND RESONANCE, OF PERSONAL POIGNANCY AND COMMON HUMAN INTERCHANGE, WENT HAND IN HAND IN ROBERT INDIANA'S SCHOOLING WITH THE LOVE OF ART. BY THE AGE OF SIX HE HAD DISCOVERED THE OUTLET OF DRAWING AND, PERHAPS FURTHER ATTRACTED BY EXPOSURE TO THE DECORATIVE STAR-SHAPED DESIGNS IN WOOD MADE BY A HOUSE-PAINTER UNCLE, DECIDED TO BECOME AN ARTIST. BEGINNING PRIMARY SCHOOL IN MOORESVILLE WHEN HE WAS SEVEN, THE BOY FOUND SWIFT ENCOURAGEMENT IN THIS AMBITION FROM HIS TEACHER, MISS RUTH COFFMAN, WHO CHOSE TWO OF HIS DRAWINGS FOR HER PERMANENT FILE. THEY WERE, HE SAYS, STRONGLY INFLUENCED BY CURRIER AND IVES SCENES, ONE OF THEM "DEPICTING THE WOMENFOLK OF HIS LARGE CLAN PREPARING SUNDAY DINNER ON THE FARM."[17]

INDIANA HAS NOT CARED TO EXPOSE HIS JUVENILE WORKS, WITH THE EXCEP-

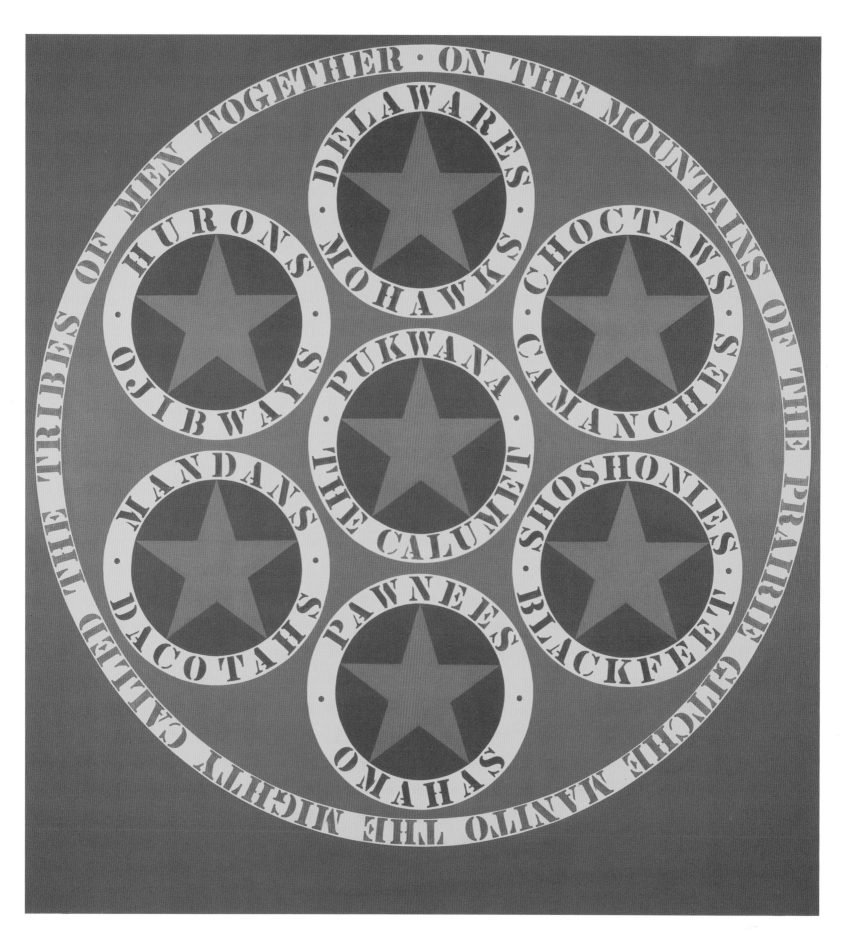

THE CALUMET. 1961. OIL ON CANVAS, 90×84″. ROSE ART MUSEUM, BRANDEIS UNIVERSITY, WALTHAM, MASSACHUSETTS. GERVIRTZ-MNUCHIN PURCHASE FUND

TION OF ONE, **HERO,** FROM ABOUT 1936, WHEN HE WAS STILL IN HIS EARLY GRADE-SCHOOL YEARS. THIS LITTLE PENCIL-AND-CRAYON DRAWING ALREADY SHOWS THREE KEYNOTES—"THE THREE C'S," HE LATER CALLED THEM—THAT CHARACTERIZE HIS MATURE OUTPUT: IT WAS "COMMEMORATIVE, CELEBRATORY, AND COLORFUL."[18] THE SUBJECT IS THE FAMILIAR STORY OF THE DUTCH BOY AT THE DIKE HOLDING BACK THE FLOOD. EVEN IN THIS FORMATIVE STAGE, WORDS ENTER THE PICTURE AS A LABEL—"RUM RUN" ON A CHILD'S EXPRESS WAGON.

IN SOME OF THE RURAL SCHOOLS THAT INDIANA FIRST ATTENDED, NO ART INSTRUCTION WAS OFFERED. IN 1942 HE WENT TO STAY WITH HIS FATHER IN INDIANAPOLIS, WHERE HE ENROLLED IN THE ARSENAL TECHNICAL HIGH SCHOOL, WHICH HAD THE STRONGEST ART CURRICULUM FOR YOUNG STUDENTS IN THE STATE. THERE HE ENCOUNTERED ANOTHER SYMPATHETIC TEACHER, MISS SARA BARD, A WATERCOLORIST, WHO FOSTERED HIS INTEREST IN ART AS A CAREER. IN AN EXHIBITION OF STUDENT WORK SPONSORED BY A DEPARTMENT STORE, HE MADE HIS FIRST SALE—TEN DOLLARS FOR A WATERCOLOR OF THE GRANARY THAT FACED HIS GRANDMOTHER'S LAST HOME IN MOORESVILLE. ALREADY HE WAS LOOKING BACKWARD AS WELL AS FORWARD. IN HIS LAST YEAR OF SCHOOL HE TOOK SIX "HOURS" A DAY UNDER MISS BARD, WHO, HE WROTE LATER, IN RETRACING HIS ROUTE TOWARD THE STAGE DESIGNS FOR VIRGIL THOMSON'S **THE MOTHER OF US ALL,** "COULD HAVE STEPPED PRIMLY" FROM GERTRUDE STEIN'S PAGES OF THE OPERA'S TEXT. MISS BARD, HE RECALLED, "WAS INTENT THAT I SHOULD KNOW ART HISTORY SINCE IMPRESSIONISM AS WELL AS SHE." HER ACADEMIC DRILLS, HE SUGGESTS, MAY HAVE "GIVEN DISPROPORTIONATE ATTENTION . . . TO MARY CASSATT, GEORGIA O'KEEFFE, AND THE FAMOUS ART PATRONESS MISS STEIN."[19] NEVERTHELESS, THE GERM OF AN INSPIRATION MAY HAVE COME FROM THERE.

IN ADDITION TO THE FULL SCHOOL PROGRAM OF ART COURSES, INDIANA ATTENDED SATURDAY FIGURE-DRAWING CLASSES AT THE NEARBY JOHN HERRON ART INSTITUTE AND BECAME FAMILIAR WITH THE CONTENTS OF ITS COLLECTION, INCLUDING A REPRODUCTION OF PICASSO'S PORTRAIT OF GERTRUDE STEIN. AFTER

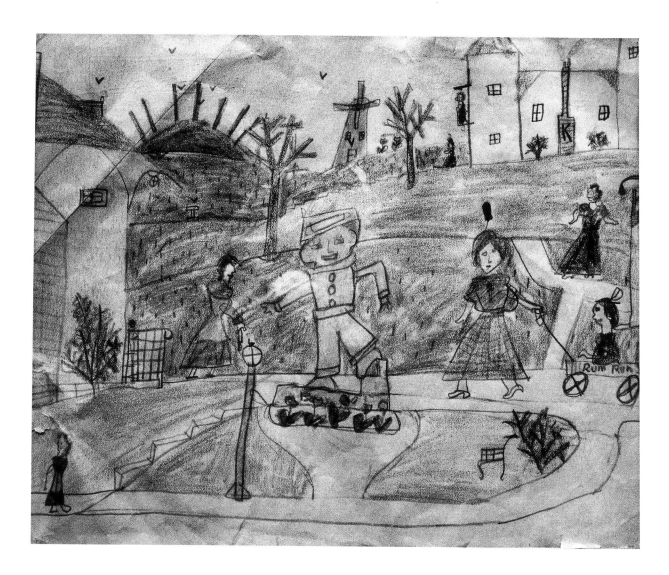

HERO. C. 1936. CRAYON AND PENCIL ON PAPER, 8⁷⁄₁₆ × 10¹⁵⁄₁₆″

SCHOOL AND ON WEEKENDS, HE WORKED IN THE OFFICES OF WESTERN UNION AND LATER AT THE **INDIANAPOLIS STAR**. SIMULTANEOUSLY HE WAS STUDYING LATIN, ENGLISH, AND JOURNALISM, AS WELL AS WRITING POETRY AND MEMORIZING REAMS OF IT. POE'S "THE BELLS" WAS ONE POEM HE LEARNED BY HEART, AND ITS "TINTINNABULATION" CLANGS AGAIN AS SPELLED OUT IN A RING OF STENCIL-FORMED LETTERS AROUND THE CENTRAL NUMERAL 3, WHICH OVERLIES AN EQUI-LATERAL TRIANGLE IN HIS 1962 POLYGON SERIES PAINTING **TRIANGLE**. OTHER FAVORITES FROM HIS STUDY OF AMERICAN CLASSICS WOULD EMERGE WHEN CIR-

CUMSTANCES FAVORED HIS BECOMING THE "POET IN PAINT" THAT HE ENVISIONED.

THE LAST YEAR OF HIGH SCHOOL IN INDIANAPOLIS WAS ALSO THE YEAR THAT INDIANA LEFT HIS HOME STATE, NEVER TO LIVE THERE AGAIN. AT GRADUATION HE WON A NATIONAL SCHOLASTIC ART AWARDS COMPETITION, WHICH WOULD HAVE GIVEN HIM A SCHOLARSHIP TO THE JOHN HERRON ART INSTITUTE, BUT INSTEAD (LIKE SOME OTHER ARTISTS OF HIS GENERATION, INCLUDING CY TWOMBLY, ROBERT RAUSCHENBERG, AND ROY LICHTENSTEIN) HE HEADED FOR THE BROADER BENEFITS OF THE GI BILL OF RIGHTS AND, AT THE AGE OF SEVENTEEN, ENLISTED IN THE ARMY AIR CORPS, TAKING HIS BASIC TRAINING AT LACKLAND AIR FORCE BASE IN TEXAS.

IN 1948, WHILE HE WAS STATIONED IN ROME, NEW YORK, ART CLASSES AGAIN BECAME AVAILABLE TO YOUNG INDIANA, THIS TIME AT SYRACUSE UNIVERSITY AND AT THE MUNSON-WILLIAMS-PROCTOR INSTITUTE IN UTICA, WHERE HE ENCOUNTERED A MORE MODERNIST POINT OF VIEW UNDER THE INSTRUCTION OF OSCAR WEISSBUCH. THAT PERIOD OF HIS LIFE OFFERED ALSO HIS FIRST GLIMPSE OF NEW YORK CITY, WHERE HE WAS TO WORK FOR OVER TWENTY YEARS.

ANCHORAGE, ALASKA, WAS THE FINAL POSTING OF HIS MILITARY SERVICE, IN 1949, WHERE HE EDITED THE **SOURDOUGH SENTINEL,** A TEST OF HIS HIGH SCHOOL JOURNALISM STUDIES. THAT YEAR, HOWEVER, HIS MOTHER DIED, AND HE WAS GIVEN COMPASSIONATE LEAVE TO RETURN TO COLUMBUS, INDIANA (A TOWN THAT MANY YEARS LATER, IN 1981, INVITED HIM BACK TO CREATE A CELEBRATORY CITY EMBLEM).

FOUR YEARS AT THE SCHOOL OF THE ART INSTITUTE OF CHICAGO UNDER THE GI BILL FOLLOWED. AT NIGHT HE WORKED VARIOUSLY FOR RYERSON STEEL, MARSHALL FIELD'S DEPARTMENT STORE, AND THE LARGE PRINTING FIRM OF R. R. DONNELLEY, WHERE HE MADE SPOT DRAWINGS FOR TELEPHONE DIRECTORY PAGES. INDIANA'S WORK WAS EXHIBITED ALONG WITH THAT OF OTHER STUDENTS, INCLUDING CLAES OLDENBURG, AND AT GRADUATION HE WAS REWARDED WITH A GEORGE BROWN TRAVELLING FELLOWSHIP AND A SUMMER SCHOLARSHIP FOR THE SKOW-

HEGAN SCHOOL OF PAINTING AND SCULPTURE IN MAINE. HOWEVER, HIS CHICAGO EXPERIENCE LEFT HIM WITH SOME SENSE OF DISAPPOINTMENT; THE ART INSTITUTE WAS "AN ENORMOUS SCHOOL WITH A HUGE FACULTY . . . BUT THERE WAS NEVER . . . THAT IDEAL SITUATION WHERE THE STUDENT COULD . . . OBSERVE THE MASTER AT WORK."[20] THE MASS-EDUCATION PATTERN OF MANY AMERICAN ART SCHOOLS SEEMED TO HIM FAR FROM IDEAL.

SKOWHEGAN WAS SOMETHING ELSE, MORE LIKE THE ATMOSPHERE OF THE JOHN HERRON, WHERE, AS INDIANA REMEMBERED, AT LEAST EACH INSTRUCTOR HAD A PRIVATE STUDIO IN THE SCHOOL. AT SKOWHEGAN, "I HAD MY OWN HORSE STALL, AND THAT WAS SO NICE, TO HAVE A LITTLE CUBICLE . . . AND KNOW THAT YOU DID NOT HAVE TO SHARE WITH TEN OTHER PEOPLE . . . THE DAY."[21] THAT PLEASURABLE INTERVAL, BRIEF THOUGH IT WAS, REMAINED IN HIS MIND; IT INFLUENCED INDIANA'S MUCH LATER MOVE TO MAINE. IT ALSO EXPLAINS HOW AND WHY HE ARRANGED HIS WORKING QUARTERS AS HE DID IN THE STUDIOS HE CAME TO OCCUPY LATER.

THE TRAVELING FELLOWSHIP HE HAD WON IN COMPETITION GAVE HIM HIS FIRST OPPORTUNITY TO VISIT AND STUDY IN EUROPE. A YEAR OF ACADEMIC COURSES AT THE UNIVERSITY OF EDINBURGH SATISFIED THE REQUIREMENTS FOR A BACHELOR OF FINE ARTS DEGREE FROM THE CHICAGO ART INSTITUTE. AT THE SAME TIME INDIANA WENT TO THE EDINBURGH COLLEGE OF ART IN THE EVENINGS TO HAND SET AND PRINT SOME OF HIS OWN POETRY WITH ILLUSTRATIONS IN LITHOGRAPHY. TRIPS TO BELGIUM, FRANCE, AND ITALY IN THE COMPANY OF ART HISTORY GRADUATE STUDENTS AND A SUMMER SESSION IN ART AND HISTORICAL SUBJECTS AT THE UNIVERSITY OF LONDON BROUGHT HIM TO THE END OF HIS FELLOWSHIP AND HIS CASH.

HE PRESENTED HIMSELF AT THE UNITED STATES EMBASSY IN LONDON DESIRING PASSAGE MONEY HOME. HIS RETURN WESTWARD TOOK HIM NO FARTHER THAN NEW YORK CITY, WHERE, HIS FORMAL EDUCATION CONCLUDED, HE STOOD READY TO BEGIN THE SERIOUS WORK OF HIS CAREER.

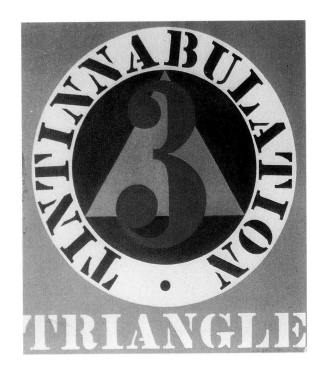

TRIANGLE. 1962. OIL ON CANVAS, 24×22".
COLLECTION MR. AND MRS. FREDERICK RUDOLPH, WILLIAMSTOWN, MASSACHUSETTS

1. IN UNIVERSITY OF TEXAS AT AUSTIN, **ROBERT INDIANA** (1977), EXHIBITION CATALOGUE, P. 37.

2. IBID., P. 40.

3. WILLIAM GASS, **IN THE HEART OF THE HEART OF THE COUNTRY AND OTHER STORIES** (NEW YORK: POCKET BOOKS, 1977).

4–7. ROBERT INDIANA, "AUTOCHRONOLOGY," IN UNIVERSITY OF TEXAS AT AUSTIN, **ROBERT INDIANA,** P. 45.

8. IN UNIVERSITY OF TEXAS AT AUSTIN, **ROBERT INDIANA,** P. 33.

9. INDIANA, "AUTOCHRONOLOGY," IN UNIVERSITY OF TEXAS AT AUSTIN, **ROBERT INDIANA,** P. 45.

10–12. **INDIANA GRAPHIK: ROBERT INDIANA, THE PRINTS AND POSTERS, 1961–1971** (STUTTGART AND NEW YORK: EDITION DOMBERGER, 1971), P. 96.

13, 14. IN UNIVERSITY OF TEXAS AT AUSTIN, **ROBERT INDIANA,** P. 33.

15, 16. ROSS LOCKRIDGE, JR., **RAINTREE COUNTY** (BOSTON: HOUGHTON-MIFFLIN, 1948), P. 5.

17. INDIANA, "AUTOCHRONOLOGY," IN UNIVERSITY OF TEXAS AT AUSTIN, **ROBERT INDIANA,** P. 45.

18. IN UNIVERSITY OF TEXAS AT AUSTIN, **ROBERT INDIANA,** P. 33.

19. MANUSCRIPT PROVIDED BY ROBERT INDIANA.

20, 21. IN UNIVERSITY OF TEXAS AT AUSTIN, **ROBERT INDIANA,** P. 33.

.... HAVING LITTLE OR NO MONEY AND NO PARTICULAR INTEREST IN THE WAVE OF ABSTRACT EXPRESSIONISM THAT HAD INUNDATED THE MIDDLE PART OF MANHATTAN, I CAME TO THE TIP END OF THE ISLAND, WHERE THE HARD EDGE OF THE CITY CONFRONTS THE WATERY PART.

THE TIME WAS THE LAST DAY OF JUNE 1956. THE PLACE WAS COEN-
TIES SLIP, "IN THAT FRINGE OF DERELICT WAREHOUSES,"[2] DAT-
ING FROM THE FIRE OF 1835, THAT FACED THE HARBOR BETWEEN
WHITEHALL AND CORLEARS HOOK. THERE THE TWENTY-EIGHT-
YEAR-OLD ARTIST RENTED A TOP-FLOOR LOFT, "A CHEAP ACCOM-
MODATION"[3] BY NECESSITY, BUT FROM ITS SIX WINDOWS (GLASS
REPLACED BY THE NEW TENANT HIMSELF, FOR A RENT CONCESSION FROM THIRTY-
FIVE TO THIRTY DOLLARS PER MONTH) HE "OVERLOOKED THE EAST RIVER;
BROOKLYN HEIGHTS; . . . ABANDONED PIERS 5, 6, 7, AND 8; THE SYCAMORES (AS
HOOSIER AS A TREE CAN BE) AND GINKGOES OF THE SMALL PARK CALLED JEAN-
NETTE; AND THE FAR SIDE OF THE BROOKLYN BRIDGE, THROUGH WHOSE ANTIQUE
CABLES THE SUN [ROSE] EACH MORNING."[4] IT WAS THERE, TOO, THAT MANY OF THE
ELEMENTS THAT WERE TO BECOME THE HALLMARKS OF HIS ART COALESCED, OR, AS
HE LATER WROTE, "SO THEN DID ALL THINGS WEAVE TOGETHER."[5]

BEFORE FINDING THAT HAVEN, INDIANA HAD SPENT THE FIRST AND BRIEFEST
PERIOD OF HIS STAY IN NEW YORK IN THE FLORAL STUDIOS, WHERE A ROOM COULD
BE HAD FOR SEVEN DOLLARS A WEEK, AND THEN HAD TAKEN TEMPORARILY A
"REAL" STUDIO ON WEST SIXTY-THIRD STREET AND A JOB SELLING ART SUPPLIES
NEARBY ON FIFTY-SEVENTH STREET. ALTHOUGH HE LIVED AND WORKED AT THE
TIME CLOSE TO THE ART STUDENTS LEAGUE AND A NUMBER OF GALLERIES, HE
FELT NO INFLUENCE FROM THEIR PROXIMITY. EVEN HAD HE BEEN ATTRACTED TO
ABSTRACT EXPRESSIONISM, "LOW IN POCKET" AS HE WAS, HE COULD NOT HAVE
AFFORDED THE HEFT OF PIGMENT OR THE EXPANSE OF CANVAS CONSUMED BY THAT
SCHOOL OF PAINTING.

AN INFLUENCE HE FREELY ACKNOWLEDGES FROM THIS EARLY PERIOD IS ELLS-
WORTH KELLY, WHO BECAME A FRIEND AND, HE SAYS, "WAS THE FIRST REALLY
PROFESSIONAL ARTIST THAT I CAME INTO CONTACT WITH."[6] THE USE OF PRIMARY
COLORS IN HARD-EDGED FORMS IMPRESSED INDIANA, AT THE TIME, AS HE PUTS IT,
A "YOUNG, RECENTLY GRADUATED ART STUDENT WHO NEVER THOUGHT ABOUT

COLOR UNTIL I KNEW ELLSWORTH AND HEARD HIS LONG DISCOURSES ON THE SUBJECT AND WATCHED HIS PAINTINGS BEING PAINTED."[7] OTHER CLOSE FRIENDS FROM THE FIRST NEW YORK YEARS INCLUDE JAMES ROSENQUIST, CHARLES HINMAN, AND JOHN HOPPE, CREATOR OF **MOBILUX,** A KINETIC LIGHT FORM THAT MAKES ABSTRACT LIGHT PATTERNS. (INDIANA WAS TO COLLABORATE WITH HOPPE OVER THE NEXT FEW YEARS IN TELEVISION AND STAGE PERFORMANCES, FORERUNNERS OF HIS MAJOR THEATRICAL DESIGN UNDERTAKINGS.)

HIS SECOND STUDIO, AT 61 FOURTH AVENUE, TOOK INDIANA INTO THE REGION OF BOOKSELLERS ROW, AN AREA ALSO FILLED WITH ARTISTS. THE FORMER SITE OF ROBERT MOTHERWELL'S SCHOOL AND LATER THE REUBEN GALLERY, IT HAD A VIEW OF WILLEM DE KOONING'S STUDIO ON THE SAME BLOCK—AS CLOSE TO ABSTRACT EXPRESSIONISM, THE YOUNG PAINTER WISECRACKED, AS HE WOULD EVER COME. THERE IS A WHIFF OF SERIOUSNESS IN THE JOKE, SINCE INDIANA AND HIS CONTEMPORARIES, VIEWING THAT MOVEMENT AS PEDANTIC, ACADEMIC, A PART OF THE PAST TO BE PUT ASIDE ALONG WITH WHAT INDIANA LABELED "THE CHICAGO MONSTER, EUROPEAN ANGST, AND THE NEW YORK GRIM REALITY SCHOOLS,"[8] WERE SOON TO CHALLENGE IT FOR THE ATTENTION OF THE ART PUBLIC.

AT THE SAME TIME, THE NOTION OF A LITERARY CAREER (NURTURED BY SCHOOLING, A HABIT OF COMMITTING THOUGHTS TO PAPER IN DIARIES AND POEMS, PATCHES OF EXPERIENCE IN JOURNALISM, AND A BACKGROUND OF READING AND MEMORIZING) STILL HELD SOME ALLURE FOR INDIANA. AFTER MEETING THE POET JOSÉ GARCÍA VILLA, WHO INTRODUCED HIM TO E. E. CUMMINGS AND THE RITUAL OF "TEA ON PATCHIN PLACE,"[9] THE WRITER IN INDIANA GAVE WAY TO THE STRONGER URGE OF THE PAINTER. HOWEVER, HE HAD NEVER TOTALLY FORSAKEN THE EXPRESSION OF AUTOBIOGRAPHICAL, CRITICAL, AND POETIC CONTENT IN PRINT AS WELL AS IN PAINT.

ONE OF THE MOST IMPORTANT WRITERS IN THE FLEDGLING ARTIST'S LITERARY CANON WAS HERMAN MELVILLE. THE WORDS WITH WHICH INDIANA RECORDED HIS DISCOVERY OF "THE TIP END OF THE ISLAND" OF MANHATTAN PAY HOMAGE TO

THE ROOF OF 3–5 COENTIES SLIP, 1957: ACTRESS DELPHINE SEYRIG, WIFE OF JACK YOUNGERMAN AND MOTHER OF DUNCAN YOUNGERMAN; ROBERT INDIANA; ELLSWORTH KELLY; JACK YOUNGERMAN; AND AGNES MARTIN

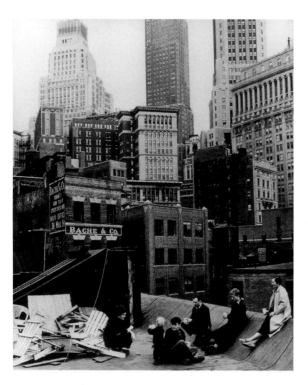

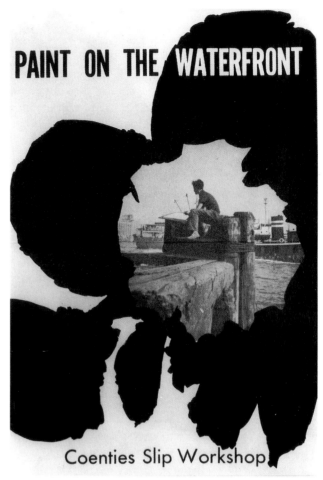

Coenties Slip Workshop

COVER OF BROCHURE FOR THE COENTIES SLIP WORKSHOP, 1957, CONSISTING OF A PHOTOGRAPH OF INDIANA ON A SOUTH STREET PIER DRAWING, SET AGAINST A MOTIF BY JACK YOUNGERMAN

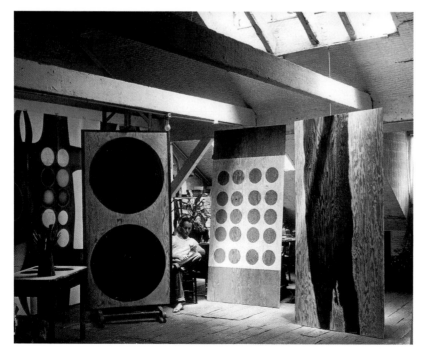

INDIANA IN STUDIO AT 25 COENTIES SLIP, 1959. FROM LEFT TO RIGHT: SEGMENT OF **STAVROSIS (CRUCIFIXION)** (PAGE 50); **COMPOSITION WITH TWO SPHERES** (PAGE 37); **COMPOSITION WITH TWENTY ORBS** (PAGE 37); **TORSO** (OIL RUBBED ON PLYWOOD)

THE OPENING PAGE OF **MOBY DICK**: "THERE NOW IS YOUR INSULAR CITY OF THE MANHATTOES, BELTED ROUND BY WHARVES AS INDIAN ISLES BY CORAL REEFS— COMMERCE SURROUNDS IT WITH HER SURF. . . . CIRCUMAMBULATE THE CITY OF A DREAMY SABBATH AFTERNOON. GO FROM CORLEARS HOOK TO COENTIES SLIP, AND FROM THENCE, BY WHITEHALL, NORTHWARD. WHAT DO YOU SEE?—POSTED LIKE SILENT SENTINELS ALL AROUND THE TOWN, STAND THOUSANDS UPON THOUSANDS OF MORTAL MEN FIXED IN OCEAN REVERIES."

MELVILLE'S DESCRIPTION, PUBLISHED IN 1851, WAS STILL COGENT FOR ARTISTS A CENTURY LATER. "HERE," INDIANA WROTE IN 1961, "THIS HEADY CONFLUENCE OF ALL ELEMENTS . . . CAUSES A NATURAL MAGNETISM THAT HAS DRAWN A DOZEN ARTISTS . . . TO THE SLIP."[10] HE, HIMSELF, WAS THE FIRST OF WHAT BECAME A COMMUNITY OF FRIENDS AND, IN SOME ENTERPRISES, COLLABORATORS TO MOVE THERE, AND HE WAS THE LAST TO LEAVE THE SLIP BEFORE TWO OF ITS THREE BLOCKS WERE DEMOLISHED IN THE MID-1960S TO MAKE WAY FOR MORE SKYSCRAPERS LIKE THE WALL STREET TOWERS IN THE BACKGROUND OF THE 1957 PHOTOGRAPH TAKEN ON A ROOFTOP NEAR HIS STUDIO AT 31 COENTIES SLIP.

THE FRIENDS IN THAT GATHERING ON THE ROOF MUST BE COUNTED AMONG THE "HEADY CONFLUENCE OF ALL ELEMENTS" THAT GAVE DIRECTION TO INDIANA'S CAREER. KELLY'S INFLUENCE HAS ALREADY BEEN MENTIONED. IN 1957, INDIANA AND JACK YOUNGERMAN, HIS NEIGHBOR AT 27 COENTIES SLIP, SET UP A STUDIO FOR FIGURE DRAWING IN YOUNGERMAN'S PREMISES. THE BROCHURE FOR THEIR UNDERTAKING, THE COENTIES SLIP WORKSHOP, BORE A JOINTLY DESIGNED COVER, IN WHICH A PHOTOGRAPH OF INDIANA, SNAPPED IN THE ACT OF DRAWING ON A SOUTH STREET PIER ACROSS FROM THE WORKSHOP, IS SET AGAINST A MOTIF BY YOUNGERMAN. THAT VENTURE, INDIANA SAYS, "UNFORTUNATELY, FROM A FINANCIAL STANDPOINT, NEVER [GREW] TO MUCH MORE THAN A LIFE DRAWING CLASS FOR THE DENIZENS OF THE SLIP."[11] AGNES MARTIN MADE HER CONTRIBUTION ON THE LITERARY SIDE; HER ENTHUSIASM FOR THE WORK OF GERTRUDE STEIN, WHICH SHE READ AND DISCUSSED WITH INDIANA, COMBINED WITH THE INTEREST IN STEIN

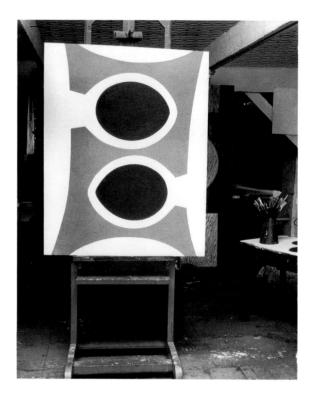

SOURCE I. 1959. OIL ON BOARD, 63½ × 38″

SOURCE II. 1959. OIL ON BOARD, 59⅞ × 47⅞″

AWAKENED IN HIM DURING HIS STUDENT DAYS IN CHICAGO, WOULD EVENTUALLY BEAR FRUIT IN THE CREATION OF HIS DESIGNS FOR **THE MOTHER OF US ALL**. THESE ARTISTS, TOGETHER WITH OTHER CREATIVE TALENTS ASSEMBLED ON COENTIES SLIP, WERE IMPRESSIVE ENOUGH FOR INDIANA LATER TO EQUATE THE LOCATION WITH THE FAMOUS **"BATEAU LAVOIRE"** IN PARIS, THE BATTERED COMPLEX OF STUDIOS AND LIVING QUARTERS THAT HOUSED A CONSTELLATION OF MODERN-ART INNOVATORS EARLY IN THE TWENTIETH CENTURY.

TO THE TRANSPLANTED HOOSIER, WHO HAD NOT BEFORE LIVED ON SUCH A WATERWAY, THESE NEW SURROUNDINGS PROVIDED "FORMAT, STYLE, MATRIX AND SUBSTANCE"[12] FOR HIS WORK. SPELLBOUND, LIKE MELVILLE'S "MORTAL MEN FIXED IN OCEAN REVERIES," HE FOUND, ON GAZING SEAWARD, THAT "EVERY SHIP THAT PASSED ON THE RIVER, EVERY TUG, EVERY BARGE, EVERY RAILROAD CAR ON EVERY FLATBOAT, EVERY TRUCK"[13] HE SAW FROM THE SLIP, AND FROM FRONT,

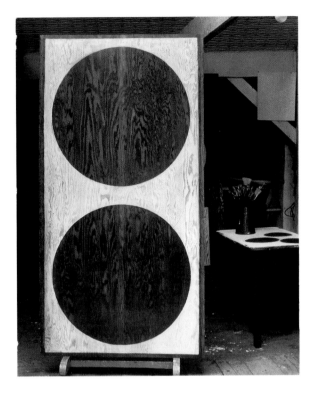

COMPOSITION WITH TWO SPHERES. 1959.
OIL ON PLYWOOD, 84½ × 43½"

COMPOSITION WITH TWENTY ORBS. 1959.
OIL ON PLYWOOD, 91 × 44½"

CAPITAL. 1959. OIL ON PLYWOOD, 94 × 48"

SLIP. 1959. OIL ON PLYWOOD, 94 × 48"

SOUTH, WATER, AND PEARL STREETS, CARRIED "THOSE MARKS AND LEGENDS" THAT WERE TO SET THE STYLE OF HIS PAINTING.

LANDWARD FROM HIS WINDOWS LAY "THAT SOLID CLIFF OF STONE THAT WALL STREET MAKES, MEETING THE SKY AS SHARPLY AS THE PIERS DO THE WATER, ALL LINES OF DEMARCATION CRISP AND SURE."[14] THE VERY OUTLINES OF THE CITY— "HARD EDGE . . . AGAINST THE WATERY PART" AND "CLIFF OF STONE . . . MEETING THE SKY"—SERVED TO REINFORCE THE GEOMETRIC, HARD-EDGE FORMAT THAT HAD IMPRESSED THE YOUNG PAINTER IN ELLSWORTH KELLY'S WORK.

EARLY ENGRAVINGS OF THE TWO BUILDINGS ON COENTIES SLIP, NUMBERS 31 AND THEN 25, IN WHICH INDIANA HAD HIS STUDIOS BETWEEN 1956 AND 1965 REVEAL THAT BOTH HAD BEEN OCCUPIED AROUND THE TURN OF THE CENTURY BY A FIRM OF SHIP CHANDLERS, THE MARINE WORKS, A COINCIDENCE OF MARITIME COMMERCE THAT PROVIDED THE ARTIST WITH A TITLE FOR ONE OF HIS EARLY CONSTRUCTIONS. SINCE NUMBER 31 WAS DEMOLISHED IN 1957, IT WAS NUMBER 25 ("MUCH MORE EXPENSIVE" AT A MONTHLY RENTAL OF FORTY-FIVE DOLLARS) THAT SAW HIS WORK BEGIN TO IMPINGE UPON THE NEW YORK ART WORLD. "EMBLAZONED WITH SIGNS OF WORDS OVER ITS ENTIRE FACADE," HE WROTE, THE BUILDING "BECAME A DAILY CONFRONTATION WITH THE FORMAT MY WORK HAD ASSUMED."[15] ON THE GROUND FLOOR A SPANISH RESTAURANT, SERVED BY A WAITRESS NAMED CARMEN, EVOKED A DIFFERENT SORT OF BACKWARD LOOK, A REMINDER OF HIS MOTHER'S DEPRESSION STRUGGLES. HISTORICAL PAST, PERSONAL PAST, AND CONTEMPORARY CONCERNS BECAME FUSED AS HE TRANSFORMED THEM INTO HIS ART.

HIS SENSE OF HISTORY FOUND SATISFACTION IN THE PLACE ITSELF. COENTIES SLIP, HE LEARNED, WAS "THE OLDEST, LARGEST, AND BUSIEST," AS WELL AS "THE LAST TO BE FILLED IN (C. 1880)," OF MANY SLIPS IN MANHATTAN, ALL OF WHICH WERE "RELICS OF THE WOODEN SHIP DAYS OF SAIL AND MAST."[16] AMONG THE PAINTINGS WITH WHICH INDIANA SALUTED THOSE BYGONE DAYS WERE TWO OF 1961: **THE FAIR REBECCA** AND **YEAR OF METEORS**. **REBECCA,** THE YANKEE SLAVE SHIP, HE SURMISED, "MAY HAVE TAKEN ON PROVISION HERE, AND 'THE GREAT EASTERN'

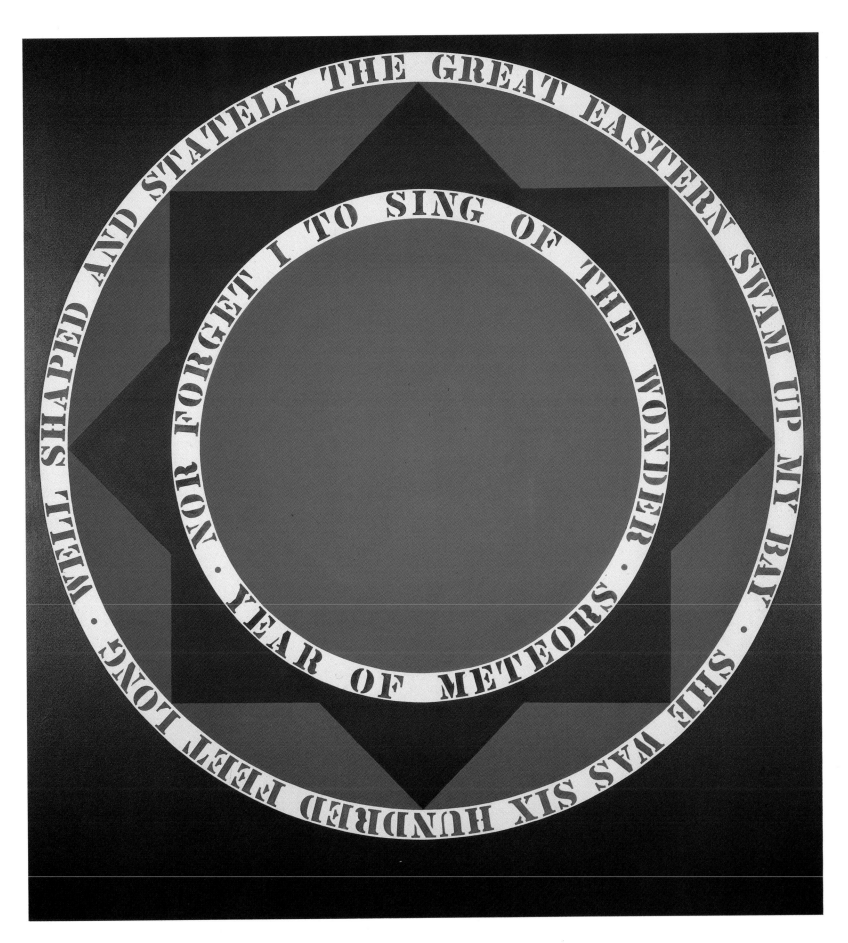

YEAR OF METEORS. 1961. OIL ON CANVAS, 90×84".

ALBRIGHT-KNOX ART GALLERY, BUFFALO, NEW YORK. GIFT OF SEYMOUR H. KNOX

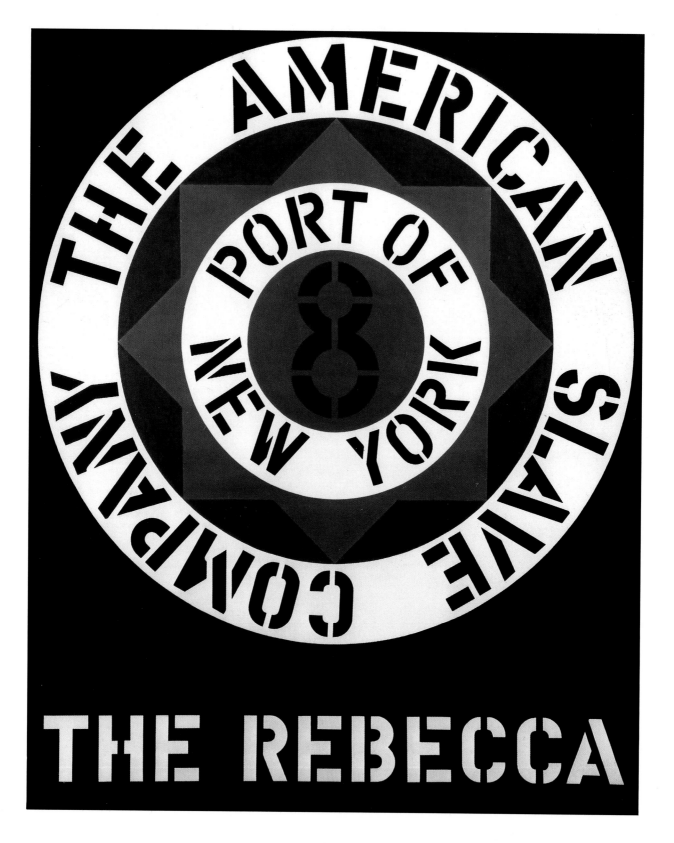

THE REBECCA. 1962. OIL ON CANVAS, 60 × 48″. WHEREABOUTS UNKNOWN

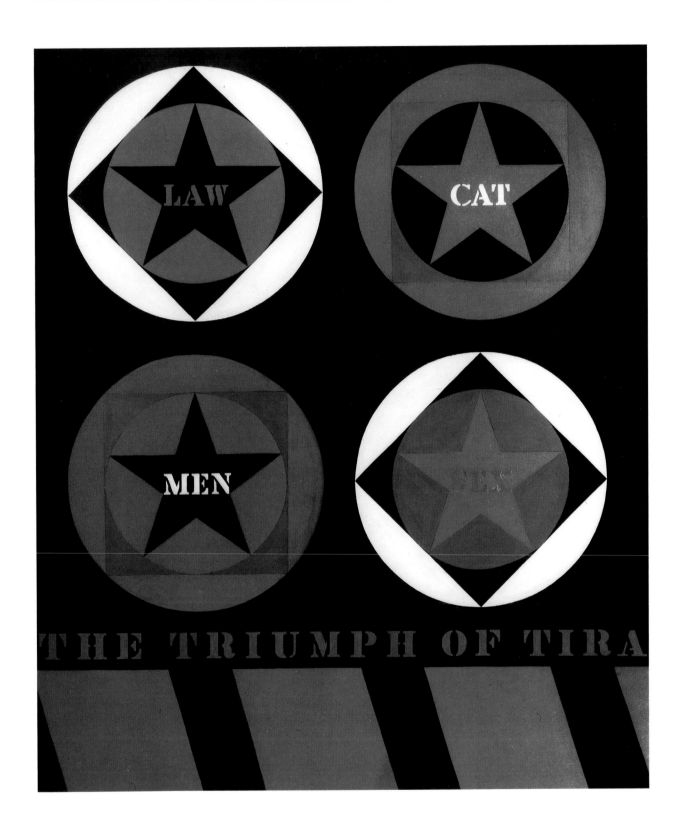

THE TRIUMPH OF TIRA. 1961. OIL ON CANVAS, 72×60″.
SHELDON MEMORIAL ART GALLERY, LINCOLN, NEBRASKA

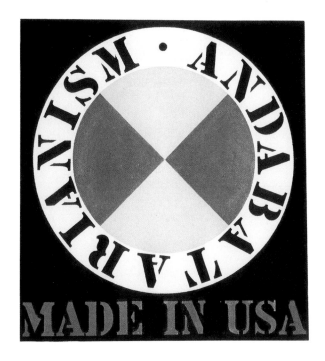 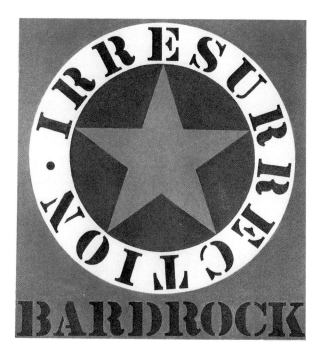

MADE IN USA. 1961. OIL ON CANVAS, 24 × 22″.
COLLECTION MR. AND MRS. EUGENE SCHWARTZ,
NEW YORK

BARDROCK. 1961. OIL ON CANVAS, 24 × 22″.
COLLECTION CAMPBELL WYLLY,
NEW YORK

THAT WALT WHITMAN CELEBRATED IN 'YEAR OF METEORS' . . . CERTAINLY DID STEAM PAST THE SLIP."[17]

WHITMAN'S POEM OF 1859–60, FROM **LEAVES OF GRASS** (1881), CATALOGUED A YEAR OF SPECTACLES AND WONDERS, NOT LEAST OF WHICH WAS THE ATLANTIC CROSSING OF THE HUGE SCREW-PROPELLERED STEAMSHIP **GREAT EASTERN,** WHICH THE POET SAW FROM THE BROOKLYN SIDE OF NEW YORK HARBOR. ON A CANVAS PAINTED IN SEA BLUE AND GREEN, INDIANA DIRECTLY QUOTED SOME OF WHITMAN'S LINES OF TRIBUTE TO THAT EVENT: "NOR FORGET I TO SING OF THE WONDER, THE SHIP AS SHE SWAM UP MY BAY, / WELL-SHAPED AND STATELY THE GREAT EASTERN SWAM UP MY BAY, SHE WAS 600 FEET LONG, / HER MOVING SWIFTLY SURROUNDED BY MYRIADS OF SMALL CRAFT I FORGET NOT TO SING." TWO CONCENTRIC CIRCLES OF WHITE BEARING THE WORDS OVER AN EIGHT-POINTED STAR CONFIGURATION SUGGEST A COMPASS ROSE.

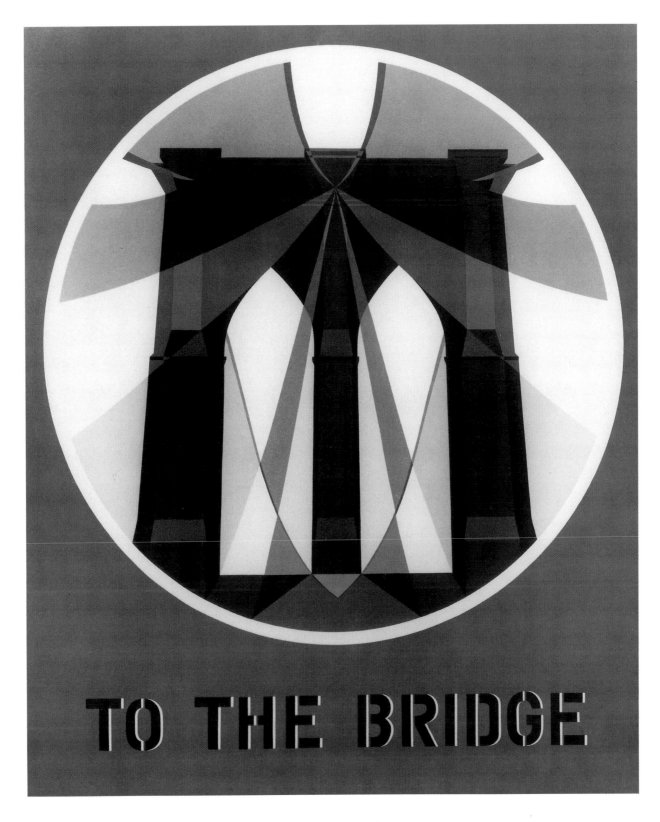

TO THE BRIDGE. 1964.
OIL ON CANVAS, 60 × 50″. PRIVATE COLLECTION, TORONTO

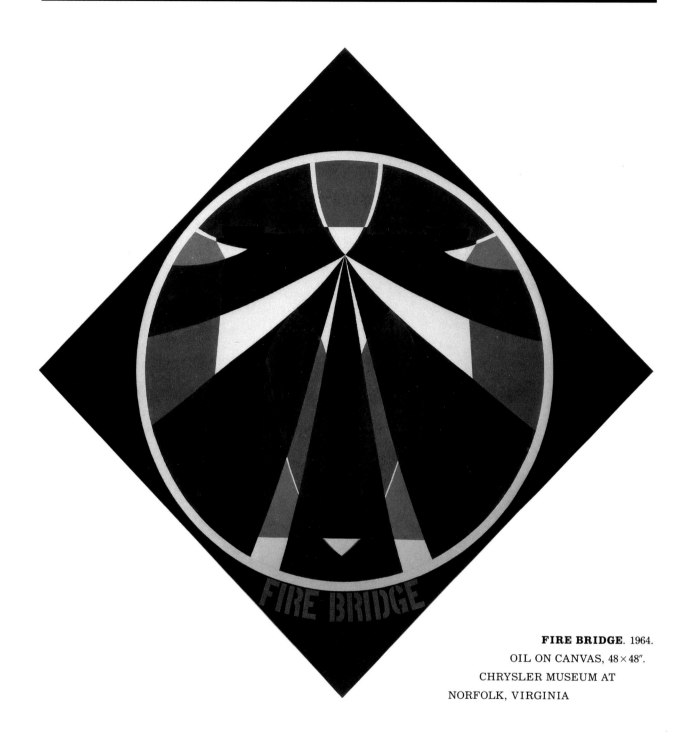

THE WORDS OF A WHITMAN DISCIPLE, HART CRANE, STAND AS THE LITERARY THEME OF INDIANA'S FOUR-PANEL PAINTING OF THE BROOKLYN BRIDGE, THAT LANDMARK WHOSE MASSIVE GRANITE PIERS AND "CHOIRING STRINGS"[18] ROSE BEFORE THE PAINTER'S EYES EACH DAY. SINCE ITS COMPLETION IN 1883, THE STRUCTURE HAS CAPTIVATED WRITERS AND ARTISTS, AMONG THEM CRANE, JOHN

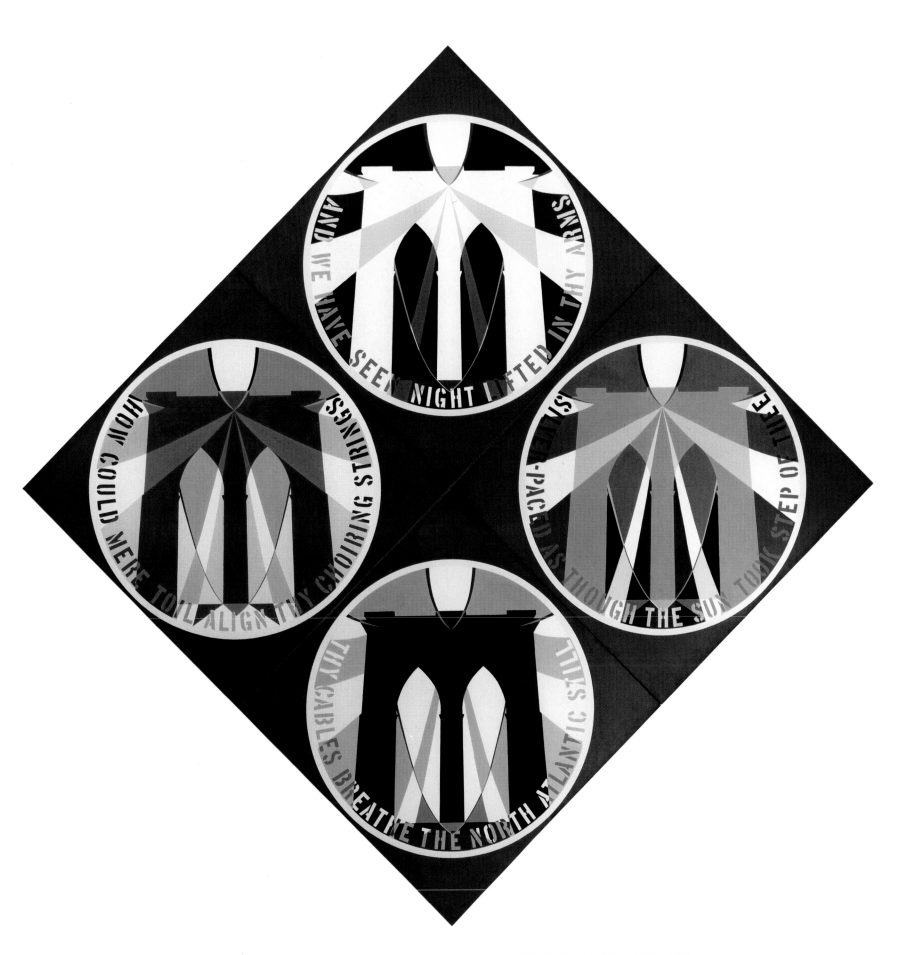

THE BRIDGE (THE BROOKLYN BRIDGE). 1964. OIL ON CANVAS, 4 PANELS, 11′3″ × 11′3″.
THE DETROIT INSTITUTE OF ARTS. FOUNDERS SOCIETY PURCHASE, MR. AND MRS. WALTER B. FORD II FUND

Marin, Georgia O'Keeffe, and Joseph Stella, as well as the photographers Edward Steichen and Berenice Abbott. Indiana's **The Bridge (The Brooklyn Bridge)** (1964) began "as an indirect homage to Joseph Stella . . . and ended as a definite salute to Hart Crane, whose life and death proved transfigured by [the bridge]."[19] Crane's long series of poems, **The Bridge** (1930), takes the great span as a symbol of the development of the United States; during the writing he lived in the Brooklyn Heights apartment where the engineer Washington Roebling, crippled by "the bends," had continued to oversee the construction of his father's bridge design. Each of Indiana's square panels, painted in subtly varied tones of gray, bears a line of Crane's poetry edging the circular format of the bridge image, seen head-on, like a gateway. Sharply contrasting with this cool, poetic version of the subject is a slightly later picture, **Fire Bridge** (1964), alight with color against black. It recalls an experience of the painter while walking late one night along South Street: he saw the collision of a tanker and a freighter, which set off an explosion and flames, casting a fiery glow upon the bridge.

Only a step from his door lay the reminders of the dockside scene described in **Moby Dick,** and in 1961 Indiana compressed them into three black-and-white panels called **The Melville Triptych,** quoting that passage. As analyzed by the critic John McCoubrey, "in the triptych's circles of Melville's 'circumambulate' are the point of Corlear's Hook, the Y-form of [Coenties] Slip, and the northward run of Whitehall. . . . The letters give the route of Melville's walk, but the cartographic signs, as they move and open from left to right, and as the vertical on the right is released from the funnel of the Slip, also tell of voyaging."[20] The sense of movement within the triptych suggested to another critic a musical experience, in which "the melody is light and graceful, and deceptively simple."[21]

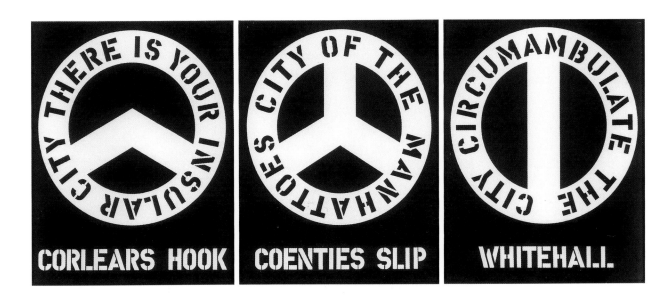

THE MELVILLE TRIPTYCH. 1961. OIL ON CANVAS, 3 PANELS, 5′×12′

DRAWING AGAIN UPON THE SAME LITERARY SOURCE, INDIANA ALSO PAINTED **MELVILLE** (1961), COMPOSED AS A TRIANGLE WITHIN A CIRCLE ON A RECTANGLE, USING CAPTAIN AHAB'S OBSESSIVE AND DEFIANT CRY INTO THE TEETH OF A GALE: "THIS BRAIN TRUCK OF MINE NOW SAILS AMID THE CLOUD SCUD" (LETTERED IN THE CIRCLE) AND "WILDEST WINDS WERE MADE FOR LOFTIEST TRUCKS" (IN THE TRIANGLE). THE WORD **TRUCK,** SO FORCIBLY REITERATED IN ITS SEAGOING CONTEXT (AS A DETAIL OF TOPMAST RIGGING), MAY HAVE SPOKEN TO THE EAR OF THIS ARTIST OF "ROAD LITERATURE"; BUT ALSO, AS MCCOUBREY REMARKED, INDIANA HERE "DRAWS CLOSE TO THE LITERARY FORM OF CONCRETE POETRY, IN WHICH THE DISPOSITION OF WORDS AND LETTERS TYPOGRAPHICALLY CARRIES PART OF THE POEM'S MEANING."[22] THE GEOMETRY OF CIRCUMNAVIGATION, GLOBE, HORIZONS, SAILS IS CERTAINLY SUGGESTED.

ALSO SUGGESTED IN THE PHYSICAL ASPECT OF THESE PAINTINGS AND IN SCULPTURES (OR CONSTRUCTIONS) SUCH AS **AHAB** (1962; SEE PAGE 67), ANOTHER OFFSHOOT OF THE MELVILLE STIMULUS, IS THE INFLUENCE OF A TROVE OF USABLE MATERIALS LYING ABOUT THE ABANDONED BUILDINGS AND ROTTING PIERS. TO AN

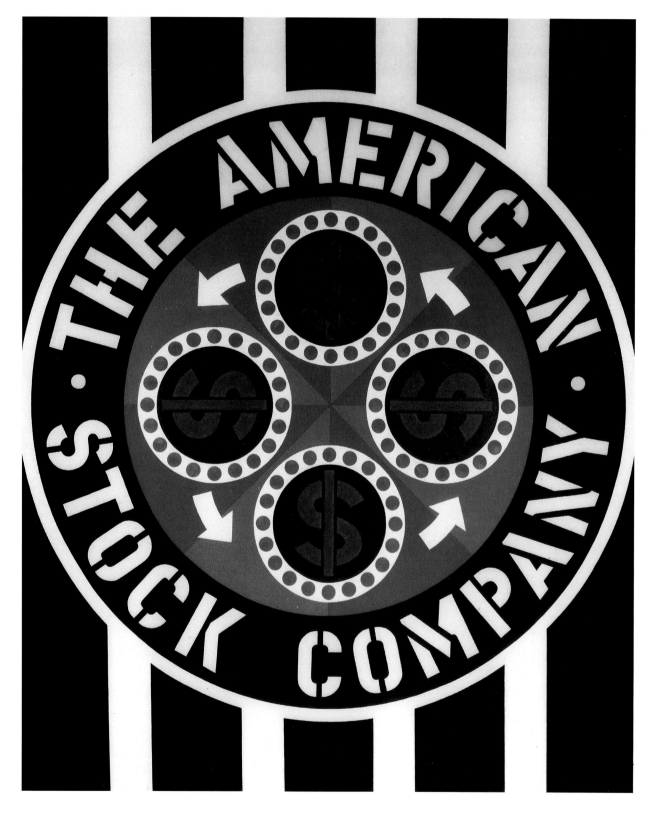

THE AMERICAN STOCK COMPANY. 1963. OIL ON CANVAS, 60 × 50".

COLLECTION MRS. ROBERT B. MAYER, CHICAGO

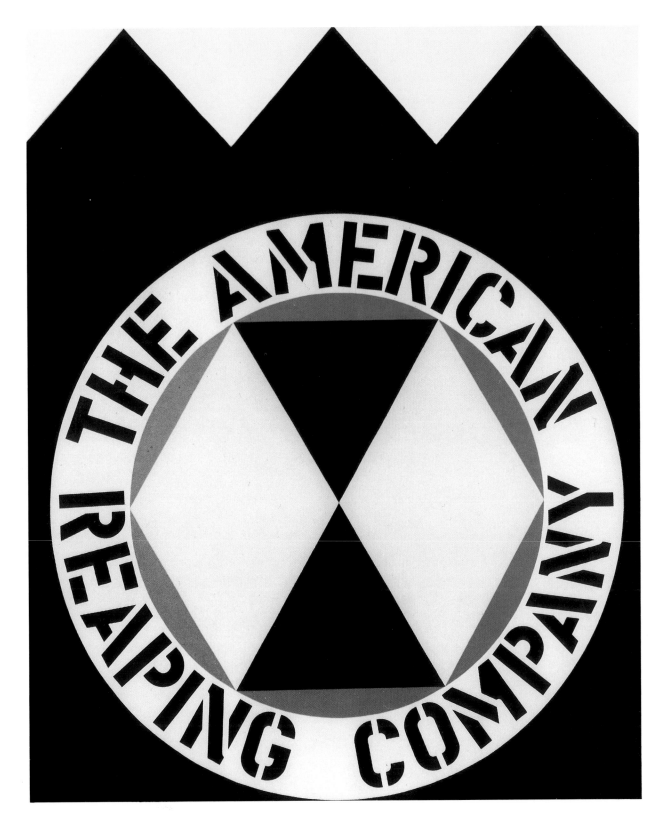

THE AMERICAN REAPING COMPANY. 1961. OIL ON CANVAS, 60 × 48″.
COLLECTION MR. AND MRS. MELVIN HIRSH, BEVERLY HILLS, CALIFORNIA

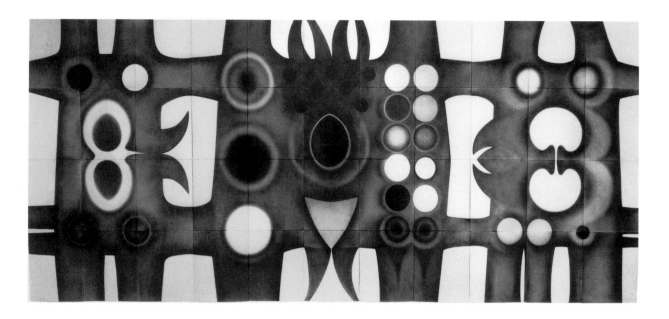

STAVROSIS (CRUCIFIXION). 1958.
PRINTER'S INK ON PAPER (44 SHEETS), 8′3″ × 18′9″

GINKGO. 1958. GESSO ON WOOD, 15½ × 8⅞ × 1⅞″

ARTIST STRUGGLING AGAINST THOSE UNFUNDED FIRST YEARS IN THE CITY, FOUND OBJECTS HAD A VALUE ALMOST EQUAL TO THE INSPIRATIONAL FACTORS OF A COMPANY OF ARTIST FRIENDS AND THE VISUAL AND HISTORICAL POINTS OF VIEW BROUGHT TO MIND BY HIS ENVIRONMENT.

COMMERCIAL STENCILS OF BRASS, WITH THEIR "NUMBERS, SAIL NAMES, NAMES OF NINETEENTH-CENTURY COMPANIES [THE AMERICAN GAS WORKS; SEE PAGE 6]," WHICH COULD BE PICKED UP FOR NOTHING IN THE DESERTED LOFTS, PROVIDED WHAT INDIANA CALLED THE "MATRIX AND FORMAT FOR MY PAINTING AND DRAWING."[23] BASICALLY, THESE WERE THE DIE-CUT LETTER AND NUMBER SYMBOLS TRANSFERRED TO CRATES AND PACKAGES FOR MANY DECADES OF COMMERCIAL SHIPPING. FOR INDUSTRY, THE METHOD DELIVERED ITS FREIGHT. FOR ROBERT INDIANA, IT CONVEYED HIS MESSAGE.

ANOTHER WINDFALL, ONE OF A KIND, WAS A SHEAF OF BLANK PAPER, FORTY-FOUR SHEETS IN ALL, THAT THE ARTIST FOUND IN HIS LOFT WHEN HE MOVED IN. PUTTING THEM ALL TOGETHER, INDIANA PAINTED AN ABSTRACT MONOCHROME INTERPRETATION OF THE CRUCIFIXION, **STAVROSIS (CRUCIFIXION)** (1958). THE IDEA GREW FROM A TEMPORARY JOB HE HAD AT THE CATHEDRAL OF SAINT JOHN THE DIVINE. WHILE "TRANSCRIBING A MANUSCRIPT OF A BOOK ON THE CROSS," HE SAYS, HE BECAME "CAUGHT UP IN THE SUBJECT."[24]

AS A WORK OF RELIGIOUS REFERENCE, **STAVROSIS** DOES NOT STAND ALONE IN INDIANA'S OEUVRE; FOR INSTANCE, EVEN IN HIGH SCHOOL HIS "MOST ELABORATE AND TIME-CONSUMING PROJECT"[25] HAD BEEN AN ILLUMINATED LATIN TRANSCRIPT OF THE NATIVITY STORY FROM LUKE 2 IN THE MEDIEVAL STYLE. LATER ON, THE STRIKING IMAGERY OF A GOSPEL HYMN ("GOD IS A LILY OF THE VALLEY") AND THE SPIRITUAL SIGNIFICANCE OF THE WORD **LOVE** (WITH ITS HEBREW EQUIVALENT, **AHAVA**) GAVE RISE TO OTHER IMPORTANT WORKS. **STAVROSIS** INTEGRATES ORGANIC WITH GEOMETRIC ELEMENTS: GINKGO LEAF (FROM THE TREES JUST OUTSIDE IN JEANNETTE PARK) AND AVOCADO SEED (FROM THE SPROUTING PLANT IN THE STUDIO), WHICH SUGGEST SYMBOLS OF LIFE AND ITS REGENERATION, TOGETHER

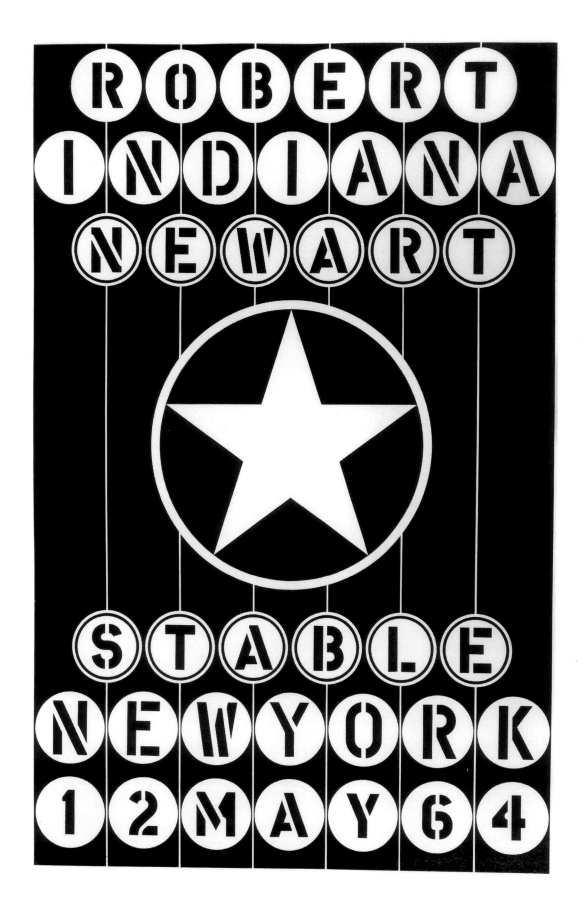

POSTER: **STABLE**. 1964.
OFFSET, 45¾ × 30½″.
STABLE GALLERY, NEW YORK

**THE GREAT AMERICAN DREAM:
SAN FRANCISCO**. 1969.
STENCIL RUBBING WITH CONTÉ, 40 × 26″

HUG. 1963.
STENCIL RUBBING WITH CONTÉ, 3¾ × 9″

WITH THE CIRCULAR MOTIFS INTERPRETED ALMOST UNIVERSALLY AS UNITY, CONTINUITY, ETERNITY.

STAVROSIS IS ONE OF THE FEW PAINTINGS STILL EXTANT THAT INDIANA PRODUCED ON SUCH RANDOMLY ACQUIRED AND PERISHABLE SURFACES. MANY OTHERS, MORE DURABLE, WERE PAINTED OVER, THE IDEAS REVAMPED OR DISCARDED, THE HANDY MATERIALS REUSED. AT THE SAME TIME, SOME OF THE CASTOFFS HE CAME ACROSS—FLOTSAM AND JETSAM OF HISTORY, AS HE SAW THEM—IMPELLED HIS ART TO ANOTHER DIMENSION, THAT OF SCULPTURE.

1–5. STATEMENT BY INDIANA, 1963, QUOTED AND EXCERPTED IN MANY EXHIBITION CATALOGUES. SEE "POP ART FROM A LOFT ON COENTIES SLIP," **SAN FRANCISCO SUNDAY EXAMINER AND CHRONICLE,** 19 OCTOBER 1969.

6, 7. IN UNIVERSITY OF TEXAS AT AUSTIN, **ROBERT INDIANA** (1977), EXHIBITION CATALOGUE, P. 27.

8, 9. ROBERT INDIANA, "AUTOCHRONOLOGY," IN UNIVERSITY OF TEXAS AT AUSTIN, **ROBERT INDIANA,** P. 46.

10–17. STATEMENT BY INDIANA, 1963. SEE NOTES 1–5.

18. HART CRANE, "TO BROOKLYN BRIDGE," **THE BRIDGE** (NEW YORK: 1930).

19. IN FINCH COLLEGE MUSEUM OF ART, NEW YORK (1964), EXHIBITION CATALOGUE.

20. JOHN W. MCCOUBREY, IN INSTITUTE OF CONTEMPORARY ART OF THE UNIVERSITY OF PENNSYLVANIA, PHILADELPHIA, **ROBERT INDIANA** (1968), EXHIBITION CATALOGUE, P. 9.

21. G. R. SWENSON, **ART NEWS** (NOVEMBER 1962), P. 14.

22. MCCOUBREY, IN INSTITUTE OF CONTEMPORARY ART OF THE UNIVERSITY OF PENNSYLVANIA, **ROBERT INDIANA,** P. 17.

23. STATEMENT BY INDIANA, 1963. SEE NOTES 1–5.

24. INDIANA, "AUTOCHRONOLOGY," IN UNIVERSITY OF TEXAS AT AUSTIN, **ROBERT INDIANA,** P. 46.

25. IBID., P. 45.

BALLYHOO. 1961. OIL ON CANVAS, 60×48″. WHEREABOUTS UNKNOWN

3

I THOUGHT OF MYSELF AS A PAINTER AND A POET AND BECAME A SCULPTOR BECAUSE THE POTENTIAL RAW MATERIALS WERE LYING OUTSIDE MY STUDIO DOOR.

DOOR. I THOUGHT OF MYSELF AS A PAINTER AND A POET AND BECAME A SCULPTOR BECAUSE THE POTENTIAL RAW MATERIALS WERE LYING OUTSIDE MY STUDIO DOOR. I THOUGHT OF MYSELF AS A PAINTER AND A POET AND BECAME A SCULPTOR BECAUSE THE POTENTIAL RAW MATERIALS WERE LYING OUTSIDE MY STUDIO DOOR. I THOUGHT OF MYSELF AS A PAINTER AND A POET AND BECAME A SCULPTOR BECAUSE THE POTENTIAL RAW MATERIALS WERE LYING OUTSIDE MY STUDIO DOOR. I THOUGHT OF MY

I N THE RUBBLE OF DEMOLISHED WAREHOUSES "THESE GORGEOUS PIECES OF WOOD WERE LYING AROUND FOR ANYONE TO TAKE."[2] THERE WERE "HEAVY WOODEN HEADERS, NOTCHED AND MORTISED, AND THE STAR-SHAPED HEADS OF TIE-RODS FROM WHICH THEY WERE ASSEMBLED";[3] "VARIOUS LENGTHS OF POLES ABOUT A FOOT IN DIAMETER, REMNANTS OF SHIP MASTS";[4] AS WELL AS SCRAPS OF RUSTY METAL FITTINGS. INDIANA SAW THIS LITTER AS "ARCHAEOLOGICAL," CARRYING "DEFINITE TRACES OF OUR HISTORY AND CIVILIZATION" AND SERVING "A PECULIAR FUNCTION ON THE WATERFRONT IN NEW YORK. . . . THEY'RE PIECES IN A JIGSAW PUZZLE. . . ."[5] AT FIRST, HE SAYS, ONLY HE AND THE SCULPTOR MARK DI SUVERO SAVED AND USED THE BIG BEAMS, "AND [DI SUVERO HAS] DONE SO IN A MUCH DIFFERENT MANNER."[6] IT WAS NOT LONG, HOWEVER, BEFORE "A BAND OF INDIGENT ARTISTS" WAS PROSPECTING THIS FERTILE GROUND FOR FREE WORKING MATERIALS. NIGHTFALL WAS THE "PROPITIOUS TIME FOR BEAM SALVAGING," BECAUSE "A BEAM SPOTTED AND 'CLAIMED' IN THE MORNING" WOULD HAVE DISAPPEARED BY DARK.[7]

THE MANNER IN WHICH INDIANA PUT HIS PIECES OF THE JIGSAW PUZZLE TOGETHER WAS SINGULARLY HIS OWN. IN 1959 HE BEGAN TO CREATE VERTICAL FIGURES THAT HE CALLS HERMS, AFTER THE GREEK COMMEMORATIVE PILLARS CROWNED BY BUSTS OR HEADS (ORIGINALLY OF HERMES). HE NOW CONSIDERS THESE CONSTRUCTIONS "THE ROOT, THE BASIS OF MY ART TODAY,"[8] BECAUSE THEY FIRST EMBODIED ARTISTIC TRAITS THAT BECAME THE INSIGNIA OF HIS PAINTING AND MUCH OF HIS WORK IN OTHER MEDIA.

IT WAS ON THE HERMS THAT WORDS FIRST APPEARED IN HIS ADULT OUTPUT. "I DON'T THINK I HAD ANY KIND OF PLAN, NOR DID I ENVISION THAT ALL OF MY WORK WOULD BE SO UTTERLY DEVOTED TO WORDS."[9] ALWAYS SHORT, THE WORDS WERE USUALLY MONOSYLLABLES, THEIR BREVITY "DICTATED BY THE SHAPE OF THE WOODEN BEAMS. . . . I COULDN'T USE MORE THAN FOUR OR FIVE LETTERS. . . . I THINK CHIEF WAS MY LENGTHIEST WORD."[10]

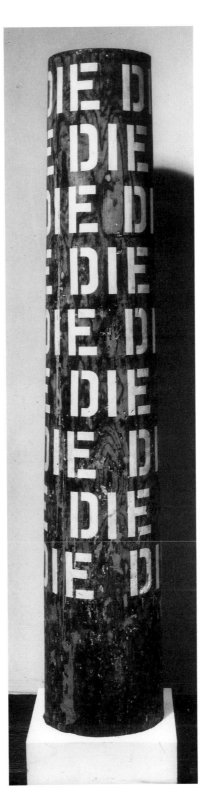

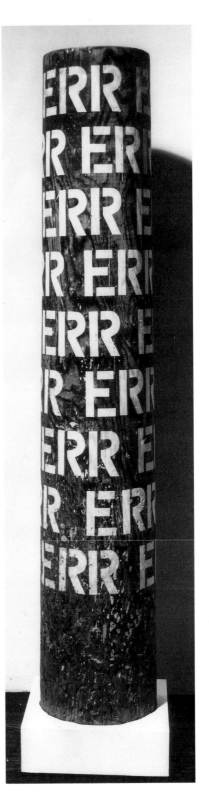

COLUMN: EAT/HUG/DIE. 1964.
GESSO ON WOOD,
HEIGHT 78″ WITH BASE

COLUMN: DIE. 1964.
GESSO ON WOOD,
HEIGHT 64″ WITH BASE

COLUMN: ERR. 1964.
GESSO ON WOOD,
HEIGHT 64″ WITH BASE

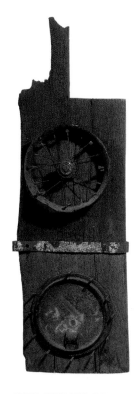

SUN AND MOON. 1960.

METAL AND WOOD, 34¾ × 12 × 4″

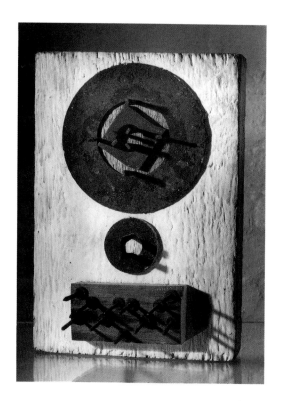

ZENITH. 1960.

METAL AND WOOD WITH GESSO, 12½ × 8¾ × 4½″

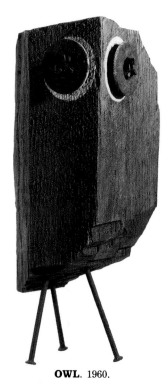

OWL. 1960.

METAL AND WOOD WITH GESSO, 14¾ × 7 × 7″

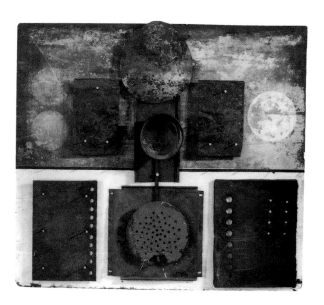

WALL OF CHINA. 1960.

METAL AND WOOD WITH GESSO AND OIL, 48 × 54¾″

The gist of the words was autobiographical, for the most part, or related to Indiana's fascination with bygone ways of life on Coenties Slip or with the numerical recurrences of dates, highway designations, and pinball turns of fortune that had gripped his mind since childhood. Format and concept merged, as when the EAT/DIE combination linked to his mother's death became the inscription easily fitted to a piece of wood no wider than a tombstone. Using the found lettering of his brass stencils on the ground of his scavenged poles and beams, the artist was intent not so much on graphic values as on the allusion to "important things in my life."[11] That aim has remained constant in his art.

Out of the fortuitous features of the battered and stained wood and the objects he attached to it, Indiana conjured a series of cryptic images, at first bringing out the suggested personae only with white gesso letters and numbers, then extending their expression with other painted symbols and the use of color. With the addition of wood or metal wheels the herms took on, as John McCoubrey noted, "a false promise of mobility."[12]

The impact of these sculptures on the viewer is strong. The titles are laconic or ambiguous, the figures themselves startling and haunting, propounding unanswerable questions, portending much but revealing little. A group of them looms like personages in a wax museum sharing a common unknown ancestry—a family, perhaps, meaning more together than each can separately.

McCoubrey's description of these works also acknowledges their inherent sense of history: ". . . the constructions are visitations from the past, revealing in the hewn, rough wood their former service." Even though "these headless herms are touched almost cruelly with the gaudy colors of a twentieth-century sensibility . . . they are redolent of a specific place and of its past, of the buildings which housed a

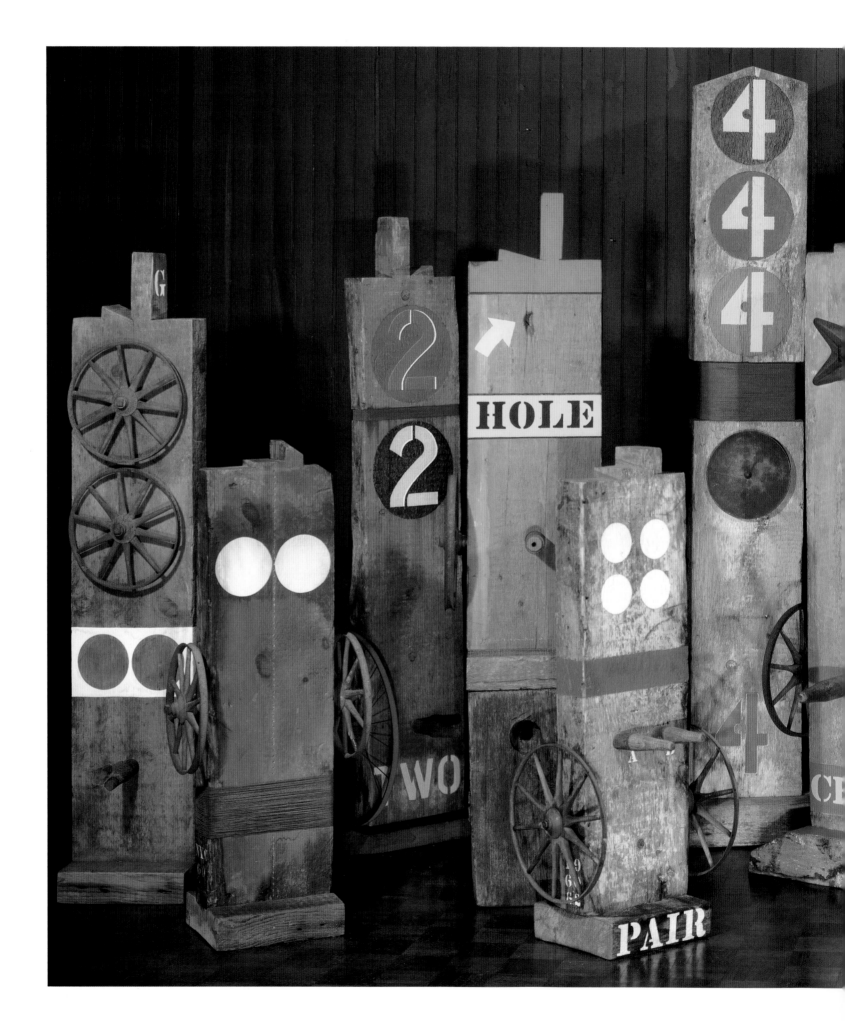

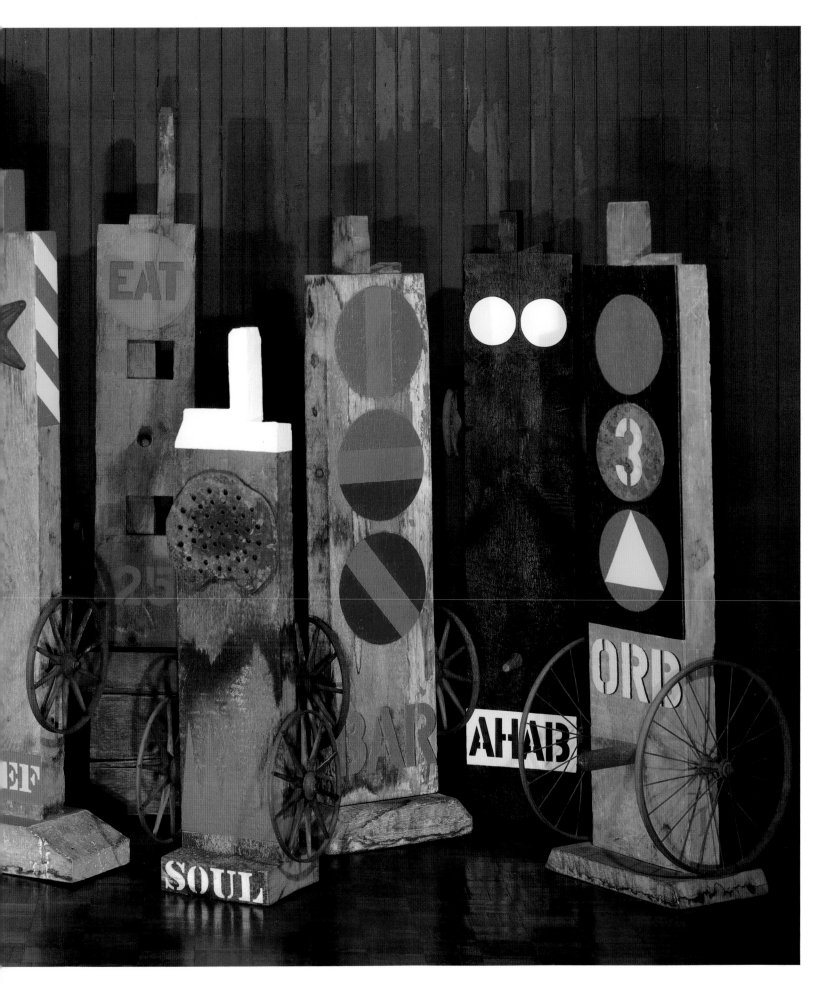

GROUP OF TWELVE CONSTRUCTIONS, C. 1960

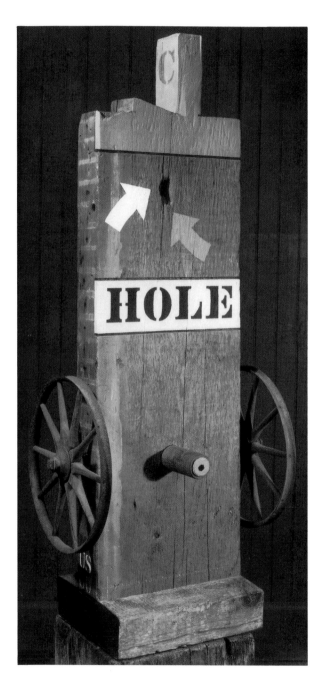

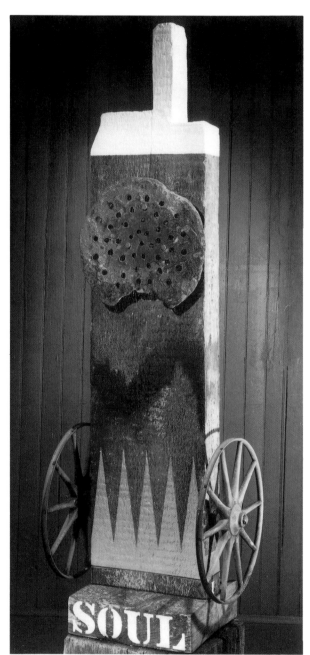

HOLE. 1960.

WOOD AND IRON WITH OIL, HEIGHT 45″

SOUL. 1960.

WOOD AND IRON WITH GESSO AND OIL, HEIGHT 42″

DEPARTED AND EXOTIC COMMERCE STILL SPELLED OUT IN THE STENCILS"[13] THAT THE ARTIST FOUND AND PUT TO HIS OWN USE.

TO SOME OBSERVERS, MORE THAN A TOUCH OF THE COMIC COMES THROUGH IN THESE WORKS, A SENSE OF MOCKERY AND SOCIAL SATIRE, ALONG WITH THE ARTIST'S SUMMONING UP OF THINGS PAST. JOHN RUSSELL, REVIEWING A RETROSPECTIVE EXHIBITION, CALLED THEM "SAUCY TOTEMS." THEY ARE, HE SAID, "IDENTIFIABLY MALE IN GENDER AND FITTED OUT WITH NAMES, ITEMS OF PERSONAL EQUIPMENT, AND OTHER SIGNALS OF AN EXPLICATORY SORT."[14] SUCH SIGNALS, HOWEVER, MAY LEAD TO A DERAILMENT OF ONE'S EXPECTATIONS. "LETTERS AND ARROWS," MCCOUBREY REMARKED, "WITH THE BLAND, IDIOTIC REDUNDANCY OF SIGNS ONE OFTEN READS BUT DOESN'T NEED, POINT TO IMPERFECTIONS [IN THE WOOD, AS IN] **(HOLE)**, CALL THEM MOCKINGLY TO LIFE **(SOUL, WOMB)**, NAME THEM **CHIEF** AND **AHAB**. . . . THERE IS SOMETHING OF WHIMSY . . . IN THE WAY THE OBJECTS' UTILITARIAN VALUES ARE FRUSTRATED AND TRANSFORMED."[15]

INDIANA IS QUICK TO STATE THAT HE DID NOT INVENT, NOR DID HE SEEK, THE COLUMNAR FORM THAT HE DEVELOPED INTO THESE ENIGMATIC FIGURES; THE FORM WAS THERE IN THE MATERIALS THAT CAME TO HAND.[16] ALSO, HIS INCORPORATION OF FOUND MATERIALS COINCIDED WITH A REVIVAL OF INTEREST IN THEIR USE IN THE 1950S, RECALLING A GENERATION OF EUROPEAN ARTISTS WHO INCORPORATED SUCH RANDOM ELEMENTS INTO THEIR CUBIST AND DADAIST WORKS EARLY IN THE CENTURY. PABLO PICASSO SAID OF THE **OBJETS TROUVÉS** IN HIS COLLAGES, "JE NE CHERCHE PAS. JE TROUVE" (I DO NOT SEEK. I FIND). KURT SCHWITTERS, ON THE OTHER HAND, DID SEARCH; HE AVIDLY COLLECTED THE DEBRIS THAT WENT INTO THE COLLAGES HE CHRISTENED WITH THE CHOPPED-OFF WORD **MERZ**. THE APOTHEOSIS OF FOUND OBJECTS WAS PRODUCED BY MARCEL DUCHAMP, WHO TURNED THEM, UNCHANGED, INTO "WORKS OF ART" SIMPLY BY CALLING THEM SUCH AND SIGNING HIS NAME TO THEM. THE TONGUE-IN-CHEEK SPIRIT OF THAT FEAT WAS HANDED DOWN IN TIME TO THE CREATORS OF A PRESUMED NEO-DADA, MANY OF WHOM CAME TO BE CALLED, AND EVEN TO CALL THEMSELVES, POP ARTISTS.

THE TERM **ASSEMBLAGE** WAS EVOLVED TO ENCOMPASS THE MULTIFORM, MULTIMEDIA EXPRESSIONS IN FOUND MATERIALS THAT CONFOUNDED THE DISTINCTION OF SCULPTURE FROM PAINTING. WITH "THE ART OF ASSEMBLAGE," THE MUSEUM OF MODERN ART IN NEW YORK MOUNTED A MAJOR EXHIBITION OF THIS CATEGORY IN 1961, AND ROBERT INDIANA WAS REPRESENTED BY HIS CONSTRUCTION **MOON** (1960; PAGE 71).

A TALL COMPOUND BEAM BEARING ITS NAME IN WHITE STENCILLIKE LETTERS AT THE TOP, **MOON** HAS FOUR WHITE MOON DISKS DOWN ITS LENGTH, EACH FLANKED BY A PAIR OF WHEELS AND SEPARATED ONE FROM ANOTHER BY OPENINGS THROUGH THE WOOD. THE CIRCULAR MOTIFS REPEAT A THEME THAT BECAME DOMINANT AROUND 1959, NOT ONLY IN HIS EARLY CONSTRUCTIONS BUT ALSO IN PAINTINGS DONE ON SHEETS OF PLYWOOD LEFT OVER FROM RENOVATIONS OF HIS WORKSHOP OR ON BOARD OR CANVAS (SEE PAGE 37).[17] IN HIS STATEMENT FOR THE CATALOGUE OF THE ASSEMBLAGE SHOW, INDIANA WROTE, "TOPICALLY THIS PIECE MAY HAVE SOMETHING TO DO WITH MAN'S INTRUSION ON ORB MOON—AN HERALDIC STELE, SO TO SPEAK. . . ." HE ALSO PUT INTO POETIC WORDS HIS FEELINGS ABOUT THE MEDIUM HE WAS USING: "THE TECHNIQUE, IF SUCCESSFUL, IS THAT HAPPY TRANSMUTATION OF THE LOST INTO THE FOUND, JUNK INTO ART, THE NEGLECTED INTO THE WANTED, THE UNLOVED INTO THE LOVED, DROSS INTO GOLD."[18]

ONLY A YEAR BEFORE, IN 1960, HE HAD MADE HIS FIRST APPEARANCE IN A MAJOR NEW YORK GALLERY, THE MARTHA JACKSON, WITH THE CONSTRUCTION **FRENCH ATOMIC BOMB,** INCLUDED IN THE EXHIBITION "NEW FORMS / NEW MEDIA." THE SHOW CREATED SUCH A STIR THAT IT WAS REPEATED, WITH WORKS BY THE SAME ARTISTS, A FEW MONTHS LATER. **GE,** INDIANA'S ENTRY IN THE SECOND SHOW, "WAS SELECTED FOR ANOTHER ASSEMBLAGE-ORIENTED SHOW AT UNION COLLEGE IN SCHENECTADY," ITS AUTHOR RECALLS.[19]

THEN, IN MAY 1961, CAME A SIGNIFICANT TWO-ARTIST SHOW WITH PETER FORAKIS, AT THE DAVID ANDERSON GALLERY, NEW YORK, PRESENTING BOTH

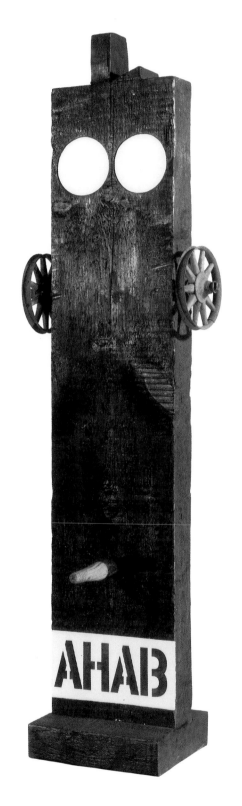

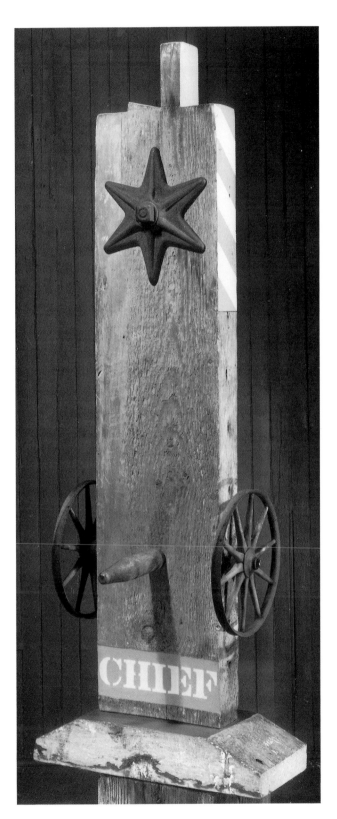

AHAB. 1962.

WOOD AND IRON WITH GESSO AND OIL, HEIGHT 61″

CHIEF. 1962.

WOOD AND IRON WITH OIL, HEIGHT 64″

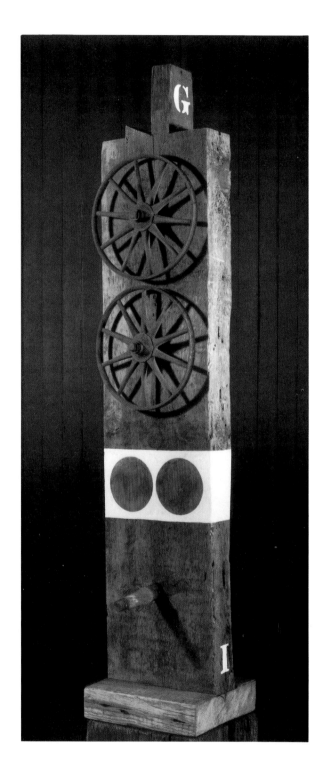

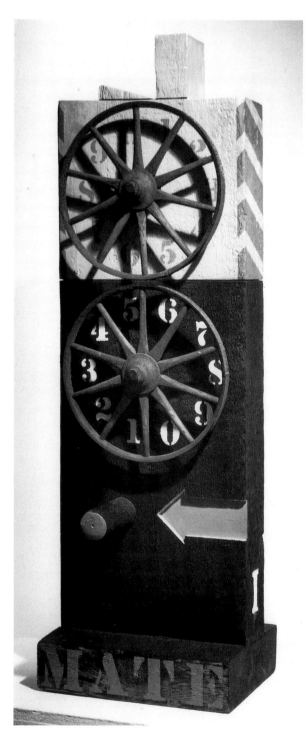

GE. 1960.
WOOD AND IRON WITH GESSO AND OIL,
HEIGHT 59″

MATE. 1962.
WOOD AND METAL WITH OIL AND GESSO,
41 × 12½ × 12¾″. WHITNEY MUSEUM
OF AMERICAN ART, NEW YORK. GIFT OF THE
HOWARD AND JEAN LIPMAN FOUNDATION, INC.

FRENCH ATOMIC BOMB. 1959–60.
POLYCHROMED WOOD BEAM AND METAL,
38⅝ × 11⅝ × 4⅞″. COLLECTION,
THE MUSEUM OF MODERN ART, NEW YORK.
GIFT OF ARNE EKSTROM

FOUR. 1962.
WOOD AND IRON WITH OIL, HEIGHT 77¾″

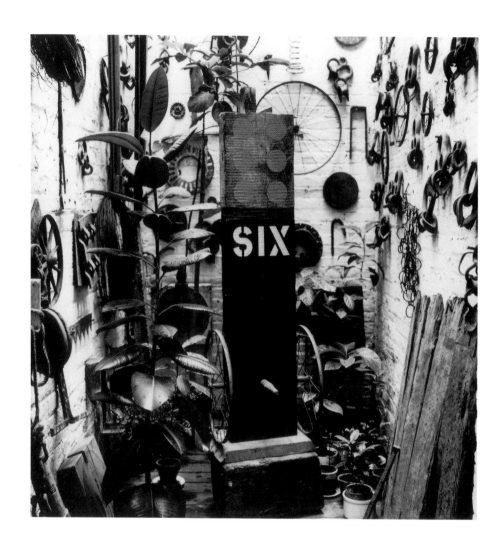

SIX. 1962. WOOD AND IRON WITH OIL, HEIGHT 61¾″.
FORMERLY COLLECTION JOHN POWERS, NEW YORK.
SHOWN IN THE ARTIST'S STUDIO

PAINTINGS AND CONSTRUCTIONS, OF WHICH THE REVIEWER GENE SWENSON SAID, "NONE OF THIS WORK LOOKS VERY MUCH LIKE ART; IT IS SIMPLE, DIRECT AND FULL OF WONDER." OF THE TWO MEN'S WORK, HE FOUND INDIANA'S TO BE THE MORE "FORMAL" AND "SYMMETRICAL"; INDIANA, HE OBSERVED, "SETS 3- OR 4-FOOT DOMINOES ON END, CUTS A BAND AROUND OR IN THEM, PAINTS OTHER BANDS OF WHITE WITH ORANGE OR OCHER STRIPES IN THEM, PAINTS ON A BLACK STAR OR FOUR RED CIRCLES, PUTS RUSTY WHEELS ON THEIR SIDES OR IN THEIR MIDDLE. . . .

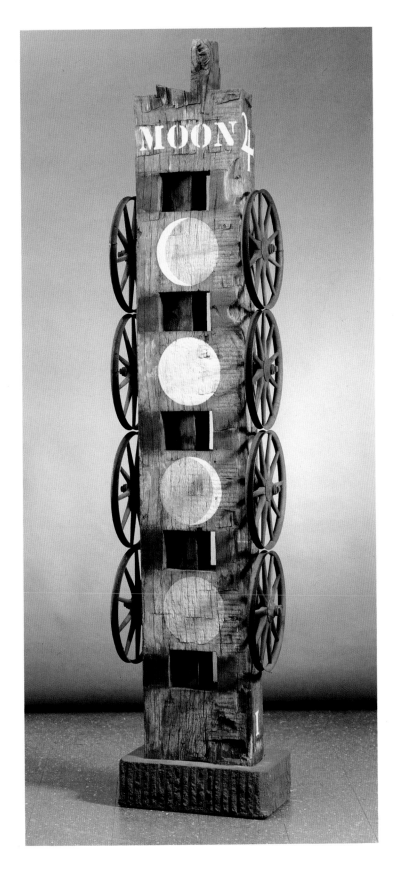

MOON. 1960.
WOOD BEAM WITH IRON-RIMMED WHEELS
AND WHITE PAINT, HEIGHT 78″.
COLLECTION, THE MUSEUM OF MODERN ART,
NEW YORK. PHILIP JOHNSON FUND

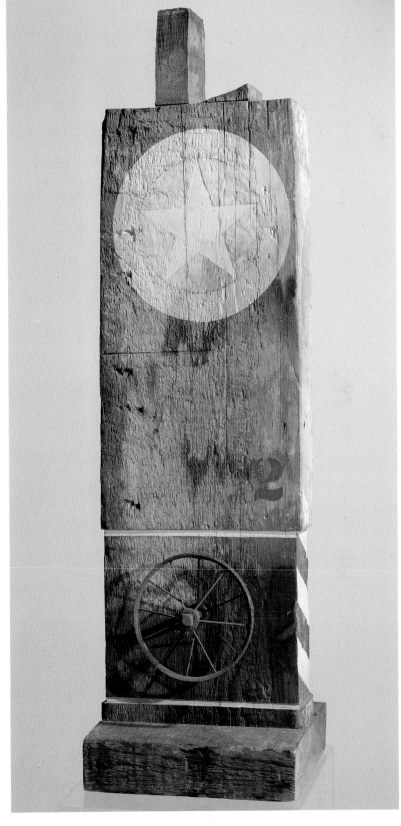

U-2. 1960.
WOOD, IRON, AND OIL PAINT.
COLLECTION MR. AND MRS. ARMAND BARTOS,
NEW YORK

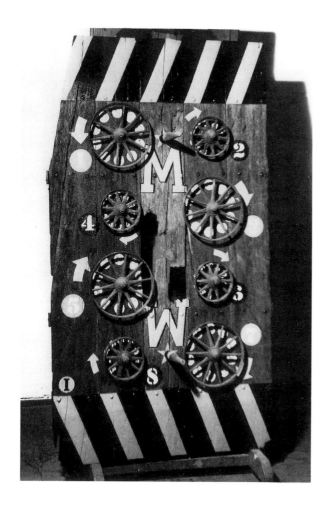

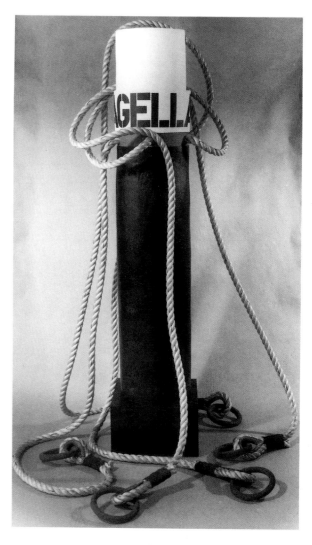

THE MARINE WORKS. 1960–62.
WOOD AND IRON WITH OIL, 72 × 44″.
THE COLLECTION OF
THE CHASE MANHATTAN BANK, NEW YORK

FLAGELLANT. 1963–69.
WOOD AND ROPE, HEIGHT 63½″

IF THEY RESEMBLE HERMAE . . . THEY REFLECT GREEK ART THROUGH ENGAGINGLY FRESH EYES."[20] AMONG THE CONSTRUCTIONS SO DESCRIBED WAS THE FIRST STAGE OF **THE MARINE WORKS,** A CRACKED AND BROKEN PANEL OF BOARDS STUDDED WITH NAILHEADS AND SUPPORTING TWO SETS OF FOUR WHEELS, NUMBERED AS IF TO SUGGEST A DIRECTION OF MOVEMENT. ABOVE AND BELOW ARE DIAGONAL STRIPES THAT SEEM TO SIGNAL A BARRIER. AS CARRIED THROUGH TO ITS FINAL STATE, IN 1962, THE INITIALS M AND W IN RED MIRRORED EACH OTHER ABOVE AND

BELOW THE GAPING HOLE AT THE CENTER OF THE PANEL, AND THE EFFECT OF SPINNING WHEELS WAS ENHANCED BOTH BY CURVED RED ARROWS AND BY NUMBERS BETWEEN THE SPOKES, ALL INDICATING DIRECTION. THIS DESIGN BEARS A CLOSE FAMILY RESEMBLANCE TO ONE OF INDIANA'S PAINTINGS IN THE SAME TWO-ARTIST SHOW; **THE AMERICAN DREAM** (SEE PAGE 102), WITH ITS PINBALL IMAGERY, SET OFF A WHOLE CYCLE UNDER THAT TITLE.

WITH THESE APPEARANCES IN EXHIBITIONS THAT WERE WIDELY REVIEWED AND OFTEN CONTENTIOUSLY CRITICIZED, THE YOUNG ARTIST RECEIVED CONSIDERABLE PUBLIC NOTICE—UNDER THE NAME HE HAD RECENTLY CHOSEN, TO IDENTIFY HIMSELF WITH HIS HOME STATE, INDIANA. AND THE CONSTRUCTIONS AND EARLY PAINTINGS THEN ASSOCIATED WITH THAT NAME DISPLAYED A BOLD STEP TOWARD THE ECONOMY OF MEANS THAT WOULD BE FUNDAMENTAL TO HIS WORK IN THE YEARS TO COME. HIS EARLY INVOLVEMENT WITH POETRY AND JOURNALISM, BOTH EXERCISES IN SUCCINCT EXPRESSION, MAY HAVE HAD SOMETHING TO DO WITH HIS PENCHANT FOR DISTILLATION OF AN IDEA, IN ADDITION TO THE COMPRESSION ENFORCED BY THE NARROWNESS OF HIS FOUND MATERIALS. THE REDUCTIVE PROCESS BY WHICH HE DEVELOPED HIS GENERALIZED, NONOBJECTIVE SET OF FORMS WAS A SLOW ONE, WORKING THROUGH THE CIRCLE SHAPE, THE STENCIL, THE BASIC PROPORTIONS, AND THE LIMITED FLAT COLORS OF HIS PALETTE, WHICH WOULD VARY ONLY SLIGHTLY OVER THE YEARS.

THE AIM, AS JOHN RUSSELL PERCEIVED IT, WAS "DE-COMPLICATION . . . AND IT DOESN'T DO TO UNDERESTIMATE THE AMOUNT OF PRELIMINARY EFFORT THAT WENT INTO [THESE WORKS]. . . . **FLAGELLANT** IS A PARTICULARLY GOOD EXAMPLE; THE HUMAN FIGURE IS HERE REDUCED TO A WHIPPING POST, AND THE WHIPS AND MANACLES ARE SUGGESTED WITH AN EPIGRAMMATIC CONCISION."[21]

THOUGH THE SUBJECTS ARE, AS INDIANA HAS SAID, "REDUCED TO THE BARE BONES,"[22] THESE PIECES CONSTITUTE A HIGHLY PERSONAL STATEMENT, IN WHICH THE ART SALVAGES AND RECONSTRUCTS IN A NEW LIFE HIS OWN PAST AND THAT OF HIS CHOSEN SURROUNDINGS. "THE AGE AND TIME THAT SITS UPON THIS MATERIAL

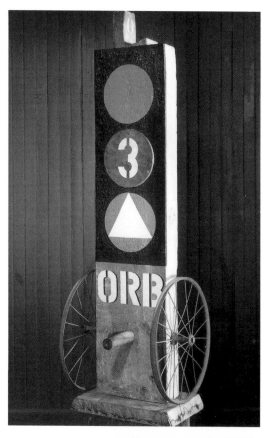

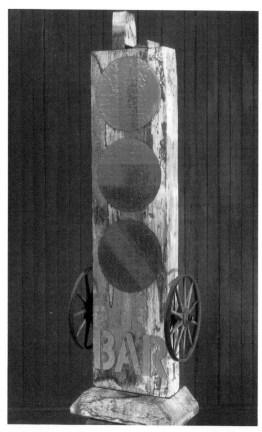

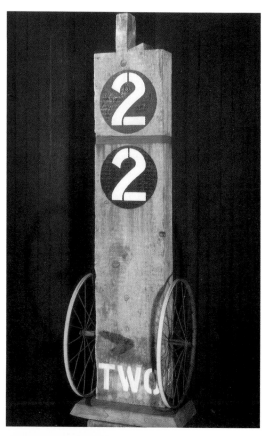

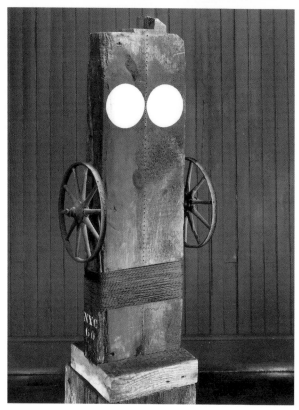

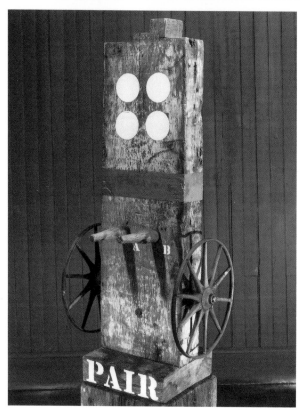

ORB. 1960.
WOOD AND METAL WITH OIL, HEIGHT 62″

BAR. 1961.
WOOD AND IRON WITH OIL, HEIGHT 60¼″

TWO. 1962.
WOOD AND IRON WITH OIL, HEIGHT 62″

THE VIRGIN. 1960.
WOOD AND IRON WITH GESSO, HEIGHT 42″

PAIR. 1960–62.
WOOD AND IRON WITH GESSO AND OIL, HEIGHT 42″

HUB. 1962.
WOOD AND IRON WITH OIL, 44 × 12½ × 11″.
PRIVATE COLLECTION

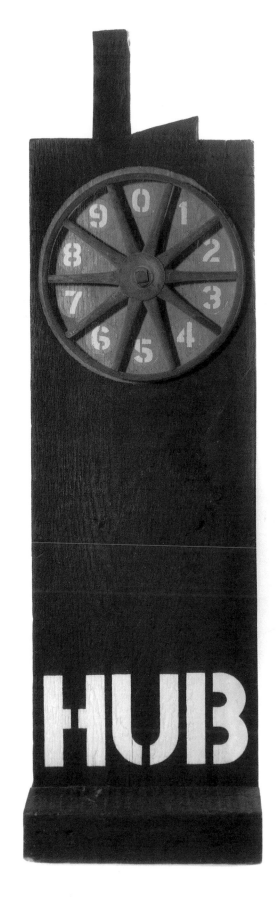

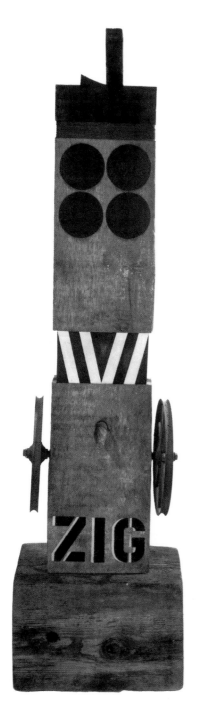
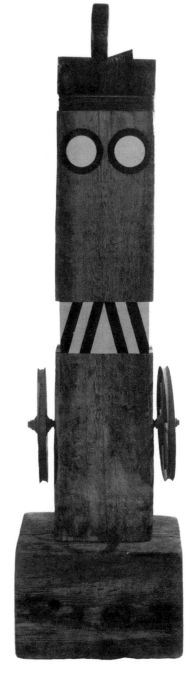

ZIG. 1960.
WOOD, WIRE, AND
METAL WITH OIL,
65 × 17¾ × 16⅛″. MUSEUM LUDWIG,
COLOGNE, WEST GERMANY

BACK VIEW OF **ZIG**

GEM. 1961.
WOOD WITH GESSO AND OIL,
67 × 11 × 6″

DRAGGED OUT OF THE PAST IS TOLD EXPLICITLY IN **HUB**," MCCOUBREY WROTE. "ITS WHEEL LIKE A WHEEL OF CHANGE OR AN ANCIENT TIME CLOCK, ITS SPOKES PRECISELY SUBTENDING A NUMBER SERIES WHICH COUNTS THE PASSAGE OF HOURS OR DECADES. IN THESE OBJECTS . . . INDIANA FOUND THE MEANS TO EXPRESS HIS FASCINATION WITH TIME AND HISTORY."[23] THAT THE ARTIST HAS KEPT MOST OF THE HERMS FOR HIS OWN COLLECTION INDICATES THE IMPORTANCE THEY HAVE FOR HIM, AS DOES THE FACT THAT HE RETURNED TO THE FORM AS RECENTLY AS 1981.

———

1. MANUSCRIPT PROVIDED BY ROBERT INDIANA.

2. IN UNIVERSITY OF TEXAS AT AUSTIN, **ROBERT INDIANA,** P. 25.

3. JOHN W. MCCOUBREY, IN INSTITUTE OF CONTEMPORARY ART OF THE UNIVERSITY OF PENNSYLVANIA, PHILADELPHIA, **ROBERT INDIANA** (1968), EXHIBITION CATALOGUE, P. 10.

4. RICHARD F. SHEPARD, **NEW YORK TIMES,** 8 MARCH 1964, P. 83.

5, 6. IN UNIVERSITY OF TEXAS AT AUSTIN, **ROBERT INDIANA,** P. 25.

7. ROBERT INDIANA, "AUTOCHRONOLOGY," IN UNIVERSITY OF TEXAS AT AUSTIN, **ROBERT INDIANA,** P. 46.

8. IN WILLIAM A. FARNSWORTH LIBRARY AND ART MUSEUM, ROCKLAND, ME., **INDIANA'S INDIANAS** (1982), EXHIBITION CATALOGUE, P. VII.

9–11. IN UNIVERSITY OF TEXAS AT AUSTIN, **ROBERT INDIANA,** P. 33.

12, 13. MCCOUBREY, IN INSTITUTE OF CONTEMPORARY ART OF THE UNIVERSITY OF PENNSYLVANIA, **ROBERT INDIANA,** P. 12.

14. JOHN RUSSELL, "DE-COMPLICATION IS THE AIM," **NEW YORK TIMES,** 14 MAY 1978.

15. MCCOUBREY, IN INSTITUTE OF CONTEMPORARY ART OF THE UNIVERSITY OF PENNSYLVANIA, **ROBERT INDIANA,** P. 12.

16. UNIVERSITY OF TEXAS AT AUSTIN, **ROBERT INDIANA,** P. 33.

17. INDIANA, "AUTOCHRONOLOGY," IN UNIVERSITY OF TEXAS AT AUSTIN, **ROBERT INDIANA,** P. 47.

18. IN INSTITUTE OF CONTEMPORARY ART OF THE UNIVERSITY OF PENNSYLVANIA, **ROBERT INDIANA,** P. 54.

19. INDIANA, "AUTOCHRONOLOGY," IN UNIVERSITY OF TEXAS AT AUSTIN, **ROBERT INDIANA,** P. 46.

20. [GENE R. SWENSON], "REVIEWS AND PREVIEWS," **ART NEWS** 60, NO. 3 (MAY 1961), P. 20.

21. RUSSELL, "DE-COMPLICATION IS THE AIM."

22. IN UNIVERSITY OF TEXAS AT AUSTIN, **ROBERT INDIANA,** P. 36.

23. MCCOUBREY, IN INSTITUTE OF CONTEMPORARY ART OF THE UNIVERSITY OF PENNSYLVANIA, **ROBERT INDIANA,** P. 12.

I AM AN AMERICAN PAINTER OF SIGNS CHARTING THE COURSE. I WOULD BE A PEOPLE'S PAINTER AS WELL AS A PAINTER'S PAINTER.

LL THROUGH HIS CAREER, INDIANA HAS BEEN UNCOMMONLY ARTICULATE AND GENEROUS IN REVEALING THE PERSONAL ROOTS AND THE FORMAL INTENTS OF HIS ART. THE 1961 STATEMENT THAT OPENS THIS CHAPTER IS PERHAPS THE MOST WIDELY QUOTED OF HIS EXPRESSED AIMS AND ONE THAT LENDS ITSELF TO THE BROADEST OF INTERPRETATIONS. HIS PAINTED "SIGNS," IN THEIR VARIETY, CORRESPOND TO MANY OF THE DICTIONARY MEANINGS OF THE WORD **SIGN,** FROM THE MOST PHYSICAL AND EXTERNAL (A BOARD, PLACARD, OR OTHER GRAPHIC NOTICE PUBLICLY DISPLAYED) TO HIGHLY ABSTRACT OR ALLUSIVE EVOCATIONS OF THE SUBJECTIVE OR THE SPIRITUAL (AS IN THE SIGN OF THE CROSS OR SIGNS OF THE TIMES). THE ADDITIONAL SENSES—OF TOKEN OR SYMBOL; CONVENTIONAL MARK STANDING FOR A COMPLEX IDEA; SIGNAL, OMEN, OR PORTENT; SPECIAL CHARACTER USED IN THE NOTATION OF A NONVERBAL SYSTEM SUCH AS MUSIC OR MATHEMATICS; GESTURE; AND SYMPTOM—MAY ALSO BE DISCERNED IN THE MESSAGES CONVEYED BY HIS "SIGN PAINTINGS." THEIR CREATOR LEAVES NO DOUBT THAT HIS NUMBERS, LETTERS, AND SHAPES **ARE** MESSAGES, HOWEVER LACONIC OR CRYPTIC THE CONTENT MAY SEEM. "I AM STUCK WITH AN OLD-FASHIONED PURPOSE. I HAVEN'T DONE A PAINTING WITHOUT A MESSAGE."[2]

AS TO HIS AMERICAN IDENTITY, HE SAID, HE HAD NO WISH TO "UNSETTLE THE SHADES" OF SUCH EARLIER GREAT AMERICAN PAINTERS AS "HOMER, EAKINS, RYDER, SHEELER, HOPPER, MARIN, ET AL.,"[3] BUT HE PROPOSED TO CONVEY HIS OWN PICTURE OF LIFE IN THIS COUNTRY THROUGH A SIGN LANGUAGE, ESPECIALLY THAT OF THE "ROAD LITERATURE" OF THE AMERICAN HIGHWAYS. HIS INTENTION WAS TO BE NOT AN "INTERNATIONALIST SPEAKING SOME GLIB ESPERANTO" BUT "A YANKEE."[4] HE HAS USED HIS CHOSEN VOCABULARY FOR NOSTALGIC RECOLLECTIONS OF EVENTS IN HIS OWN LIFE; FOR CELEBRATION OF AMERICAN LITERARY AND HISTORIC HIGH POINTS THAT HAD A PARTICULAR IMPACT ON HIM; AND, ESPECIALLY DURING THE 1960S, AS A "PEOPLE'S PAINTER," FOR SOCIAL SATIRE AND COMMENTARY AS WELL.

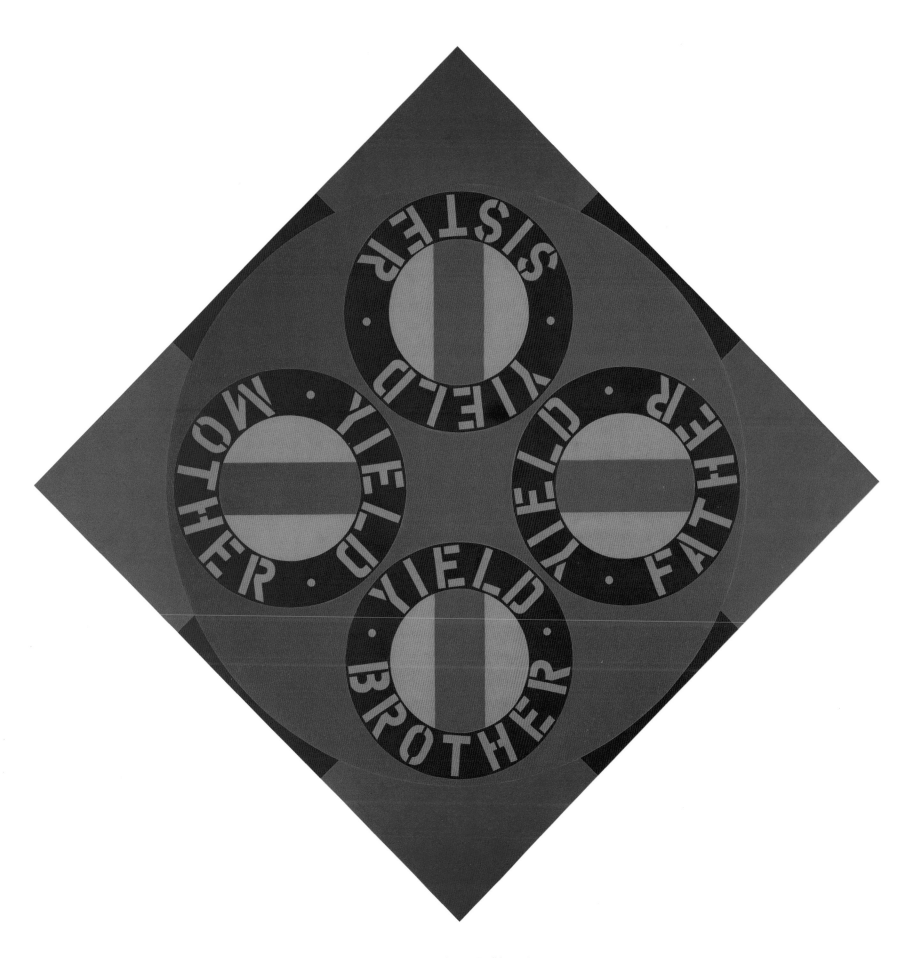

YIELD BROTHER #2. 1963.

OIL ON CANVAS, 84½ × 84½″. THE ABRAMS FAMILY COLLECTION

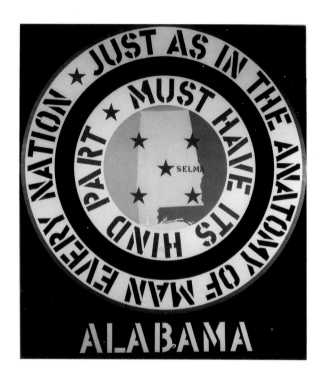

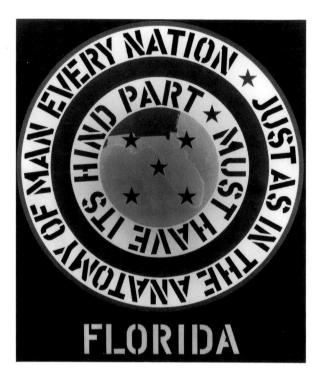

THE CONFEDERACY: ALABAMA. 1965.
OIL ON CANVAS, 70 × 60″.
COLLECTION WALTER AND DAWN CLARK NETSCH,
CHICAGO

THE CONFEDERACY: FLORIDA. 1966.
OIL ON CANVAS, 70 × 60″.
INSTITUTE OF CONTEMPORARY ART,
UNIVERSITY OF PENNSYLVANIA, PHILADELPHIA

TWO SERIES OF PAINTINGS IN THIS LAST VEIN, YIELD AND THE CONFEDER-ACY, PRESENT SOME OF THE MOST OUTSPOKEN AND UNEQUIVOCAL OF INDIANA'S SIGN MESSAGES, COMBINING THE IRONY AND HUMOR CHARACTERISTIC OF MANY OF HIS HERMS WITH THE IDEALISM OF PROTEST AND ADVOCACY. **YIELD BROTHER** (1962), A GIFT FOR THE BERTRAND RUSSELL PEACE FOUNDATION, IS BASED ON THAT "ARROGANT ADMONITION OF THE AMERICAN HIGHWAY [YIELD] . . . EMBLAZONED ON THAT UNEXPECTED SHAPE: THE DESCENDING TRIANGLE."[5] THIS IS TRANS-FORMED INTO THE UNIVERSAL PEACE SYMBOL COMBINED IN FOUR ATTITUDES, AND FOR THE ARTIST IT RECALLS THE CARTOGRAPHIC FORM OF THE INVERTED Y THAT HE USED TO DESCRIBE COENTIES SLIP. THE FIRST YIELD PAINTING WAS FOLLOWED BY A FAMILY OF OTHERS, ADDRESSING MOTHER, FATHER, AND SISTER. AFTER

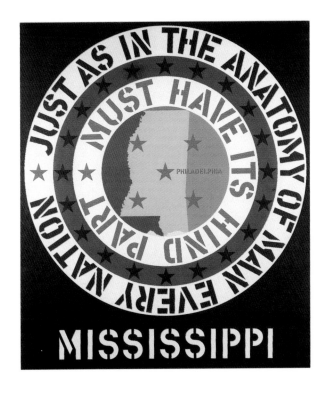

THE CONFEDERACY: MISSISSIPPI. 1965.
OIL ON CANVAS, 70×60″.
COLLECTION MRS. ROBERT B. MAYER,
CHICAGO

THE CONFEDERACY: LOUISIANA. 1965–66.
OIL ON CANVAS, 70×60″.
KRANNERT ART MUSEUM,
UNIVERSITY OF ILLINOIS, CHAMPAIGN

BEING EXHIBITED IN ENGLAND, **YIELD BROTHER** WAS INCLUDED IN A 1967 EXHIBITION CALLED "PROTEST AND HOPE" AT THE NEW SCHOOL FOR SOCIAL RESEARCH IN NEW YORK.

WHILE THE PERSONAL REFERENCE TO THE SLIP MIGHT ESCAPE THE AVERAGE VIEWER, THE ROAD SIGN AND THE "BAN THE BOMB" SYMBOL COULD SPEAK TO MILLIONS. IN THE SERIES THE CONFEDERACY (1965–66), THE VERBAL CONTENT HAS ALL THE PITH AND PUNCH OF A MAXIM: "JUST AS IN THE ANATOMY OF MAN EVERY NATION MUST HAVE ITS HIND PART." THE TARGET OF THIS GIBE WAS WHAT INDIANA CALLED "OUR LEAST YIELDING REGION ENTRENCHED . . . IN THE DOCTRINE OF WHITE SUPREMACY."[6] INITIATED DURING THE VOTER-REGISTRATION DRIVES OF THOSE YEARS, THE SERIES WAS PLANNED TO EXTEND TO ALL "THE SECESSIONIST

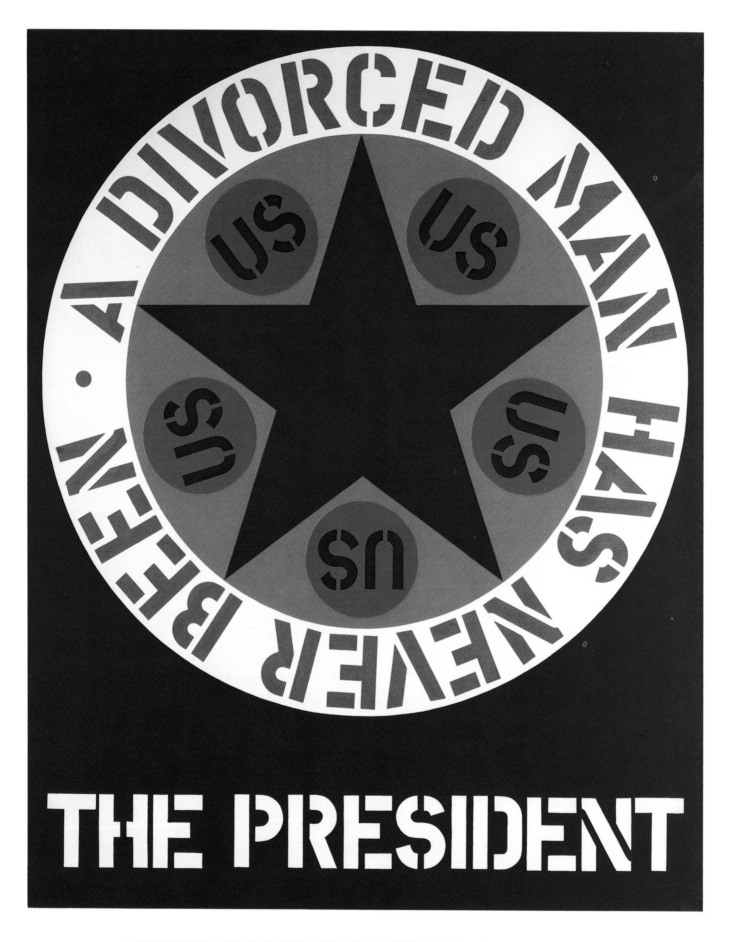

A DIVORCED MAN HAS NEVER BEEN THE PRESIDENT. 1961. OIL ON CANVAS, 60 × 48″.
SHELDON MEMORIAL ART GALLERY, UNIVERSITY OF NEBRASKA-LINCOLN. GIFT OF PHILIP JOHNSON

STATES."[7] IN EACH OF THE PAINTINGS THE WORDS APPEAR, AS IN THE RINGS OF A TARGET, AROUND A BULL'S-EYE PRICKED BY A PATTERN OF STARS. OFTEN WITHIN THE BULL'S-EYE ON A MAP OF THE STATE (DERIVED FROM AN OLD MAP BOOK) IS SITED A PLACE NOTORIOUS FOR OUTBREAKS OF VIOLENCE—FOR ALABAMA, SELMA; FOR MISSISSIPPI, PHILADELPHIA; FOR LOUISIANA, BOGALUSA. **MISSISSIPPI** (1965) WAS A GIFT FROM THE ARTIST TO THE CONGRESS OF RACIAL EQUALITY.

INDIANA'S SYMPATHIES IN THE MOVEMENT AGAINST SOCIAL INJUSTICE WERE REINFORCED BY SOME ENCOUNTERS OF HIS OWN WITH INTRUSIVE AUTHORITY. HIS SLEEPING PALLET HAD TO BE CONCEALED IN THE RAFTERS OF HIS QUARTERS, "FOR THIS WAS A LOFT ILLEGAL FOR LIVING AND HAD NEITHER HEAT NOR HOT WATER— SUITABLE CLIMATE FOR PROTEST."[8] ON COENTIES SLIP, HE RECALLS, "I WAS ARRESTED FOR WASHING MY WINDOWS ON SUNDAY. . . . AT THAT TIME I HAD VERY BAD FEELINGS ABOUT THE LAW AND THE KIND OF INJUSTICES THAT UNDERPRIVI-LEGED PEOPLE IN NEW YORK ENJOY."[9] SUCH FEELINGS FOUND EMBODIMENT IN ONE OF HIS EARLY CONSTRUCTIONS, "A VERY PRIM, PURE KIND OF PIECE CALLED **LAW**,"[10] FORMERLY IN THE COLLECTION OF PHILIP JOHNSON.

A POLITICAL COMMENT MADE SOMEWHAT EARLIER THAN THE CONFEDERACY GROUP, **A DIVORCED MAN HAS NEVER BEEN THE PRESIDENT** (1961), WAS SIMILAR AND SLIGHTLY SIMPLER IN FORMAT. THIS DICTUM HAS, OF COURSE, BEEN CONTRA-DICTED SINCE THE POSTELECTION YEAR IN WHICH INDIANA SET IT DOWN, A SIGN THAT SOME OF THE PROTESTED SOCIAL MORES YIELD TO PRESSURE.

IN 1962, A WAVE OF POPULAR SENTIMENT AND REGRET SWEPT THE COUNTRY WITH THE SUICIDE OF MARILYN MONROE. (AMONG THE NUMEROUS SUICIDES PRECIPITATED BY HER ACT WAS THAT OF A FRIEND AND NEIGHBOR OF INDIANA'S ON COENTIES SLIP.) ARTISTS IN MANY FIELDS, NOTABLY POP, HASTENED TO ELEGIZE HER IN THEIR WORK. INDIANA, AS HE NOTED IN HIS "AUTOCHRONOLOGY," WAITED ALMOST SIX YEARS, "ONE OF HER OWN MYSTICAL NUMBERS AND A REASONABLY RESPECTABLE TIME,"[11] BEFORE CREATING HIS OWN MEMORIAL, **THE META-MORPHOSIS OF NORMA JEAN MORTENSON** (1967). "HIS FEELINGS TOWARD HER

MYTH," JOHN MCCOUBREY WROTE,[12] "WERE CRYSTALLIZED BY AN OLD CALENDAR TURNED UP BY CHANCE. IT BORE THE NUDE PHOTOGRAPH ON WHICH THE FIGURE IN [THE PAINTING] WAS BASED. THE LETTERPRESS READ 'GOLDEN DREAMS' AND MORE PORTENTOUSLY IN SMALL TYPE 'WHOLESALE CALENDAR COMPANY, NEW ALBANY, INDIANA.'"

THE "MYSTICAL NUMBERS" PLAY UPON THE NUMEROLOGICAL COMBINATIONS THAT HAVE ALWAYS ATTRACTED THE ARTIST. "SIX DIVIDED BY TWO. '26 THE YEAR OF HER BIRTH; '62 THE YEAR OF HER DEATH. AT TWO [SHE] WAS ALMOST SUFFOCATED BY A HYSTERICAL NEIGHBOR; AT SIX A MEMBER OF HER 12 (6 × 2) FOSTER FAMILIES TRIED TO RAPE HER. IN '52 (26 + 26) WHEN SHE WAS 26 . . . SHE [FIRST] STARRED IN A DRAMATIC ROLE AND, IN THE FIRST WEEK AT THE MANHATTAN BOX OFFICE, THE FILM GROSSED $26,000. DEATH CAME BY HER HAND ON THE SIXTH DAY OF AUGUST, THE EIGHTH MONTH (6 + 2). . . ."[13]

INDIANA WAS ALSO INTRIGUED, HE SAID, BY THE METAMORPHOSIS OF HER REAL NAME INTO HER HOLLYWOOD NAME, THROUGH THE ADDITION OF THREE LETTERS AND THE SUBTRACTION OF THREE OTHERS, "SIX AGAIN." THESE LETTERS ARE SET IN BANDS OF GRAY IN THE PAINTING. THE FATEFUL NUMBERS 6 AND 2 AND THE LETTERS OF BOTH NAMES, CENTERED IN SMALL CIRCLES, TAKE THE SHAPE OF THE DIAL OF A TELEPHONE (THE INSTRUMENT SHE HELD AS SHE DIED). IT SURROUNDS THE STYLIZED IMAGE OF THE DREAM GIRL, PAINTED IN "COSMETIC COLORS" AGAINST A GOLDEN STAR WHOSE TIPS INAUSPICIOUSLY SEEM TO MOCK THE DREAMS BY POINTING OUT "I MOON."[14]

IN **THE SWEET MYSTERY** (1960–61) INDIANA USED AS PRINCIPAL MOTIF A SYMBOL OF BOTH PERSONAL AND ANCIENT SIGNIFICANCE. HE HAS OUTLINED THE GENESIS OF THE WORK AT SOME LENGTH. HE HAD BEEN READING **I CHING,** THE ANCIENT CHINESE COSMOLOGICAL **BOOK OF CHANGES,** POPULARLY STUDIED IN BOTH OCCIDENT AND ORIENT FOR DIVINATION AND GUIDANCE IN DAILY LIFE THROUGH INTERPRETATION OF ITS SYSTEM OF SIXTY-FOUR HEXAGONS. ALSO, FOR A YEAR IN COENTIES SLIP, HE HAD BEEN WORKING OUT, IN HIS EXPERIMENTS WITH

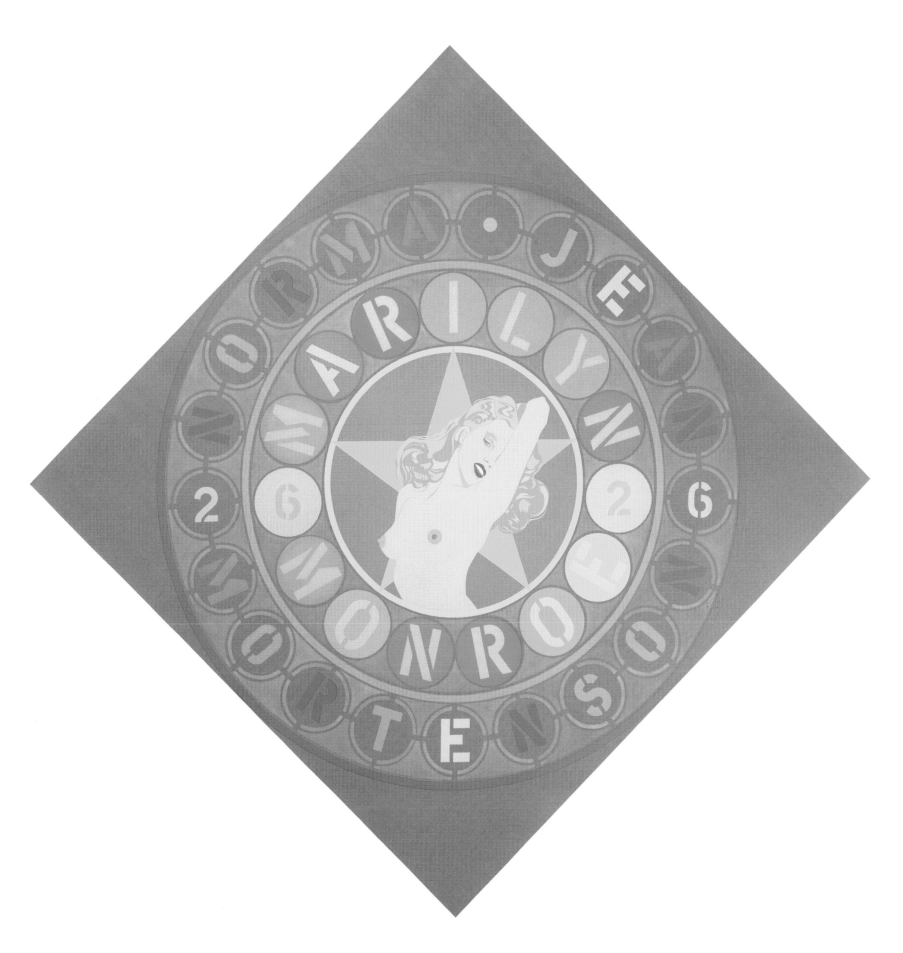

THE METAMORPHOSIS OF NORMA JEAN MORTENSON. 1967. OIL ON CANVAS, 8′6″ × 8′6″.

COLLECTION R. L. B. TOBIN, NEW YORK

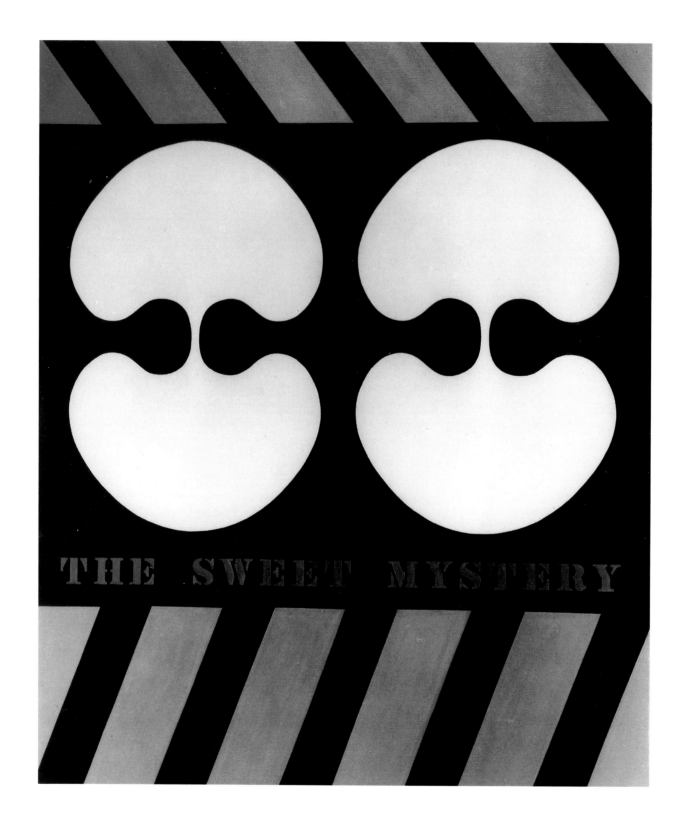

THE SWEET MYSTERY. 1960–61. OIL ON CANVAS, 72×60″

THE HARD-EDGE STYLE, "VARIOUS MUTATIONS OF THE DOUBLED GINKGO LEAF SHAPE" FROM THE TREES "OF PREHISTORIC ORIENTAL BOTANIC ORIGIN"[15] IN NEARBY JEANNETTE PARK. HE ASSOCIATED THE LEAF SHAPE WITH YANG AND YIN, THE VISUAL SIGN IN CHINESE COSMOLOGY FOR THE ACTIVE AND PASSIVE, OPPOSITE AND COMPLEMENTARY, MALE AND FEMALE PRINCIPLES COMBINED IN ALL THAT EXISTS.

THE TITLE WORDS, DRAWN FROM A LYRIC OF LIGHT OPERA, WERE "AMONG [HIS] FIRST CAUTIOUS USES OF [WORDS] ON CANVAS, HERE MUTED AND RESTRAINED." THE COLORS—YELLOW GOLD, EARTH RED, AND BLUE BLACK—REFLECT THE CYCLE OF THE YEAR, LIFE AND DEATH, AS WELL AS THE ARTIST'S OWN AFFINITY FOR YELLOW, "PARTICULARLY IN ITS DARKENED ASPECTS, THE BROWNS AND EARTHS."[16]

OBVIOUSLY, THE SOURCES OF A PAINTING ARE NOT THE SAME AS ITS MESSAGE. THEY DO, HOWEVER, ILLUMINATE THE CREATIVE PROCESS THROUGH WHICH AN ARTIST REACHES THE GIST OF HIS COMMUNICATION. PRIVATE ALLUSIONS HAVE MUCH TO DO WITH THE OVERALL ATMOSPHERE OF A WORK, BUT THE SELECTION OF THE FEW VISUAL ELEMENTS TO BE INCLUDED OUT OF THE MANY COMPLEX SOURCES OF INSPIRATION IS WHAT PROVIDES A BASIS OF EXPERIENCE COMMON TO BOTH ARTIST AND OBSERVER ON WHICH COMMUNICATION AND RESPONSE CAN TAKE PLACE. IN SUCH A PAINTING AS **THE SWEET MYSTERY** THE DISTILLATION OF SO MANY INGREDIENTS (BARELY SUMMARIZED HERE) WITHIN THE DELIBERATELY LIMITED RANGE OF HARD-EDGE IMAGE, FLAT COLOR AND SHAPE, AND TERSE WORDING IS THE ESSENCE OF "SIGN PAINTING" AS INDIANA HAS PRACTICED IT FROM THE EARLY STAGES OF HIS CAREER.

THE LABEL "SIGN PAINTER," ALTHOUGH INDIANA APPLIED IT TO HIMSELF, WAS NOT ENTIRELY LITERAL. JAMES ROSENQUIST, HE POINTED OUT, "WAS ACTUALLY UP THERE DANGLING FROM A SCAFFOLD AND PAINTING THOSE BROADWAY SIGNS. I NEVER HAD THAT KIND OF EXPERIENCE."[17] NOR COULD HE ACCEPT THE PREMISE THAT "ROBERT INDIANA IS ROBERT INDIANA BECAUSE OF AMERICAN ROAD SIGNS."[18] RATHER, IT SEEMED TO HIM A MARVELOUS COINCIDENCE THAT

SIGNS WERE READY-MADE FOR THE STYLE IN WHICH HE HAD BEGUN TO WORK. "A GOOD SIGN IS FLAT WITH HARD EDGES. IT DOESN'T HAVE BUMPS AND TEXTURE AND ALL THOSE SUBTLE NUANCES . . . ASSOCIATED WITH EUROPEAN PAINTING."[19] BY INCORPORATING INTO HIS PAINTINGS THE LINGUA FRANCA OF SIGNS, HE PROPOSED TO SPEAK OF HUMAN CONCERNS; OF FAITH, LUCK, AND DEATH; OF NUMEROLOGY, GEOMETRY, GEOGRAPHY, POETRY, HISTORY—AND SOMETIMES TO CRACK A JOKE OR HAZARD A PUN. WHOLE SUITES OF RELATED PAINTINGS COALESCED AS HE DEVELOPED HIS THEMES IN THIS VISUAL LANGUAGE; THE AMERICAN DREAM (SEE CHAPTER 5) AND THE LOVE SERIES (CHAPTER 7) OCCUPIED HIM FOR YEARS AND STILL HAVE A PART IN HIS THINKING.

DESPITE DRAWING SO MUCH FROM THE SEMIOTICS OF VEHICULAR ACTIVITY, INDIANA HAS VERY RARELY TAKEN HIS IMAGES FROM THE VEHICLES THEMSELVES. ONE OF THE EXCEPTIONS IS **HIGHBALL ON THE REDBALL MANIFEST** (1963; SEE PAGE 3); HERE, A LOOMING OLD STEAM LOCOMOTIVE MANIFESTS ITSELF HEAD-ON, COMPLETE WITH CYCLOPEAN HEADLIGHT, COWCATCHER, AND ENGINE NUMBER 25 DISPLAYED ON A COGWHEEL SHAPE AT THE CENTER OF THE BOILER. THE TITLE IS AN OLD RAILROAD TERM FOR THE SIGNAL "ALL CLEAR FOR A. FAST EXPRESS."[20] INDIANA'S PATERNAL GRANDFATHER DROVE A LOCOMOTIVE AND HIS FATHER WORKED BRIEFLY FOR THE PENNSYLVANIA RAILROAD. THE NUMBER 25 WAS THE PAINTER'S SECOND ADDRESS ON COENTIES SLIP.

THE GRAYS OF "THIS PREDOMINATELY GRISAILLE WORK WERE TAKEN FROM THE SAME PAINT JARS" USED FOR HIS **MOTHER** AND **FATHER** DIPTYCH (BEGUN IN 1963 BUT NOT COMPLETED UNTIL 1967; SEE PAGES 118–19). THE MODEL TS IN THE DIPTYCH AND IN **THE MOTHER OF US ALL** (SEE PAGE 129) CONSTITUTE HIS "ONLY OTHER EXCURSIONS INTO THE MECHANICAL GENIUS OF AMERICA."[21] THE SPEEDING FIRE ENGINE THAT TRAVELED FROM A POEM TO A CHARLES DEMUTH PAINTING AND INTO THE FIFTH OF INDIANA'S AMERICAN DREAM SEQUENCE WAS REPRESENTED ONLY BY ITS NUMBER, "THE FIGURE 5 IN GOLD" (SEE PAGES 109–12).

NUMBERS, HERE AS THROUGHOUT INDIANA'S WORK, ARE POWERFUL SIGNS TO

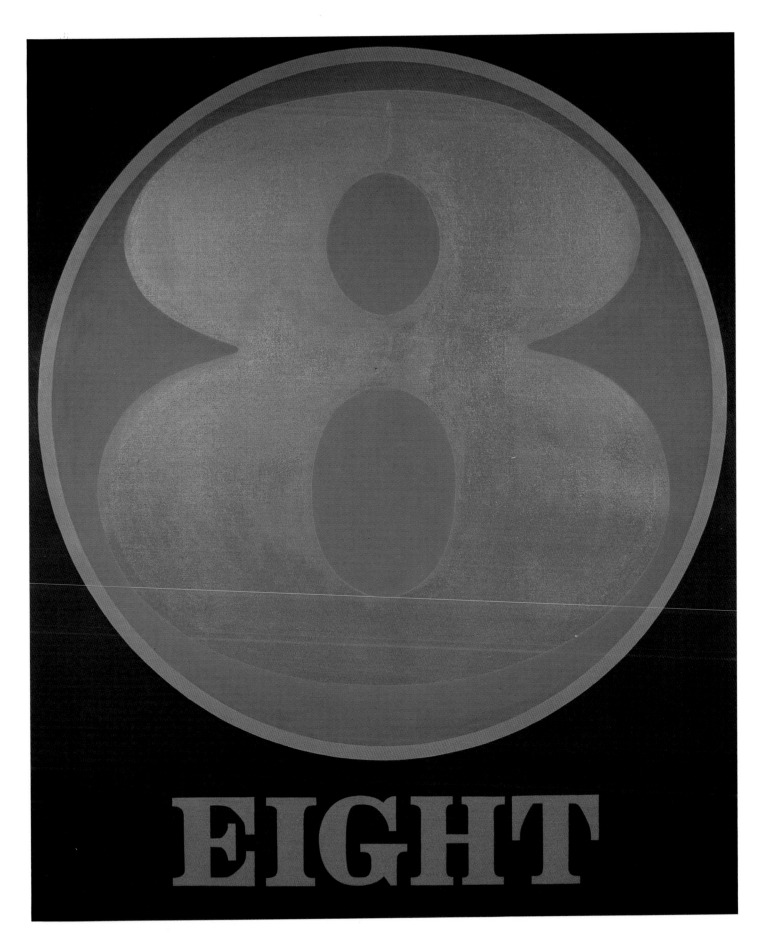

EIGHT. 1965.

OIL ON CANVAS, 60×50″. STEDELIJK MUSEUM, AMSTERDAM

CONJURE WITH. "THEY ARE AN INCREDIBLE INVENTION AND SHOULD BE CELE-
BRATED. . . ."[22] HIS NUMBER PAINTINGS, IN WHICH THE INTEGERS STAND ALONE,
CELEBRATE AND PERSONIFY THE MAGIC OF SINGULARITY, DUALITY, TRINITY, AND
SO ON TO NOTHINGNESS OR INFINITY.

AN EXTENSIVE SECTION OF INDIANA'S WORK DIFFERS IN PURPOSE FROM THE
PAINTINGS THAT USE THE IDIOM OF PUBLIC SIGNS TO DEAL WITH A MULTITUDE OF

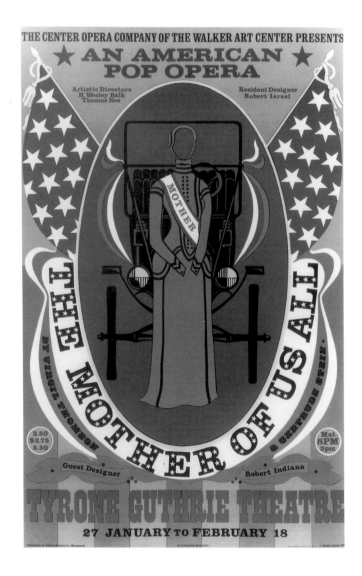

POSTER: **THE MOTHER OF US ALL**. 1967. OFFSET, 37 × 24″.
THE CENTER OPERA COMPANY OF
THE WALKER ART CENTER, MINNEAPOLIS

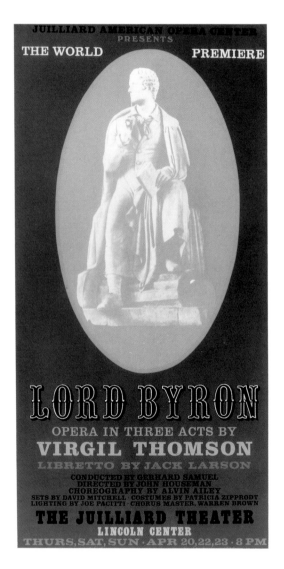

POSTER: **LORD BYRON**. 1972.
SILKSCREEN, 80¼ × 39¾″.
LIST ART POSTERS, HKL LTD., BOSTON

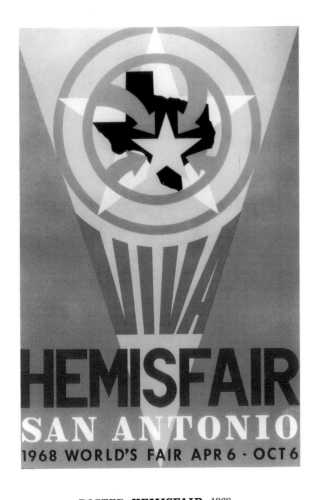

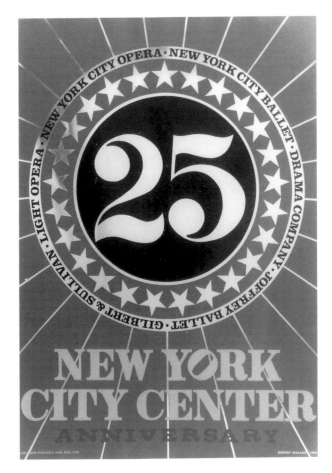

POSTER: **HEMISFAIR**. 1968.
OFFSET, 46 × 30″.
SAN ANTONIO 1968 WORLD'S FAIR, TEXAS

POSTER: **NEW YORK CITY CENTER**. 1968.
SILKSCREEN, 36 × 25½″.
LIST ART POSTERS, HKL LTD., BOSTON

THEMES. HIS POSTERS AND BANNERS ARE THEMSELVES SIGNS, IN THE SENSE OF PUBLIC NOTICES AND ANNOUNCEMENTS, OFTEN WIDELY DISPLAYED. COMMISSIONED TO ADVERTISE EXHIBITIONS, MUSICAL AND THEATRICAL PERFORMANCES, AND OTHER EVENTS, THEY ARE DESIGNED TO CATCH AND COMMAND THE EYE OF THE PASSERBY AND TO CONVEY PRECISE INFORMATION AT A GLANCE. THE MESSAGE IN THESE CASES IS NOT THAT OF THE ARTIST BUT OF THE COMMISSIONER. THE RECOGNIZABLE INDIANA STYLE IS PECULIARLY ADAPTED TO MEET THOSE REQUIREMENTS AND STILL OFFER A DAZZLING VARIETY OF SOLUTIONS, WHICH DO NOT DIFFER VISUALLY FROM HIS MORE SUBJECTIVE "SIGN PAINTINGS."

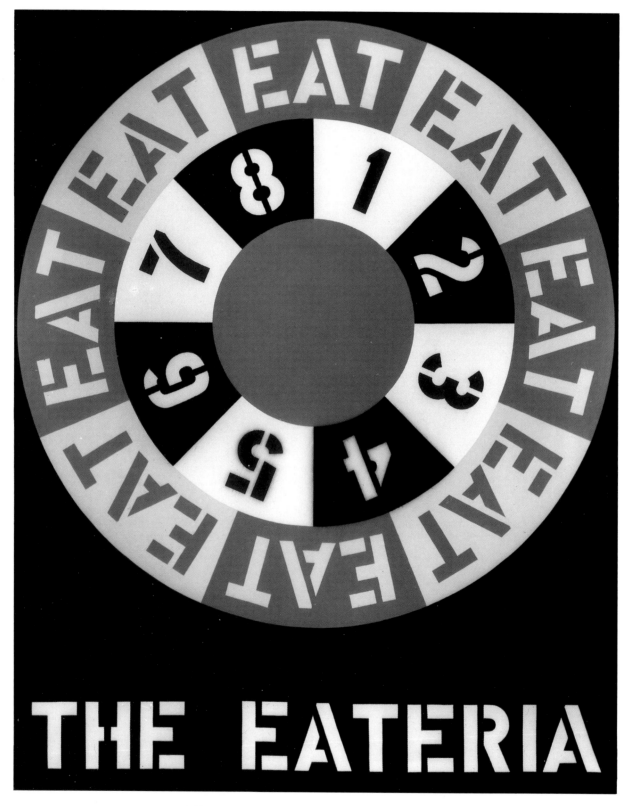

THE EATERIA. 1962. OIL ON CANVAS, 60 × 48″.
HIRSHHORN MUSEUM AND SCULPTURE GARDEN, SMITHSONIAN INSTITUTION, WASHINGTON, D.C.

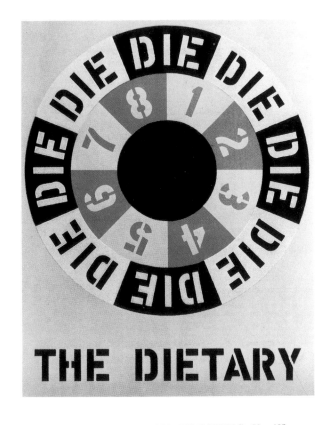

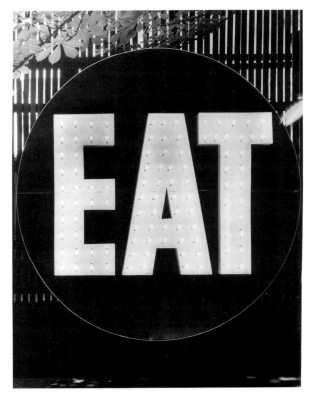

THE DIETARY. 1962. OIL ON CANVAS, 60 × 48″.
WHEREABOUTS UNKNOWN

EAT SIGN (SMALL VERSION). 1964.
METAL WITH ELECTRIC BULBS, DIAMETER 6′

THE MAJORITY OF THE POSTERS ARE NONREPRESENTATIONAL. AMONG THE
FEW TO INCLUDE REALISTIC ELEMENTS ARE **THE MOTHER OF US ALL** (1967), WITH
THE MOTHER HERSELF IN FRONT OF A MODEL T SURROUNDED IN HERALDIC STYLE
BY THE AMERICAN FLAG, AND THE 1972 POSTER FOR VIRGIL THOMSON'S OPERA
LORD BYRON, BEARING A CAMEOLIKE MINIATURE OF A WELL-KNOWN PORTRAIT
STATUE OF THE POET. FOR THE **HEMISFAIR** POSTER, CELEBRATING THE WORLD'S
FAIR HELD IN SAN ANTONIO, TEXAS, IN 1968, INDIANA USED A MAP OF THE STATE IN
A MANNER RECALLING THE CONFEDERACY SERIES AND FOCUSED ON THE SITE WITH
A WHIRL OF ARROWS AND A FLOODLIGHT BEAMED ON RAYS THAT SPELL VIVA. THE
TWENTY-FIFTH ANNIVERSARY POSTER FOR NEW YORK'S CITY CENTER (1968) IS
REMINISCENT OF THE BASIC FORMAT OF **HIGHBALL ON THE REDBALL MANIFEST**
(SEE PAGE 3), STRIPPED OF ALL LOCOMOTIVE ATTRIBUTES BUT CENTERING ON THE

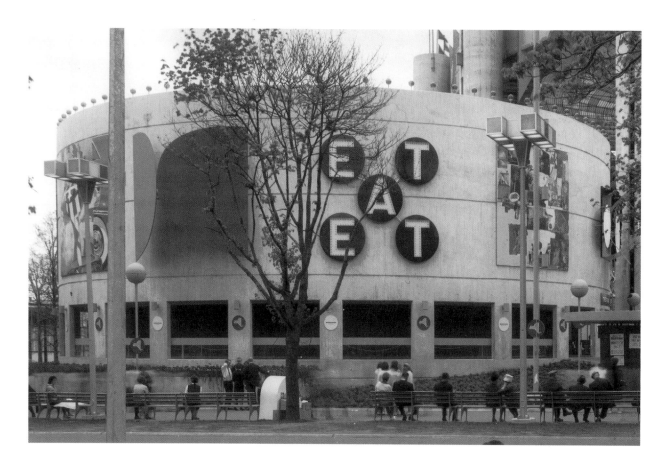

EAT, ELECTRIC MURAL SIGN ON CIRCARAMA BUILDING
OF PHILIP JOHNSON'S NEW YORK STATE PAVILION, NEW YORK WORLD'S FAIR, 1964–65.
LIGHTED ON OPENING DAY ONLY, BECAUSE OF PUBLIC MISINTERPRETATION OF ITS PURPOSE.
OTHER WORKS, FROM LEFT: BY JAMES ROSENQUIST, ELLSWORTH KELLY,
ROBERT RAUSCHENBERG, AND ALEXANDER LIBERMAN

NUMBER 25. A DETAILED RATIONALE OF DESIGN CONSIDERATIONS FOR THE INAUGURAL POSTER FOR THE NEW YORK STATE THEATER AT LINCOLN CENTER IS GIVEN IN CHAPTER 8, WITH THE DISCUSSION OF THE ARTIST'S PROCEDURES.

THE **EAT SIGN** COMMISSIONED FOR THE NEW YORK WORLD'S FAIR IN 1964 PRESENTS A PARADOX. TO ALL APPEARANCES IT WAS A BONA FIDE COMMERCIAL SIGN—HUGE (20 BY 20 FEET), THREE DIMENSIONAL, STUDDED WITH ELECTRIC LIGHT BULBS, AND MOUNTED OUTDOORS. YET ITS FUNCTION BELIED ITS APPEARANCE; IT WAS A UNIQUE WORK OF FINE ART, NOT THE SUMMONS TO AN EATERY.

WHEN INDIANA BEGAN ON HIS "SIGN PAINTINGS," HE RELISHED THE PERIOD

FLAVOR OF THE LETTER AND NUMBER FORMS AND THE STYLIZED IMAGES OF HIS FOUND MODELS (THE STENCILS, CALENDARS, MAPS, AND SO ON). "IN HIS FONDNESS FOR SOME OF THE OLDER AND LESS CHANGEFUL FORMS OF COMMERCIAL EXPRESSION," McCOUBREY COMMENTED, "AND IN HIS INSISTENCE ON THEIR PERSONAL AS WELL AS GENERAL SIGNIFICANCE," INDIANA SEEMS TO HALT TO SOME EXTENT "THEIR HEADLONG PROCESS OF CHANGE AND MAKE HIS OWN THE TERRIFYING IMPERSONALITY WITH WHICH THEY CLAIM US."[23] IN COMBINING THOSE ALREADY ANTIQUATED FORMS WITH THE TIMELESSNESS OF GEOMETRIC SHAPES AND THE CONTEMPORARY HARD-EDGE MANNER, INDIANA EVOLVED THE INDIVIDUAL STYLE THAT SET HIM APART FROM OTHER PRACTITIONERS OF "SIGN PAINTING," WHOSE WORK MORE OFTEN INCORPORATED ELEMENTS DIRECTLY FROM THE MASS MEDIA OF THE MOMENT.

1. IN INSTITUTE OF CONTEMPORARY ART OF THE UNIVERSITY OF PENNSYLVANIA, PHILADELPHIA, **ROBERT INDIANA** (1968), EXHIBITION CATALOGUE, P. 9.

2. IN VIVIEN RAYNOR, "THE MAN WHO INVENTED LOVE," **ART NEWS** 72, NO. 2 (FEBRUARY 1973), P. 62.

3, 4. IN INSTITUTE OF CONTEMPORARY ART OF THE UNIVERSITY OF PENNSYLVANIA, **ROBERT INDIANA,** P. 9.

5–7. IBID., P. 20.

8. MANUSCRIPT PROVIDED BY ROBERT INDIANA.

9, 10. IN UNIVERSITY OF TEXAS AT AUSTIN, **ROBERT INDIANA** (1977), EXHIBITION CATALOGUE, P. 41.

11. ROBERT INDIANA, "AUTOCHRONOLOGY," IN UNIVERSITY OF TEXAS AT AUSTIN, **ROBERT INDIANA,** P. 47.

12. JOHN W. McCOUBREY, IN INSTITUTE OF CONTEMPORARY ART OF THE UNIVERSITY OF PENNSYLVANIA, **ROBERT INDIANA,** P. 40.

13, 14. IN INSTITUTE OF CONTEMPORARY ART OF THE UNIVERSITY OF PENNSYLVANIA, **ROBERT INDIANA,** P. 45.

15, 16. IBID., P. 15.

17, 18. IN UNIVERSITY OF TEXAS AT AUSTIN, **ROBERT INDIANA,** P. 36.

19. IBID., P. 40.

20, 21. MANUSCRIPT PROVIDED BY ROBERT INDIANA.

22. IN UNIVERSITY OF TEXAS AT AUSTIN, **ROBERT INDIANA,** P. 40.

23. McCOUBREY, IN INSTITUTE OF CONTEMPORARY ART OF THE UNIVERSITY OF PENNSYLVANIA, **ROBERT INDIANA,** P. 42.

." THE AMERICAN DREAM: "WHEN I D
ID THAT PAINTING, I HAD NO IDEA ITS T
HEME WOULD OCCUPY MOST OF MY LI
FE." THE AMERICAN DREAM: "WHEN
I DID THAT PAINTING, I HAD NO IDEA IT
S THEME WOULD OCCUPY MOST OF M
Y LIFE." THE AMERICAN DREAM: "W
HEN I DID THAT PAINTING, I HAD NO ID
EA ITS THEME WOULD OCCUPY MOST O
F MY LIFE." **THE AMERICAN DREAM:
"WHEN I DID THAT PAINTING, I HAD NO
IDEA ITS THEME WOULD OCCUPY MOST
OF MY LIFE."** THE AMERICAN DREAM
: "WHEN I DID THAT PAINTING, I HAD N
O IDEA ITS THEME WOULD OCCUPY MO
ST OF MY LIFE." THE AMERICAN DRE
AM: "WHEN I DID THAT PAINTING, I HA

5

I N THE LATE 1950S INDIANA STARTED A PAINTING THAT, AS HE WORKED AND REWORKED IT, TURNED INTO HIS FIRST **AMERICAN DREAM** (1960–61), "A PIVOTAL CANVAS AND A CRUCIAL ONE"[2] TO HIM, FOR IT SET HIM ON A PARTICULAR ARTISTIC COURSE THAT HE STILL FOLLOWS. IT WAS EXHIBITED ALONG WITH HIS EARLY CONSTRUCTIONS, WHEN, AS HE SAYS, HIS MOTIFS "CHANGED FROM A CLASSIC WHITE GEOMETRY TO THE NEON POLYCHROMY OF NOW AMERICA."[3] AND IT WAS THE "SPELLBINDING" WORK THAT ALFRED BARR SINGLED OUT AMONG THE NEW ACQUISITIONS OF THAT YEAR FOR THE MUSEUM OF MODERN ART IN NEW YORK.

THE FAMILIAR PHRASE OF ITS TITLE WAS KNOWN TO THE ARTIST FROM BOYHOOD, BUT THE IMMEDIATE SPARK OF THE IDEA WAS EDWARD ALBEE'S PLAY OF THE SAME NAME, WHICH INDIANA HAD SEEN AND LIKED. SOME OF THE DRAMA'S APPEAL TO THE ARTIST MAY BE FOUND IN ALBEE'S RESPONSE TO HIS CRITICS: "THE PLAY IS . . . AN ATTACK ON THE SUBSTITUTION OF ARTIFICIAL FOR REAL VALUES IN OUR SOCIETY, A CONDEMNATION OF COMPLACENCY, CRUELTY, EMASCULATION, AND VACUITY; IT IS A STAND AGAINST THE FICTION THAT EVERYTHING IN THIS SLIPPING LAND OF OURS IS PEACHY-KEEN."[4] INDIANA, TOO, WAS FEELING "CRITICAL OF CERTAIN ASPECTS OF THE AMERICAN EXPERIENCE" AT THAT PERIOD, AND USED THE WORD "DREAM . . . IN AN IRONIC SENSE."[5] IN THE NATIONAL CLIMATE OF ASSASSINATIONS, FOREIGN WARS, CIVIL INJUSTICES, AND MORAL LAXITY, HE FOUND HIMSELF IN AGREEMENT WITH ALBEE THAT "EVERY HONEST WORK IS A PERSONAL, PRIVATE YOWL" AND SHARED THE HOPE THAT **THE AMERICAN DREAM** (HIS OWN, AS WELL AS THE PLAYWRIGHT'S) "TRANSCENDS THE PRIVATE AND HAS SOMETHING TO DO WITH THE ANGUISH OF US ALL."[6]

UNLIKE HIS HIGH-COLORED LATER PAINTINGS, THAT FIRST **AMERICAN DREAM** IS "DARK," THE ARTIST SAYS, "FULL OF THE BLACKNESS OF THE PAINTINGS I DID WHEN I WAS VERY DEPRESSED ON MY ARRIVAL IN NEW YORK."[7] THE BASIC TONES, ARRIVED AT BY UNDERPAINTING, ARE AN UMBER-OCHER COMBINATION AGAINST A BLACK GROUND, WITH ONLY SMALL AREAS PICKED OUT IN BRIGHTER

COLORS. EACH OF THE FOUR TONDO FORMS THAT OCCUPY THE RECTANGULAR FORMAT CENTERS ON A FIVE-POINTED STAR, BUT THE SHAPES AND COLORS SURROUNDING THOSE CENTRAL STARS PLAY TRICKS ON THE EYE AS IT PASSES FROM ONE TO ANOTHER. VERTICAL BARS, CONCENTRIC CIRCLES, DIAMONDS WITHIN CIRCLES, AND A STAR-TIPPED PENTAGON ACTIVATE FORM AND COUNTER FORM, FIGURE AND GROUND, SO THAT ALL APPEARS TO BE IN MOTION. SMALLER STARS IN ORBIT— WHITE, BLUE, GREEN—SEEM TO FLICKER ON AND OFF; WORDS—TAKE ALL, TILT (THE LATTER GIVEN A BOUNCE BY BLACK DOTS STAGGERED BELOW THE LETTERS)— FLASH OUT. THE TITLE WHEELS AROUND THE LOWER RIGHT CIRCLE IN A CYCLE OF RED, BLUE, GREEN, AND YELLOW STENCILED LETTERS. AS INDIANA INTENDED, THE PAINTING SPEAKS OF "ALL THOSE MILLIONS OF PIN BALL MACHINES AND JUKE BOXES IN ALL THOSE HUNDREDS OF GRUBBY BARS AND ROADSIDE CAFES, ALTERNATE SPIRITUAL HOMES OF THE AMERICAN."[8] TO LOOK AT IT IS ALSO TO HEAR THE CLANK OF THE INNER WORKINGS, THE BELLS AND BUZZERS THAT PUNCTUATE THE GAME, AND THE JINGLE OF COINS THAT VANISH DOWN THE SLOT OR, JUST MAYBE, ON SOME NIGHT OF LUCKY STARS, RAIN DOWN A SHOWER OF WEALTH.

THE AUTOBIOGRAPHICAL ALLUSIONS IN THE PINBALL MOTIFS HAVE BEEN POINTED OUT BY THE PAINTER HIMSELF. AT THE UPPER LEFT THE YELLOW AND BLACK BARS OF ROAD-SIGN WARNINGS ARE MARKED WITH THE ROUTE NUMBERS, 37, 40, 29, AND 66, THAT HE ASSOCIATES WITH HIS FATHER. AND THE JARGON OF THE GAMES IS A REMINDER THAT FOR HIS PARENTS THE MACHINES BECAME A FOLLY, A FALSE HOPE OF BREAKING OUT OF THE DEPRESSION AND POVERTY THAT GRIPPED THEM AFTER HIS FATHER HAD LOST HIS JOB—A PASSION RIVALING THAT FOR THE AUTOMOBILE ITSELF, "THE VERY KEYSTONE OF THEIR 'DREAM.'"[9]

AS THE AMERICAN DREAM PROLIFERATED INTO A SERIES, THE MOOD REMAINED "CAUSTIC," IF NOT "CYNICAL," FOR THE FIRST TWO OR THREE. "THEN, AS THEY PROGRESSED, THEY LOST THAT IRONY . . . PARTICULARLY WITH THE FIFTH DREAM," INDIANA SAYS, "AND AS THE DREAMS CONTINUE . . . NEGATIVE ASPECTS HAVE PRETTY WELL DISAPPEARED. THEY ARE ALL CELEBRATIONS."[10]

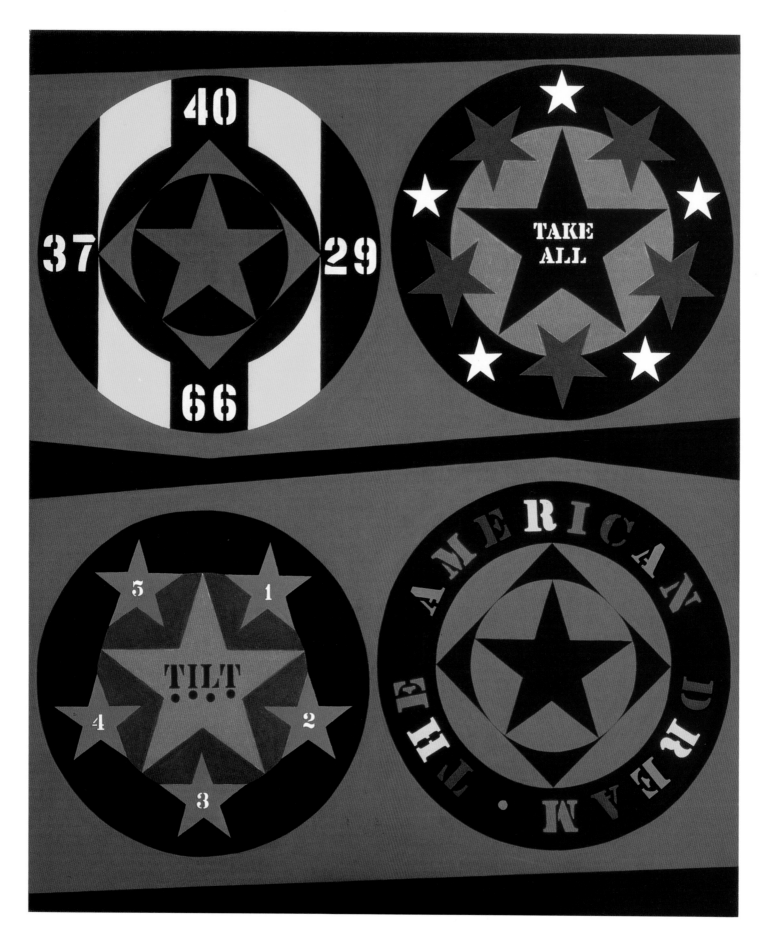

THE AMERICAN DREAM. 1960–61. OIL ON CANVAS, 72 × 60⅛″.
COLLECTION, THE MUSEUM OF MODERN ART, NEW YORK. LARRY ALDRICH FOUNDATION FUND

THE SECOND, **THE BLACK DIAMOND AMERICAN DREAM #2** (1962), STILL ON THE DARK SIDE, AS ITS TITLE INDICATES, INTRODUCED THE DIAMOND FORMAT, WHICH WAS TO BE REPEATED IN SEVERAL SUCCEEDING PAINTINGS OF THE SERIES. ALSO, WHILE RETAINING THE CONCENTRIC CIRCLE AND STAR MOTIFS OF THE FIRST AMERICAN DREAM, IT BROUGHT INTO PLAY THE WORDS JACK AND JUKE AND THE MONITORY EAT, WHICH FORMS AN ACROSTIC IN THE TOP CIRCLE. THE SERIAL NUMBER 2 MARKS THE CENTER OF THE TITLE WHEEL AT THE BOTTOM.

NUMBER 3, **THE RED DIAMOND AMERICAN DREAM #3** (1962), IS A COMPOSITE OF FOUR DIAMOND-SHAPED PANELS. AGAINST ITS STRONG RED GROUND STANDS A BOLD ALTERNATION OF BLACK AND WHITE FORMS, LETTERS, AND NUMBERS. THE HIGHWAY SIGNS HAVE RETURNED, IN THE TOP TONDO, AS HAVE THE WORDS TILT AND TAKE ALL, BELOW IT TO THE LEFT AND RIGHT, BUT WITH VARIATIONS. THE ROUTE NUMBERS HERE CENTER ON US. TILT HAS ACQUIRED AN OCTAGONAL DIAL AND A POINTER FOR THE EIGHT NUMBERS IN THE BLACK-AND-WHITE CIRCLE SEGMENTS SURROUNDING IT. THE WORD ALL NOW IS REITERATED IN FOUR SEGMENTS OF THE OUTER RING AROUND TAKE, WHICH HAS AS SATELLITES TWO BLACK-AND-WHITE DISKS SPINNING, IT SEEMS, LIKE PINWHEELS. A GLEAM OF YELLOW COMES THROUGH FROM THE INNER CIRCLES OF EACH TONDO, ALL BUT ECLIPSED BY SUPERIMPOSED OCTAGONS. IN THE TITLE RING, THE SERIAL NUMBER 3 IS INTERSECTED INTO GEMLIKE FACETS BY THE QUARTERING OF ITS RED-AND-BLACK OCTAGON.

THE IDENTIFYING NUMBER IS PROMINENT IN THE FOURTH AMERICAN DREAM, **THE BEWARE—DANGER AMERICAN DREAM #4** (1963), ANOTHER DIAMOND OF FOUR PANELS. A RED 4, BLAZING AGAINST THE DIAGONAL BLACK-AND-WHITE BARS OF THE DANGER SIGN, OCCUPIES THE CENTER OF EACH CIRCLE. ALONG WITH EAT AND THE JUKE–JACK TEASER APPEARS A NEW WORDPLAY—JILT PAIRED WITH TILT—ALL IN DAZZLING YELLOW-AND-RED WORD WHEELS.

AFTER THIS STAGE IN THE AMERICAN DREAM SEQUENCE, THE PINBALL-JUKEBOX-SLOT MACHINE IMAGERY GAVE WAY TO OTHER THEMATIC REFERENCES. NUMBERS WERE STILL OF FUNDAMENTAL INTEREST; AUTOBIOGRAPHY REMAINED

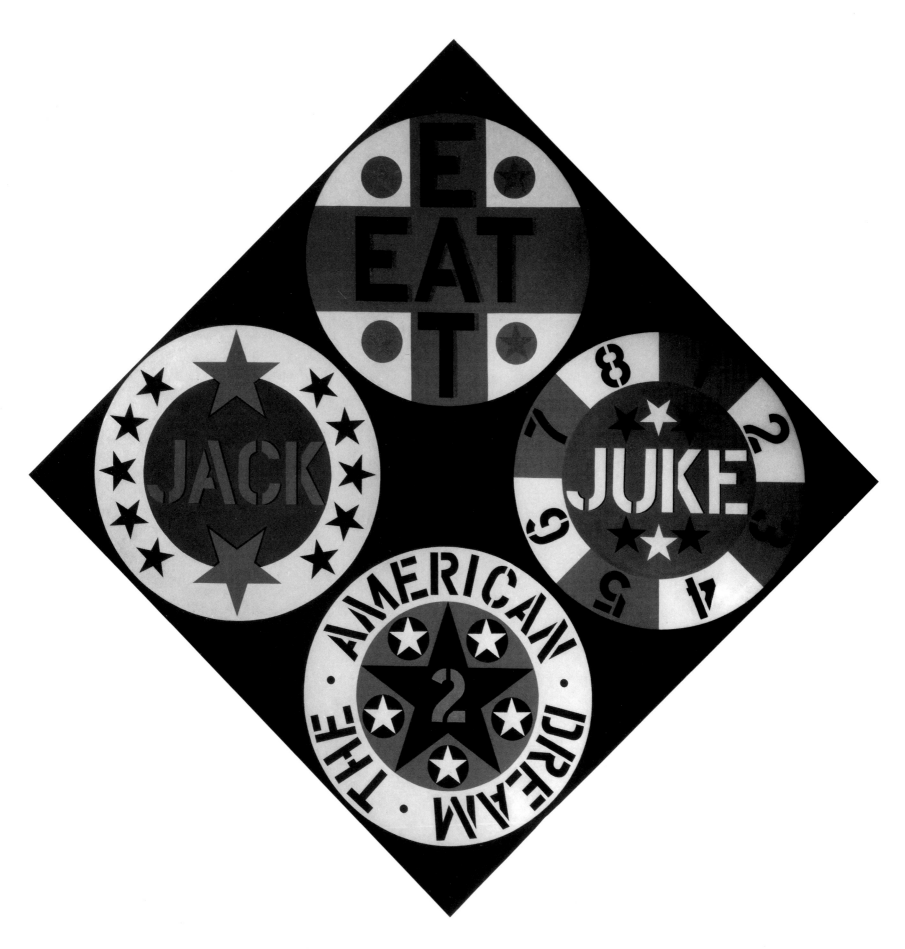

THE BLACK DIAMOND AMERICAN DREAM #2. 1962.
OIL ON CANVAS, 85×85″. PRIVATE COLLECTION

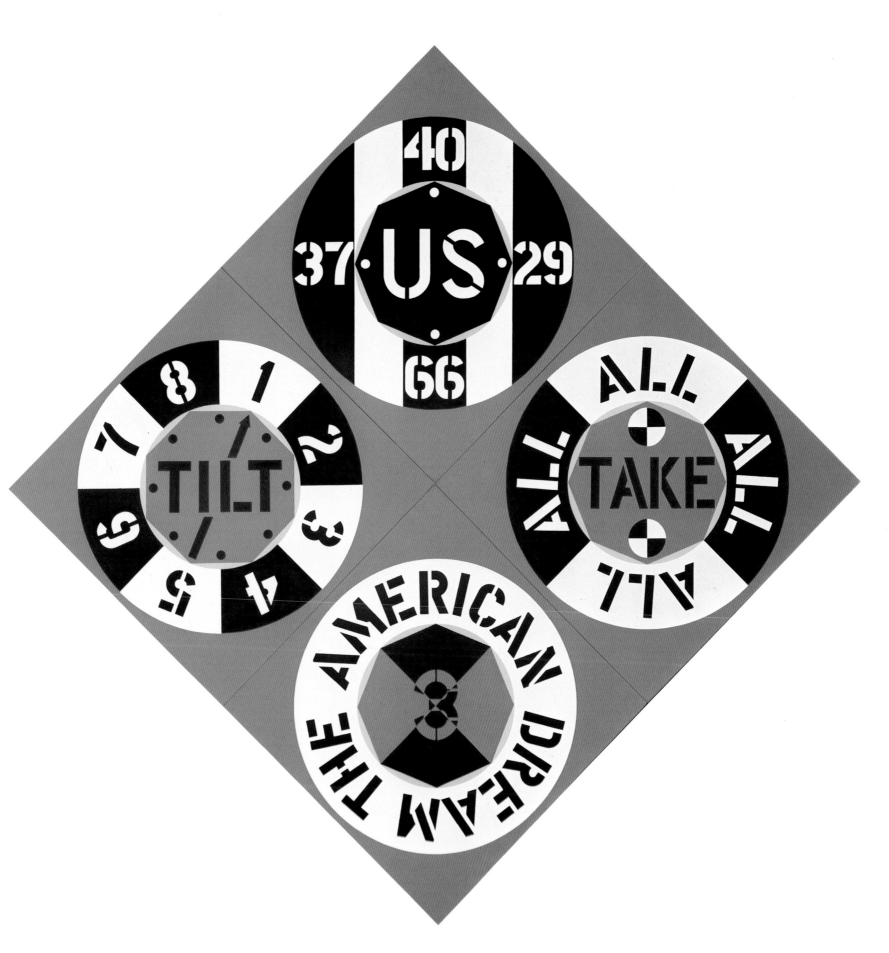

THE RED DIAMOND AMERICAN DREAM #3. 1962. OIL ON CANVAS, 4 PANELS, 8′6″ × 8′6″.

VAN ABBEMUSEUM, EINDHOVEN, NETHERLANDS

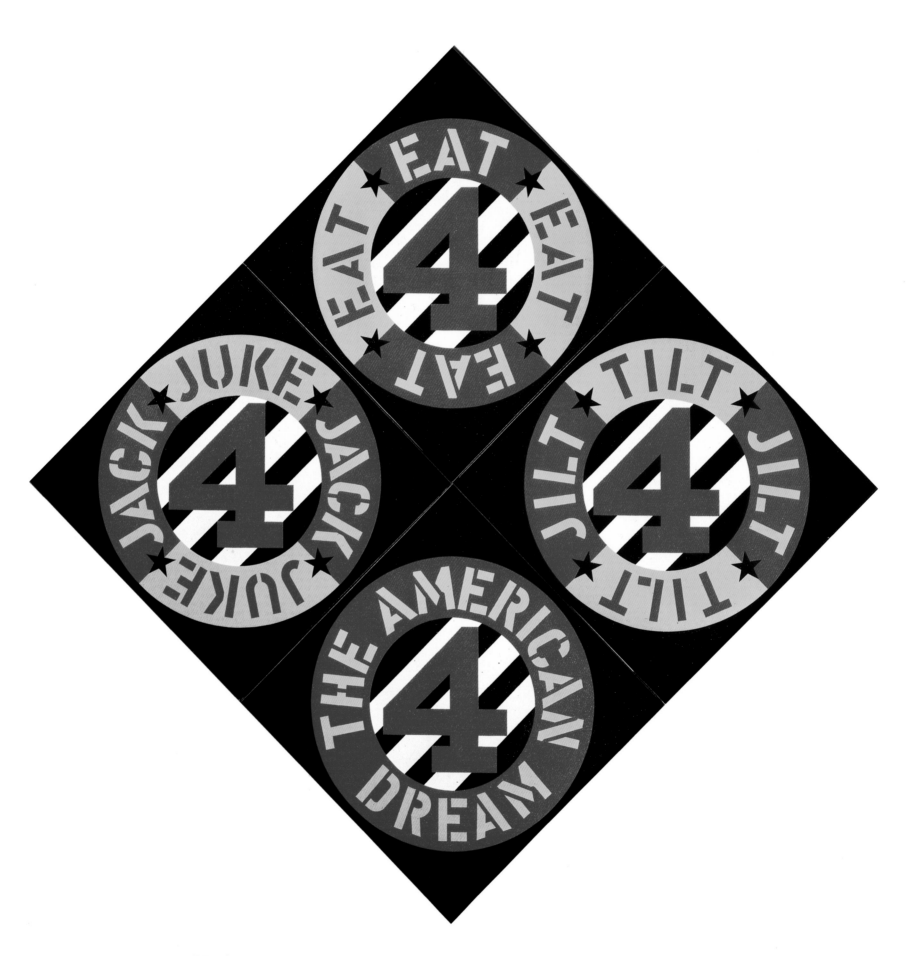

THE BEWARE—DANGER AMERICAN DREAM #4. 1963. OIL ON CANVAS, 4 PANELS, 8'6"×8'6".
HIRSHHORN MUSEUM AND SCULPTURE GARDEN, SMITHSONIAN INSTITUTION, WASHINGTON, D.C.

IMPLICIT, IF NOT EXPLICIT; AND THE FORMAL VOCABULARY OF GEOMETRY, HARD-EDGED SHAPE, AND FLAT COLOR HANDLING PERSISTED; BUT A NEW OPENING CAME WITH THE NUMBER 5 AND ITS ASSOCIATED CANVASES. IT WAS IN THE FIFTH AMERICAN DREAM, INDIANA SAYS, THAT HE "BECAME INVOLVED WITH THE IMAGERY AND THE EXPERIENCE OF DEMUTH."[11] MUCH EARLIER, AS A STUDENT AT THE ART INSTITUTE OF CHICAGO, HE HAD FOUND A KINSHIP IN THE WORK OF CHARLES DEMUTH, PERHAPS BECAUSE "NOT VERY MANY OTHER AMERICAN ARTISTS BROUGHT THEMSELVES TO PAINT WORDS OR ANYTHING ELSE THAT HAD MUCH TO DO WITH THE FACT THAT THE WORLD WAS MOVING ON. . . . IT SEEMED TO BE A MODERN STEP."[12]

INDIANA'S FAVORITE AMERICAN PAINTING IS DEMUTH'S **I SAW THE FIGURE 5 IN GOLD,** WHICH HE SAW IN NEW YORK'S METROPOLITAN MUSEUM OF ART. THAT WORK WAS INSPIRED, AS MANY OF HIS OWN HAVE BEEN, BY POETRY, IN THIS CASE "THE GREAT FIGURE" BY DEMUTH'S FRIEND WILLIAM CARLOS WILLIAMS. ON HIS WAY TO MARSDEN HARTLEY'S STUDIO IN NEW YORK CITY, THE POET HEARD "A GREAT CLATTER OF BELLS AND THE ROAR OF A FIRE ENGINE PASSING . . . DOWN NINTH AVENUE." HE TURNED TO GLIMPSE A GOLD FIVE ON A RED GROUND AS THE ENGINE FLASHED BY. ON THE SPOT HE JOTTED DOWN THESE LINES:

> AMONG THE RAIN
> AND LIGHTS
> I SAW THE FIGURE 5
> IN GOLD
> ON A RED
> FIRETRUCK
> MOVING
> TENSE
> UNHEEDED
> TO GONG CLANGS
> SIREN HOWLS
> AND WHEELS RUMBLING
> THROUGH THE DARK CITY

DEMUTH'S PAINTING CAPTURING THE IMPRESSION OF THOSE WORDS, AS WELL AS THE DATES AND NUMBERS MARKING THE WHOLE SEQUENCE OF EVENTS, OFFERED INDIANA A CHAIN OF ENGROSSING COINCIDENCES. THE PICTURE IS DATED 1928, THE YEAR OF INDIANA'S BIRTH. **THE DEMUTH AMERICAN DREAM #5,** INDIANA'S HOMAGE TO THE EARLIER WORK AND ITS ARTIST, WAS DONE IN 1963, THE YEAR OF WILLIAMS'S DEATH. TO FOLLOW INDIANA'S LINKAGE: 1963 MINUS 1928 LEAVES 35, "A NUMBER SUGGESTED BY THE SUCCESSION OF THREE FIVES (5 5 5) DESCRIBING THE SUDDEN PROGRESSION OF THE FIRETRUCK IN THE POET'S EXPERIENCE."[13] IT WAS ALSO IN 1935 THAT DEMUTH DIED.

ONE OF THE 1963 PAINTINGS THAT COMPRISE INDIANA'S FIFTH AMERICAN DREAM SUITE IS **THE FIGURE FIVE,** WHICH HE CALLS "A THRENODY ON THAT NUMBER." IT PICKS UP THE CALLIGRAPHIC FORMALITY OF DEMUTH'S THREE 5S, WHICH CAN BE READ EITHER AS ADVANCING OR RETREATING IN MOTION; IT CENTERS THEM ON A STAR WITHIN A PENTAGON WITHIN A CIRCLE, AS IN VARIOUS STAGES OF THE PRECEDING AMERICAN DREAMS; AND IT INCORPORATES SOME OF THE MINGLED HIGHWAY-AUTOBIOGRAPHY SIGNS: EAT, DIE, HUG, ERR, AND USA. BETWEEN THE PENTAGON AND THE SURROUNDING CIRCLE, RAYS OF SUBDUED COLOR SUGGEST BOTH RADIATION AND SPIN. THE TITLE APPEARS WITHIN THE SPACE OF THE TOTAL RECTANGULAR FORMAT. ANOTHER VERSION OF THE SAME ELEMENTS IS **THE SMALL DEMUTH DIAMOND FIVE**.

FOR THE MAJOR PAINTING OF THIS SUITE, **THE DEMUTH AMERICAN DREAM #5,** "I CHOSE THE CRUCIFORM, A POLYPTYCH OF UNUSUAL FORM IN THE HISTORY OF PAINTING . . . BY THE USE OF WHICH I MEANT TO SET THIS PARTICULAR PAINTING MOST APART FROM ALL OTHERS GIVEN THAT ITS THEME AND INTERNAL FORM IS IN DIRECT DIALOGUE WITH THE ORIGINAL INSPIRATION."[14] OF THE FIVE LARGE SQUARE PANELS THAT COMPOSE THE CROSS, THE CENTRAL ONE, WHICH BEARS THE TITLE AND THE DATES OF BOTH DEMUTH'S AND INDIANA'S PAINTINGS, IS MOST CLOSELY RELATED TO DEMUTH'S COMPOSITION AND TO THE TWO VERSIONS DESCRIBED ABOVE. "THE HEAD, THE ARMS, THE FOOT . . . ECHO AND REINFORCE

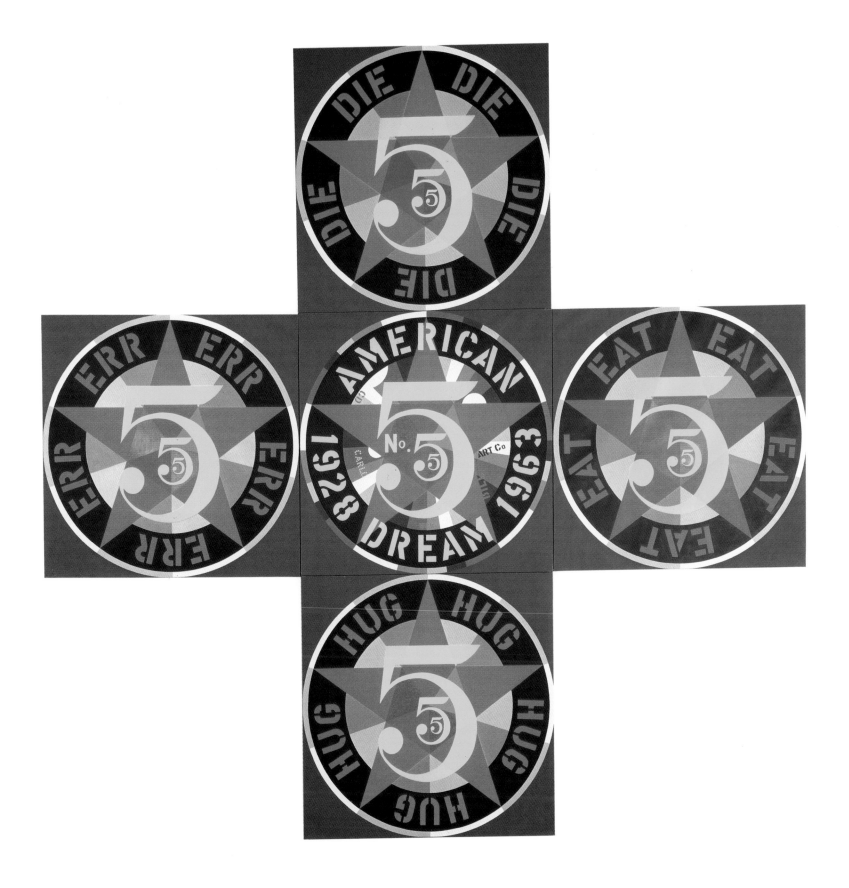

THE DEMUTH AMERICAN DREAM #5. 1963. OIL ON CANVAS, 5 PANELS, 12′ × 12′.
ART GALLERY OF ONTARIO, TORONTO. GIFT FROM THE WOMEN'S COMMITTEE FUND, 1964

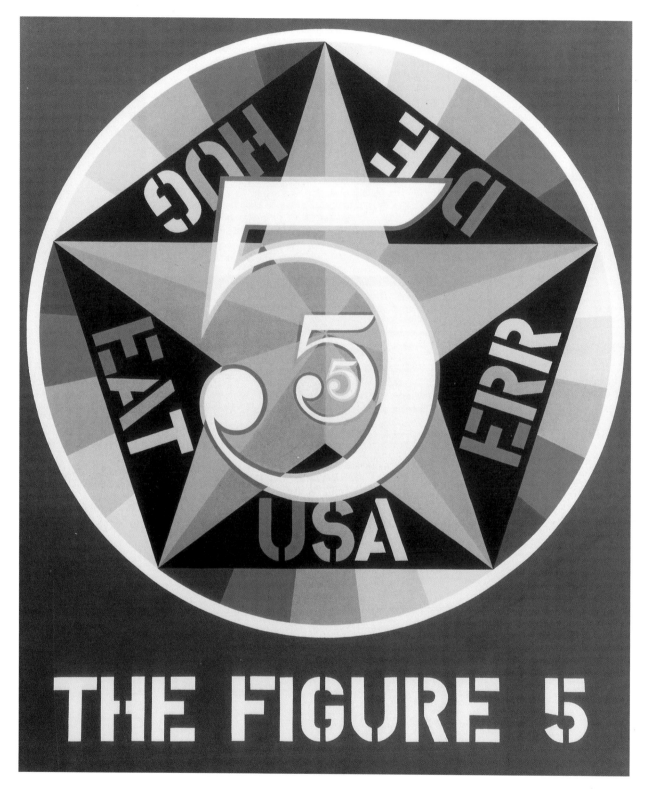

THE FIGURE FIVE. 1963. OIL ON CANVAS, 60 × 50⅛″.
NATIONAL MUSEUM OF AMERICAN ART, SMITHSONIAN INSTITUTION, WASHINGTON, D.C.
ON LOAN FROM THE ARTIST

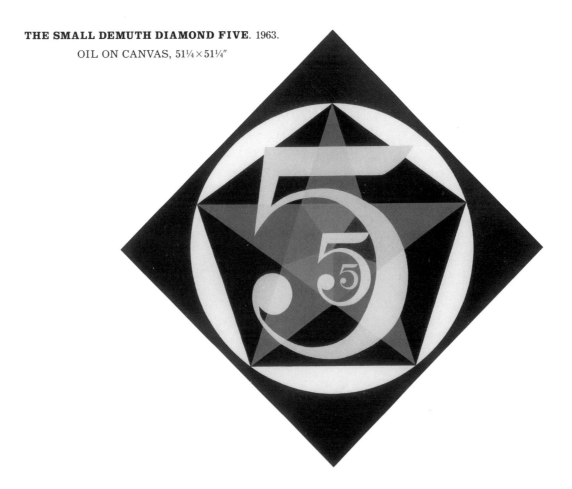

THE SMALL DEMUTH DIAMOND FIVE. 1963.
OIL ON CANVAS, 51¼ × 51¼″

[THAT] COMPOSITION THOUGH SOMEWHAT SIMPLIFIED TO FIT THE NATURE OF MY OWN WORK, STRIPPED AS IT IS OF THE ALLUSIONS TO A CUBIST CITYSCAPE."[15] IN THOSE SURROUNDING MEMBERS OF THE CROSS, EACH OF THE WORDS EAT, DIE, HUG, ERR HAS ITS OWN CIRCLE.

SECOND ONLY TO THAT MAJOR PAINTING OF THE FIFTH **DREAM** SUITE THE ARTIST HIMSELF RANKS **X-5,** WHICH, LIKE THE OTHERS, DATES FROM 1963. "IT CAME INTO BEING MORE FROM A DESIRE TO MAKE USE OF THE EXTRAORDINARY VARIATION IT PRESENTED IN RELATION TO THE CRUCIFORM CENTRAL PAINTING THAN FOR ANY CONSCIOUS MOTIVE TO EXPLOIT THE LATENT EMOTIONAL RESPONSES TO THE X ITSELF."[16] ITS FIVE PANELS, THOUGH JOINED IN AN X LIKE THAT OF A RAILROAD-CROSSING DANGER SIGN, ARE INTENDED AS "A LYRICAL FUGUE OF THE SUBJECT OF 5,"[17] IN WHICH SUBTLY VARIED COLOR INDIVIDUALIZES IDENTICAL FORMS.

WILLIAM KATZ, WRITING ON "INDIANA'S NEW AMERICAN GEOMETRY," SIN-

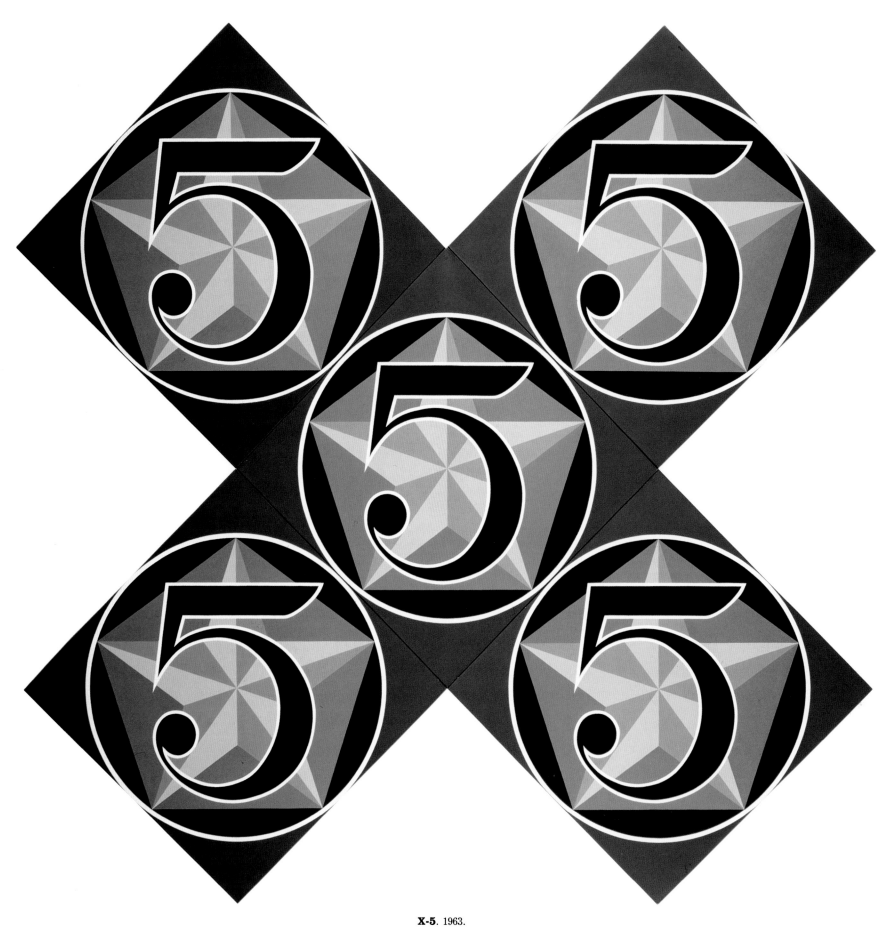

X-5. 1963.
OIL ON CANVAS, 5 PANELS, EACH 36×36″.
WHITNEY MUSEUM OF AMERICAN ART, NEW YORK

GLED OUT THE FIFTH AMERICAN DREAM AS A CRUCIAL POINT IN THE ARTIST'S DEVELOPMENT IN THE 1960S, WHICH HE DESCRIBED AS A PROCESS OF "DISTILLATION"—AN EFFORT TO COMPRESS MEANING INTO MONOSYLLABLES OF NO MORE THAN FOUR LETTERS AND "TO MAKE GEOMETRIC SHAPES CARRY MORE AND MORE COMPLEX MESSAGES." THE WORDS THAT INDIANA BUILT INTO HIS **DEMUTH AMERICAN DREAM #5,** KATZ WROTE, "ARE INSPIRED COMPANIONS TO A FIRST BOLD USE OF A NUMBER STANDING ALONE": THAT OF CHARLES DEMUTH'S PAINTING, WHICH SET OFF INDIANA'S FIVE SERIES. FROM THIS POINT ON, "THE OUTWARD APPEARANCE OF INDIANA'S WORK [WAS] COMPLETELY CHANGED." BY WAY OF COMPARISON, THE TEN POLYGONS THAT INDIANA PAINTED IN 1962 (**TRIANGLE** TO **DUODECAGON**) BEAR NUMERALS THAT ARE "QUAINT AND ROMANTIC . . . UNLIKE THE CLASSIC 5" IN THE **DREAM;** AND THE PAINTINGS ARE "BRIGHT AND COLORFUL, CHILDLIKE IN THE DELIGHT IN ALLITERATION AND REPETITION OF WORD AND COLOR . . . ('QUARE QUADRANGLE,' SAYS THE **SQUARE**). . . ." BUT AFTER **THE FIGURE FIVE,** IN KATZ'S VIEW, "THE DOORS WERE OPENED . . . TO GEOMETRY, TO POETRY, TO AUTOBIOGRAPHY, TO NUMEROLOGY. . . . HIS HALLMARK BECAME THE SPARE AND TAUT, THE ELEGANCE OF SIMPLICITY AND DIRECTNESS."[18]

THE DEEP SIGNIFICANCE OF THE FIGURE 6 IN INDIANA'S CHILDHOOD ASSOCIATIONS OF LIFE WITH HIS FATHER HAVE BEEN NOTED IN CHAPTER 1. ONE OF THE SIXTH GROUP OF THE AMERICAN DREAM PAINTINGS, **USA 666** (1964–66; SEE PAGE 17), WAS COMPLETED THE YEAR OF HIS FATHER'S DEATH. THIS WORK, AGAIN FIVE PANELS FORMING AN X, "BRINGS TO THE **DREAMS** THEIR STARKEST IMAGE," THE PAINTER HAS SAID.[19] HERE, THE HIGH-VISIBILITY BLACK AND YELLOW COLORS OF THE WARNING X SHAPE DELIBERATELY RECALL THE GRADE CROSSINGS "WHERE INSTANT DEATH BEFELL THE OCCUPANTS OF STALLED CARS, SCHOOL BUSSES IN FOGGY WEATHER, OR AUTOS RACING . . . BEFORE THE ONRUSHING . . . LOCOMOTIVE."[20] YET A PUNNING REFERENCE IN THIS FATEFUL COLOR SCHEME BRINGS UP FROM THE DEPTHS OF MEMORY THE SLOGAN "USE 666" FOR A COMMON COLD REMEDY, WHICH "DOTTED THE PASTURES AND FIELDS LIKE BLACK-EYED SUSANS."[21]

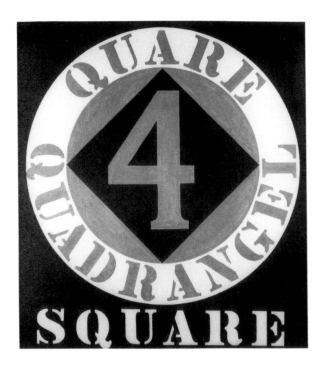

POLYGON: **SQUARE**. 1962. OIL ON CANVAS, 24×22″.
PRIVATE COLLECTION

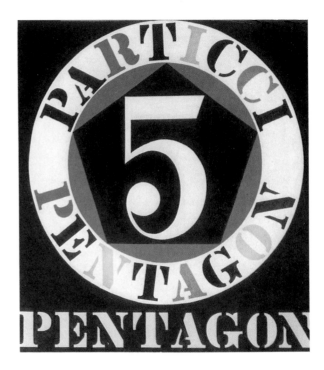

POLYGON: **PENTAGON**. 1962.
OIL ON CANVAS, 24×22″

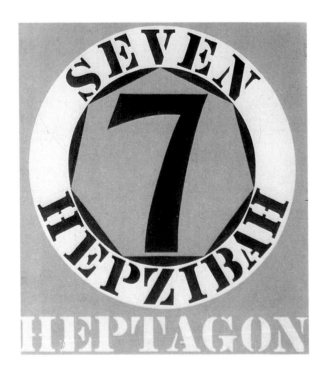

POLYGON: **HEPTAGON**. 1962. OIL ON CANVAS, 24×22″.
FORMERLY COLLECTION
MR. AND MRS. ELMER RIGELHAUPT, BOSTON

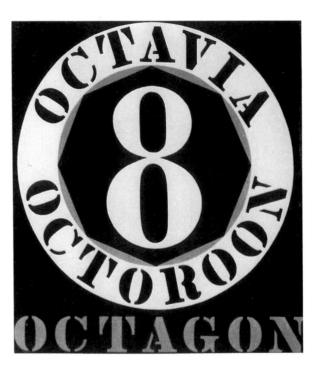

POLYGON: **OCTAGON**. 1962. OIL ON CANVAS, 24×22″.
COLLECTION ALBERT R. RADOCZY,
CRESSKILL, NEW JERSEY

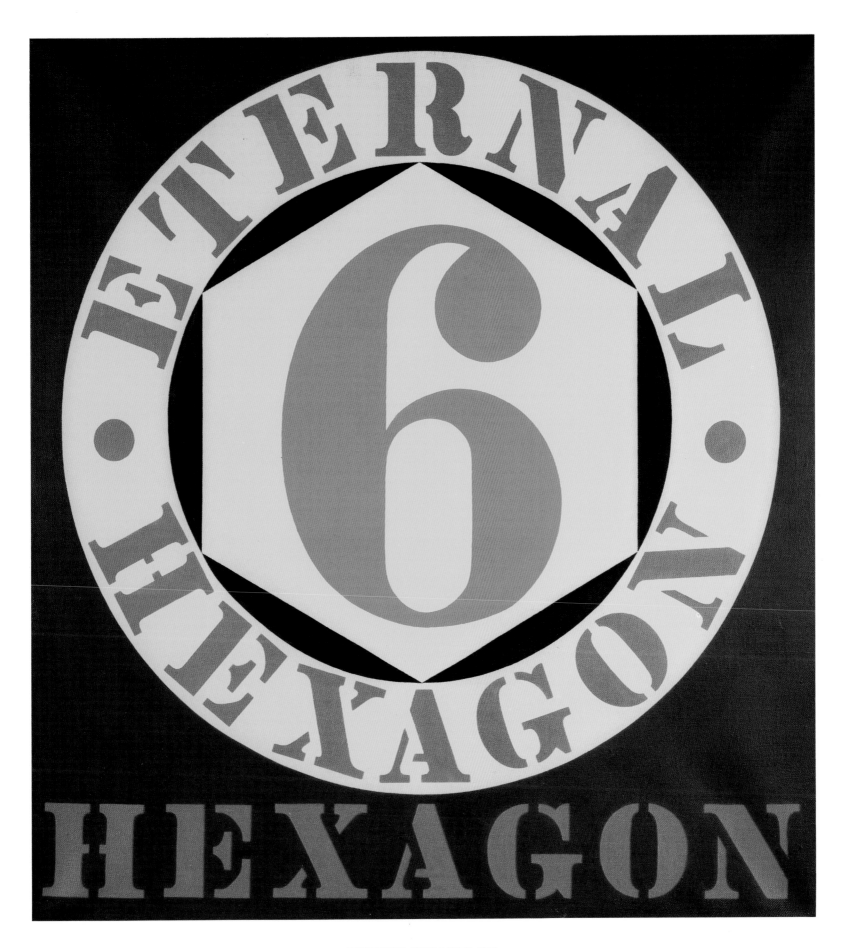

POLYGON: HEXAGON. 1962.

OIL ON CANVAS, 24×22″. COLLECTION BLANCHETTE H. ROCKEFELLER

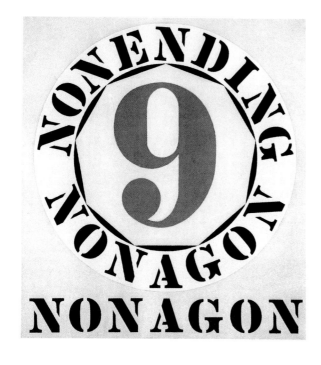

POLYGON: NONAGON. 1962. OIL ON CANVAS, 24 × 22".
RICHARD BROWN BAKER COLLECTION,
NEW YORK

POLYGON: DECAGON. 1962. OIL ON CANVAS, 24 × 22".
COLLECTION CARLO AND GRAZZIELLA RUBBOLI,
MILAN

HALF OF THE CANVASES IN THE SIXTH AMERICAN DREAM SERIES WERE PAINTED IN THE VIBRANT RED, BLUE, AND GREEN COMPANY COLORS ONCE USED BY INDIANA'S FATHER'S EMPLOYER, PHILLIPS 66. AMONG THEM, **FOUR SIXES** (1964) IS COMPOSED OF FOUR DIAMOND PANELS WITH THE 6S UNITED FOOT TO FOOT IN A DIAMOND WHOLE. THESE COLORS, "THE MOST CHARGED . . . OF MY PALETTE," ACCORDING TO INDIANA, BRING "AN OPTICAL, NEAR-ELECTRIC QUALITY TO MY WORK."[22] THEY ALSO APPEAR PROMINENTLY IN HIS LOVE PAINTINGS.

INDIANA CHARACTERIZES HIS **MOTHER** AND **FATHER** DIPTYCH (1963–67), ALSO, AS "PART AND PARCEL OF MY **AMERICAN DREAM** SERIES."[23] SOME OF THE SALIENT CONNECTIONS HAVE BEEN POINTED OUT EARLIER: THE FOCUS ON THE FAMILY CAR, THE ROUTE NUMBERS OF THE FATHER'S QUEST FOR FORTUNE (OR EVEN A LIVING), THE PASSION FOR THE PINBALL AND SLOT MACHINES. "THE REAL REASON THAT I PAINTED MY MOTHER AND FATHER WAS A PROFESSIONAL COMPULSION BORN OUT OF

A KNOWLEDGE OF ART HISTORY," INDIANA HAS SAID. "I WAS IMMENSELY IM-
PRESSED BY ARSHILE GORKY'S PORTRAIT OF HIMSELF AS A CHILD WITH HIS
MOTHER, AND THEN IT OCCURRED TO ME THAT VERY FEW ARTISTS COME TO MIND
WHO ARE KNOWN FOR HAVING PAINTED BOTH FATHER AND MOTHER. I WANTED THAT
DISTINCTION."[24] HE EMPHASIZES THAT THE DIPTYCH, WITH ITS LABELS A MOTHER
IS A MOTHER AND A FATHER IS A FATHER, IS "A SINGLE WORK . . . IN HOMAGE, AND
RESPECT TOO, TO TWO PEOPLE CONSPICUOUSLY CRUCIAL TO MY LIFE AND MY
BECOMING AN ARTIST. . . . OTHERWISE THEY WERE IMMENSELY UNIMPORTANT IN
THEIR WORLD—DEFINITELY OF THE 'LOST GENERATION.' THEY WERE LOST AND
THEY GOT THERE FAST ON WHEELS!"[25]

THE MOTHER, CARMEN ("WARM AND VIBRANT" IN HER SON'S MEMORY), AND
THE FATHER, EARL ("COLORLESS AS HIS NAME AND THE GRAYS . . . USED TO DEPICT
HIM" BUT, NEVERTHELESS, IN HIS OWN MIND, A "CHIP OFF THE AMERICAN
BLOCK"), STAND "BESIDE THEIR MODEL-T . . . STOPPED MOMENTARILY (FOR-
EVER)," AS THEY WERE IN THE FADING KODAK SNAPSHOTS ON WHICH THE IMAGES
WERE BASED. "HE WAS THE AMERICAN DREAMER . . . WHO NEVER QUITE GOT
THERE. . . . HE LOVED ALL THREE OF HIS WIVES, BUT WITH CARMEN HE WAS IN HIS
PRIME. HE WOOED HER ON WHEELS (LOVE) AND SHE WAS CRAZY FOR IT. . . .
SEALED IN TIME . . . YOUNG AND FLUSH . . . THEY'RE HAPPY WITH THEMSELVES
AND THEIR TIN LIZZIE . . . TOTALLY UNAWARE OF THE SAD TRIP AHEAD."[26] THE
MIDWINTER SETTING OF A RUTTED AND FROZEN BACK ROAD BEARS DOUBLE REFER-
ENCES: FIRST, THE HEAVILY COATED BUT PARTIALLY NUDE COUPLE SUGGESTS THE
SEASON AND CIRCUMSTANCES OF THEIR SON'S CONCEPTION IN 1927 (THE YEAR ON
THE INDIANA LICENSE PLATE). SECOND, THE RAIL FENCE AND HICKORY TREES IN
THE DIPTYCH ALLUDE TO THE SAME ELEMENTS IN THE INDIANA STATE SEAL, THUS
BORROWING A HERALDIC EMBLEM FOR THE NATIVE SON WHO WAS TO TAKE THE
STATE'S NAME FOR HIS OWN.

ALTHOUGH SO CLOSELY TIED, IN THE ARTIST'S OWN WORDS, TO THE SIGNIFI-
CANCE BEHIND THE NONOBJECTIVE AND GEOMETRIC MOTIFS OF THE EARLIER

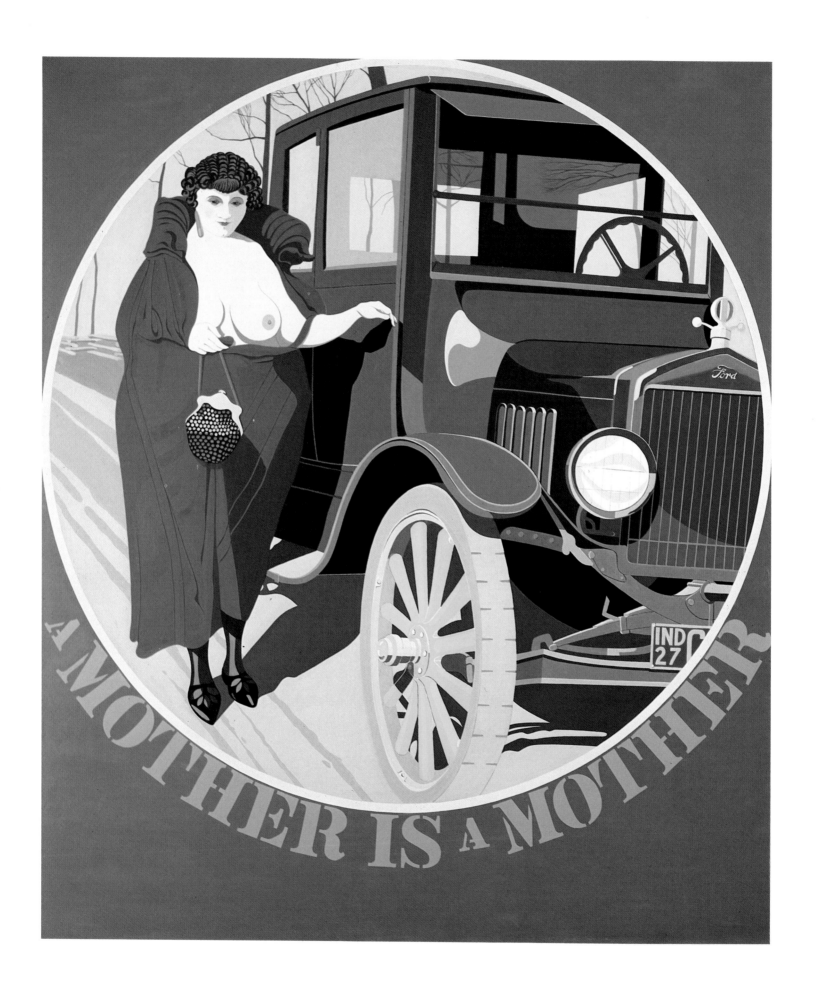

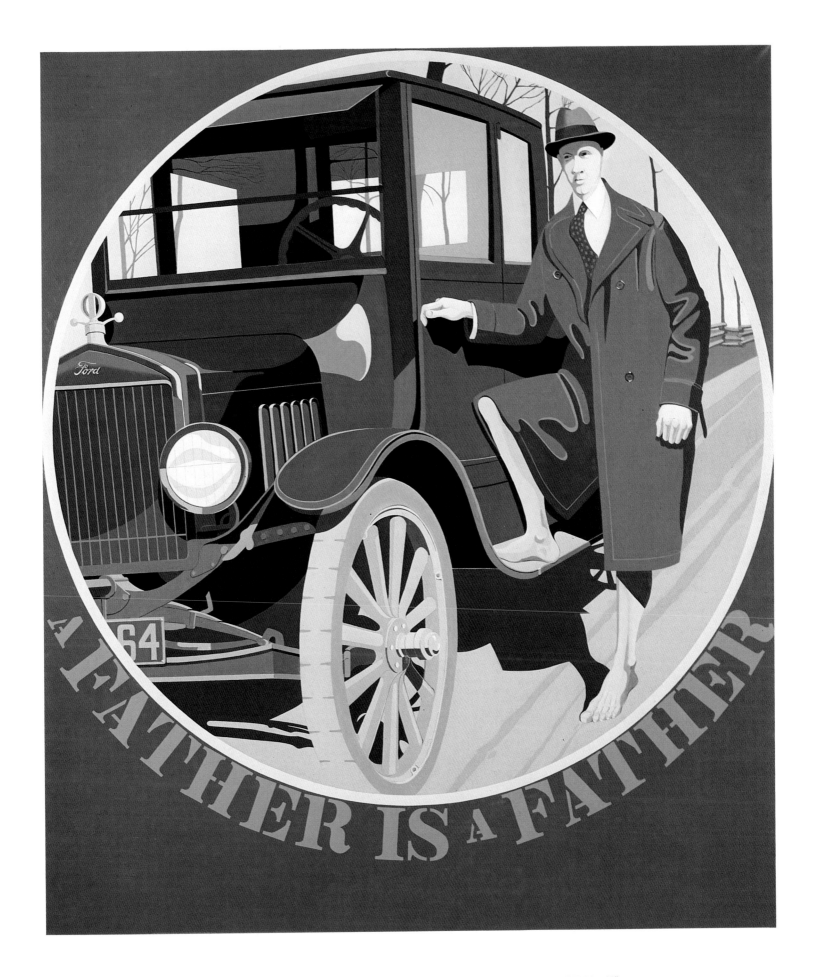

MOTHER AND **FATHER**. 1963–67. OIL ON CANVAS, 2 PANELS, EACH 70×60″

AMERICAN DREAM PAINTINGS, THIS DIPTYCH IS A STRIKING DEPARTURE IN IMAGERY. HERE, THE PERSONAL ASSOCIATIONS SO CAREFULLY SUBMERGED IN RELATED WORKS ARE OPENLY CONFRONTED IN A WAY THAT IS UNPARALLELED EVEN IN THE COMPARATIVELY FEW OTHER PAINTINGS HE HAS PRODUCED IN A REALISTIC VEIN. HIS ADOPTION OF THIS STYLE, THEREFORE, PRESENTS A DILEMMA FOR VARIOUS ART HISTORIANS AND REVIEWERS WHO HAVE SEEN, AT LEAST IN THE FIRST FOUR GROUPS OF THE AMERICAN DREAM PAINTINGS, INDIANA'S CLOSEST BRUSH WITH THE POP ART MOVEMENT, APART FROM HIS FIRST CONSTRUCTIONS OF FOUND OBJECTS.

IN THE HEAT OF EARLY POP EXHIBITIONS AND THE ATTENDANT CRITICAL POLEMICS, INDIANA WAS AS PARTISAN IN DEFENSE OF THE CATEGORY AS HIS FELLOW EXHIBITORS.[27] HOWEVER, TAKING A LONGER VIEW WITH THE PASSAGE OF A FEW YEARS, THE HISTORIANS—TO THE ARTIST'S CONCURRENCE—HAVE MORE OR LESS SET HIM APART FROM THE MOVEMENT. LUCY LIPPARD SAYS OF INDIANA THAT HE HAS "FROM THE BEGINNING STRADDLED THE GAP BETWEEN POP ICONOGRAPHY AND ABSTRACTION." IN HER BOOK **POP ART,** SHE DISTINGUISHES HIS WORK FROM "HARD-CORE" POP AS "FUNDAMENTALLY NON-OBJECTIVE." ALTHOUGH SHE FINDS HIS ATTITUDES "AS MUCH IN KEY WITH THE POP PROGRAM AS ANYONE'S" AND POINTS OUT THAT, WITH HIS MOTIFS OF PINBALL MACHINES AND TRAFFIC SIGNS, HE WAS "ONE OF THE FIRST TO EXPLOIT THE NEW SUBJECT MATTER," SHE SEES A MAJOR DIFFERENCE IN HIS BEING "THE MOST LITERARY OF ALL." HIS CONTRIBUTION, SHE SAYS, "HAS BEEN THE MARRIAGE OF POETRY AND GEOMETRIC CLARITY VIA THE INCLUSION OF AMERICAN LITERATURE AND HISTORY IN A NON-OBJECTIVE ART." HE IS "AN OUT-AND-OUT ROMANTIC," SHE CONCLUDES, "DESPITE HIS SUPERFICIALLY PURIST'S STYLE."[28]

JOHN McCOUBREY ALSO HAS DRAWN DISTINCTIONS BETWEEN INDIANA AND OTHER ARTISTS OF THE POP GENERATION: INDIANA'S CONCERNS, HE SAYS, ARE BROADER. THE POP ARTISTS ARE MORE COMMITTED "TO THE IMMEDIACY OF THE PRESENT. . . . MORE INTERESTED IN THE IMAGERY OF THE MASS MEDIA AND THE

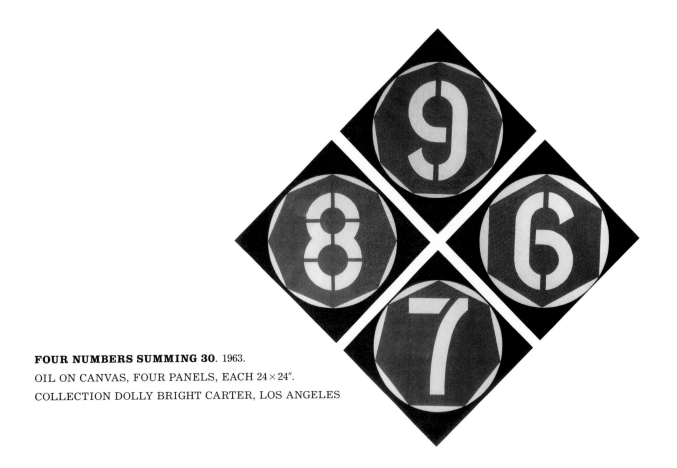

FOUR NUMBERS SUMMING 30. 1963.
OIL ON CANVAS, FOUR PANELS, EACH 24 × 24″.
COLLECTION DOLLY BRIGHT CARTER, LOS ANGELES

PRODUCTS THEY SELL"; WHEREAS "INDIANA PREFERS MORE ABSTRACT COMMER-CIAL SIGNS, MORE EXPERTLY DESIGNED. . . . HIS PAINTINGS CALL MORE ATTEN-TION TO THEMSELVES AS PAINTING—POP ART CALLS ATTENTION TO WHAT IS REPRESENTED. POP ART IS ABOUT THE MEANS OF POPULAR COMMUNICATION—INDIANA'S PAINTINGS . . . ADVERTISE HIS OWN TELEGRAPHIC MESSAGES ABOUT AMERICA."[29]

INDIANA HIMSELF, LOOKING BACK TO THAT PERIOD DURING AN INTERVIEW FOR HIS RETROSPECTIVE EXHIBITION IN 1982, RECOGNIZED THE BOOST GIVEN TO HIS CAREER AND FAME BY HIS EARLY IDENTIFICATION WITH POP BUT, SINCE HIS ART HAS TAKEN MANY DIFFERENT DIRECTIONS, REJECTED ANY SUCH CATEGORIZATION AS BEING TOO NEATLY PIGEONHOLED. SPEAKING OF THE SIX ARTISTS ONCE SO CLOSELY ASSOCIATED WITH THE POP MOVEMENT—ROSENQUIST, OLDENBURG, LICHTENSTEIN, TOM WESSELMANN, ANDY WARHOL, AND HIMSELF—HE RE-

MARKED, "THERE HAVE BEEN NO DESERTIONS FROM THE RANKS . . . NO RECANTERS, NO SUICIDES. THE SIX OF US GO ON PAINTING OR SCULPTING, BUT WE HAVE ALL GONE ON FROM WHAT WE WERE ORIGINALLY; WE HAVE ALL GROWN IN OUR ART."[30] HE PREFERS TO DROP THE LABEL AND FOCUS ATTENTION ON ASPECTS OF HIS LATER WORK AND THAT STILL TO COME.

NOW, AS IN THE PAST, THE DEEP EMOTIONAL RESERVES BEHIND THE AMERICAN DREAM PAINTINGS REMAIN VALID FOR THE ARTIST. "THE WORK I'M DOING NOW, MY **AUTOPORTRAITS** [A SEQUENCE OF PAINTINGS AND SERIGRAPHS HE BEGAN IN 1971, CELEBRATING THE EVENTS OF EACH DECADE OF HIS LIFE], I REGARD AS AN EXTENSION OF THE **DREAM** SERIES—MY OWN PERSONAL AMERICAN DREAM. IN OTHER WORDS, THEY HAVE BECOME SELF-PORTRAITS. I THINK OF MYSELF FIRST OF ALL AS AN AMERICAN, THEN AS AN AMERICAN PAINTER PAINTING AN AMERICAN THEME. AND THIS WILL CONTINUE."[31]

1, 2. IN WILLIAM A. FARNSWORTH LIBRARY AND ART MUSEUM, ROCKLAND, ME., **INDIANA'S INDIANAS** (1982), EXHIBITION CATALOGUE, P. 5.

3. MANUSCRIPT PROVIDED BY ROBERT INDIANA.

4. EDWARD ALBEE, PREFACE TO **THE AMERICAN DREAM** (NEW YORK: COWARD MCCANN, 1961), P. 38.

5. IN UNIVERSITY OF TEXAS AT AUSTIN, **ROBERT INDIANA** (1977), EXHIBITION CATALOGUE, P. 27.

6. ALBEE, PREFACE TO **THE AMERICAN DREAM**, P. 38.

7. IN WILLIAM A. FARNSWORTH LIBRARY AND ART MUSEUM, **INDIANA'S INDIANAS**, P. 5.

8. IN INSTITUTE OF CONTEMPORARY ART OF THE UNIVERSITY OF PENNSYLVANIA, PHILADELPHIA, **ROBERT INDIANA** (1968), EXHIBITION CATALOGUE, P. 23.

9. IBID., P. 36.

10–12. IN UNIVERSITY OF TEXAS AT AUSTIN, **ROBERT INDIANA**, P. 27.

13–15. IN INSTITUTE OF CONTEMPORARY ART OF THE UNIVERSITY OF PENNSYLVANIA, **ROBERT INDIANA**, P. 27.

16, 17. MANUSCRIPT PROVIDED BY ROBERT INDIANA.

18. WILLIAM KATZ, "POLYCHROME—POLYGONALS; ROBERT INDIANA'S NEW AMERICAN GEOMETRY," IN UNIVERSITY OF TEXAS AT AUSTIN, **ROBERT INDIANA**, PP. 20–21.

19–22. MANUSCRIPT PROVIDED BY ROBERT INDIANA.

23–26. IN INSTITUTE OF CONTEMPORARY ART OF THE UNIVERSITY OF PENNSYLVANIA, **ROBERT INDIANA**, P. 36.

27. IN INTERVIEW WITH G. R. SWENSON, "WHAT IS POP ART?," **ART NEWS** 62, NO. 7 (NOVEMBER 1963), P. 24.

28. LUCY LIPPARD, **POP ART** (NEW YORK: PRAEGER, 1966), P. 122.

29. JOHN W. MCCOUBREY, IN INSTITUTE OF CONTEMPORARY ART OF THE UNIVERSITY OF PENNSYLVANIA, **ROBERT INDIANA,** P. 23.

30. IN WILLIAM A. FARNSWORTH LIBRARY AND ART MUSEUM, **INDIANA'S INDIANAS,** P. VII.

31. IBID., P. 5.

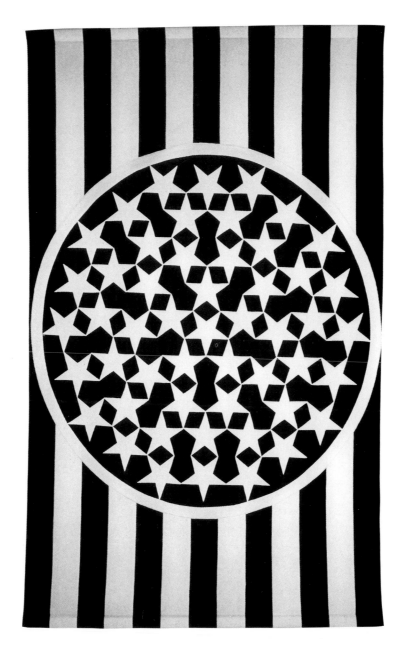

NEW GLORY BANNER I. 1963. FELT, 88 × 52″.
INDIANA UNIVERSITY MUSEUM, BLOOMINGTON

PREDESTINATION SET IN WHEN GERTRUDE STEIN GAVE THE ROMANTIC LEAD . . . IN "THE MOTHER OF US ALL" THE UNLIKELY NAME OF INDIANA ELLIOT!

During the late 1960s and the 1970s, many honors, exhibitions, commissions, and much public acclaim crowned Indiana's fifth decade. While the **Mother** and **Father** diptych toured the world and the road sign and highway paintings rolled along on their way to and from a number of museums and galleries, their creator brought into the light of the opera house a distinctly different sort of work that had been fourteen years in the making: the set and costume designs for **The Mother of Us All,** the second operatic collaboration between Gertrude Stein and Virgil Thomson.

In Indianapolis, in the middle of his high school education, Indiana had encountered Gertrude Stein for the first time via Picasso's portrait of her. A few years later in Chicago a schoolmate at the Art Institute had given him the original 78-rpm album of the Stein-Thomson opera **Four Saints in Three Acts**. (Oddly enough, on a visit to that same friend in New Orleans, Indiana caught a glimpse of Tennessee Williams on a street in the French Quarter, a chance occasion that later influenced his decision to adopt his home state's name as his own.) During the next few years Indiana acquainted himself with the fascinating but difficult prose style of Stein.

In the mid-1950s a production of **The Mother of Us All** at the Phoenix Theater in New York introduced the artist to the character of the militant feminist Indiana Elliot. Until then, so far as he knew, "the only other person in history named Indiana was a half-breed Indian maiden killed in an early insurrection on the site of the future Chicago."[2] In the late 1950s he became an Indiana himself.

As a (then self-professed) Pop artist "concerned with themes explicitly American, I . . . came to know the [composer] of that music which had so fascinated me as a young bohemian art student."[3] In 1964, approach-

INDIANA ELLIOT. DESIGN FOR **THE MOTHER OF US ALL**. 1976. PAPIERS COLLÉS, 25⅞ × 19¾″.
COLLECTION MARION KOOGLER MCNAY ART INSTITUTE, SAN ANTONIO, TEXAS. COURTESY THE ARTIST

ING HIS SECOND SOLO SHOW AT THE STABLE GALLERY, NEW YORK, INDIANA REALIZED THAT "ALMOST EVERY ONE OF [THE] PAINTINGS . . . TO BE EXHIBITED . . . TOUCHED UPON ONE OR ANOTHER THEME THAT MR. THOMSON HAD SET MUSI-CALLY. . . ." THEREFORE, "IT SEEMED . . . APPROPRIATE TO ENHANCE THE OPEN-ING WITH AN ALL-THOMSON CONCERT,"[4] WHICH TOOK PLACE ON THE APTLY HAR-MONIOUS DATE OF MOTHER'S DAY.

NOT LONG AFTERWARD THOMSON INVITED THE BY-THEN WELL-KNOWN PAINTER TO DESIGN THE SETS AND COSTUMES FOR A LOS ANGELES PRODUCTION OF **THE MOTHER OF US ALL**. INDIANA WORKED OUT THE PRELIMINARY SKETCHES, BUT PRESSURES OF TIME AND OTHER PROJECTS PREVENTED HIS GOING FURTHER. IN 1967 JAN VAN DER MARCK, THE CURATOR WHO HAD ORGANIZED INDIANA'S FIRST MUSEUM SHOW FOR THE WALKER ART CENTER IN MINNEAPOLIS, INVITED HIM TO DESIGN THE PRODUCTION OF THE THOMSON-STEIN OPERA TO BE GIVEN AT THE TYRONE GUTHRIE THEATER IN THAT CITY. HAVING RENDERED OBJECTIVELY THE ARCHETYPAL MOTHER WHO HAUNTS US ALL IN HIS **MOTHER** AND **FATHER** DIPTYCH OF 1963, AND READY TO APPROACH THE SUBJECT IN A LIGHTER MOOD, INDIANA SET TO WORK ON THE MATTER HE SAW AS "PREDESTINED," HIS 1964 SKETCHES ALREADY IN HAND.

NOT BEING A PROFESSIONAL STAGE DESIGNER, HE FELT COMPELLED "TO CON-TRIBUTE TO THIS ENDEAVOR MORE THAN A SCENICALLY CONVENTIONAL RENDER-ING OF A . . . TRADITIONALLY CAST WORK." AS HE RECALLED, "I PROCEEDED TO REVISE THE SCENARIO, INJECTING SOMETHING OF . . . THE SPIRIT OF MY OWN WORK."[5]

VIRGIL THOMSON ASKED INDIANA TO PROCLAIM IN THE POSTER FOR THE OPENING THAT THE PRODUCTION WAS "AN AMERICAN POP OPERA," AND THE ARTIST ACQUIESCED (SEE PAGE 92). WITHIN THAT LABEL, HOWEVER, HIS INDIVID-UAL APPROACH WAS CLEAR IN HIS USE OF SIGNS, HIS DEFINITION OF COLOR AREAS, HIS MOTIFS OF THE AUTOMOTIVE AGE, HIS GEOMETRIC FORMATS. "JUST AS MY EVERY PAINTING OR SCULPTURE INCLUDES A WORD OR WORDS," HE WRITES, "I

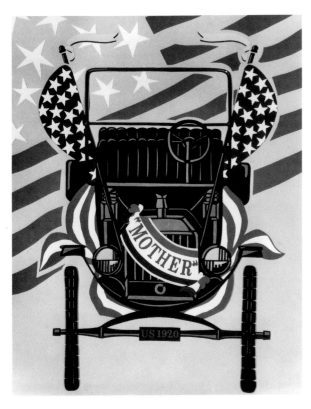

THE MODEL T

SUSAN B.

COSTUMED EACH OF THE THIRTY-ODD CHARACTERS . . . WITH HIS OR HER OWN INDIVIDUAL NAME SASH, WHICH, AT AN APPROPRIATE MOMENT . . . BECOMES BY REVERSAL THE . . . 'VOTES FOR WOMEN' EMBLAZONMENT WORN . . . BY ALL RIGHT-THINKING LADIES OF THAT ERA."[6]

EXECUTED IN THE EXIGENT MEDIUM OF PAPIERS COLLÉS, A LABOR NOT SOON FORGOTTEN BY THE ARTIST AND HIS MANY HELPERS, THE DESIGNS FOR **THE MOTHER OF US ALL** BLAZE WITH COLOR, "LIKE THE PAGEANT IT REALLY IS,"[7] AS THE PAINTER SAYS. THE RED, WHITE, AND BLUE OF PATRIOTIC AND POLITICAL EMBLEMS AND LOGOS CONFRONT A SPECTRUM OF OTHER COLOR ALLUSIONS.

SUSAN B. (QUAKER),
REVISED 1976

GERTRUDE S.

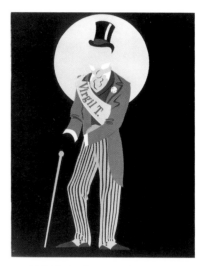

VIRGIL T., REVISED 1976

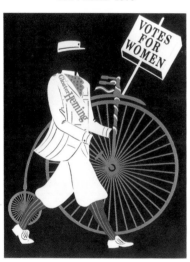

GLOSTER HEMING

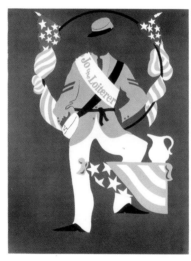

JO THE LOITERER

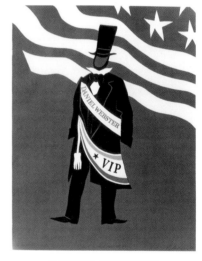

DANIEL WEBSTER

LILLIAN RUSSELL

JENNY REEFER

ANNE, REVISED 1976

POSTER: **THE SANTA FE OPERA**. 1976. SILKSCREEN, 31 × 22″.
COURTESY THE SANTA FE OPERA, NEW MEXICO

IT SEEMED QUITE NECESSARY TO INDIANA, WITH HIS PECULIARLY AMERICAN SLANT ON HISTORY, "TO ADD ANOTHER CONSPICUOUS ELEMENT OF THAT PASSING AMERICAN PARADE . . . ONE OF THE VERY KEYSTONES OF THE DREAM ITSELF, THE MODEL-T FORD."[8] IT WAS THE MODEL T THAT HAD BEEN THE CENTRAL "CHARACTER" CONNECTING HIS **MOTHER** AND **FATHER** PORTRAITS (SEE PAGES 118–19), AND, IN HIS VIEW, IT HAD "CONTRIBUTED FAR MORE TO THE LIBERATION OF THE CITIZENRY OF THIS NATION THAN ALL THE LEGISLATION COMBINED."[9] ON ANOTHER LEVEL, THE MODEL T HAD BEEN GERTRUDE STEIN'S FAVORITE POSSESSION IN FRANCE.

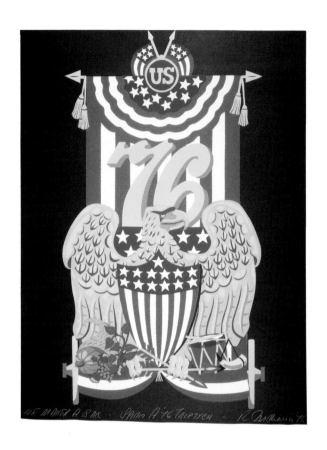

FREEDOM.
DESIGN FOR **THE MOTHER OF US ALL**. 1976.
PAPIERS COLLÉS, 26 × 20″.
THE MCNAY ART INSTITUTE, SAN ANTONIO,
TEXAS. GIFT OF ROBERT L. B. TOBIN

SHIP OF STATE AND **SPIRIT OF 76** FLOATS. 1976.
SANTA FE OPERA, NEW MEXICO

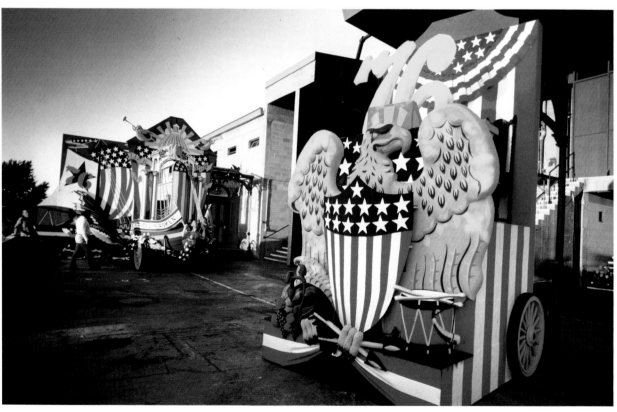

PAGES 133–36: SET DESIGNS FOR
THE MOTHER OF US ALL, PRESENTED BY
THE SANTA FE OPERA, 1976. PAPIERS COLLÉS,
EXCEPT AS NOTED; AVERAGE SIZE, 26 × 20″.
COLLECTION MARION KOOGLER MCNAY ART
INSTITUTE, SAN ANTONIO, TEXAS. GIFT OF
ROBERT L. B. TOBIN

FREEDOM

SIDE OF **FREEDOM** FLOAT

SIDE OF **PATRIAS PATER** FLOAT

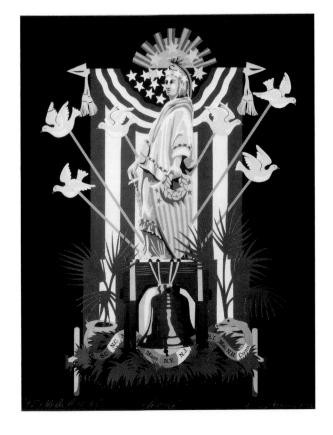

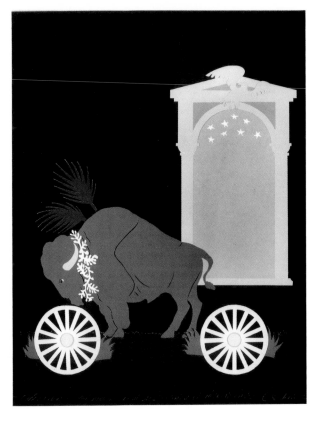

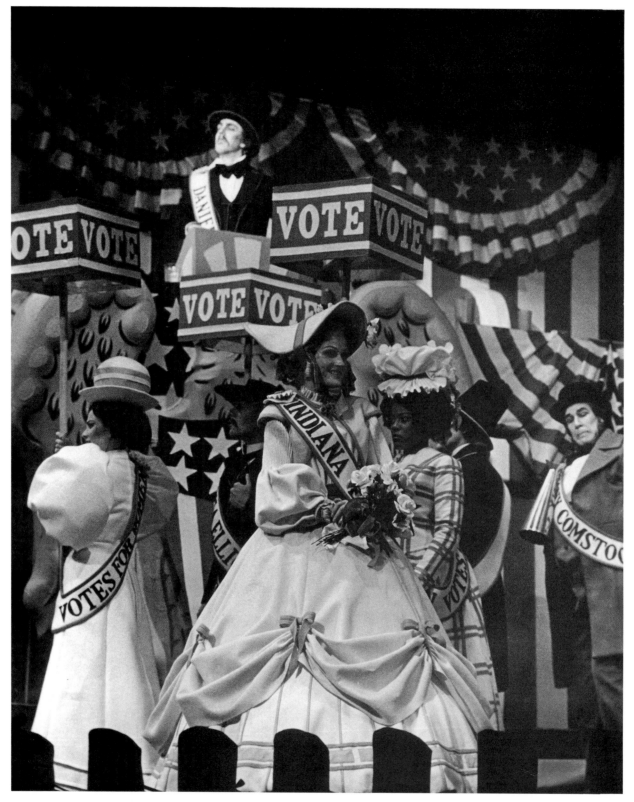

INDIANA ELLIOT, ROMANTIC LEAD, ONSTAGE AT THE SANTA FE OPERA, 1976.
ROSE BOUQUET, GOWN, PLATFORM, AND BANNERS ALL EXECUTED IN FELT

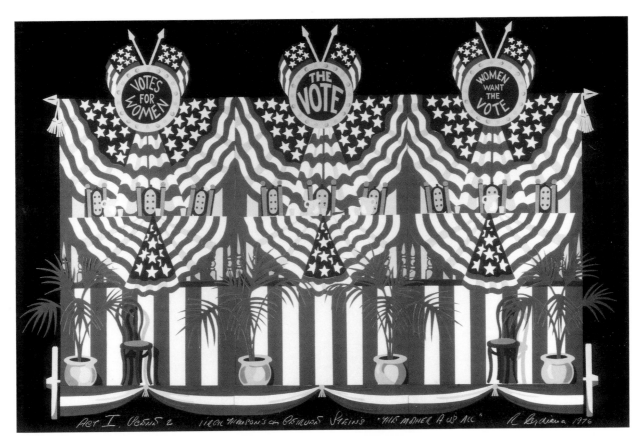

THE POLITICAL PLATFORM

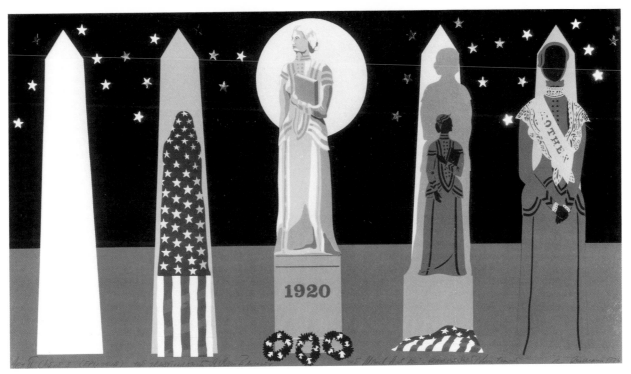

THE TRANSFIGURATION OF SUSAN B. ANTHONY

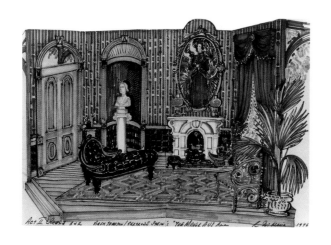

PRELIMINARY DRAWING FOR **DRAWING ROOM IN THE HOUSE OF SUSAN B. ANTHONY**.
MARKER ON PAPER

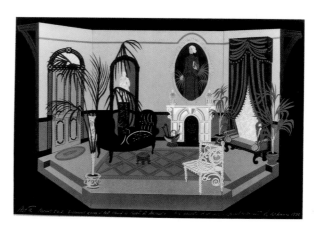

DRAWING ROOM IN THE HOUSE OF SUSAN B. ANTHONY

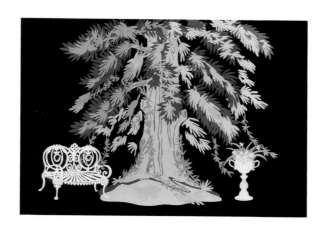

THE VILLAGE GREEN

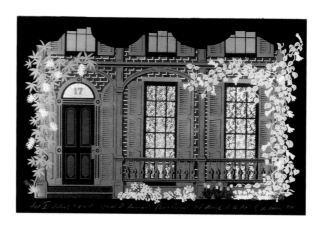

SUSAN B. ANTHONY'S FRONT PORCH

LOGICALLY, INDIANA THOUGHT, IT "BECAME THE CENTRAL SCENIC MOTIF . . . ON THE THRUST STAGE OF THE TYRONE GUTHRIE THEATER . . . THE VERY SYMBOL OF THOSE STRUGGLES THAT GERTRUDE STEIN AND SUSAN B. ANTHONY . . . SHARED (AS THIS VERY AUTOBIOGRAPHICAL LIBRETTO SUGGESTS) IN THEIR SEPARATE BATTLES, ONE FOR ELECTIVE SUFFRAGE, THE OTHER FOR LITERARY SUFFERANCE."[10]

THE BICENTENNIAL CELEBRATIONS OF 1976 FITLY BROUGHT ABOUT A SPECTACULAR REPRISE OF THIS WORK. IN HONOR OF THE TWENTIETH ANNIVERSARY OF THE SANTA FE OPERA COMPANY, AS WELL AS THE COUNTRY'S TWO-HUNDREDTH,

INDIANA WAS COMMISSIONED TO DESIGN A NEW PRODUCTION OF **THE MOTHER OF US ALL**—SETS, COSTUMES, POSTER, AND PROGRAM COVER. A COMPREHENSIVE EXHIBITION OF THE DESIGNS WAS HELD AT THE GALERIE DENISE RENÉ IN NEW YORK AHEAD OF THE PERFORMANCES, AND A SELECTION WAS SHOWN AT THE SANTA FE MUSEUM OF FINE ARTS DURING THE RUN.

A DISPLAY OF REAL FIREWORKS OPENED THE PRODUCTION, MADE POSSIBLE BY THE OPEN-AIR CONSTRUCTION OF THE OPERA HOUSE. A GENUINE VINTAGE MODEL T, DRIVEN BY AN IMPRESSIVE FIGURE WITH THE NAME SASH GERTRUDE S., TRUNDLED ONSTAGE, TRANSPORTING VIRGIL T. AS PASSENGER. "ROBERT INDIANA TURNED OUT TO BE THE KEY PERSON IN THE PRODUCTION," REPORTED **TIME**. "INCORPORATING POP ART'S HARD-EDGE FEELING . . . HE SPLASHED THE STAGE WITH CIRCUS COLORS. . . . DOUBLE-DUTY SETS SOLVED THE PROBLEM OF A BACKLESS STAGE. THE RED-AND-WHITE-STRIPED BANDSTAND . . . CRACKS OPEN INTO A PINK PARLOR FOR THE NEXT VIGNETTE."[11]

THE PAINTER'S IMAGINATION TOUCHED THE ACTION ITSELF, AS CRITIC ALFRED FRANKENSTEIN NOTED IN HIS **SAN FRANCISCO CHRONICLE** REVIEW: "THE . . . SCENERY AND COSTUMES BY ROBERT INDIANA . . . GAVE CARDS AND SPADES, OR FLAGS AND BANNERS, TO GERTRUDE STEIN'S BEST PLAY. . . . THE SETTING . . . REARRANGED ITSELF IN SO MANY DIFFERENT WAYS THAT IT BECAME AN INTEGRAL PART OF THE DRAMA, COMBINING THE BEST FEATURES OF THREE GREAT AMERICAN ENTERTAINMENTS: A POLITICAL CONVENTION, A TRAVELING CIRCUS, AND A BEAUTY-QUEEN PAGEANT."[12]

THE SUCCESS OF THAT HIT COLLABORATION CONTINUED WITH A RECORD ALBUM, TELEVISION REPETITIONS, AND A 1977 PBS DOCUMENTARY ON THE STAGING OF THE OPERA. BUT THE RECURRENT THEMES AND VARIATIONS IN INDIANA'S DESIGNS FOR IT RECAPITULATED OTHER EXPERIENCES AS WELL, NOTABLY HIS SOMEWHAT MYSTIFIED ATTRACTION TO MUSIC. "I THINK I'VE BEEN DRAWN TO MUSICAL THEMES . . . OUT OF [A] PERSONAL DEFICIENCY OF MINE . . . THAT I'M SO UNMUSICAL," HE SAYS.[13] AS A CHILD HE WONDERED AT HIS FATHER'S TALENT FOR

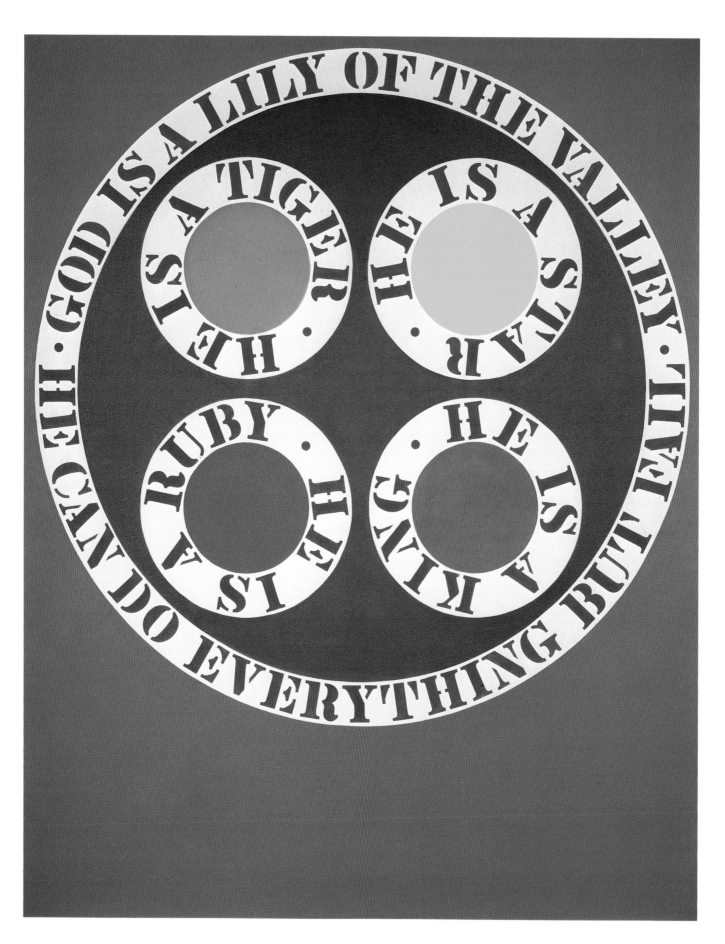

GOD IS A LILY OF THE VALLEY. 1961–62.

OIL ON CANVAS, 60×48″. R. OSUNA COLLECTION, WASHINGTON, D.C.

INDIANA'S FIRST COSTUME DESIGN FOR
THE NEW YORK THEATER:
FRED HERKO AS ICARUS IN JAMES WARING'S
BALLET **IN THE HALLELUJAH GARDENS**,
HUNTER COLLEGE, 1963

PLAYING BY EAR ANY PIECE THAT HE HAD JUST HEARD—A GIFT THE BOY DID NOT SHARE. "I LIKE MUSIC . . . BUT I'VE NEVER HAD ANY MUSICAL ABILITY . . . ANY TRAINING AND, ACCORDING TO MOST PEOPLE, DON'T HAVE AN 'EAR.' . . . THERE'S A KIND OF GULF NOW, MORE SO THAN EVER, BETWEEN [THE] DIFFERENT ARTS, AND DOING A PAINTING ABOUT MUSIC ISN'T MAKING TOO MUCH OF A BRIDGE. BUT . . . 'THE MOTHER OF US ALL' IS A BRIDGE."[14]

OTHER BRIDGES OF THIS KIND HAD APPEARED IN SEVERAL WORKS OF THE 1960S. THE STRAIN OF MUSIC IS ONE OF THE ELEMENTS THAT INDIANA WOVE INTO HIS **SWEET MYSTERY** OF 1960–61 (SEE PAGE 88)—"SONG BREAKING THROUGH THE DARKNESS." A GOSPEL SONG HEARD ON THE RADIO ONE NIGHT WAS RESPONSIBLE FOR ANOTHER PAINTING OF THAT PERIOD, **GOD IS A LILY OF THE VALLEY** (1961–62).

THE VIVID SIMILES TO GOD IN THE STANZAS OF THIS RELIGIOUS FOLK SONG, KNOWN IN SEVERAL VERSIONS TO GENERATIONS OF SOUTHERN CHOIRS, BLACK AND WHITE, GAVE THE ARTIST MATERIAL FOR ONE OF HIS "WHEELS OF WORDS." **RED SAILS,** A 1963 PAINTING (APPARENTLY LOST), WAS BASED ON A POPULAR SONG.

ALSO LOST WAS THE 1967 PAINTING **MOZART,** WHICH THE ARTIST SAYS "HAS DISAPPEARED INTO THE EUROPEAN ART SCENE"; FORTUNATELY, A PRINT VERSION, **EINE KLEINE NACHTMUSIK,** SURVIVES. THE PAINTING WAS DONE AS "KEY MONEY" FOR THE LANDLORD OF THE LOFT BUILDING INDIANA WAS RENTING ON THE BOWERY, A MAN FORTUITOUSLY NAMED KLEIN. "THE PAINTING HAS A SHAPE IN IT WHICH I'VE NEVER USED . . . THE CIRCLE IS BROKEN UP SO THAT IT DESCRIBES A KEYHOLE. . . . IT MIGHT BE MORE NICELY APPRECIATED IF ONE THOUGHT I JUST . . . WANTED TO ENTHUSE ABOUT A COMPOSER WHO **IS** ONE OF MY FAVORITES."[15]

BOTH BEFORE AND AFTER **THE MOTHER OF US ALL,** INDIANA DESIGNED WORKS RELATED TO THE WORLD OF THEATER AND BALLET. HIS FIRST COSTUME DESIGN FOR THE NEW YORK THEATER WAS COMMISSIONED BY JAMES WARING FOR HIS BALLET **IN THE HALLELUJAH GARDENS** PRESENTED AT HUNTER COLLEGE IN 1963. THE DANCER FRED HERKO, IN THE ROLE OF A CONTEMPORARY ICARUS, WORE THE COSTUME, CONSISTING PRINCIPALLY OF WHEELS STRAPPED TO HIS BASICALLY NUDE BODY, AS HE EVOKED THE PAIN OF THE MYTHICAL FALL BY SCREAMING AND ROTATING THE MAIN WHEELS WHILE WALKING SLOWLY ACROSS THE STAGE. (IRONICALLY, HERKO MET HIS OWN DEATH A FEW YEARS LATER IN A PLUNGE FROM A GREENWICH VILLAGE WINDOW—THE KIND OF RETURNING CYCLE OF EVENTS THAT HAS SO POWERFUL AN IMPACT ON INDIANA'S CREATIVE IMAGINATION.) THE COSTUME HAS BEEN WORN IN A DIFFERENT CONTEXT BY SEVERAL DANCERS ASSOCIATED WITH LOUIS FALCO IN NEW YORK.

OTHER COMMISSIONS INCLUDED POSTERS AND EVEN BANNERS, IN ONE CASE HARKING BACK AGAIN TO THE ARTIST'S GREAT INTEREST IN GERTRUDE STEIN: IT WAS BECAUSE OF THAT INTEREST THAT NEW YORK'S MUSEUM OF MODERN ART ASKED HIM TO DESIGN FIVE LARGE BANNERS TO FLY FROM THE FRONT OF THE

POSTER: **THE AMERICAN FOUR
(4 AMERICANS IN PARIS)**. 1970.
SILKSCREEN, 46×23″.
COLLECTION, THE MUSEUM OF MODERN ART,
NEW YORK

FIVE 18-FOOT BANNERS COMMISSIONED BY
THE MUSEUM OF MODERN ART, NEW YORK,
FOR THE EXHIBITION "4 AMERICANS IN PARIS,"
1970, SHOWN FLYING OVER THE MUSEUM'S
FRONT FACADE

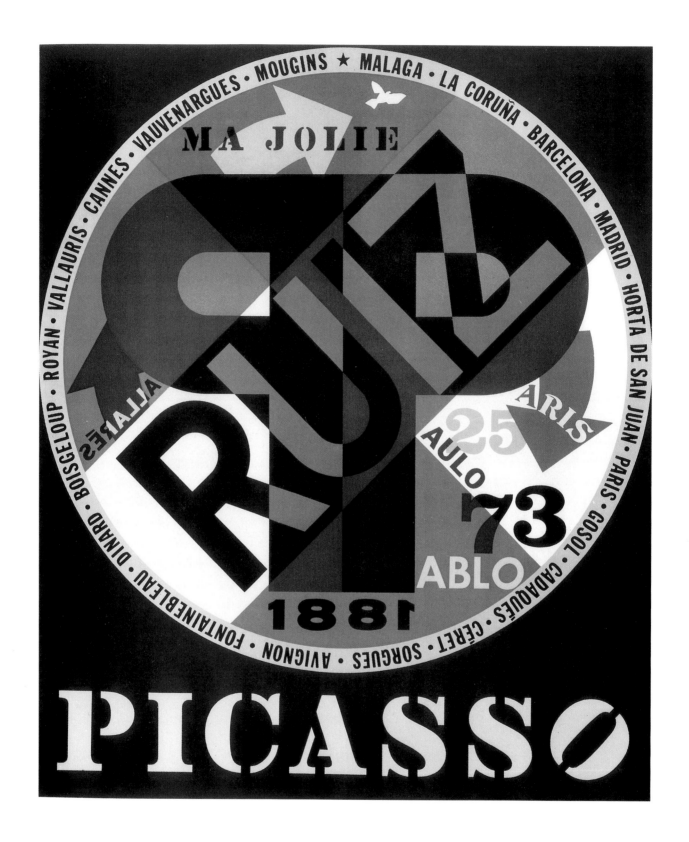

PICASSO. 1974. SERIGRAPH, 30 × 22″

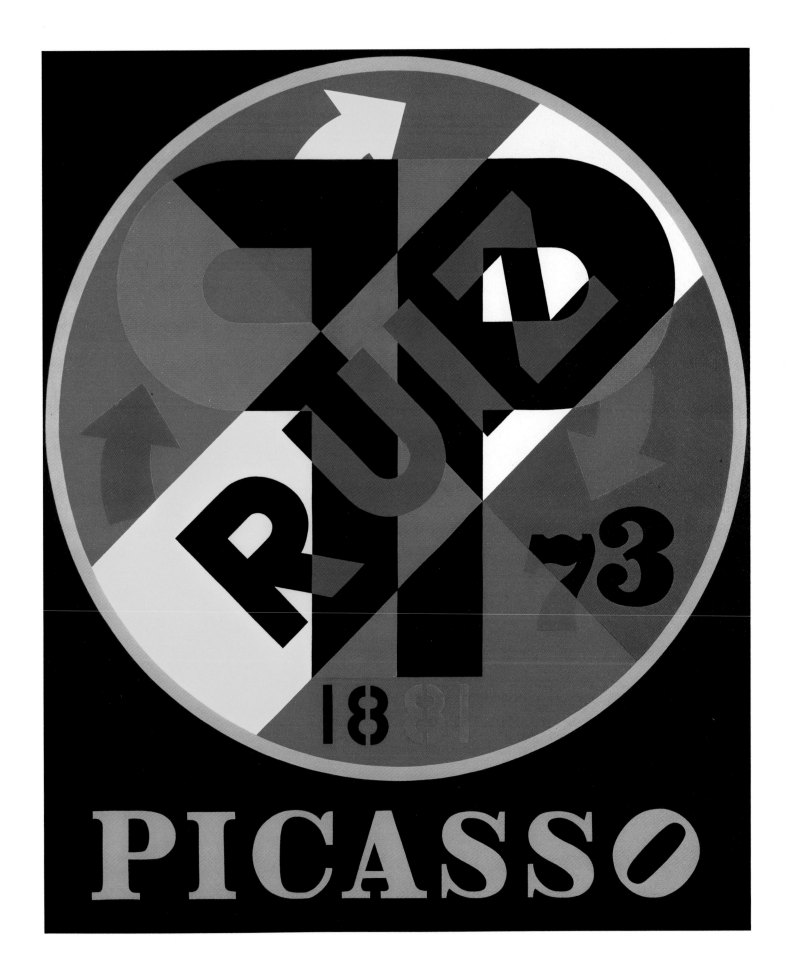

PICASSO. 1974. OIL ON CANVAS, 60 × 50″

DECADE: AUTOPORTRAIT 1961. 1971.
OIL ON CANVAS, 24 × 24″

DECADE: AUTOPORTRAIT 1962. 1971.
OIL ON CANVAS, 48 × 48″.
AUCTIONED, 1973, BENEFIT MUSEUM OF
CONTEMPORARY ART, CHICAGO

BUILDING ON THE OCCASION OF THE EXHIBITION "4 AMERICANS IN PARIS" IN 1970.

IN 1973 INDIANA WAS INVITED, ALONG WITH AN INTERNATIONAL GROUP OF FIFTY-NINE OTHER ARTISTS, TO CREATE A PRINT FOR A PORTFOLIO, **HOMMAGE À PICASSO,** IN HONOR OF THE SPANISH MASTER'S NINETIETH BIRTHDAY. THE COMMISSION HAD AN IMMEDIATE APPEAL FOR INDIANA, RECALLING HIS EARLY INTRODUCTION TO THE PICASSO PORTRAIT OF GERTRUDE STEIN AND, IN PARTICULAR, INVOLVING THE COINCIDENCE OF ANOTHER ARTIST WHO SIGNED HIS WORK WITH A NAME OF HIS OWN CHOOSING. PICASSO'S FATHER WAS JOSÉ RUIZ BLASCO, BUT FROM 1901 ON HE USED THE SURNAME OF HIS MOTHER, MARIA PICASSO. "SO CAUGHT UP WITH THE SUBJECT AND PLEASED WITH THE RESULT"[16] WAS INDIANA THAT HE TRANSLATED THE PRINT INTO AN OIL (1974).

THE NAME RUIZ IS EMBLAZONED ON A DIAGONAL BAND ACROSS THE DOMINANT CIRCULAR ELEMENT OF THE DESIGN, LIKE THE IDENTIFYING SASHES WORN IN **THE MOTHER OF US ALL**. AGAINST THE SUBTLE COLOR INTERSECTIONS OF UNDER-

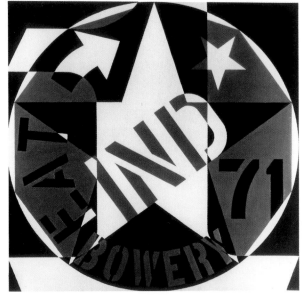

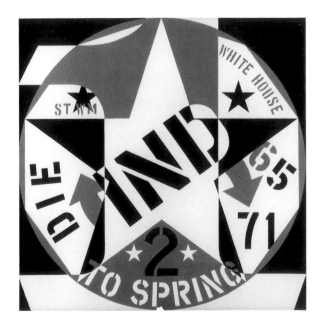

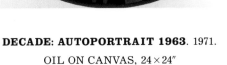

DECADE: AUTOPORTRAIT 1963. 1971.
OIL ON CANVAS, 24×24″

DECADE: AUTOPORTRAIT 1965. 1971.
OIL ON CANVAS, 48×48″

LYING GEOMETRIC, NUMERICAL, AND ALPHABETIC MOTIFS, THE LETTERS R, U, I, AND Z SEEM TO FLICKER. IN CONTRAST, THE NAME PICASSO, ITS O TILTED AS IN INDIANA'S LOVE LOGO, READS BOLDLY ACROSS THE DARK GROUND UNDER THE CIRCLE. IN A TALL, KEYLIKE SHAPE WITHIN THE CIRCLE, THE TWO PS OF PABLO PICASSO'S INITIALS, THE FIRST REVERSED AS A MIRROR IMAGE, STAND BACK TO BACK. AT THE FOOT OF THE PS ARE THE NUMERALS OF PICASSO'S BIRTH DATE, 1881 (1 PLUS 8 EQUALS 9, AND 8 PLUS 1 EQUALS 9, AND TOGETHER THEY EQUAL 18). PAINTED IN TWO COLORS TO DISTINGUISH THOSE PAIRINGS, THE DATE READS THE SAME FORWARD AS BACKWARD, LIKE A PALINDROME, REPEATING THE JANUS FORWARD-AND-BACKWARD ASPECT OF THE INITIALS.

PICASSO IS AN EXAMPLE OF INDIANA'S EXPLORATION OF BIOGRAPHY WITHIN HIS CHARACTERISTIC, STRICTLY CONTROLLED FORMAT. IN 1971 HE HAD EMBARKED UPON A COMPLEX AUTOBIOGRAPHICAL PROJECT, HIS DECADE: AUTOPORTRAITS, WHICH WAS TO COMMAND HIS INTEREST IN SUBSEQUENT YEARS. (INDIANA CHOSE

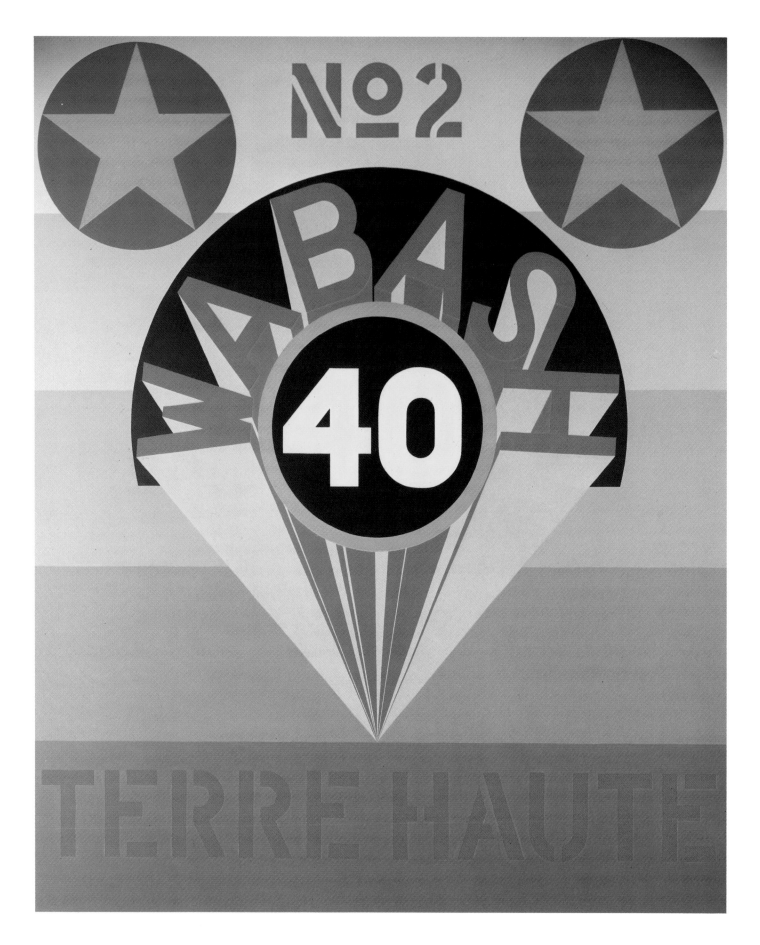

TERRE HAUTE #2. 1969.
ACRYLIC ON CANVAS, 60 × 50″. PRIVATE COLLECTION, WESTCHESTER, NEW YORK

THE PREFIX **AUTO,** WITH ITS ASSOCIATION TO THE AUTOMOBILE—AN ASSOCIATION ALSO CONJURED UP IN HIS "AUTOCHRONOLOGY"—OVER THE CONVENTIONAL **SELF**.) THE FIRST WORKS IN THIS SERIES OF TEN OIL PAINTINGS, EACH DEVOTED TO A YEAR OF THE ARTIST'S LIFE DURING THE DECADE OF THE 1960S, WERE SHOWN IN NOVEMBER 1972 AT THE GALERIE DENISE RENÉ IN NEW YORK. IT WAS NOT THE FIRST TIME THAT INDIANA HAD LOOKED AT THE PASSAGE OF TIME IN TEN-YEAR SEGMENTS IN HIS WORK. AS SAM HUNTER NOTED IN THE EXHIBITION CATALOGUE, THE HERM **HUB** (1962) BEARS STENCILED NUMBERS FROM ZERO THROUGH NINE BETWEEN THE SPOKES OF THE WHEEL ON ITS FACE (SEE PAGE 75). "THESE CIPHERS TELL THE PASSAGE OF DECADES RATHER THAN THE HOURS, IT WOULD SEEM." THE AUTOPORTRAITS HE DESCRIBED AS "COMMEMORATIVE AND CELEBRATORY" IN NA-TURE. "THEIR ASSOCIATIONS ARE CODED IN WORDS EASILY UNDERSTOOD ON AT LEAST ONE LEVEL, THOUGH HERE AND THERE SECONDARY MEANINGS REMAIN STUBBORNLY PRIVATE AND OPAQUE."[17]

SEVERAL OF THESE PAINTINGS BEAR DIAGONAL IDENTITY BANDS WITH THE LETTERS IND, FORESHADOWING THE TREATMENT OF RUIZ IN **PICASSO**. THE PAINTING FOR 1964, IN WHAT HUNTER CALLED "EYE-POPPING COMPLEMENTARY COLORS," INCORPORATES THE WORD **CHAMPION** AND PAYS HOMAGE TO STUART DAVIS, "A BRILLIANT VISUAL POET OF THE COMMONPLACE WORD AND SIGN,"[18] WHO DIED THAT YEAR.

INDIANA'S COMMEMORATION OF THE DECADE OF THE SIXTIES ALSO INCLUDED, IN 1971, "A COMPLEX 'MULTIPLE' WHICH CONSISTED OF A VARIETY OF PHOTOGRAPHS OF HIMSELF, AND EXQUISITELY EXECUTED SCREENPRINTS TAKEN FROM THESE PARTICULAR PAINTINGS WHICH SEEMED TO BEST EPITOMIZE EACH YEAR."[19] A PORTFOLIO OF THE TEN SERIGRAPHS WAS ISSUED BY MULTIPLES, NEW YORK. THE TITLES OF THE TEN PAINTINGS INDIANA CHOSE FOR THE SERIGRAPHIC SERIES AS HIS MOST SIGNIFICANT WORKS FROM 1960 THROUGH 1969 ARE: **THE AMERICAN DREAM** (PAGE 102), **THE CALUMET** (PAGE 24), **YIELD BROTHER** (PAGE 81), **THE FIGURE FIVE** (PAGE 110), **THE BRIDGE (THE BROOKLYN BRIDGE)** (PAGE 45), **THE**

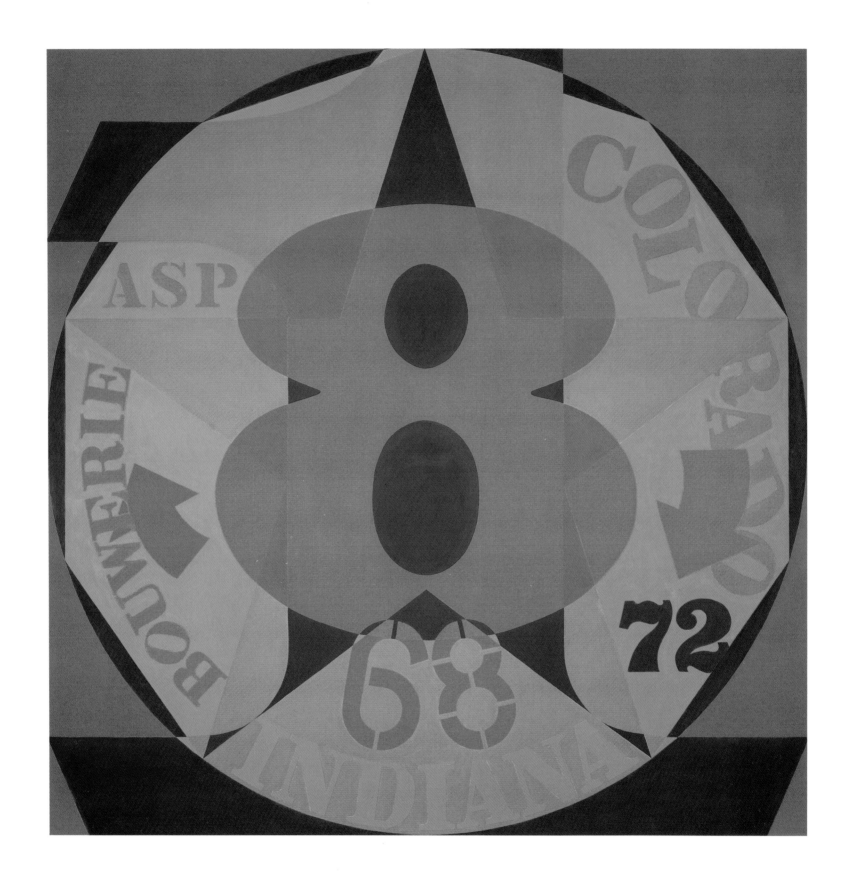

DECADE: AUTOPORTRAIT 1968. 1972. OIL ON CANVAS, 48×48″

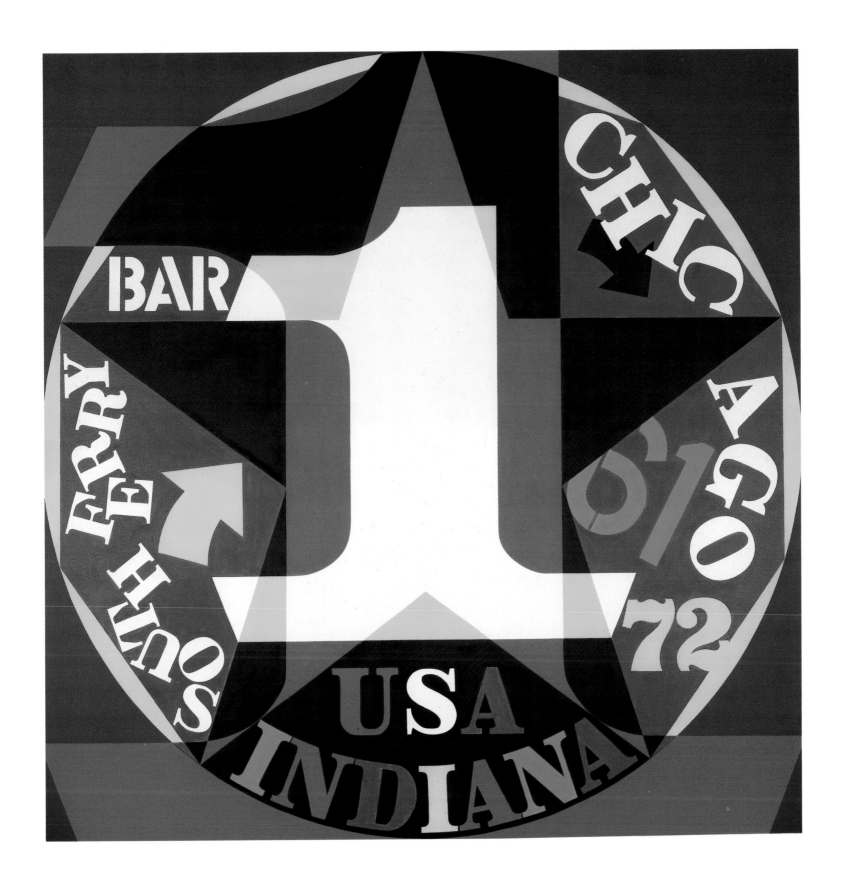

DECADE: AUTOPORTRAIT 1961. 1972.

OIL ON CANVAS, 72 × 72″. COLLECTION R. L. B. TOBIN, NEW YORK

CONFEDERACY: MISSISSIPPI (PAGE 83), **USA 666** (PAGE 17), **PARROT** (PAGE 210), **LOVE RISING (THE BLACK AND WHITE LOVE)** (PAGE 165), AND **TERRE HAUTE #2** (PAGE 146). SOME OF THE WORDS IN THOSE PAINTINGS ARE RECALLED IN THE AUTOPORTRAITS, WHICH ALSO RECORD THE NAMES OF PLACES WHERE HE LIVED, WORKED, OR VISITED (THE SLIP, BOWERY, BROOKLYN, SOUTH FERRY, HARBOUR). IN **DECADE: AUTOPORTRAIT 1965,** FOR INSTANCE, THE WORDS TO SPRING REFER TO HIS MOVE FROM COENTIES SLIP TO THE BUILDING AT THE CORNER OF SPRING STREET AND THE BOWERY, AND WHITE HOUSE CELEBRATES THE HANGING OF HIS **CALUMET** IN AN EXHIBITION AT THE INVITATION OF PRESIDENT AND MRS. LYNDON JOHNSON. **DECADE: AUTOPORTRAIT 1969** SAYS SKID ROW AND THEN PROGRESSES TO PENOBSCOT AND ELI, COMMEMORATING HIS FIRST VISIT TO VINALHAVEN IN MAINE. LIKE SEVERAL OTHERS OF THE SERIES, COMPLETED IN THE LATE 1970S, THIS ONE ALSO SPELLS OUT THE CHOSEN NAME, INDIANA, WHICH BY THEN HAD ACHIEVED RECOGNITION ABROAD AS WELL AS IN THE UNITED STATES.

1–10. MANUSCRIPT PROVIDED BY ROBERT INDIANA.

11. **TIME,** 23 AUGUST 1976, P. 37.

12. ALFRED FRANKENSTEIN, REVIEW, **SAN FRANCISCO CHRONICLE,** 29 AUGUST 1976, P. 27.

13, 14. IN UNIVERSITY OF TEXAS AT AUSTIN, **ROBERT INDIANA** (1977), EXHIBITION CATALOGUE, P. 31.

15. IBID., P. 30.

16. ROBERT INDIANA, "AUTOCHRONOLOGY," IN UNIVERSITY OF TEXAS AT AUSTIN, **ROBERT INDIANA,** P. 53.

17–19. SAM HUNTER, INTRODUCTION TO GALERIE DENISE RENÉ, NEW YORK, **ROBERT INDIANA** (1972), EXHIBITION CATALOGUE, N.P.

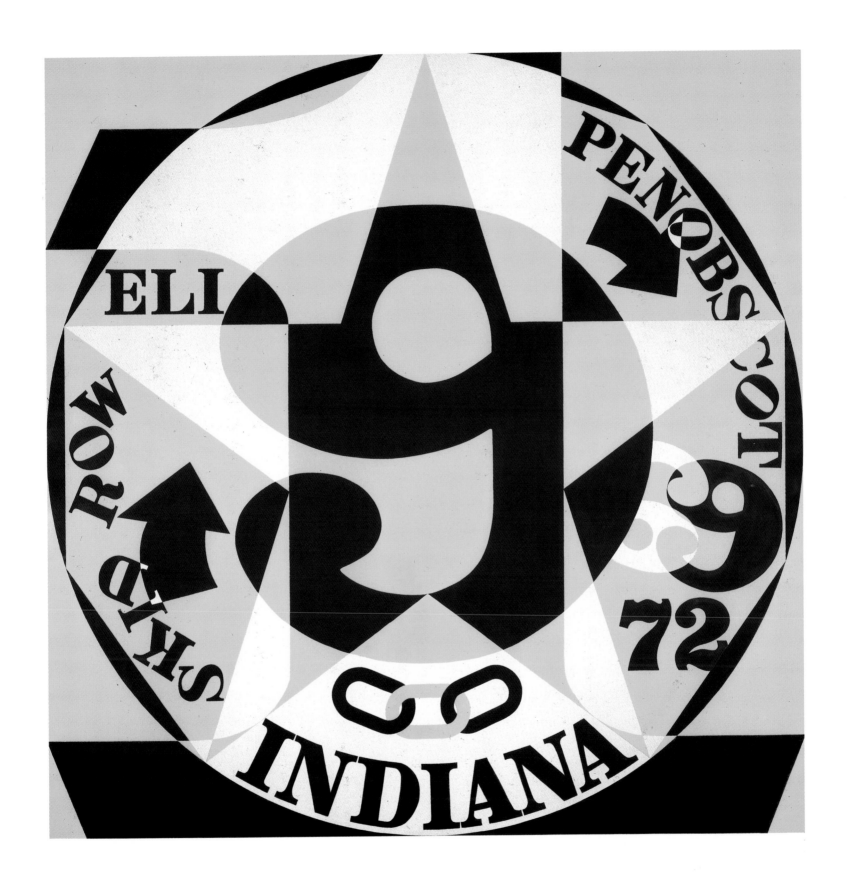

DECADE: AUTOPORTRAIT 1969. 1977. OIL ON CANVAS, 72×72″

LOVE ... WAS THE DRAWING OF A CIRCLE BACK TO THE BEGINNINGS OF MY KNOWN WORK. ... LOVE ... WAS THE DRAWING OF A CIRCLE BACK TO THE BEGINNINGS OF MY KNOWN WORK. ... LOVE ... WAS THE DRAWING OF A CIRCLE BACK TO THE BEGINNINGS OF MY KNOWN WORK. ... LOVE ... WAS THE DRAWING OF A CIRCLE BACK TO THE BEGINNINGS OF MY KNOWN WORK. ... LOVE ... WAS THE DRAWING OF A CIRCLE BACK TO THE BEGINNINGS OF MY KNOWN WORK. ... LOVE ...

O F ALL INDIANA'S IMAGES, THE MOST WIDELY RECOGNIZED IS **LOVE,** WHICH HE CARRIED THROUGH MANY VARIATIONS OF DESIGN, COLOR, SCALE, AND MEDIUMS. IT SO STRUCK THE FANCY OF THE TIMES WHEN IT FIRST MET THE PUBLIC EYE THAT IT WAS COPIED IN MILLIONS OF COMMERCIAL ARTIFACTS AND COUNTERFEITS, AS WELL AS AMATEUR ADAPTATIONS. SO NUMEROUS DID THE PIRATED VERSIONS BECOME THAT INDIANA CONSIDERED COLLECTING THEM BUT ABANDONED THE PROJECT AS TOO CUMBERSOME EVEN FOR HIS EXTENSIVE ARCHIVES.

THE INITIAL MEANING OF THE LOVE THEME WAS "SPIRITUAL," THE ARTIST SAYS. "THE REASON I BECAME SO INVOLVED IN [IT] IS THAT IT IS SO MUCH A PART OF THE PECULIAR AMERICAN ENVIRONMENT, PARTICULARLY IN MY OWN BACKGROUND, WHICH WAS CHRISTIAN SCIENTIST. 'GOD IS LOVE' IS SPELLED OUT IN EVERY CHURCH."[2] HE HAD PAINTED A SMALL **LOVE** IN 1962, BUT WHAT REALLY "SET OFF THE LONG CHAIN THAT **LOVE** HAS BECOME" WAS A WORK COMMISSIONED BY LARRY ALDRICH FOR THE OPENING OF A MUSEUM IN A CONVERTED CHRISTIAN SCIENCE CHURCH (OLD HUNDRED) IN CONNECTICUT.[3] THIS PAINTING, **LOVE IS GOD** (1964), IS A DIAMOND-SHAPED CANVAS WITH ITS MESSAGE IN STENCIL LETTERS WITHIN A CIRCLE. THE FAMOUS FOUR-LETTER LOGO HAD NOT YET COME INTO BEING, BUT THE SUBJECT IN GENERAL HAD BEEN IN HIS MIND AS FAR BACK AS HIS EMPLOYMENT AT SAINT JOHN THE DIVINE AND HIS **STAVROSIS** OF 1958. "MY MOST SERIOUS WORK," HE SAID OF THE SERIES, "IS THE **LOVE** CROSS I DID FOR THE ROTHKO CHAPEL IN TEXAS."[4] (IT WAS NOT INSTALLED THERE, BEING CONSIDERED "TOO LIGHT-HEARTED.")

FOR SOME YEARS INDIANA HAD BEEN USING WORDS AS "AN APPROPRIATE . . . **ELEMENT** OF ART"; WITH LOVE HE REACHED THE CONCEPT THAT A SINGLE WORD STANDING ALONE "IS ALSO A PROPER AND VIABLE **SUBJECT** FOR ART."[5] THE BASIC MOTIF, NOW A CLICHÉ TO MILLIONS, WAS FIRST EXHIBITED IN THE 1966 **LOVE** PAINTING, A SQUARE CANVAS WITH PAIRS OF RED LETTERS—L AND TILTED O

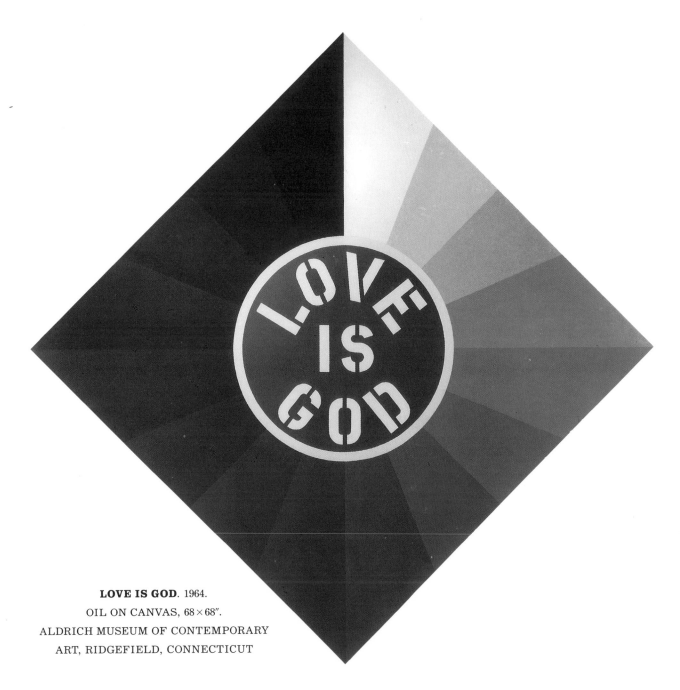

LOVE IS GOD. 1964.
OIL ON CANVAS, 68 × 68″.
ALDRICH MUSEUM OF CONTEMPORARY
ART, RIDGEFIELD, CONNECTICUT

STACKED ON TOP OF VE—AGAINST A GROUND OF BLUE AND GREEN. THIS DESIGN, HE SAYS, IS "ALSO A RETURN, AFTER SEVERAL YEARS OF FASCINATION WITH THE CIRCLE (SYMBOLIC . . . OF THE ETERNAL) AS THE DOMINATING FORM IN MY WORK, TO THE QUARTERED CANVAS."[6] HE RELATES THIS COMPOSITION TO THE FORMATIVE STAGES OF HIS FIRST AMERICAN DREAM PAINTING (SEE PAGE 102), WHICH HAD NO WORDS, NUMBERS, STARS, OR STRIPES BUT, INSTEAD, "SIMPLY FOUR DISKS AR-

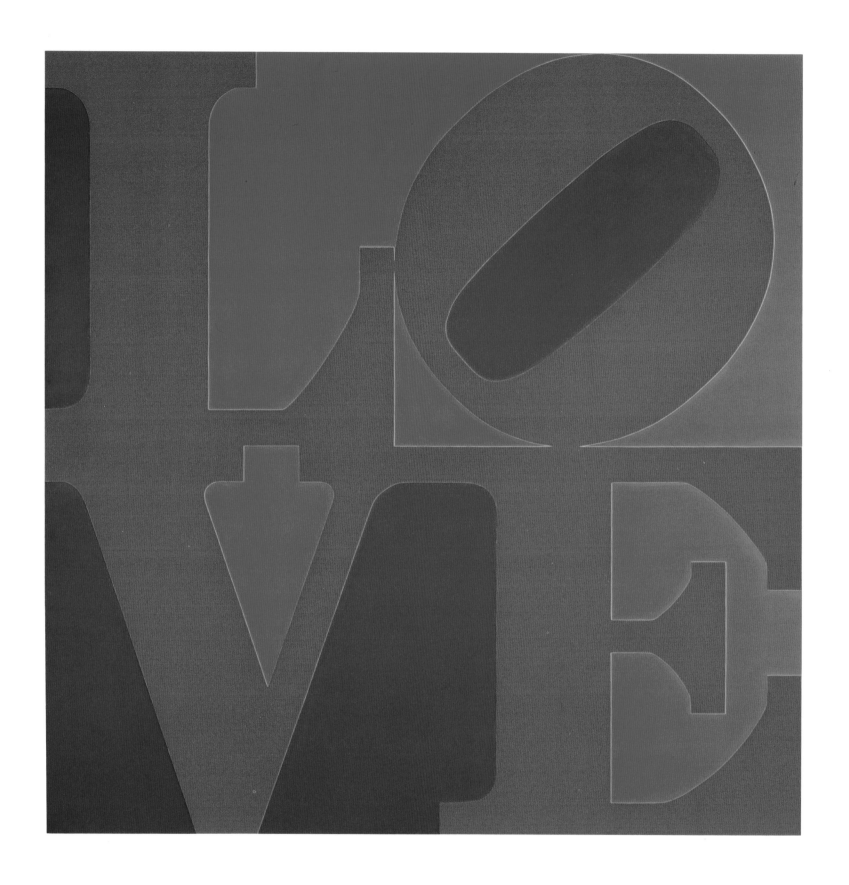

LOVE. 1966. OIL ON CANVAS, 72 × 72″.

© INDIANAPOLIS MUSEUM OF ART. JAMES E. ROBERTS FUND

RANGED ON A STRUCTURED FIELD QUADRILATERALLY. HERE THE QUARTERED FIELD IS FILLED WITH THE FOUR [LETTERS] . . . AS COMPACTLY AND ECONOMICALLY AS POSSIBLE," AND ONLY THE THRUSTING O CALLS TO MIND "THE DORMANT INTEREST IN THE CIRCLE."[7]

ONCE CONCEIVED, THIS SEMINAL GRAPHIC THEME, LIKE A SMALL MELODIC GEM, LENT ITSELF TO ALMOST INFINITE VARIATIONS BOTH IN VISUAL TERMS AND IN MOOD.

THE COLOR SCHEME OF RED-BLUE-GREEN, RECALLING ONCE AGAIN THE PHILLIPS 66 TRADEMARK OF HIS FATHER'S EMPLOYER, SERVED MORE THAN MEMORY. "PEOPLE COMING TO MY STUDIO DID NOT RECOGNIZE THE OPTICAL EFFECT" OF THOSE COLORS, INDIANA HAS SAID, "AND I WAS NEVER INCLUDED IN OPTICAL SHOWS OF THE TIME."[8] YET SOME OBSERVERS NOTED THAT IN THE LOVE SERIES INDIANA EXPLORED THE OPTICAL EFFECTS OF COLOR MOST INTENSIVELY, COMING MUCH CLOSER THERE TO OP THAN TO POP ART. "FIGURE AND GROUND IN THE **LOVE** PAINTINGS TEND TO BE SEEN AS EQUIVALENTS," JOHN MCCOUBREY COMMENTED. "SO STRONG IS HIS CONSCIOUSNESS OF THE FIELD THAT IN QUICK DRAWINGS OF LOVE HE DOES NOT PUT DOWN THE LETTERS BUT GENERATES THEM BY DISJUNCTIVE CONTOURS DRAWN INWARD FROM THE EDGES OF THE SQUARE."[9]

THE POWERFUL EFFECT OF THE COUNTER FORMS IS ESPECIALLY CLEAR IN THE FOUR-PANEL **THE GREAT LOVE (LOVE WALL)** OF 1966, IN THE SAME THREE COLORS. THE COMPOSITE WORK COULD BE READ EQUALLY WELL IF HUNG UPSIDE DOWN; IN EITHER DIRECTION THE BASIC LOGO FORMS THE UPPER-RIGHT PANEL AND ITS MIRROR IMAGE ADJOINS IT TO ITS LEFT. THE OS POINT TO THE CORNERS, THE ES ARE TWINNED FACING THE SIDES, THE LS ARE BACK TO BACK AT CENTER TOP AND BOTTOM, AND THE VS JOIN FOOT TO FOOT TO FORM TALL X SHAPES IN THE MIDST. THIS AMBIGUITY OF INSIDE OUT AND UPSIDE DOWN BEGUILES THE VIEWER'S EYE INTO THE PERCEPTION OF LOZENGES, SPADES, DUMBBELLS, AND OTHER ECCENTRIC FORMS COMING THROUGH THE LETTERS, WHICH SEEM CONJOINED INTO SOME FANTASTIC, MONOGRAMMATIC RED OPENWORK.

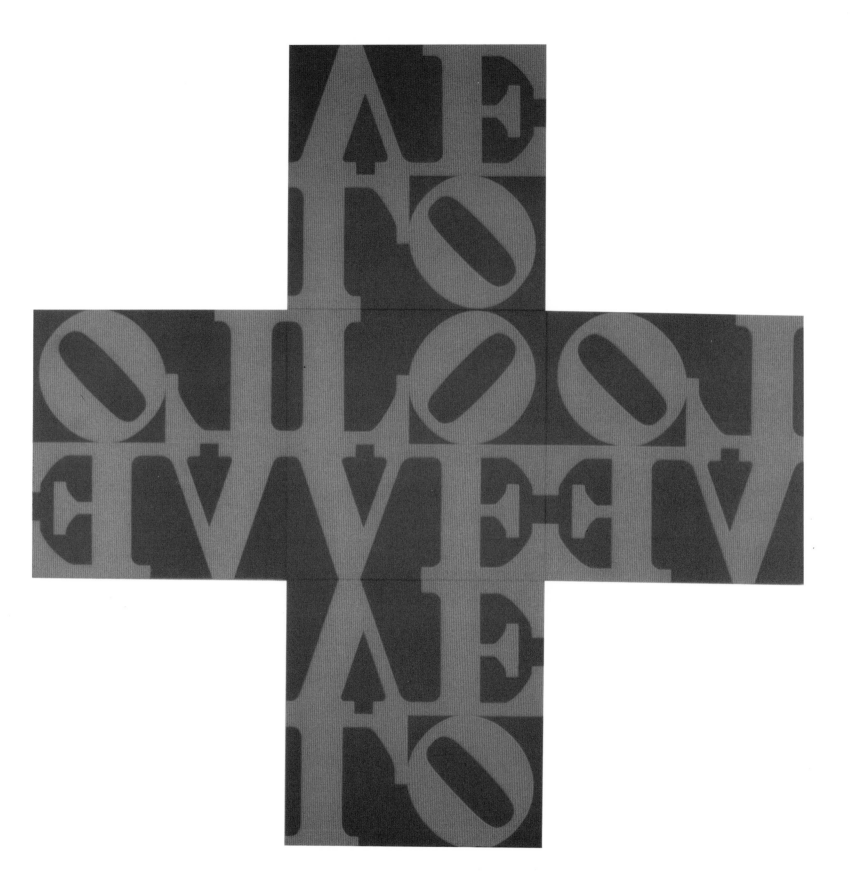

LOVE CROSS. 1968. OIL ON CANVAS, 5 PANELS, 15′ × 15′.
PRIVATE COLLECTION, UNITED STATES

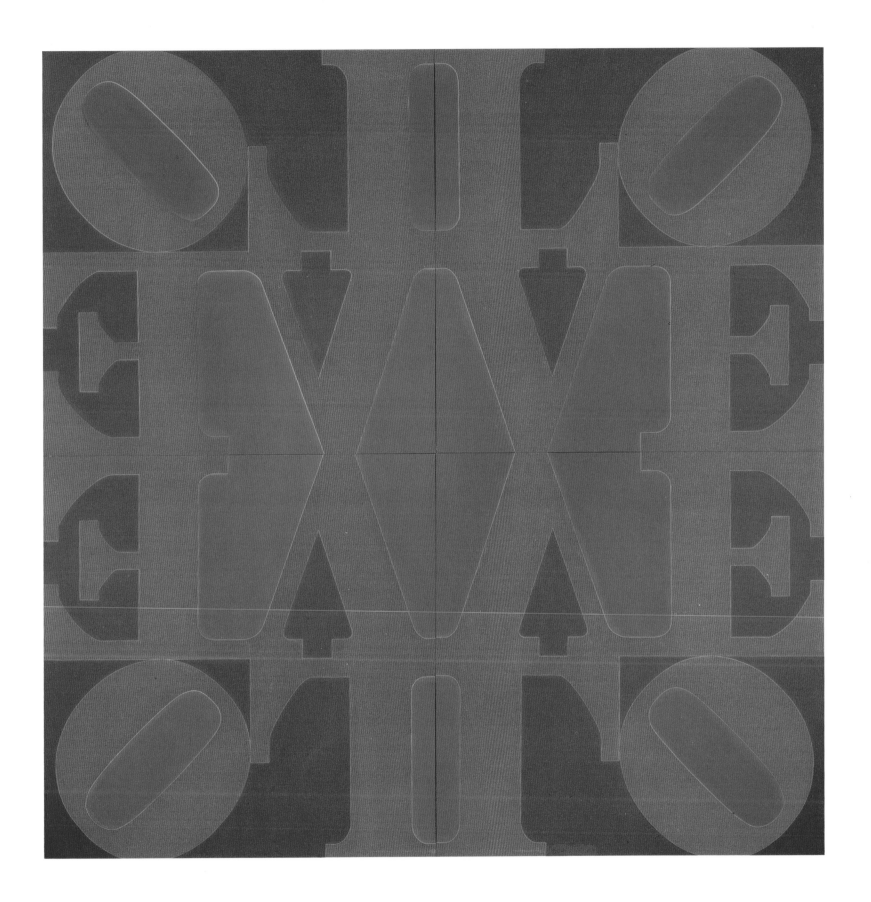

THE GREAT LOVE (LOVE WALL). 1966.

OIL ON CANVAS, 4 PANELS, 10′ × 10′. CARNEGIE MUSEUM OF ART, PITTSBURGH.

MUSEUM PURCHASE: GIFT OF WOMEN'S COMMITTEE OF THE MUSEUM OF ART, 1967

A QUITE DIFFERENT EFFECT IS PRODUCED BY A PLAY ON THE SAME COMPOSITIONAL DEVICE IN **LOVE RISING (THE BLACK AND WHITE LOVE),** WHICH WAS IN PROGRESS AT THE TIME MARTIN LUTHER KING, JR., WAS ASSASSINATED IN 1968 (PAGE 165). THIS TIME THE LOGO APPEARS IN NORMAL ATTITUDE IN THE LOWER LEFT OF THE FOUR PANELS AND IS FLOPPED, LIKE A PHOTOGRAPHIC NEGATIVE, HORIZONTALLY TO ITS RIGHT; THE UPPER TWO PANELS CONSTITUTE A VERTICAL FLOP OF THE LOWER PAIR, SO THAT AGAIN THE DESIGN READS EITHER WAY UP. IN THIS ARRANGEMENT, HOWEVER, STRONG, STRAIGHT ELEMENTS OF THE LETTERS CREATE A MORE STATIC FRAMING AT THE EDGES, WHILE THE OS EXERT A CENTRIPETAL FORCE. THIS LARGEST OF THE LOVE PAINTINGS, ITS PIGMENTS LIMITED TO BLACK AND WHITE FOR CLEARLY SYMBOLIC EFFECT, WAS DEDICATED TO THE SLAIN CIVIL RIGHTS LEADER AND FIRST EXHIBITED AT A BENEFIT FOR BLACKS.

IN SOME OF THE LOVE SERIES THE DAZZLING COMPLEMENTARY COLOR, GREEN, WAS DROPPED, BUT STILL THE VIBRANCY OF RED LETTERS ON A BLUE GROUND TEASED THE VIEWER'S EYE IN ITS ATTEMPT TO TRACE THE TRANSMUTATIONS OF THE LOGO. **THE IMPERIAL LOVE** (1966; SEE PAGE 169), A DIPTYCH, AND THE FIVE-PANEL **LOVE CROSS** OF 1968 REPRESENT THIS COLOR PHASE. IN THE LATTER'S CRUCIFORM ARRANGEMENT, IT IS THE CENTRAL PANEL THAT BEARS THE SIGN UPRIGHT.

OTHER VARIATIONS ON THE THEME ASSUMED NATIONAL COLORS. A SERIGRAPH COMMISSIONED IN 1968, **DIE DEUTSCHE LIEBE,** FLASHES THE YELLOW, RED, AND BLACK OF WEST GERMANY, CELEBRATING THE EARLY ACCEPTANCE AND EXHIBITION OF INDIANA'S WORK IN THAT COUNTRY. (HE ALSO DID A **DEUTSCHE VIER** PRINT IN THE SAME COLORS IN THE SAME YEAR, DRAWN FROM HIS **NUMBERS** PAINTINGS DATING A BIT EARLIER.) IN THE GERMAN LOVE, CONSISTING OF THE SIMPLE LOGO, WITHOUT ELABORATION, THE LETTERS ARE YELLOW, THE GROUND RED AND BLACK.

IN 1972 THE COLORS OF THE AMERICAN FLAG SHOWED UP IN **THE AMERICAN LOVE WALL,** A WORK IN FOUR PANELS, EACH DEVOTED TO A SINGLE LETTER IN

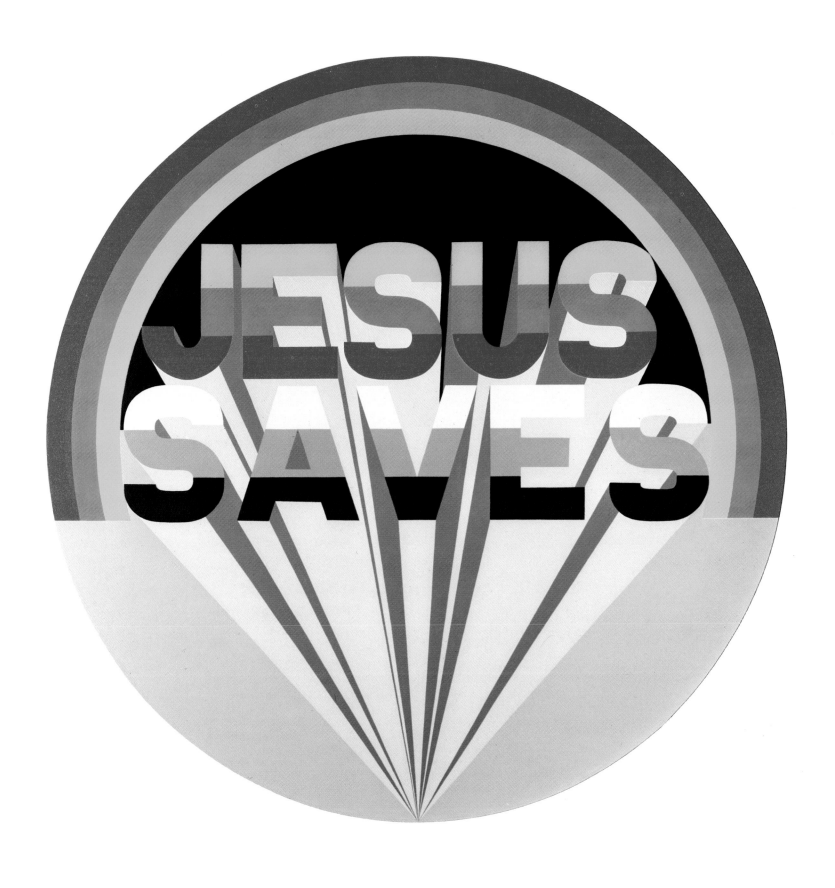

JESUS SAVES. 1969–70. OIL ON CANVAS, DIAMETER 60″. CORCORAN GALLERY OF ART, WASHINGTON, D.C.
GIFT OF LOWELL B. NESBITT IN MEMORY OF MILDRED C. NESBITT

THE AMERICAN LOVE WALL. 1972. OIL ON CANVAS, 4 PANELS, EACH 72 × 72″

WHITE WITH THE COUNTER FORMS IN RED AND BLUE. AS EXHIBITED IN A SOLO SHOW AT THE GALERIE DENISE RENÉ, THIS WALL WAS MOUNTED HORIZONTALLY, IN REGULAR READING ORDER FROM LEFT TO RIGHT. THE SAME FOUR PANELS, HOW-EVER, LEND THEMSELVES TO STACKING (LO ABOVE VE), AS IN THE PRIMARY QUADRIPARTITE DESIGN.

AS THE SERIES EVOLVED AND THE MOTIF WAS TRANSLATED INTO OTHER MEDIUMS, SOMETIMES BY OTHERS THAN ITS ORIGINATOR, THE INITIAL SPIRITUAL INTENT, NOT SURPRISINGLY, WAS SUBJECT TO CHANGE. IRONY AND SOCIAL COM-MENT CREPT IN AS INDIANA HIMSELF ASSOCIATED CERTAIN OF THE PAINTINGS WITH THE POLITICAL TEMPER OF THE PERIOD, AND AS HE SOMEWHAT WRYLY OBSERVED THE PUBLIC USE AND INTERPRETATION OF HIS CONCEPT. REVIEWING THAT 1972 SOLO SHOW, EMILY GENAUER REMARKED: "WHEN . . . ROBERT INDIANA

CONCEIVED THE FIRST OF HIS MANY PAINTED AND SCULPTURED VERSIONS OF
LOVE, HE NEVER DREAMED THEY'D BECOME THE SARDONIC SYMBOL OF THE
WHOLE 'LOVE GENERATION' THAT KNOCKED LOPSIDED OUR CONVENTIONAL CON-
CEPTS AND CONNOTATIONS OF THE WORD." SHE CREDITED SOME OF THE SYMBOL'S
EXTENSION INTO "A FAMILIAR ICON" TO THE FACT THAT IT HAD BEEN USED WITH
MINOR ALTERATIONS AS JACKET AND PROMOTIONAL COPY FOR A POPULAR NOVEL,
LOVE STORY, BY ERICH SEGAL.[10]

BE THAT AS IT MAY, INDIANA'S CONCRETE POEM "WHEREFORE THE PUNCTUA-
TION OF THE HEART," WHICH HE DATES 1958–69 (SAYING THAT IT WAS "MAINLY
WRITTEN AT THE CATHEDRAL OF ST. JOHN THE DIVINE IN THE FIFTIES"[11]), RE-
VEALS WIDE-RANGING CONNOTATIONS OF THE WORD FROM THE SUBLIME TO THE
EARTHY. ITS WITTICISMS ARE VERBAL, VISUAL, AND SEMIOTIC. THE POEM (RE-

WHEREFORE THE PUNCTUATION OF THE HEART

WHEREFORE THE PUNCTUATION OF THE HEART

WHEN THAT SLIM PRIM AGAPÉ

LOVE

ERRED INTO

L,O,V,E,

ENCOMMA'D IN UNCERTAINTY,

IS NEITHER

L;O;V;E;

HALTERED IN SOME PHILISTINE DESIGN;

NOR

L:O:V:E:

ENCUMBERED IN EVEN DEEPER DISCELEBRATION:

LET NOT

L/O/V/E/

STAGGERED STUMBLE UNREQUITEDLY/

QUITE NOT

L-O-V-E-

SHACKLED IN MEASURED IRONY—

SHOULD NOT BE

(L)(O)(V)(E)

(BUTTRESSED INCARCERATION)

BUT MOST NOT

L.O.V.E.

HATED ANAGRAM OF DEATH.

INSTEAD QUOTH

"L"O"V"E"

NOT "NEVERMORE," FOR "EVERMORE"

OR

L?O?V?E?

IN QUEST, NOT QUESTION?

RISE BRIGHT PHOENIXWISE

E

V

O

L

ECSTATIC

ERECT

EROTIC

HAVING DOVE (SIC)

L

O

V

E

TO EMERGE PURGED.

LET SHOUT EXULT

L!O!V!E!

FROM EVERY GLYPH!

YEA INCREASE

L&O&V&E&

AMPLY COMPANIONED

TO BE

EMBLOSSOMED

L*O*V*E*

IN AN ASTERISM OF EROSIA

TO MAKE

LO

VE

ARCHITECTED IN ETERNAL FORM.

ROBERT INDIANA, 1958–69

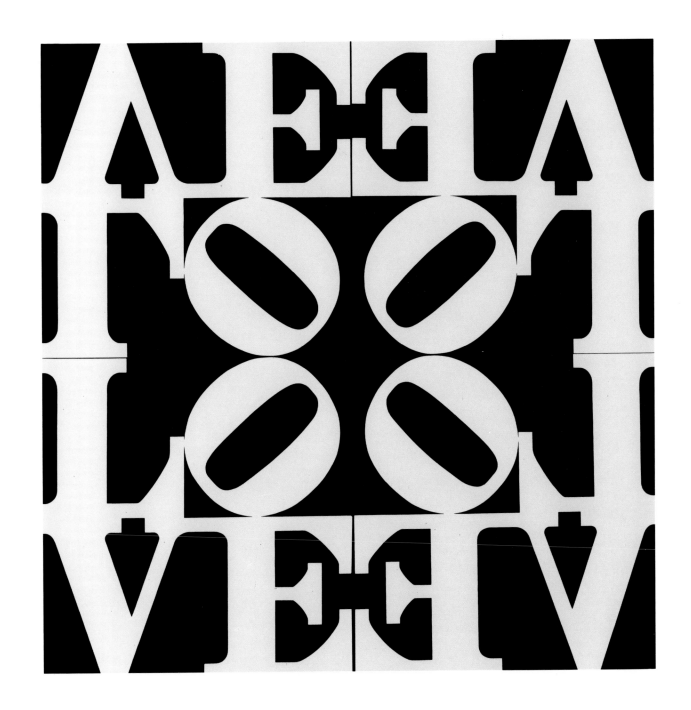

LOVE RISING (THE BLACK AND WHITE LOVE). 1968.
ACRYLIC ON CANVAS, 4 PANELS, 72×72″.
NEUE GALERIE-LUDWIG COLLECTION, AACHEN, WEST GERMANY

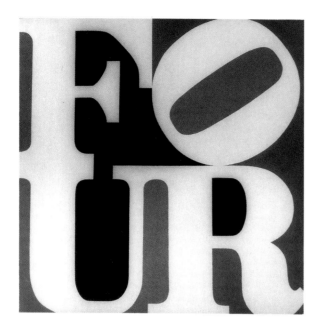

FOUR. 1965.
OIL ON CANVAS, 12 × 12″

ERECTION OF THE 12-FOOT COR-TEN STEEL **LOVE**
FOR TEMPORARY VIEWING IN CENTRAL PARK,
NEW YORK, CHRISTMAS, 1971

AHAVA, THE HEBREW VERSION OF **LOVE,**
EXHIBITED IN CENTRAL PARK, NEW YORK,
BEFORE SHIPMENT TO ITS PERMANENT SITE
IN ISRAEL, 1978

PRODUCED ON PAGE 164) HAS A CURIOUS LINK WITH ONE COLOR PHASE OF LOVE
THAT OWES ITS EXISTENCE TO A TECHNICAL ERROR.

PURPLE HAD NOT BEEN AMONG INDIANA'S CHOSEN COLORS UNTIL 1975, WHEN
THE FRIENDS OF THE PHILADELPHIA MUSEUM COMMISSIONED A SERIGRAPH, **THE
PHILADELPHIA LOVE,** WHICH WAS OFFERED TO PATRONS, ALONG WITH A PRINTED
VERSION OF THE POEM, AS A FUND-RAISER. THE PRINT COMMEMORATED THE
ISSUANCE AT THAT MUSEUM OF A GOVERNMENT-COMMISSIONED "SPECIAL STAMP
FOR SOMEONE SPECIAL" (THE LOVE STAMP) ON VALENTINE'S DAY, 1973. ALSO
REPRISED IN THE PRINT WAS THE INADVERTENT CONVERSION OF BLUE TO VIOLET
THAT SHOCKED THE ARTIST WHEN HE FIRST SAW WHAT THE GOVERNMENT PRINT-
ERS HAD WROUGHT IN EXECUTING HIS STAMP DESIGN, INTENDED FOR THE PHIL-
LIPS 66 COLORS. BY THE TIME OF **THE PHILADELPHIA LOVE,** HOWEVER, HE HAD
BEEN WON OVER, PERHAPS PARTLY BECAUSE OF THE ENORMOUS POPULARITY OF
THE SO-CALLED "HIPPIE STAMP"; HE UTILIZED THE ERROR AND MADE THE COLOR
HIS OWN, NOT ONLY IN THE PRINT BUT ALSO IN THE BACKGROUND OF THE SUBSE-
QUENT ALBUM COVER HE DID FOR A RECORDING OF **THE MOTHER OF US ALL** (1977).
IN THESE WORKS THE ACTUAL MIXTURE OF RED AND BLUE PIGMENTS ACHIEVED

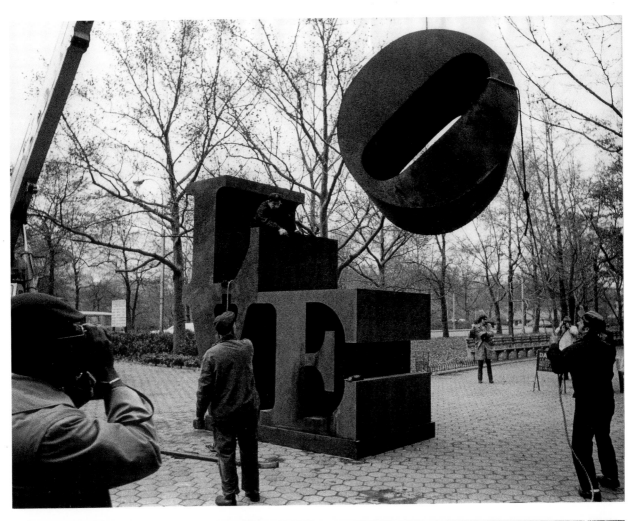

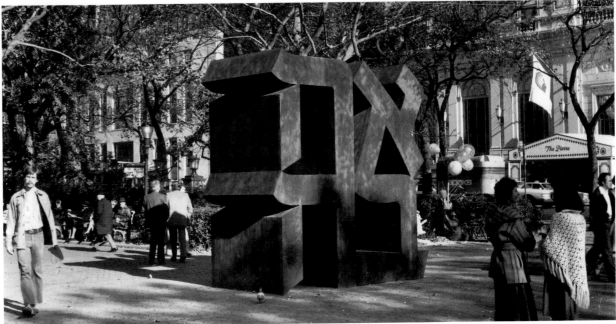

THE EFFECT THAT HAD BEEN PRODUCED IN OTHER WORKS SIMPLY BY THE OPTICAL RESPONSE OF THE VIEWER TO THE CLEAR, LUCID RED-AND-BLUE JUXTAPOSITIONS OF, SAY, **THE IMPERIAL LOVE**.

LIKE THE POSTAGE STAMP, A NUMBER OF OTHER PROJECTS INVOLVING THE LOVE THEME WERE GIVEN OVER BY THE PAINTER FOR ULTIMATE EXECUTION BY SPECIALISTS. AMONG THESE WERE A DEEP-PILED RUG, OR TAPESTRY; A CHRISTMAS CARD FOR THE MUSEUM OF MODERN ART IN NEW YORK; A RING; AND SCULPTURES IN VARIOUS METALS AND AT SCALES UP TO THE MONUMENTAL. THESE DEVELOPMENTS ARE DISCUSSED IN THE FOLLOWING CHAPTER, WHICH DEALS WITH INDIANA'S STUDIO PRACTICES AND MATERIALS AND THE PLANNING STAGES OF HIS WORK.

DESPITE ALL THE ASPECTS OF THE WORD **LOVE** SUGGESTED BY THESE MANY WORKS IN DIVERSE MEDIUMS, THE SPIRITUAL WAS NEVER TOTALLY SUBMERGED. INDIANA'S LAST GREAT SCULPTURAL TRIBUTE TO THE THEME, **AHAVA** (OR HEBREW LOVE) OF 1977, IS A FULL RETURN TO THE SPIRITUAL. FOR HIM, AS HE SAYS IN HIS "AUTOCHRONOLOGY," "IT IS IN MEMORY OF THE PRIEST WHO HAD MUCH TO DO WITH HIS INVOLVEMENT IN THE CONCEPT OF LOVE IN THE FIRST PLACE AND WHO DIED IN THE ISRAEL DESERT—BISHOP PIKE, FOR WHOM HE WORKED AT THE CATHEDRAL OF ST. JOHN THE DIVINE."[12] THE HEBREW CHARACTERS EMBODY A PRAYER FOR LOVE RECITED DAILY IN JEWISH RITUALS.

NO MATTER HOW COMPLEX THE CONTEXT OF THE LOVE CYCLE MAY BE, THE EVOLUTION OF THE LOGO ITSELF IS CONSISTENT WITH INDIANA'S STRIVING FROM HIS EARLIEST WORK TO DISTILL THE ESSENCE OF A WORD TO ITS MOST IMMEDIATELY COMMUNICATIVE VISUAL FORM. "IN A SENSE," HE HAS SAID, "I GOT DOWN TO THE SUBJECT MATTER OF MY WORK . . . THE SUBJECT IS DEFINED BY ITS EXPRESSION IN THE WORD ITSELF . . . LOVE IS PURELY A SKELETON OF ALL THAT WORD HAS MEANT IN ALL THE EROTIC AND RELIGIOUS ASPECTS OF THE THEME, AND TO BRING IT DOWN TO THE ACTUAL STRUCTURE OF THE CALLIGRAPHY [IS TO REDUCE IT] TO THE BARE BONES."[13]

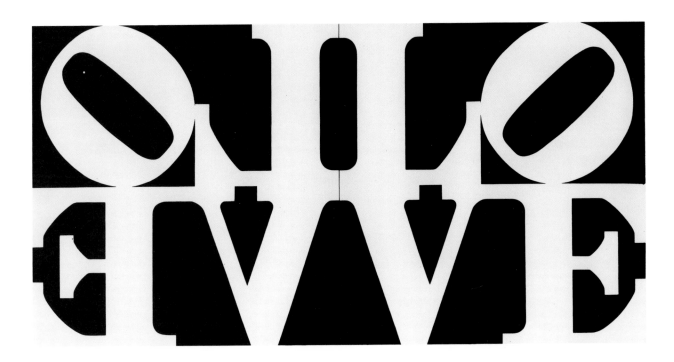

THE IMPERIAL LOVE. 1966. OIL ON CANVAS, 2 PANELS, 6′ × 12′

1. IN A STATEMENT PROVIDED BY ROBERT INDIANA FOR THE EXHIBITION AT GALERIE DENISE RENÉ, NEW YORK, 1972.

2. IN VIVIEN RAYNOR, "THE MAN WHO INVENTED LOVE," **ART NEWS** 72, NO. 2 (FEBRUARY 1973), P. 60.

3. LETTER FROM ROBERT INDIANA TO LARRY ALDRICH, THE ALDRICH MUSEUM OF CONTEMPORARY ART, RIDGEFIELD, CONN., 11 FEBRUARY 1973.

4. IN RAYNOR, "THE MAN WHO INVENTED LOVE," P. 60.

5–7. IN STATEMENT BY INDIANA, 1972. SEE NOTE 1.

8. IN RAYNOR, "THE MAN WHO INVENTED LOVE," P. 62.

9. JOHN W. MCCOUBREY, IN INSTITUTE OF CONTEMPORARY ART OF THE UNIVERSITY OF PENNSYLVANIA, PHILADELPHIA, **ROBERT INDIANA** (1968), EXHIBITION CATALOGUE, P. 34.

10. EMILY GENAUER, "WILL **ART** REPLACE THE **LOVE** SYMBOL?," **ARTS,** 8 DECEMBER 1972, P. 11A.

11. ROBERT INDIANA, "AUTOCHRONOLOGY," IN UNIVERSITY OF TEXAS AT AUSTIN, **ROBERT INDIANA** (1977), EXHIBITION CATALOGUE, P. 53.

12. IBID., P. 55.

13. IN UNIVERSITY OF TEXAS AT AUSTIN, **ROBERT INDIANA,** P. 36.

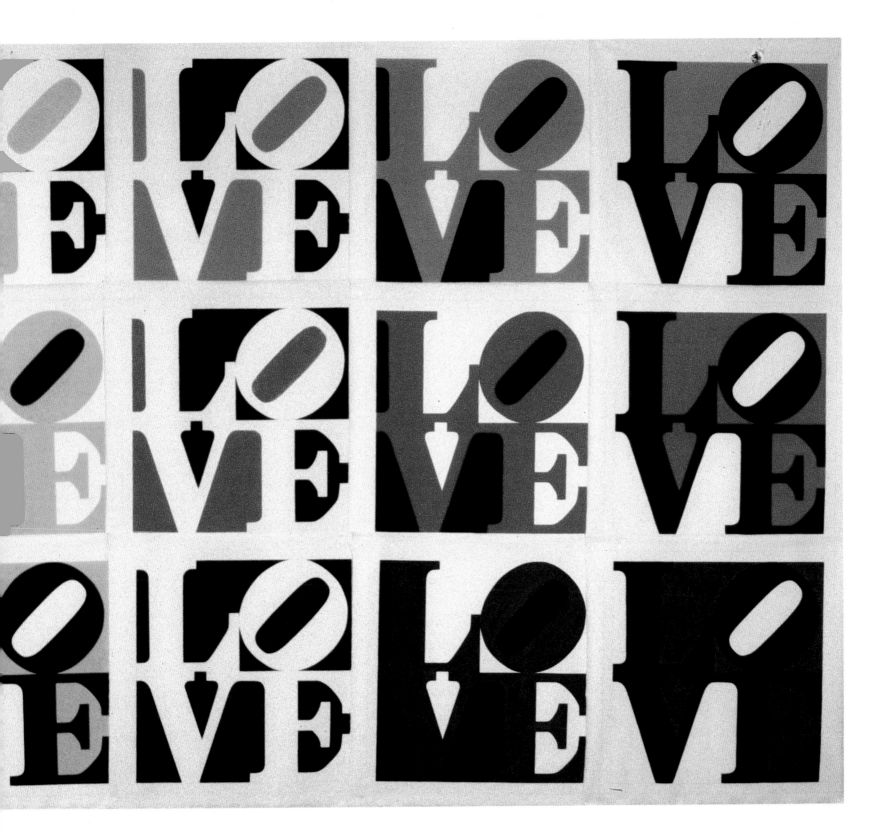

LOVE WALL. 1988. OIL ON CANVAS, 21 PANELS, EACH 24″ SQUARE

THERE'S NOTHING VIRTUOSIC ABOUT MY WAY OF PAINTING. . . . VIRTUOSITY SEEMS TO ME TO BE THE OTHER SIDE OF SERENITY.

T HE TECHNICAL DRUDGERY, THE MECHANICAL LEARNING PROCESS REQUIRED IN MANY ART EDUCATION COURSES SUCH AS INDIANA EXPERIENCED AT THE ART INSTITUTE OF CHICAGO SEEMED TO HIM CONTRARY TO THE FREEDOM THAT "AGREED WITH THE WHOLE CONCEPT AND PICTURE OF BEING AN ARTIST."[2] YET HIS MATURE WORK, PARADOXICALLY, BEARS THE STAMP OF DISCIPLINE, BOTH CONCEPTUAL AND TECHNICAL. THAT DISCIPLINE IS IMPOSED BY THE ARTIST'S MOST FREQUENT CHOICE OF IMAGES—STYLIZED LETTERS, WHICH BEAR CRYPTIC MONOSYLLABIC MESSAGES OR BRIEF LITERARY ALLUSIONS, AND STARK NUMERALS, ORACULAR IN THEIR ISOLATION. IT IS ALSO IMPOSED BY HIS DELIBERATELY REDUCTIVE MEANS OF EXPRESSION—THE STRICT GEOMETRIC STRUCTURE, THE HARD-EDGED FORMS, AND THE FLAT COLORS IN DIRECT JUXTAPOSITION. PERHAPS MOST OF ALL, THAT DISCIPLINE DERIVES FROM THE ARTIST'S PERSONAL NEED FOR ORDER, FOR CONCENTRATION, FOR A DELIBERATE PACE IN HIS WORK.

INDIANA REJECTS THE IDEA OF VIRTUOSO PERFORMANCE AS A KIND OF GYMNASTIC STUNT, SUCH AS "DIVERS DOING TEN FLIP-FLOPS," WHICH HE REGARDS AS NOT ONLY "TEDIOUS" BUT ALSO "TAKING RISKS."[3] INSTEAD, HE THINKS OF HIS APPROACH TO PAINTING AS "JUST WALKING A SLOW, STRAIGHT PATH. . . . IT MIGHT HAVE SOMETHING TO DO WITH SERENITY. . . . WHAT I MYSELF FEEL BEING AN ARTIST IS [TO BE] IN TOTAL COMMAND OF ONESELF."[4]

"FROM THE AGE OF SEVEN ON I WAS . . . CAUGHT UP WITH ARCHITECTURE . . . I REALLY WANTED TO BE AN ARCHITECT UNTIL IT DAWNED ON ME THAT MY INABILITY TO COPE WITH MATHEMATICS . . . WOULD MAKE IT A VERY DIFFICULT CAREER," HE HAS SAID.[5] "MY PAINTINGS, I THINK . . . ARE REALLY BUILT . . . DESIGNED IN THE WAY AN ARCHITECT ARRIVES AT HIS BUILDINGS . . . FROM PATTERNS (ALMOST WHAT YOU COULD CALL BLUEPRINTS) MUCH MORE THAN [THOSE OF] MOST OTHER ARTISTS I CAN THINK OF."

OVER THE YEARS HE HAS BEEN STRUCK BY THE DIFFERENCE IN THE WORKING HABITS AND STUDIO PROCEDURES OF ARTISTS, "THE DICHOTOMY BETWEEN THE

MESSY ARTIST AND THE ORDERLY ARTIST."[6] "I'D LOVE TO BE THE KIND OF PERSON WHO COULD GET UP AT THE CRACK OF DAWN AND . . . PAINT FOR A COUPLE OF HOURS AND THEN . . . DRAW FOR A COUPLE OF HOURS AND THEN . . . PRINT FOR A COUPLE OF HOURS . . . BUT I'M NOT. ONCE I'M INTO SOMETHING, I'M INTO IT COMPLETELY, AND EVERYTHING ELSE GETS NEGLECTED."[7]

THE LOFT BUILDING THAT INDIANA ACQUIRED WHEN HE FINALLY HAD TO GIVE UP HIS BELOVED COENTIES SLIP LOCATION OFFERED AMPLE ROOM AND FACILITIES TO ACCOMMODATE HIS PREFERRED WORKING AND LIVING ARRANGEMENTS. A TALL BUILDING ON THE CORNER OF THE BOWERY AND SPRING STREET, IT HAD FOUR EXPOSURES OF THE UPPER FLOORS AND A FREIGHT ELEVATOR AND ROOM FOR A PRIVATE GALLERY ON THE GROUND FLOOR. THERE HE COULD SET UP A SEPARATE STUDIO FOR EACH OF THE MEDIUMS HE WORKED IN—PAINTING, DRAWING, GRAPHICS, AND SCULPTURE—AS WELL AS MAINTAIN HIS ARCHIVES, LIBRARY, OFFICE, AND PRIVATE QUARTERS FOR HIMSELF AND HIS PLANTS AND ANIMALS.

HIS APPROACH TO PAINTING, AS HE HAS DESCRIBED IT IN THAT SETTING, IS, ABOVE ALL, ORDERLY. THE "ARCHITECTURE" IS "WELL WORKED OUT IN MY MIND. . . . THE PAINTING ITSELF, THE CANVAS AND THE PAINT AND THE STRETCHERS AND ALL THAT . . . IS PRE-FIXED."[8] ON RARE OCCASIONS HE DEPARTS FROM HIS PLAN DURING THE PAINTING, BUT "THIS MAINLY OCCURS WITH COLOR CHOICES," HE SAYS.[9] "IT'S DESIRABLE FROM JUST A TECHNICAL STANDPOINT NOT TO [CHANGE COLORS ON THE CANVAS ITSELF] IF ONE IS GOING TO PRESENT THE PERFECT KIND OF SURFACE I LIKE TO DEAL WITH."[10]

"CONSERVATIVE"[11] IS THE WORD THAT HAS BEEN APPLIED TO INDIANA'S PAINTING TECHNIQUE, IN WHICH PENCIL-DRAWN FORMS ARE PAINTED IN WITH OIL PIGMENTS (OFTEN JUST AS THEY COME FROM THE TUBE) AND WITH ARTISTS' BRUSHES, UNASSISTED BY MASKING TAPE TO DEFINE THE EDGES. THIS MANNER OF WORKING HAS ENABLED HIM TO MAINTAIN THE "SIGN-PAINTER'S" CRISPNESS OF OUTLINES EVEN WHEN HE DEPARTS FROM HIS PREDOMINANTLY GEOMETRIC SHAPES FOR REPRESENTATIONAL IMAGES AND FROM STRONG, CONTRASTING COLORS FOR MORE

INDIANA IN THE LIVING QUARTERS OF HIS LOFT BUILDING ON THE BOWERY, NEW YORK,
SEATED IN FRONT OF **EAT SIGN** (PAGE 95), A CONDENSED VERSION OF THE WORLD'S FAIR PROJECT
OF 1964. THE TRUNKS AT THE RIGHT ARE REMINDERS OF THE PRODUCTS ONCE
MANUFACTURED IN THE LOFTS, FORMERLY SWEATSHOPS

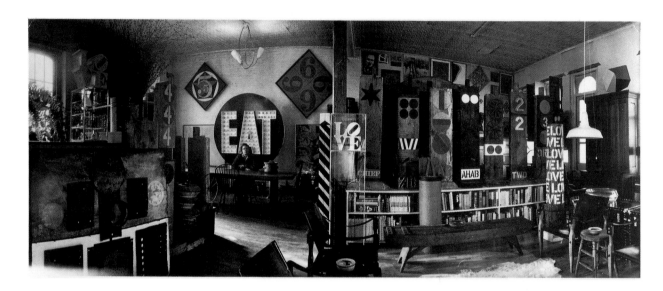

TWO VIEWS OF THE MAIN STUDIO OF INDIANA'S LOFT BUILDING ON THE BOWERY, NEW YORK,
1972, JUST BEFORE THESE CANVASES OF THE DECADE: AUTOPORTRAIT SERIES WENT ON
EXHIBIT IN HIS FOURTH NEW YORK SOLO SHOW AT THE GALERIE DENISE RENÉ

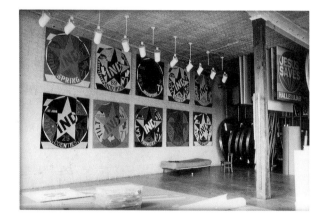

PRIVATE GALLERY IN INDIANA'S BOWERY LOFT BUILDING, NEW YORK,
WITH ENTRANCE ON THE GROUND FLOOR AT 2 SPRING STREET. NEIGHBORS INCLUDED
LOUISE NEVELSON, ROY LICHTENSTEIN, ADOLPH GOTTLIEB, AND MARK ROTHKO

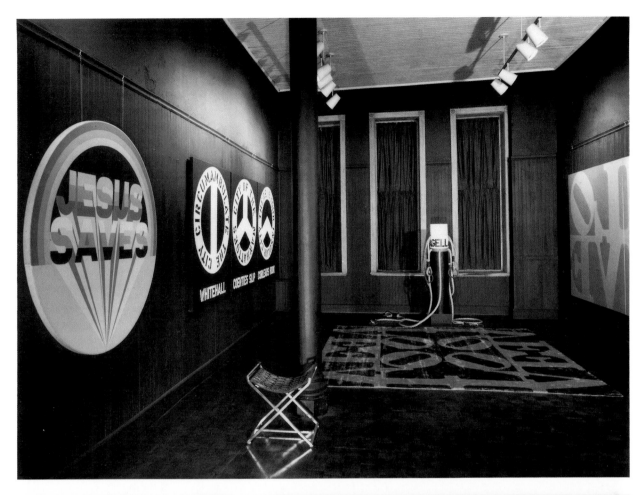

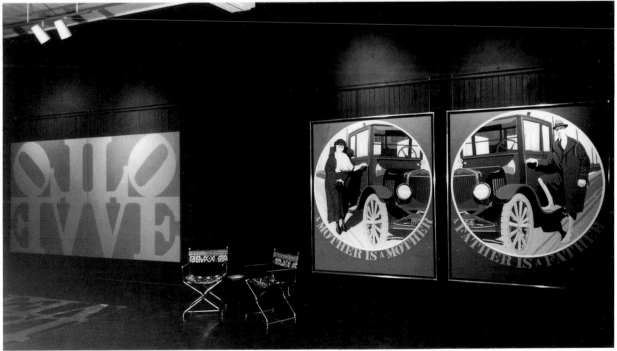

SUBTLE TONES. IN THE FOUR-PANELED **THE BRIDGE (THE BROOKLYN BRIDGE)** (1964; SEE PAGE 45), FOR EXAMPLE, AND IN THE **FATHER** PANEL OF THE **MOTHER** AND **FATHER** DIPTYCH (1963–67; SEE PAGE 119), COLOR IS SUBDUED TO GRISAILLE. IN THE FLUID CONTOURS OF **LEAVES** (1965; SEE PAGE 219) AND THE CLOISONNÉ COMPARTMENTS OF THE PLUMAGE IN **PARROT** (1967; SEE PAGE 210), COLOR REFLECTS THE TINTS OF NATURE. ALL THESE EFFECTS, HOWEVER, ARE ACHIEVED WITH FLAT PAINT AREAS CONTAINED WITHIN CLEARLY DELINEATED EDGES.

THE SAME IS TRUE, FOR THE MOST PART, OF INDIANA'S DESIGNS FOR THE FIGURAL REPRESENTATION OF CHARACTERS, COSTUMES, PROPS, AND SETS FOR **THE MOTHER OF US ALL** (SEE PAGES 127–36). THERE HE CHOSE THE MEDIUM OF CUT PAPER TO PRESENT EACH FORM IN BRILLIANT HUE AND KNIFE-SHARP SILHOUETTE. THE LABOR OF EXECUTING A PROJECT OF SUCH MAGNITUDE WAS CARRIED OUT WITH THE AID OF MANY STUDIO ASSISTANTS, WORKING FROM PRELIMINARY DRAWINGS DONE BY INDIANA IN FELT MARKER ON PAPER. ULTIMATELY, THE CUTOUT EFFECT WAS MAINTAINED IN THE FULL-SCALE PIECES BY THE USE OF CUT FELT AS THE PRINCIPAL MATERIAL. IN CERTAIN DETAILS THE HARD-EDGE MODE GAVE WAY TO PAINTERLY TOUCHES, WITH SOME HINT OF THREE-DIMENSIONAL MODELING AND MODULATION OF COLOR, COMPATIBLE WITH THE PRESENCE OF LIVE PERFORMERS.

THE DECIDEDLY NONPAINTERLY AND NONREPRESENTATIONAL IMAGES—THE LETTER AND NUMBER SYMBOLS SO OFTEN COMBINED AS MESSAGES WITHIN GEOMETRIC FORMATS IN INDIANA'S PAINTINGS AND PRINTS—ALLUDE TO ANTIQUATED AND HISTORICAL MEANS OF ACHIEVING UNIFORMITY OF STYLE MECHANICALLY, WITH STENCILS, STAMPS, DIES, AND LETTERPRESS PRINTING. THE ENTRANCE OF THESE METHODS INTO HIS WORK HAS BEEN MENTIONED EARLIER, BY WAY OF HIS JOYOUS ACCEPTANCE OF FOUND OBJECTS TO SERVE INSTEAD OF COSTLY ART SUPPLIES; THEIR IMPRINT ON HIS ESTABLISHED ARTISTIC INDIVIDUALITY HAS OUTLIVED ANY STRAIN UPON THE PURSE.

UNLIKE A NUMBER OF OTHER PAINTERS IDENTIFIED WITH POP ART IN THE 1960S, INDIANA DID NOT ADOPT THE "SIGN-PAINTING" STYLE AS A RESULT OF

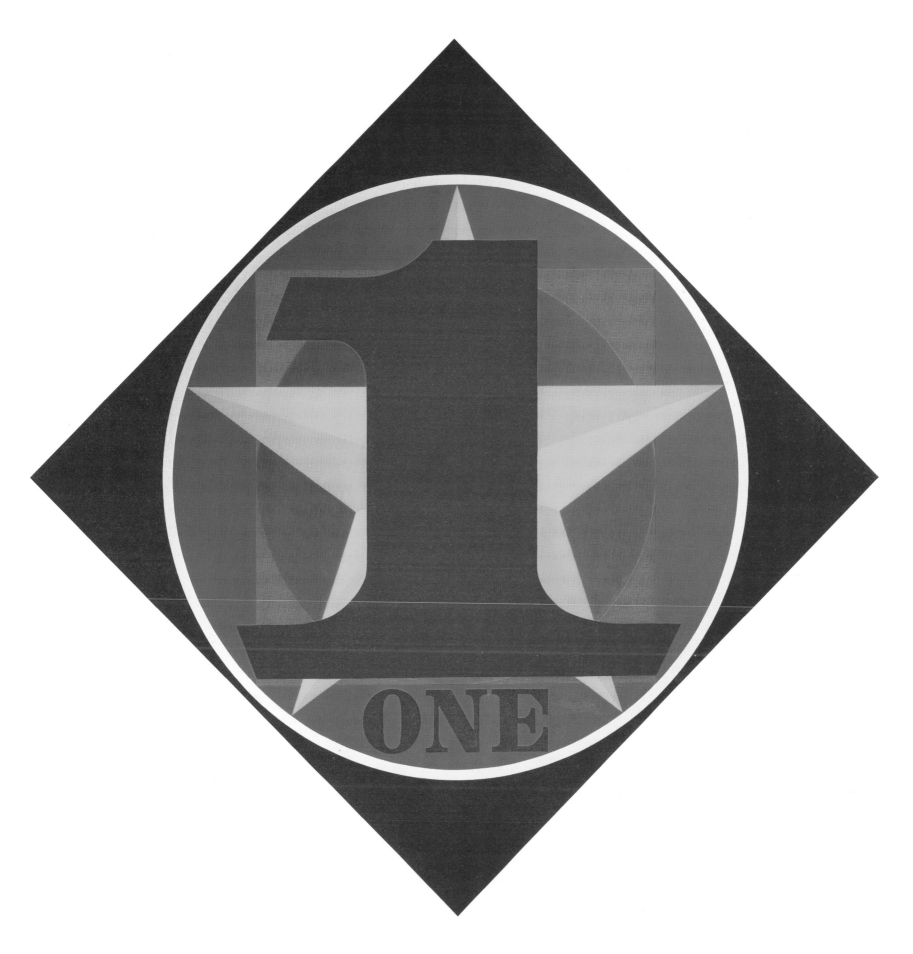

ONE INDIANA SQUARE. 1970.
OIL ON CANVAS, 85×85″. THE INDIANA NATIONAL BANK, INDIANAPOLIS

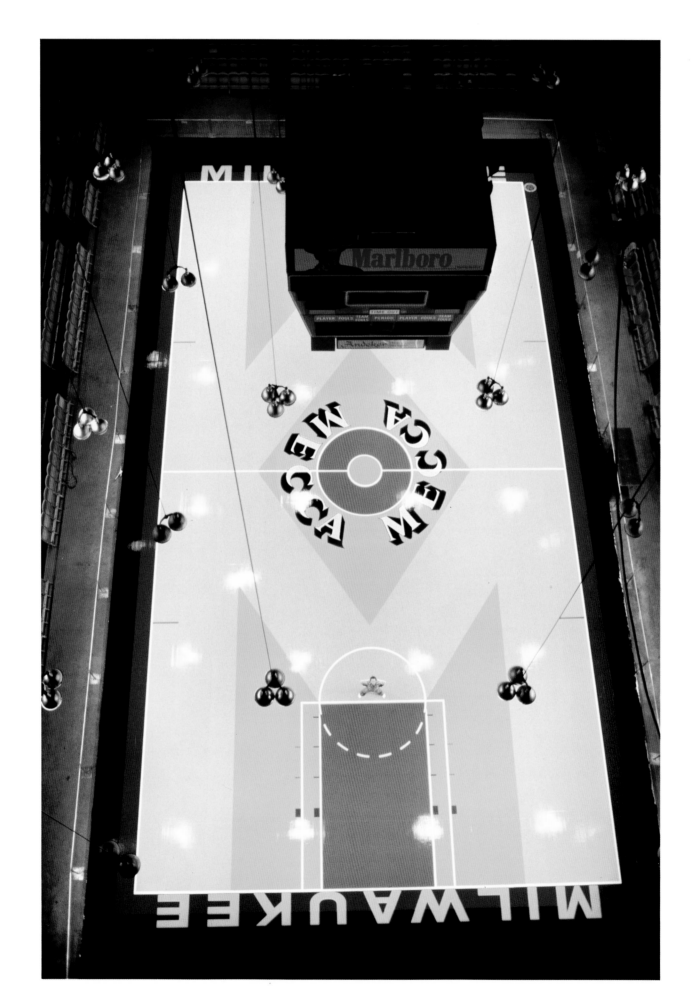

BASKETBALL COURT AT MILWAUKEE EXPOSITION
CONVENTION CENTER ARENA, 1977,
ENAMEL ON WOOD, 94′ × 50′

MECCA I. 1977.
SERIGRAPH (EDITION OF 100
BASED ON ORIGINAL MAQUETTE), 36 × 25″

TRAINING OR EXPERIENCE IN COMMERCIAL ART. HIS BRUSH WITH THAT FIELD WAS
SUMMED UP IN THE SPOT DRAWINGS FOR TELEPHONE DIRECTORY PAGES THAT HE
DID AT NIGHT WHILE STUDYING AT THE ART INSTITUTE OF CHICAGO. AS HE HAS
SAID OF THE LETTERS AND NUMERALS HE USES, "MY WORK IS CERTAINLY CLOSE TO
TYPOGRAPHIC DESIGN, BUT I AM INTERESTED IN THAT ONLY IN A PERIPHERAL WAY
AND USE JUST THE ROMAN AND GOTHIC FACES AND, OF COURSE, THE STENCILS I
FOUND ON THE WATERFRONT."[12] THESE TOOLS AND MATERIALS CAME READY-MADE
TO TRANSMIT HIS CONDENSED COMMUNICATIONS; THEY ALSO CONFORMED TO THE
LOOK OF THE "ROADSIDE LITERATURE" THAT HE HAS ENCODED INTO HIS EXPRES-
SION OF REMINISCENCE, SOCIAL SATIRE, HOMAGE, CELEBRATION, WORDPLAY.

INDIANA'S LARGEST PAINTING, THE BASKETBALL FLOOR FOR THE MILWAUKEE
EXPOSITION CONVENTION CENTER ARENA (MECCA), WHICH WAS UNVEILED IN
OCTOBER 1977, PRESENTED A DESIGN PROBLEM OF COLOSSAL PROPORTIONS. HIS
CHALLENGE WAS TO CREATE A SYMBOL OF THE PLACE AND ITS IDENTITY AND AT THE

DECADE: AUTOPORTRAIT 1969. 1973.
LITHOGRAPH, 12¼ × 9½″

55555. 1967. RUBBER STAMP, 9½ × 6½″

SAME TIME TO PRESERVE THE REQUISITE LINES AND AREAS FOR PLAYING THE GAME. AS WITH OTHER ENTERPRISES OF TREMENDOUS SIZE, THE COMMISSION WAS CARRIED OUT FROM THE ARTIST'S SPECIFICATIONS BY A COMMERCIAL ORGANIZA-TION. INDIANA'S MAQUETTE WAS FIRST DONE IN CUT PAPER OF ORANGE, BLUE, YELLOW, AND RED, CAREFULLY CALIBRATED TO THE PRESCRIBED COURT MARK-INGS. THE FLOOR ITSELF IS YELLOW, BORDERED IN BLUE. AT CENTER COURT THE JUMP CIRCLE IS SURROUNDED BY THE WORD **MECCA** IN RED AND BLUE, SPELLED OUT TWICE TO FACE EACH END. TWO GIANT MS, DEVELOPED IN ALTERNATE BANDS OF YELLOW AND ORANGE, MEET HEAD TO HEAD AT THE CENTER LINE OF THE COURT AND EXTEND THE ENTIRE FLOOR LENGTH. THE COUNTER FORMS OF THE LETTERS ARE PAINTED IN RED, CREATING A DIAMOND THAT ENCLOSES THE **MECCA** CIRCLE AT CENTER AND DELIMITING THE FREE-THROW LANES THAT FACE THE BASKET AT EACH END. A SERIGRAPH BASED ON THE ORIGINAL MAQUETTE BRINGS THE HUGE DESIGN INTO A FOCUS COMPREHENSIBLE WITHIN A BOOK PAGE.

THE PRELIMINARY PLANNING PHASES OF INDIANA'S PAINTING (APART FROM THE DESIGNS FOR **THE MOTHER OF US ALL**) HAVE NOT OFTEN BEEN SEEN IN PUBLIC. HOWEVER, A GROUP EXHIBITION OF FINISHED WORKS WITH THEIR PREPARATORY STAGES HELD AT FINCH COLLEGE, NEW YORK, IN 1964, PRESENTED A LONG SERIES OF THE SKETCHED IMPRESSIONS, MEASURED CALCULATIONS, AND IMAGE ASPECTS THAT WENT INTO HIS TREATMENTS OF THE BROOKLYN BRIDGE. AGAIN, WHEN THE MUSEUM OF MODERN ART'S "WORD AND IMAGE" EXHIBITION OF POSTER ART TRAVELED TO THE SAN ANTONIO WORLD'S FAIR IN 1968, INDIANA'S POSTER FOR THAT OCCASION WAS EXHIBITED AT THE HEMISFAIR ALONG WITH STUDIES MADE IN THE PROCESS OF ITS CREATION (SEE PAGE 93).

INDIANA'S APPROACH TO HIS GRAPHIC WORKS HAS BEEN AUTHORITATIVELY DISCUSSED BY WILLIAM KATZ[13]—ARTIST, DESIGNER, AND WRITER—WHO HAS LONG ASSISTED IN SEEING THOSE WORKS THROUGH THE PROCESS OF EDITION PRINTING. KATZ VIEWS THE MAKING OF PRINTS AS "A GENEROUS ACTIVITY," TURNING "ONE INTO MANY."[14] MOST OF THE PRINTS ARE SERIGRAPHS MADE AT REDUCED SCALE AFTER COMPLETED OIL PAINTINGS, INCLUDING, NOTABLY, THE NUMBERS SERIES AND THE DECADES, THE POLYGONS, VARIOUS VERSIONS OF THE LOVE THEME, AND OTHER RECURRENT THEMES. THE USUAL ORDER OF PRINT AFTER PAINTING WAS REVERSED FOR THE FIRST TIME WITH A COMMISSIONED PRINT, **PICASSO** (1974), WHICH WAS TRANSLATED INTO OIL LATER THAT YEAR (SEE PAGES 142–43).[15] IN SIZE, THE GRAPHICS RANGE FROM WHAT KATZ CALLS "THE RATHER MODEST (9½ BY 6½ INCHES) TO THE LARGE (60 BY 40 INCHES),"[16] DEPENDING ON THE MEDIUM. THERE ARE A FEW EXPERIMENTS IN LITHOGRAPHY, INTAGLIO, AND EVEN RUBBER STAMP.

FOR POSTERS IN LARGE FORMATS, DEPENDING ON THE DISPLAY PURPOSES FOR WHICH THEY WERE COMMISSIONED, THE FINAL PRINTING IS USUALLY COMMERCIAL OFFSET LITHOGRAPHY. THE PREPARATORY DESIGN, HOWEVER, IS ANOTHER STORY, ONE VERSION OF WHICH INDIANA RECOUNTED IN "BIOGRAPHY OF A POSTER." INVITED TO DO THE INAUGURAL POSTER FOR THE OPENING IN APRIL 1964 OF THE NEW YORK STATE THEATER IN LINCOLN CENTER, INDIANA WENT TO THE CON-

POLYGON: TRIANGLE. 1975.

SERIGRAPH, FROM A PORTFOLIO OF 7 PRINTS, 31×28″

POLYGON: SQUARE. 1975.

SERIGRAPH, FROM A PORTFOLIO OF 7 PRINTS, 31×28″

POLYGON: HEPTAGON. 1975.

SERIGRAPH, FROM A PORTFOLIO OF 7 PRINTS, 31×28″

POLYGON: OCTAGON. 1975.

SERIGRAPH, FROM A PORTFOLIO OF 7 PRINTS, 31×28″

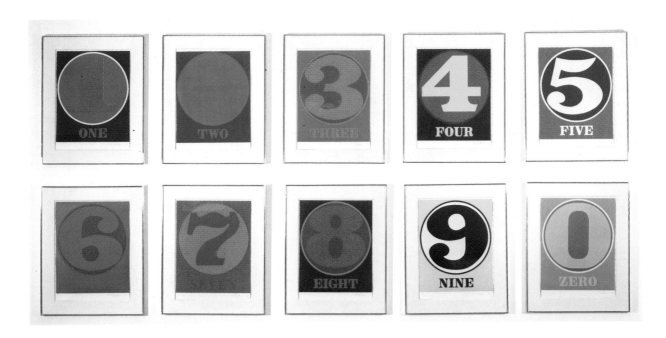

NUMBERS. 1968. TEN SERIGRAPHS,
BASED ON THE ORIGINAL SUITE OF 10 OIL PAINTINGS, EACH 25½ × 19⅝″

STRUCTION SITE LOOKING FOR IDEAS. COINCIDENTALLY, IT OCCUPIED A BLOCK ON WEST SIXTY-THIRD STREET WHERE HE HAD FOUND HIS FIRST MANHATTAN STUDIO, A COLD-WATER WALK-UP LATER "BULLDOZED INTO OBLITERATION"; THE ONCE TEEMING SLUM AREA WAS "COVERED OVER WITH IMPORTED MARBLES AND GRANDEUR AND THE MOST SPLENDIFEROUS ARCHITECTURE NEW YORK HAS SEEN. . . . IN THE HALF-COMPLETED PLAZA," HE WROTE, "WERE THE BEGINNINGS OF [PHILIP] JOHNSON'S FOUNTAIN: THE VERY HUB OF LINCOLN CENTER AND THE CORE FOR MY POSTER, WHICH SPRANG INTO DESIGN FROM ITS RADIATING SPOKES AND CONCENTRIC WHEELS OF TRAVERTINE AND MOSAIC. I COULD NEITHER FIND NOR INVENT A MORE APPROPRIATE MOTIF FOR **CENTER**. . . . TO COMPLETE THE DESIGN I TURNED TO THE THEATER ITSELF. THE AUDITORIUM WAS ALREADY A DARK RED, AND GILDERS WERE AT WORK ON THE GOLD OF THE RING FACES AND THE VAST CEILING OF THE PROMENADE; HENCE THE KEY COLORS OF RED AND YELLOW. . . . FROM THE ARCHITECTURAL PATTERN [OF] THIN VERTICAL BRONZE STRUTS OF THE

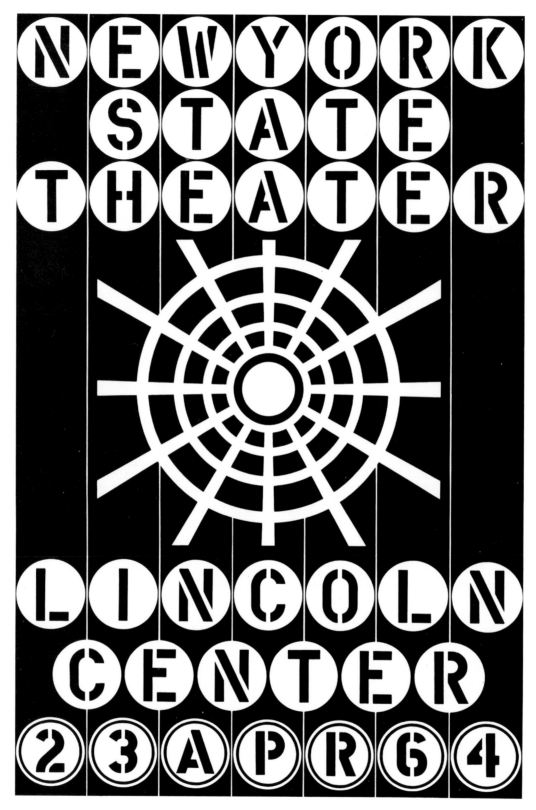

POSTER: **NEW YORK STATE THEATER**. 1964. OFFSET, 46×30″.
COURTESY ALBERT A. LIST FOUNDATION, NEW YORK

UPPER PROMENADE DECKS I FOUND THE BASIS FOR THE SEVEN RED BARS AND THIN YELLOW STRIPES. THE YELLOW DISKS WHICH CONTAIN THE SEPARATE STENCILED LETTERS ARE MEANT TO SUGGEST THE ROUND DIAMOND-FACETED LIGHTS THAT PUNCTUATE . . . THOSE SPACES, BUT ALSO TO RECALL THE THEATRICAL TRADITION OF FOOTLIGHTS."[17]

THE PAINTING OF THIS DESIGN WAS A CANVAS 7 FEET 8 INCHES BY 5 FEET WIDE, WHICH WAS REPRODUCED BY OFFSET IN ABOUT SIX THOUSAND COPIES DISTRIBUTED BOTH IN THE UNITED STATES AND, THROUGH THE U.S. INFORMATION AGENCY, TO CULTURAL INSTITUTIONS ABROAD.

ANALYZING THE POSTERS, KATZ WROTE, "THE SHEER BULK OF INFORMATION, WHICH IN EVERY CASE IS SIMPLIFIED INTO AS FEW ELEMENTS AS POSSIBLE, MAKES [THEM], IN A REVERSAL OF THE USUAL SITUATION, MORE COMPLICATED VISUALLY AND GRAPHICALLY THAN HIS OTHER WORK." YET, BECAUSE OF THE ORGANIZING POWER OF THE DESIGN, THEY "SEEM TO GIVE UP THEIR INFORMATION WITHIN THE SPAN OF CASUAL VISION."[18]

THIS CONDENSATION, OR DISTILLATION, OF IDEA, IMAGE, AND MESSAGE IS CHARACTERISTIC ALSO OF INDIANA'S SCULPTURE, ALTHOUGH THE TECHNIQUES AND MATERIALS HE HAS EMPLOYED RANGE FROM THE UNSOPHISTICATED HANDY-MAN PROCEDURES OF ASSEMBLING FOUND OBJECTS IN THE EARLY HERMS TO THE FOUNDRY-MACHINED FINISH OF METAL MONUMENTS TO BE SITED IN PUBLIC AREAS.

LOOKING BACK TO THE YEARS 1959 TO 1962, INDIANA IS AWARE OF A "PROCESS OF CHANGE" IN THE HERMS (SEE PAGES 59–77); "THAT IS," HE SAYS, "THEY ONLY BECAME WHAT THEY ARE AS TIME WENT ON. THEY WERE NOT CONCEIVED EITHER IN POLYCHROME OR BARREN WOOD; THEY WERE EXERCISES IN NATURAL FINISHES . . . AND THE HARMONIES WERE VERY CLOSE AND EARTHY."[19] SOMETIMES, AS HE RE-CALLS OF ONE "SLIM, STERN, AND SOLEMN LITTLE CONSTRUCTION" CALLED **LAW,** THERE WAS "ALMOST NO APPLICATION OF ANY PARTICULAR ARTISTIC INGENUITY."[20] THE TRANSFORMATION OF THESE PIECES, "AT FIRST GEOMETRIC AND SEVERE, RUSTED METAL AND WHITE GESSO AGAINST WOOD STAINED AND SCARRED WITH

POSTER: **KUNST KÖLN**. 1967. SILKSCREEN, 33 × 18″.
ASSOCIATION OF PROGRESSIVE GERMAN DEALERS, COLOGNE, WEST GERMANY

POSTER: **PREMIUMS**. 1961. OFFSET, 9×21″. STUDIO FOR DANCE, NEW YORK

POSTER: **INDIANA/FORAKIS**. 1961. OFFSET, 8½×13½″. DAVID ANDERSON GALLERY, NEW YORK

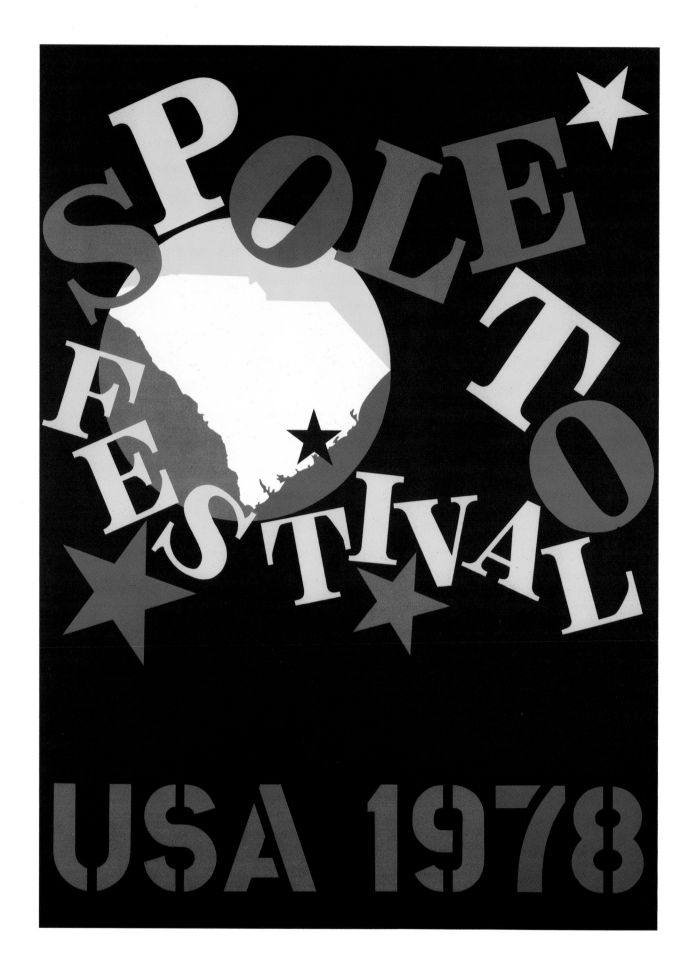

POSTER: **SPOLETO FESTIVAL USA**. 1978. SERIGRAPH

FOUR WINDS. 1964. LITHOGRAPH, 16 × 22¾"

AGE," ADVANCED "WITH THE POLYCHROMY OF COMMERCE'S SIGNS, RAMPANT ON WAREHOUSE, TRUCK, AND SHIP,"[21] THAT HE SAW FROM THE DORMER WINDOWS OF HIS COENTIES SLIP STUDIO, WHILE HE WORKED SURROUNDED BY HIS STOCK OF SALVAGED MARITIME REMNANTS. "I USED TO SKETCH MARINE SCENES," HE TOLD A VISITOR. "I TOOK MANY DESIGNS ON SHIPS AND FUNNELS AS THE BASIS FOR IDEAS."[22] WHATEVER THE SOURCE OF INSPIRATION, THE LETTERS, BRIEF WORDS, AND NUMERALS HE APPLIED TO WHAT HAVE BEEN CALLED "ASSISTED PIECES" CONSISTENTLY CONFORMED TO THE PATTERNS OF THE NINETEENTH-CENTURY STENCILS HE HAD PICKED UP.

PURIM: THE FOUR FACETS OF ESTHER. 1967.
SERIGRAPH, 32 × 26¾″. THE JEWISH MUSEUM, NEW YORK

THE ARTIST'S ARCHITECTURAL BENT COMES MOST STRIKINGLY TO THE FORE IN THE PROJECTION OF HIS WORD AND NUMBER THEMES FROM CANVAS OR PRINT TO THE THIRD DIMENSION AS METAL SCULPTURE. LOVE, WHICH HE VIEWS AS HIS MOST ARCHITECTURAL DESIGN, WITH ITS STACKED LETTERS COMPACTLY FITTED INTO A SQUARE FORMAT, ITS O LEANING RIGHTWARD TO HOLD ITS ALLOTTED SPACE, WAS THE FIRST TO EMERGE FROM ITS VARIED TWO-DIMENSIONAL ASPECTS INTO THE ROUND, FREESTANDING. THE HEAD-ON VIEW OF THAT LOGO AS SEEN IN PAINTING OR SERIGRAPH MAY BE THOUGHT OF AS AN ARCHITECT'S FACADE ELEVATION FOR AN ENVIRONMENTAL STRUCTURE THAT ONE COULD WALK AROUND, CLIMB ON, CRAWL THROUGH, OR STROKE TO RECEIVE SENSATIONS OF TEXTURE, HARDNESS, WARMTH, OR COLD FROM THE MATERIAL.

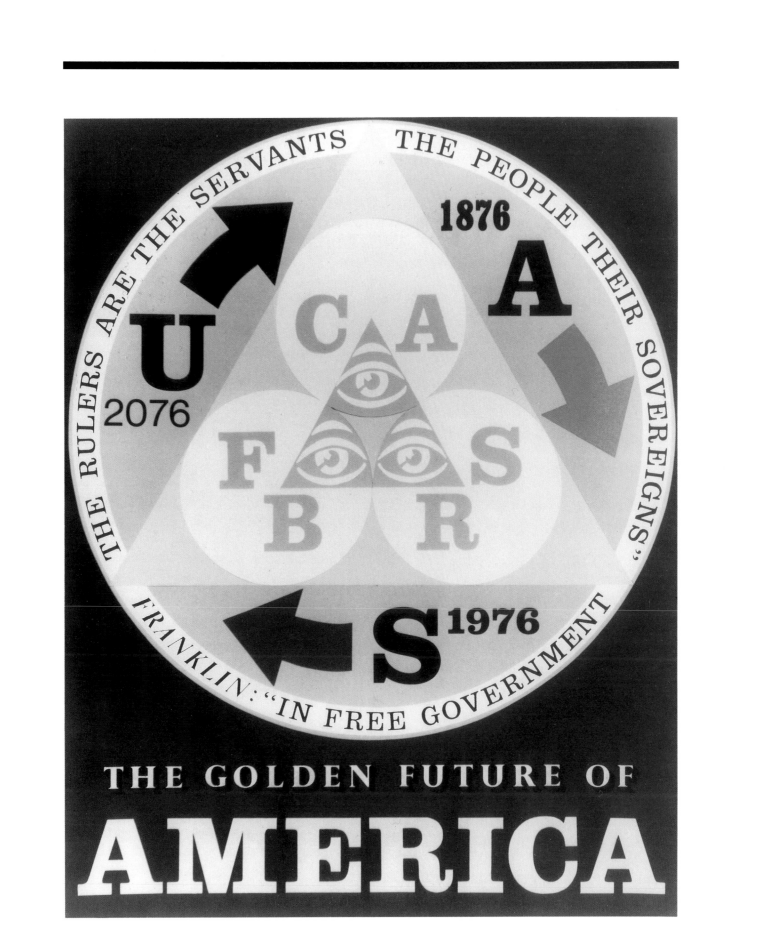

THE GOLDEN FUTURE OF AMERICA. 1976. SERIGRAPH, 26 × 19½″

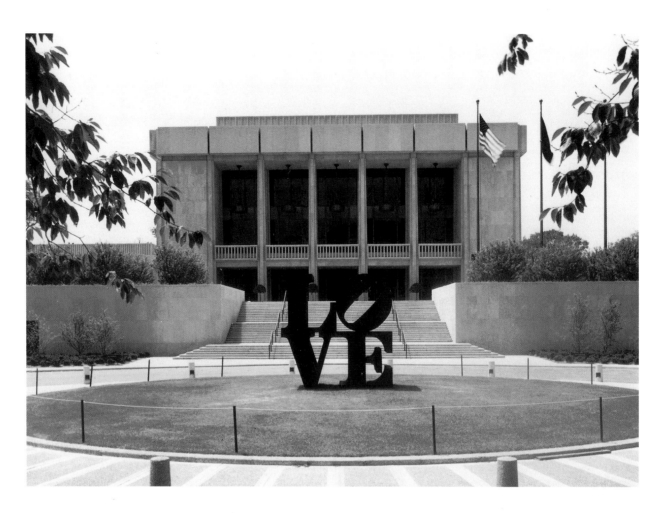

TEMPORARY SITE OF THE LARGE **LOVE** SCULPTURE AT ITS PERMANENT HOME,
THE INDIANAPOLIS MUSEUM OF ART. A FOUNTAIN NOW OCCUPIES THE CIRCLE, AND THE
SCULPTURE STANDS UNDER THE PORTAL OPPOSITE THE FLAGS

NOT ALL THE LOVE SCULPTURES WERE THAT LARGE, OF COURSE. THE SMALL-EST FORM WAS THAT OF A GOLD RING, MANUFACTURED IN A LIMITED EDITION BY A PHILADELPHIA JEWELRY FIRM AND FIRST WORN BY INDIANA AT AN EXHIBITION OPENING IN 1968. TWO YEARS EARLIER, MULTIPLES, NEW YORK, HAD SPONSORED THE CREATION OF A LOVE SCULPTURE IN AN EDITION OF SIX. SOFTLY GLEAMING IN CARVED SOLID ALUMINUM, IT WAS EXECUTED WITH THE TECHNICAL COLLABO-RATION OF HERBERT FEUERLICHT IN MODEST DIMENSIONS, 12 INCHES HIGH BY 12 INCHES WIDE BY 6 INCHES DEEP. THOSE PROPORTIONS WERE PRECISELY ENLARGED

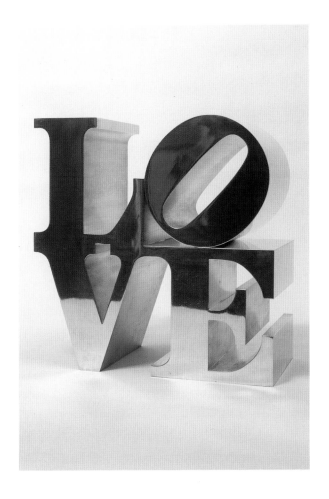

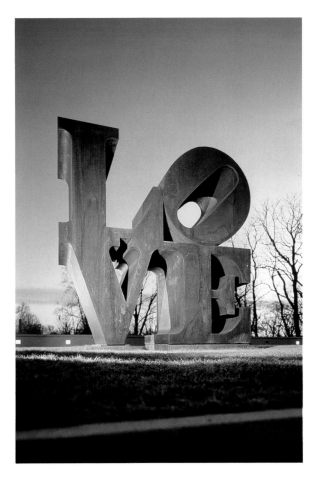

LOVE. 1966. ALUMINUM, 12×12×6″.
WHITNEY MUSEUM OF AMERICAN ART,
NEW YORK. GIFT OF THE HOWARD AND JEAN
LIPMAN FOUNDATION, INC.

LOVE. 1970. COR-TEN STEEL, 12′×12′×6′.
© INDIANAPOLIS MUSEUM OF ART. GIFT OF
THE FRIENDS OF THE INDIANAPOLIS MUSEUM
OF ART IN MEMORY OF HENRY F. DEBOEST

IN THE BIGGEST VERSION OF ALL, 12 FEET BY 12 FEET BY 6 FEET, PRODUCED IN COR-TEN STEEL FROM INDIANA'S MODELS AT THE LIPPINCOTT FOUNDRY IN CONNECTICUT IN 1970.

IN 1972 A POLYCHROME ALUMINUM VERSION IN AN EDITION OF THREE AT HALF THE SCALE OF THE 1970 EDITION RETURNED TO THE BRIGHT RED OF THE 1966 **LOVE** PAINTING. EXHIBITED AT THE GALERIE DENISE RENÉ, NEW YORK, THE SCULPTURE STOOD OUT FROM A WALL DISPLAYING THE CANVAS **THE AMERICAN LOVE WALL** (ALSO OF 1972), WHOSE LETTERS, PICKED OUT IN WHITE ON A BACKGROUND OF

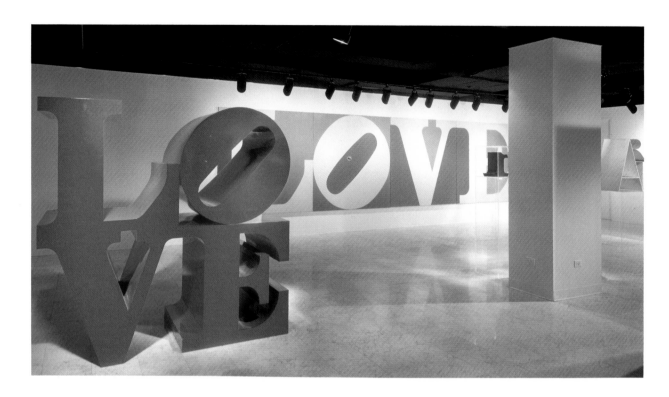

EXHIBITION AT GALERIE DENISE RENÉ, NEW YORK, 1972

RED AND BLUE, SUGGEST THE PATTERN FOR CUTTING THE FRONT CONTOURS OF THE ALUMINUM GLYPHS, REPEATED MIRRORWISE ON THE BACK (SEE PAGES 162–63). THE BACKGROUND COLORS BECOME THE VOIDS THAT PIERCE THE SOLIDS. IN THE DEVELOPMENT OF THE RIGHT SIDE OF THE SCULPTURE, THE HARD EDGES DRAWN FROM THE PAINTED LETTER SHAPES BECOME THE END BOUNDARIES OF THE SQUASHED ALUMINUM CYLINDER OF THE O TURNING IN ABOVE THE THICK PRONGS OF THE E'S SERIFS. TO THE LEFT SIDE, THE STRONG SLAB OF THE L UPRIGHT TOPS THE STEEPLY INCLINED PLANE OF THE V.

THROUGHOUT THIS SERIES THE DESIGNER HAD TO ENTRUST THE ULTIMATE EXECUTION OF EACH PROJECT TO OUTSIDE TECHNICIANS, SOMETIMES BECAUSE OF THE SCALE BUT ALSO BECAUSE OF THE SPECIALIZED HANDLING REQUIRED BY THE MATERIAL, FROM THE GOLDSMITH'S DELICATE CRAFT TO THE MECHANIZED PRACTICES OF HEAVY INDUSTRY. THE EXACTITUDE OF HIS PREPARATORY STUDIES AND

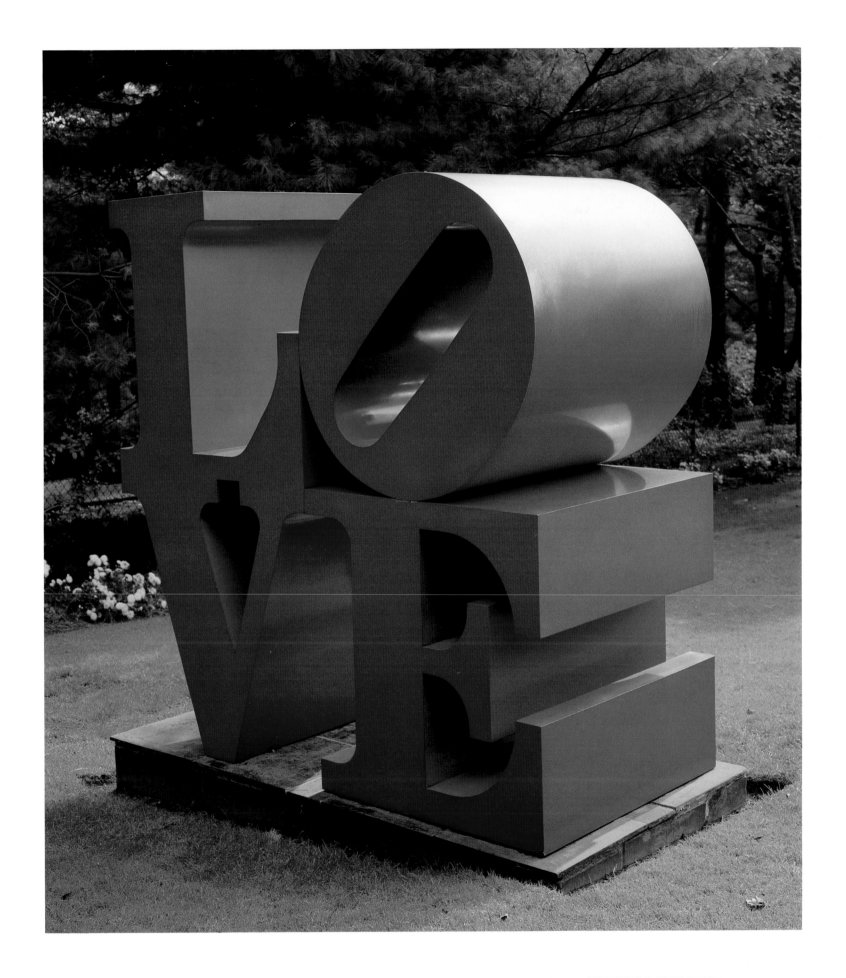

LOVE. 1972. POLYCHROME ALUMINUM, 72 × 72 × 36″. COLLECTION HANNELORE B. SCHULHOF, NEW YORK

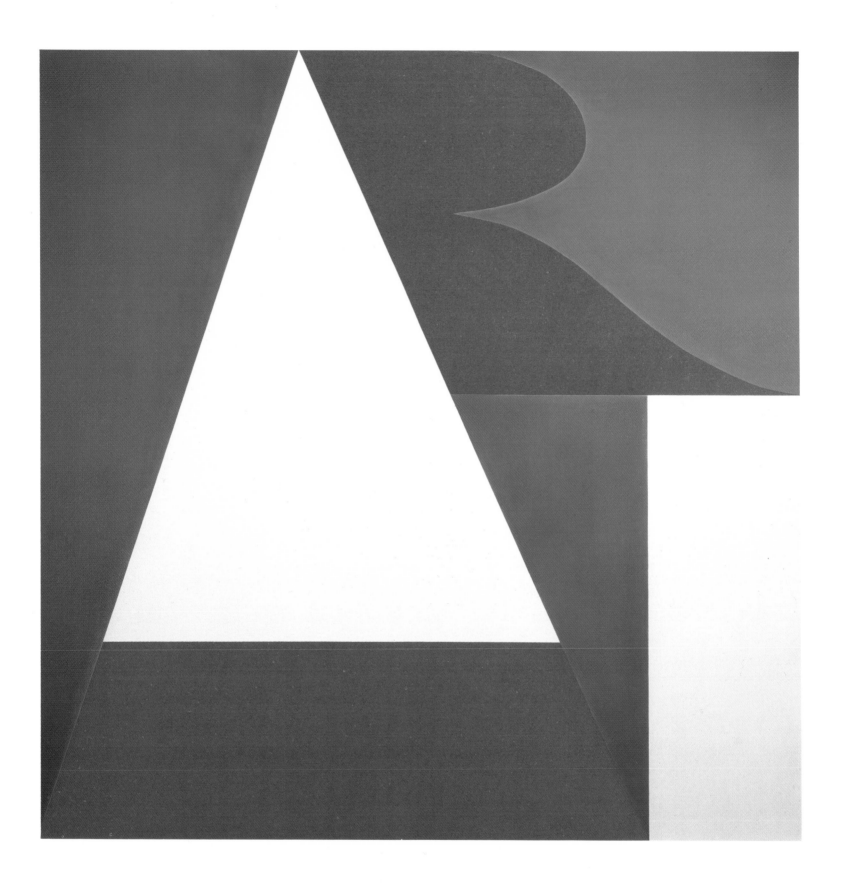

ART. 1972. OIL ON CANVAS, 72×72″. COLLECTION R. L. B. TOBIN, NEW YORK

POSTER: **AMERICAN ART SINCE 1960**. 1970.
SILKSCREEN, $25 \times 35''$.
THE ART MUSEUM, PRINCETON UNIVERSITY,
NEW JERSEY. GIFT OF THE
DEPARTMENT OF ART AND ARCHAEOLOGY

HIS FAITHFUL ATTENDANCE ON EACH STEP IN THE COMPLETION PROCESS WERE CRUCIAL TO THE SUCCESS OF THE FINAL PRODUCT.

INDIANA'S TWO OTHER LARGE WORD SCULPTURES, **ART** AND **AHAVA,** ARE QUITE DIFFERENT IN THEIR IMPACT. **ART,** A MUCH AIRIER REALIZATION OF LETTER FORMS, WAS FIRST SHOWN ON A SILKSCREEN POSTER COMMISSIONED FOR THE EXHIBITION "AMERICAN ART SINCE 1960" AT THE ART MUSEUM, PRINCETON UNIVERSITY, NEW JERSEY, IN MAY 1970. THIS "ALPHAGRAPH," AS IT HAS BEEN CALLED,[23] REPRESENTS THE VOIDS OF THE LETTERS AS FLAT COLOR AREAS; THEIR LINEAR ELEMENTS EXIST ONLY AS TANGENT EDGES WHERE THEY ADJOIN EACH OTHER OR SEPARATE FROM THE GROUND UNDERLYING THEM. THE A, A TALL TRIANGLE, DIVIDES HORIZONTALLY INTO TWO COLOR FORMS AT THE LEVEL OF ITS CROSSBAR, CREATING A TRAPEZOID BELOW THE COLOR BREAK. THE UPRIGHT OF

THE R LIES ALONG THE UPPER RIGHT SLOPE OF THE A, AND THE LUXURIOUS CURVES OF ITS RIGHT SIDE MARK THE ONLY DEPARTURE FROM STRAIGHT LINES IN THE WHOLE COMPOSITION. THE TOP EDGE OF THE T PROVIDES A BASE FOR THE R, WHILE ITS VERTICAL STEM IS SIMPLY ANOTHER JUNCTION OF COLOR FORMS. THE SAME SCHEME, BUT SET WITHIN A CIRCULAR FORMAT, WAS USED AGAIN IN A POSTER FOR THE INDIANAPOLIS MUSEUM OF ART A FEW MONTHS LATER.

IT TOOK THIN SHEETS OF POLYCHROME ALUMINUM TO BRING THIS FINE-EDGED CONCEPT INTO THE THIRD DIMENSION. IN CONTRAST TO THE SOLIDITY OF THE LOVE SCULPTURES, THE ART SCULPTURES (1972) APPEAR WEIGHTLESS, ALL SLENDER OUTLINE AND SHIMMERING SKIN, RADIATING COLOR INTO THE AIR AROUND AND WITHIN. YET THIS SEEMING DELICACY IS MISLEADING; COMPLETED IN ITS LARGEST DIMENSIONS OF ABOUT 7 FEET HIGH AND WIDE AND 3 FEET 6 INCHES DEEP, **ART** SECURELY PITS ITS TENSILE STRENGTH AGAINST OUTDOOR EXPOSURE AT THE NEUBERGER MUSEUM IN PURCHASE, NEW YORK.

THE FOUR-CHARACTER **AHAVA** (1977), FABRICATED IN COR-TEN STEEL AT A HEIGHT OF 12 FEET FOR A HILLTOP SETTING AT THE ISRAEL MUSEUM IN JERUSALEM, IS A RETURN TO MASSIVENESS. ONE DESIGN ELEMENT PECULIAR TO THIS WORK IS THAT THE HEBREW SCRIPT IS READ FROM RIGHT TO LEFT, BEGINNING WITH THE ALEPH (A) AS THE UPPER RIGHT-HAND MEMBER OF THE STACK OF LETTERS. A SLIGHT CURSIVE SWING LIGHTENS THE OTHERWISE BLOCKY FORMS THAT THE BOLD STROKES OF THE HEBREW ALPHABET CREATE WHEN DEVELOPED THREE DIMENSIONALLY.

OF THE VARIOUS THEMES THAT HAVE ENGAGED INDIANA THROUGHOUT HIS CAREER IN MANY MEDIUMS, THE LATEST TO ACHIEVE SCULPTURAL REALIZATION IS NUMBERS. THE MONUMENTAL SERIES FROM 1 TO 9, IN SEPARATE ALUMINUM FIGURES 8 FEET IN HEIGHT, WAS COMMISSIONED IN 1981 BY A PRIVATE COMPANY FOR THE INDIANAPOLIS MUSEUM OF ART (SEE PAGE 217). THE FORMS GO BACK TO THOSE FORTHRIGHT CURLY NUMERALS HE FIRST ADOPTED (AND ADAPTED) FROM THE DATES ON THE BUSINESS CALENDAR HE RESURRECTED ABOUT TWENTY YEARS

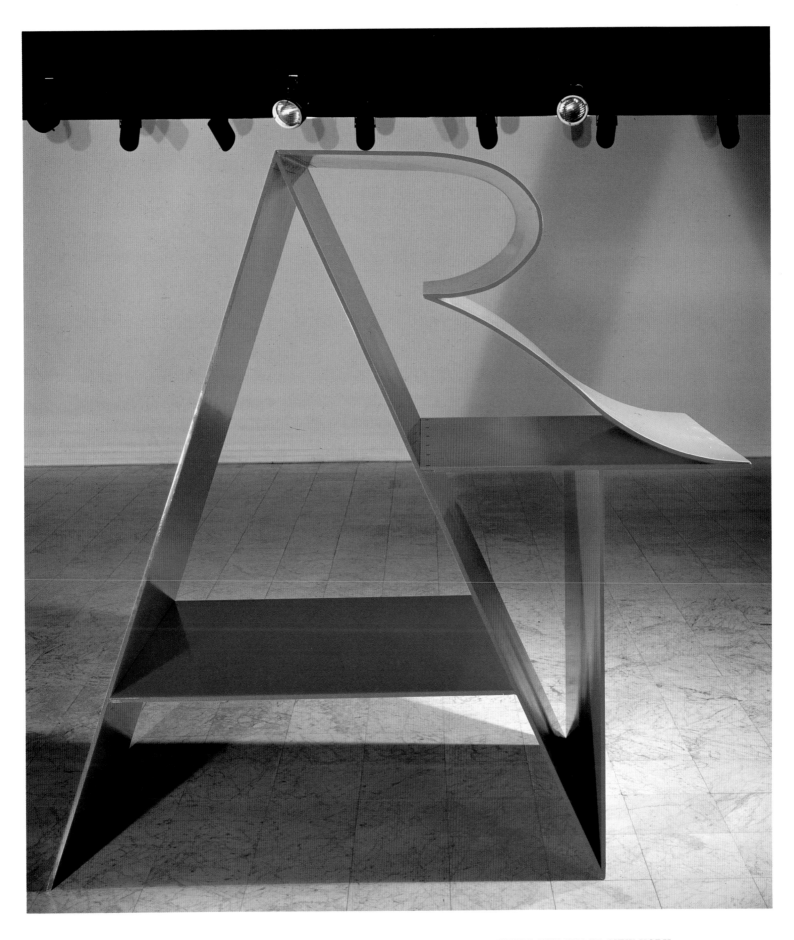

ART. 1972. POLYCHROME ALUMINUM, 84 × 84 × 42″. NEUBERGER MUSEUM, PURCHASE, NEW YORK.
PURCHASED THROUGH A NATIONAL ENDOWMENT FOR THE ARTS MATCHING GRANT

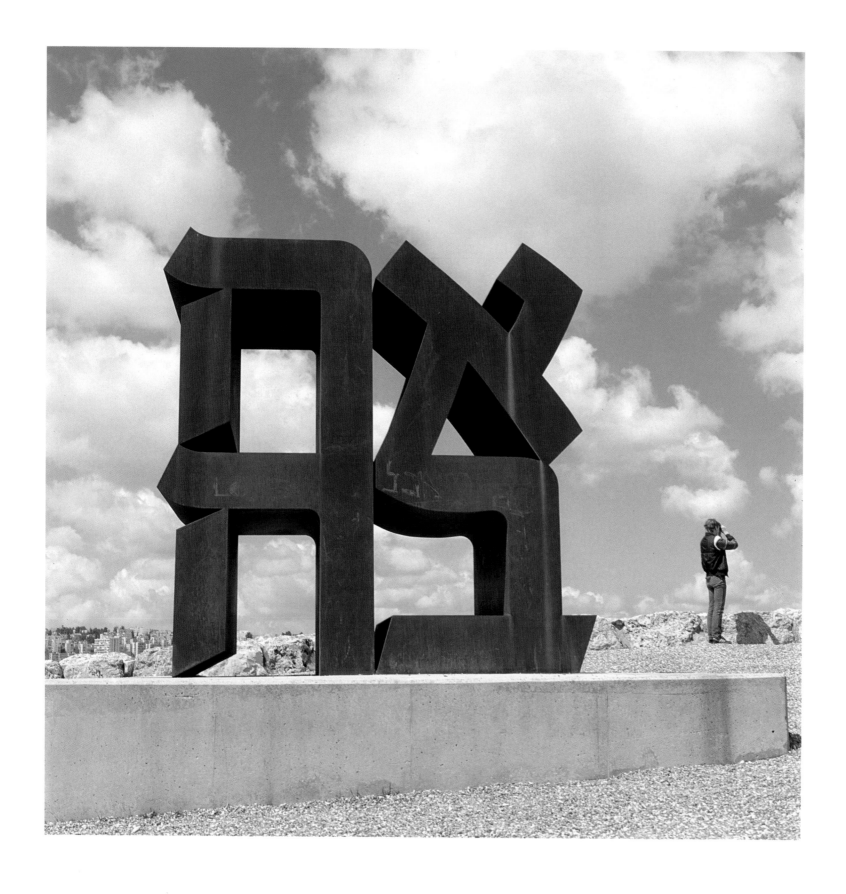

AHAVA. 1977. COR-TEN STEEL, 12′×12′×6′. THE ISRAEL MUSEUM, JERUSALEM

EARLIER. A SLIM AND ELEGANT VERSION OF THE OLD-FASHIONED 5, LIKE THAT IN DEMUTH'S **I SAW THE FIGURE 5 IN GOLD,** HAD SURFACED IN THE PAINTINGS COMPRISING INDIANA'S FIFTH AMERICAN DREAM GROUP (1963), WHILE OTHERS OF THE AMERICAN DREAM SERIES ALMOST SIMULTANEOUSLY CONTINUED THE STEN-CILLIKE FIGURES THAT INDIANA HAD USED FOR HIS EARLIEST NEW YORK WORKS (SEE PAGES 102–9). OVER THE YEARS, IN THE CANVASES, PRINTS, AND POSTERS FOR NUMBERS, POLYGONS, DECADES, AND SO ON, THE CALENDAR-STYLE NUMERALS SOMETIMES EXHIBITED THE SUAVITY OF **THE DEMUTH FIVE,** SOMETIMES THE OPULENT BULK OF THE **CARDINAL NUMBERS** (1966) AND THE **EXPLODING NUMBERS** (1964–66). FOR THE SCULPTURE GROUP, THE ARTIST CHOSE THE BROAD-BASED, BROAD-FACED NUMERALS, WHICH WERE TO BE REFLECTED IN A POOL AT THE DESTINED SITE OUTSIDE THE INDIANAPOLIS MUSEUM OF ART.

"IT IS THE SCALE AND THE AUDIENCE WHICH ARE THE TWO PRIME FACTORS FOR ARTISTS UNDERTAKING PUBLIC COMMISSIONS," INDIANA HAS SAID,[24] AND THE BROAD PUBLIC EXPOSURE ACCORDS WITH HIS EXPRESSED INTENTION TO COMMUNI-CATE THROUGH HIS WORK.[25] EVEN SO, SOME OF HIS COMMISSIONS AIMED AT THE COMMUNICATION OF SYMBOLIC VALUES TO A VAST AUDIENCE HAVE REQUIRED FUL-FILLMENT AT MINIMAL SCALE. THE EIGHT-CENT **LOVE** STAMP FIRST ISSUED BY THE UNITED STATES POSTAL SERVICE IN 1973 BORE A PRINTED IMAGE OF ONLY ABOUT ⅞ BY 1½ INCHES. THE ARTIST SPECIFIED THE COLOR SCHEME OF HIS 1966 **LOVE** PAINTING, RED, BLUE, AND GREEN. A PURPLISH TINT CREPT INTO A FEW PRINTING RUNS, FALSIFYING THE ORIGINAL SCHEME, BUT BY THE TIME RERUNS HAD BROUGHT THE TOTAL COPIES TO OVER 300 MILLION STAMPS, THE ERROR HAD BEEN CORRECTED. (SEE CHAPTER 7, PAGES 166–68, FOR A FULLER DISCUSSION.)

IT WAS AS A SCULPTOR THAT INDIANA, AMONG OTHERS, RECEIVED IN 1962 A COMMISSION FROM THE MAGAZINE **ART IN AMERICA** TO PARTICIPATE IN UNOFFI-CIALLY REDESIGNING THE UNITED STATES CURRENCY. "THE LOWLY PENNY," HE SAYS,[26] FELL TO HIS LOT. THE DESIGN WAS PREPARED AS A TWO-PART OIL PAINTING, SHOWING THE OBVERSE AND THE REVERSE OF A POLYCHROME DECAGONAL COIN

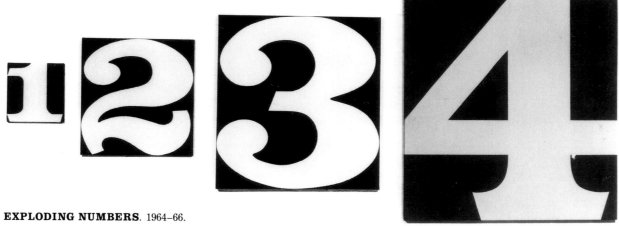

EXPLODING NUMBERS. 1964–66.
OIL ON CANVAS, FOUR SQUARE PANELS,
LEFT TO RIGHT: 12″, 24″, 36″, 48″

PLANNED TO BE MANUFACTURED IN PLASTIC. EMPLOYING THE RED, WHITE, AND BLUE AND THE STARS AND STRIPES OF THE NATIONAL FLAG, INDIANA EVOLVED HIS "NEW GLORY" PENNY. ON ONE FACE THE STRIPES APPEAR AS BROAD DIAGONAL BARS OF ALTERNATE RED AND WHITE CONNECTING CORRESPONDING ANGLES ACROSS THE TEN-SIDED SHAPE (A REFERENCE TO THE DECIMAL SYSTEM). OVERLYING THE BARS IN DARK BLUE IS A VERTICAL DESIGN COMPOSED OF THE WORD CENT BISECTED BY A TALL NUMERAL 1 AND CENTERED OVER THE ANTICIPATED DATE 1963, ALL IN INDIANA'S FAMILIAR STENCIL MODE. THE OTHER SIDE BEARS A SINGLE FIVE-POINTED WHITE STAR EXTENDING TO THE ALTERNATE ANGLES OF THE RED DECAGONAL GROUND. THE STENCIL INITIALS U S IN BLUE ARE CENTERED WITHIN THE STAR. THOUGH THE MAGAZINE COMMISSIONS WERE NEVER EXPECTED TO TRANSLATE INTO "COIN OF THE REALM," THE DESIGN HAD TO CONVEY INSTANT RECOGNITION OF IDENTITY, GOVERNMENT BACKING, AND VALUE. IT WAS A REMARKABLE RETHINKING OF A CONCEPTION TRAPPED IN TRADITION.

INDIANA'S WORK, WHATEVER THE SCALE AND THE LEVEL OF APPEAL TO PUBLIC OR PRIVATE AUDIENCES, IS STRONGLY STRUCTURAL. HIS WORKING METHODS AND MATERIALS, IF NOT, AS HE PUTS IT, "VIRTUOSO," ARE CHOSEN TO CONTRIBUTE TO ARCHITECTURAL CLARITY AND TO THE SENSE THAT "LESS IS MORE."

1–4. IN UNIVERSITY OF TEXAS AT AUSTIN, **ROBERT INDIANA** (1977), EXHIBITION CATALOGUE, P. 25.

5. IBID., PP. 26–27.

6, 7. IBID., P. 31.

8–10. IBID., P. 30.

11. VIVIEN RAYNOR, "THE MAN WHO INVENTED LOVE," **ART NEWS** 72, NO. 2 (FEBRUARY 1973), P. 62.

12. IN UNIVERSITY OF TEXAS AT AUSTIN, **ROBERT INDIANA,** P. 37.

13. WILLIAM KATZ, INTRODUCTION TO **INDIANA GRAPHIK: ROBERT INDIANA, THE PRINTS AND POSTERS, 1961–1971** (STUTTGART AND NEW YORK: EDITION DOMBERGER, 1971), P. 11.

14. IBID., P. 12.

15. UNIVERSITY OF TEXAS AT AUSTIN, **ROBERT INDIANA,** P. 53.

16. KATZ, IN **INDIANA GRAPHIK,** P. 12.

17. "BIOGRAPHY OF A POSTER," MANUSCRIPT PROVIDED BY ROBERT INDIANA.

18. KATZ, IN **INDIANA GRAPHIK,** P. 12.

19, 20. IN UNIVERSITY OF TEXAS AT AUSTIN, **ROBERT INDIANA,** P. 25.

21. ROBERT INDIANA, "AUTOCHRONOLOGY," IN UNIVERSITY OF TEXAS AT AUSTIN, **ROBERT INDIANA,** P. 46.

22. IN RICHARD F. SHEPARD, **NEW YORK TIMES,** 8 MARCH 1964, P. 83.

23. KATZ, IN **INDIANA GRAPHIK,** P. 100.

24. IN WILLIAM A. FARNSWORTH LIBRARY AND ART MUSEUM, ROCKLAND, ME., **INDIANA'S INDIANAS** (1982), EXHIBITION CATALOGUE, P. VII.

25. UNIVERSITY OF TEXAS AT AUSTIN, **ROBERT INDIANA,** P. 26.

26. INDIANA, "AUTOCHRONOLOGY," IN UNIVERSITY OF TEXAS AT AUSTIN, **ROBERT INDIANA,** P. 49.

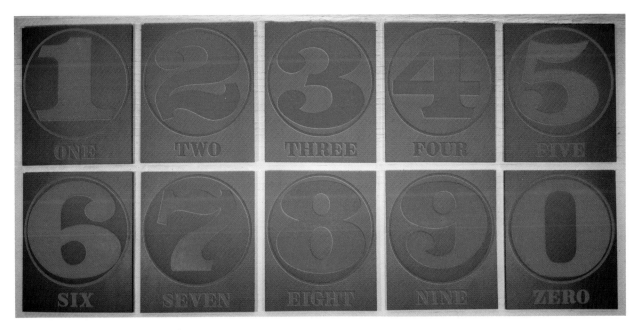

THE CARDINAL NUMBERS. 1966. OIL ON CANVAS, 10 PANELS, EACH 60 × 50″. PRIVATE COLLECTION

I HAVE ALWAYS THOUGHT OF MY WORK AS BEING CELEBRATORY.

PUBLISHED IN 1977, INDIANA'S SELF-ASSESSMENT SEEMS TO HOLD GOOD FOR THE DECADE OF THE 1980S AS WELL, WITH THE WORK EMANATING FROM HIS LATEST HOME, VINALHAVEN, MAINE, AN ISLAND OFF THE COAST IN PENOBSCOT BAY. IN 1969, WHILE RE-VISITING THE SKOHEGAN SCHOOL OF PAINTING AND SCULPTURE, WHICH HE HAD ATTENDED AS A STUDENT IN 1953, INDIANA MET THE PHOTOGRAPHER ELIOT ELISOFON AND WAS INVITED TO VISIT ELISOFON'S SUMMER PLACE ON THE ISLAND. ON THAT BRIEF TRIP INDIANA FOUND HIS FUTURE HOME AND STUDIO, THE HUNDRED-YEAR-OLD ODD FELLOWS LODGE BUILDING, CALLED THE STAR OF HOPE, WHICH HE DESCRIBED AS "CHARLES ADDAMSESQUE" IN ATMOSPHERE.

FRIENDLY COINCIDENCES WERE NOT LACKING. THE FERRY TO VINALHAVEN FROM THE MAINLAND DEPARTED FROM ROCKLAND, HOMETOWN OF SCULPTOR LOUISE NEVELSON, INDIANA'S SPRING STREET NEIGHBOR AND FRIEND. ALSO, THE LODGE BUILDING WAS ERECTED AT A TIME WHEN THE ISLAND'S MAJOR INDUSTRY WAS GRANITE, SOME OF WHICH WENT INTO THE MAJESTIC PIERS OF THE BROOKLYN BRIDGE, WHICH FOR OVER TWENTY YEARS INDIANA COULD SEE FROM HIS STUDIOS ON COENTIES SLIP AND LATER THE BOWERY, AND WHICH HE HAD PAINTED IN VARIOUS ASPECTS IN THE MID-1960S.

DURING THE 1970S VINALHAVEN SERVED AS A SUMMER REFUGE FROM NEW YORK AND FROM THE PRESSURES IMPOSED ON A SUCCESSFUL ARTIST BY THE BOOMING ART WORLD. THEN, TOWARD THE END OF 1978, INDIANA ABRUPTLY ABANDONED THE "INSULAR CITY OF THE MANHATTOES" THAT HAD SEEN HIS PROFESSIONAL EMERGENCE FOR A SELF-IMPOSED EXILE IN THE REMOTENESS OF HIS OTHER ISLAND.

ARTISTICALLY, AS HE SPECULATED AT THE TIME, THIS MOVE MIGHT "FOREBODE EITHER A COLDER OR A HOTTER PALETTE."[2] PRACTICALLY, IT REPRESENTED AN UPHEAVAL THAT COULD BE DISRUPTIVE FOR ANYONE SO ORDERLY AND SO DISCIPLINED IN HIS WORKING METHODS. ALL THE CONTENTS OF HIS WELL-

STAR OF HOPE LODGE, INDIANA'S VINALHAVEN HOME AND STUDIO BUILDING
BEFORE RENOVATION OF 1982

ORGANIZED LOFT BUILDING ON THE BOWERY AT SPRING STREET HAD TO BE
SHIPPED AND REDISPOSED IN THE MORE CONFINED QUARTERS OF THE STAR OF
HOPE LODGE. "EVERY BRUSH, EVERY PAINT TUBE HAS TO BE IN PLACE BEFORE I
CAN GET STARTED," HE TOLD AN INTERVIEWER.[3]

TO HOUSE THE OVERFLOW HE FOUND ANOTHER BUILDING NEARBY, WHICH
TURNED OUT TO HAVE BEEN THE STUDIO OF MARSDEN HARTLEY AFTER THAT
EARLIER PAINTER ALSO WITHDREW FROM THE ART SCENE OF NEW YORK TO THE

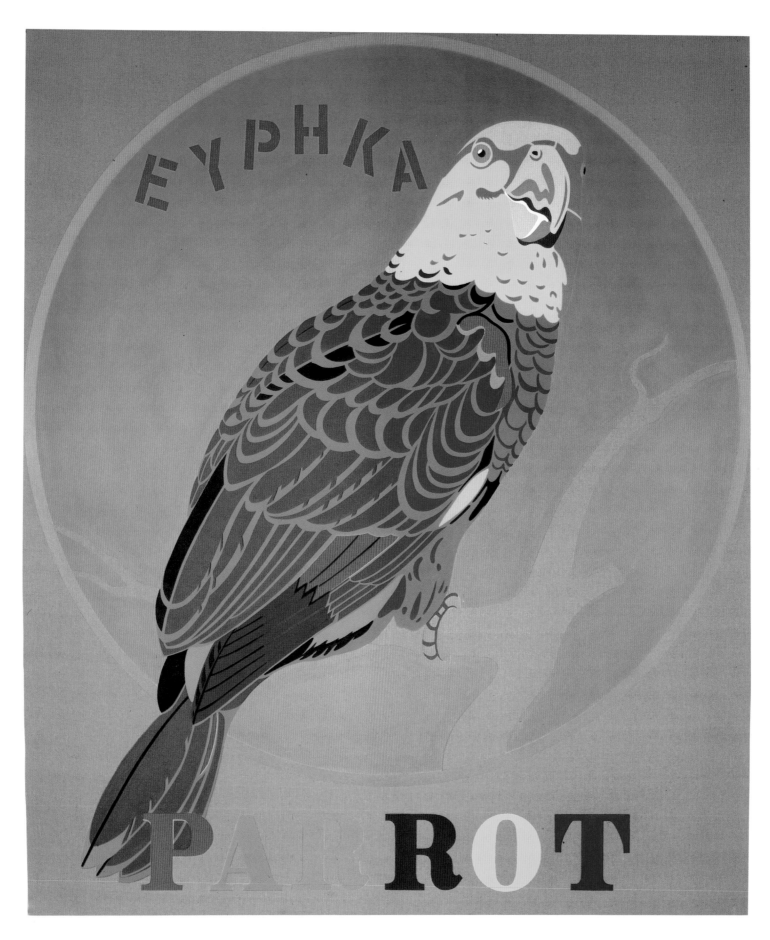

PARROT. 1967. ACRYLIC ON CANVAS, 70×60″.
COLLECTION PROFESSOR AND MRS. JOHN A. GARRATY, NEW YORK

ISOLATION OF VINALHAVEN. MARSDEN HARTLEY! IT WAS ON THE WAY TO VISIT HIM THAT THE POET WILLIAM CARLOS WILLIAMS SAW A FIRE ENGINE BEARING THAT "FIGURE 5 IN GOLD," WHICH INSPIRED HIS POEM "THE GREAT FIGURE" AND, IN TURN, THE CHARLES DEMUTH PAINTING **I SAW THE FIGURE 5 IN GOLD;** THIS, IN **ITS** TURN, ELICITED INDIANA'S TRIBUTES TO DEMUTH AND HIS NUMBER 5 (WHICH INDIANA SUPERIMPOSED ON A STAR AND A PENTAGON) AND TO THE "AMERICAN DREAM" OF HOPE FOR A WINDFALL. HARTLEY, DEMUTH, NUMBERS, HOPE, STARS, STAR OF HOPE—ONCE AGAIN THE KIND OF LINKAGE THAT HAD SO OFTEN BEFORE IN INDIANA'S EXPERIENCE SPARKED THE CREATIVE IMPULSE.

"I FEEL AN HOMAGE TO THIS ARTIST [HARTLEY], PARTICULARLY IN RELATION TO HIS BERLIN PERIOD, IS IN ORDER AND VERY MUCH IN THE OFFING,"[4] INDIANA WROTE TO FRIENDS IN APRIL 1980. THE CANVASES TO WHICH HE REFERS—THOSE EMBLEMATIC, HERALDIC WORKS THAT HARTLEY PAINTED IN 1914–15, WITH THEIR SHARP COLOR CONTRASTS, GEOMETRIC IMAGES, AND ESPECIALLY THEIR INCOR-PORATION OF LETTER FORMS, NUMBERS, AND GRAPHIC SYMBOLS—PRESENT OB-VIOUS AFFINITIES FOR INDIANA.

HE SURMISES THAT AS HE SINKS DEEPER ROOTS IN VINALHAVEN, THE MODE OF REALISM THAT SURFACED IN SOME OF HIS EARLIER WORK (FOR EXAMPLE, THE **MOTHER** AND **FATHER** DIPTYCH, THE DESIGNS FOR **THE MOTHER OF US ALL,** AND **PARROT**) MAY RECUR,[5] JUST AS REPRESENTATION APPEARED IN HARTLEY'S MAINE PAINTINGS OF THE STARK SCENERY OF THE ISLANDS, THE HARSH LIFE OF THE FISHERMEN, AND THE STRUCTURES AND GEAR OF OFFSHORE INDUSTRY.

MEANWHILE, THE FIRST FRUIT OF THE MOVE WAS A NEW SERIES OF TEN SILKSCREEN PRINTS CALLED THE VINALHAVEN SUITE, CONTINUING THE DECADE: AUTOPORTRAITS THEME. LIKE THE GROUP OF PAINTINGS AND PRINTS ON THE 1960S UNDER THE SAME GENERAL TITLE, THE NEW SUITE COMMEMORATES EVENTS, WORKS, PLACES, AND PERSONS OF IMPORTANCE TO THE ARTIST DURING THE PRE-CEDING DECADE OF HIS LIFE—IN THIS CASE, THE YEARS 1970 THROUGH 1979, WHICH MARKED HIS ASSOCIATION WITH VINALHAVEN. AMONG THE NAMES INTEGRATED

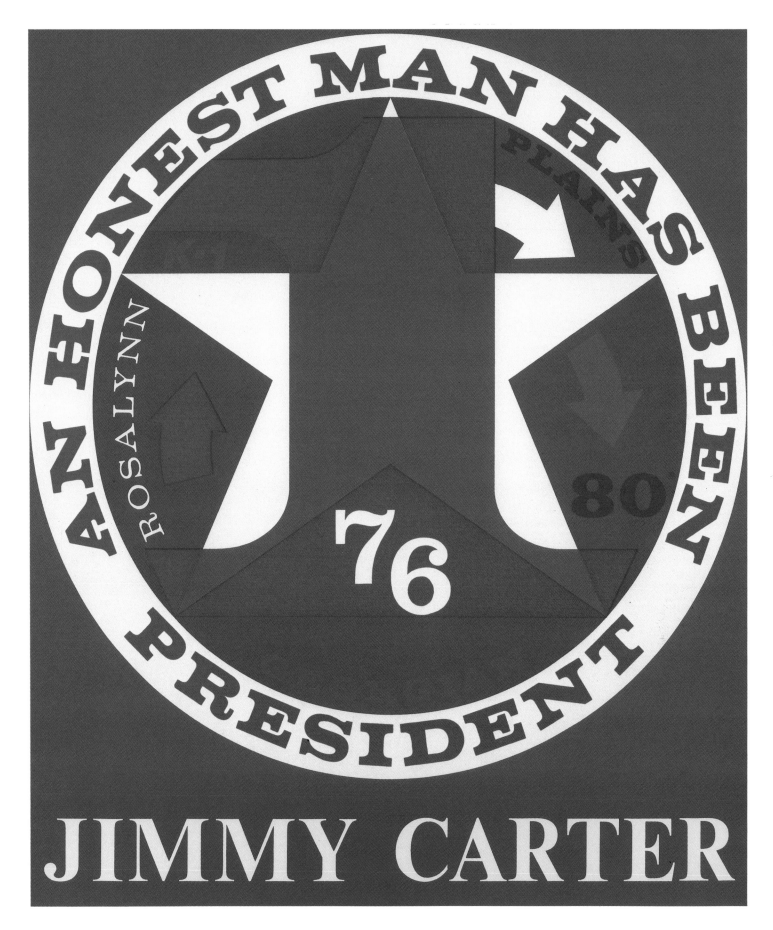

AN HONEST MAN HAS BEEN PRESIDENT: A PORTRAIT OF JIMMY CARTER. 1980.
SERIGRAPH, 23½ × 19¾″. COLLECTION CHARLOTTE FERST, ATLANTA

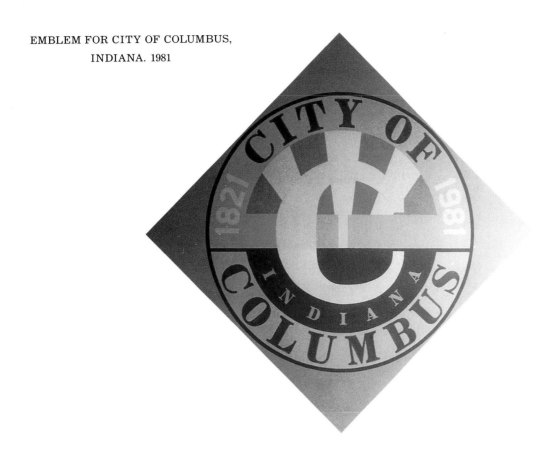

EMBLEM FOR CITY OF COLUMBUS,
INDIANA. 1981

INTO THEM, ALONG WITH THOSE OF WORKS, SUCH AS **AHAVA,** AND OF FRIENDS, SUCH AS VIRGIL (THOMSON), APPEAR THOSE OF SEVERAL GEOGRAPHICAL LANDMARKS OF PENOBSCOT BAY. IN ITS COLORS RELATED TO THE **NUMBERS** SERIES OF PRINTS, THIS SERIES RINGS SUBTLE CHANGES IN THEIR INTERACTIONS.

IN 1980, IN RECOGNITION OF HIS CONTRIBUTION TO THE CARTER PRESIDENTIAL CAMPAIGN, INDIANA WAS INVITED BY THE DEMOCRATIC NATIONAL CONVENTION TO CREATE A SERIGRAPH IN A VERY LIMITED EDITION. THE ARTIST CHOSE TO EXECUTE A PORTRAIT OF JIMMY CARTER, DONE STRICTLY ON HIS OWN TERMS: THAT IS, AS AN ICONOGRAPHY OF SIGNIFICANT NAMES AND NUMBERS, FOLLOWING THE STYLE OF HIS OWN AUTOPORTRAITS AND HIS HOMAGES TO PICASSO AND OTHERS.

ALSO IN 1981 HIS NEWLY ADOPTED STATE CONFERRED ON INDIANA AN HONORARY DEGREE FROM COLBY COLLEGE, AT WATERVILLE, AND THE TOWN OF COLUMBUS IN HIS NATIVE STATE CALLED HIM BACK WITH A COMMISSION TO PAINT AN

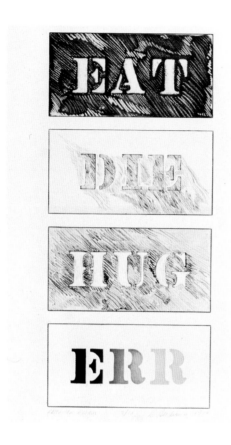

AMERICAN DREAM. 1986.
ETCHING, AQUATINT, DRYPOINT, AND STENCIL
ON ARCHES PAPER, 37 × 21″. VINALHAVEN
PRESS, VINALHAVEN, MAINE

EMBLEM OF THE CITY TO BE HUNG IN ITS NEW CITY HALL. THE COMPOSITION, AN EQUILATERAL DIAMOND BEARING THE NAME OF THE CITY AND THE STATE, MAKES USE OF INTERNAL CIRCULAR FORMS REPEATING THE INITIAL C AND OF RADIAL SECTORS—ALL IN FLAT HUES OF YELLOW, ORANGE, GREEN, BLUE, AND BLUE RED.

ONE TREMENDOUS ASSIGNMENT, REQUIRING AT LEAST THREE YEARS FOR ITS EXECUTION ("THE BIGGEST OF MY LIFE," INDIANA SAYS), ALSO CAME TO HIM IN 1981. THE PROJECT WAS A GROUP OF TEN EIGHT-FOOT-HIGH ALUMINUM SCULPTURES OF HIS NUMERICAL FORMS, COMMISSIONED BY MELVIN SIMON AND ASSOCIATES, SHOPPING-PLAZA DEVELOPERS, AND DESTINED FOR THE INDIANAPOLIS MUSEUM OF ART. "BUSIER THAN IN NEW YORK," SAYS A SCRIBBLED NOTE FROM THE ARTIST AT THE END OF THAT EVENTFUL YEAR.

HIS PRODUCTIVITY IS ENSURED BY THE GRADUAL TRANSFORMATION OF HIS VINALHAVEN WORKING AND LIVING QUARTERS TO SOMETHING LIKE THE EFFI-CIENCY AND THE PERSONAL STAMP OF HIS LAST NEW YORK HOME. THE STAR OF

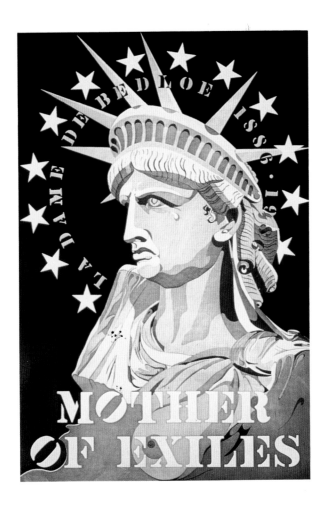

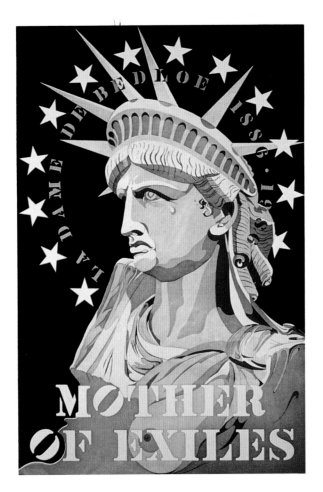

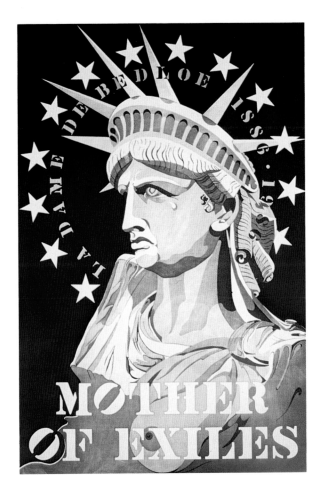

MOTHER OF EXILES. 1986.
ETCHING AND AQUATINT ON
ARCHES PAPER, EACH 47½ × 31½".
VINALHAVEN PRESS, VINALHAVEN, MAINE

HOPE LODGE HOUSES SOME OF THE SAME CATS, DOGS, AND PLANTS THAT EN-LIVENED THE BOWERY STUDIO. CASSO, A GREAT DANE NICKNAMED AFTER PICAS-SO, TRANSFERRED HIS POWERFUL PRESENCE TO MAINE. AMONG A PRIDE OF CATS ARE A COUPLE OF SUITABLY NAMED DESCENDANTS OF INDIANA'S FIRST CAT, PAR-TICCI, WHO FIGURES IN THE 1962 **PENTAGON** OF THE POLYGON SERIES. AND THE LUXURIANT DRACAENA PLANT THAT POSED IN 1965 FOR THE PAINTING **LEAVES** STILL THRIVES IN THE CLIMATE OF PENOBSCOT BAY. DOWNSTAIRS, THE SHELVES AND BINS OF A FORMER NEWS AND MAGAZINE DEALER PROVIDE SPACE FOR LIBRARY AND ARCHIVES. (INDIANA HAS ALWAYS BEEN HIS OWN BEST ARCHIVIST AND CON-SERVATOR, KEEPING METICULOUS FILES AND DOCUMENTATION, EVEN ON THE MANY WORKS ACQUIRED BY BOTH AMERICAN AND FOREIGN COLLECTORS.) SUCH WORKS AS HE HAS NOT CARED TO PART WITH BLAZE OUT IN THE DISPLAY SPACES HE HAS CREATED WITHIN THE STAR OF HOPE, MUCH AS THEY DID IN HIS BOWERY LOFT.

FOUND OBJECTS, "PIECES OF HISTORY," AS HE CALLS THEM, SIMILAR TO THOSE HE COLLECTED FOR WORKING MATERIALS SINCE THE EARLY DAYS ON COEN-TIES SLIP—EVEN SOME OF THE ORIGINAL OBJECTS—ARE CAREFULLY ARRANGED FOR INTERIOR DECORATION OR POSSIBLE SUPPLIES, AMONG THEM RECENT FLOT-SAM AND JETSAM FROM VINALHAVEN. COMING FULL CIRCLE IN THE 1980S TO AN ART FORM THAT OCCUPIED MOST OF HIS EFFORTS IN 1960, INDIANA RETURNED TO THE HUMANOID CONSTRUCTIONS OF SALVAGED MATERIALS THAT HE ONCE LIKENED TO CLASSICAL GREEK HERMS OR TO TOMBSTONES. A SMALL PIECE, LABELED **BAY** IN CERULEAN BLUE LETTERS AND GIVEN DIRECTIONAL SIGNALS BY TWO ARROWS IN THE SAME COLOR, COMPRISES A "TORSO" OF NATURAL WOOD, TWO JUNKED WHEELS, AND A NAVELLIKE FOCUS OF MARINE RINGS THAT SUGGEST A BOAT MOORING.

INDIANA HAS SAID, ". . . BY NATURE I AM A KEEPER. I JUST DON'T DISCARD THINGS."[6] IN THIS STATEMENT, AS IN MANY OF THE OTHER CLUES HE HAS SO FREELY OFFERED TO THE SOURCES AND THE MEANINGS OF HIS ART, ROBERT INDIANA HAS BEEN CONSISTENT. IN THE 1980S AND BEYOND, WHILE WORKING IN CHANGED SURROUNDINGS AND ON NEW INSPIRATIONS, HE IS, NEVERTHELESS,

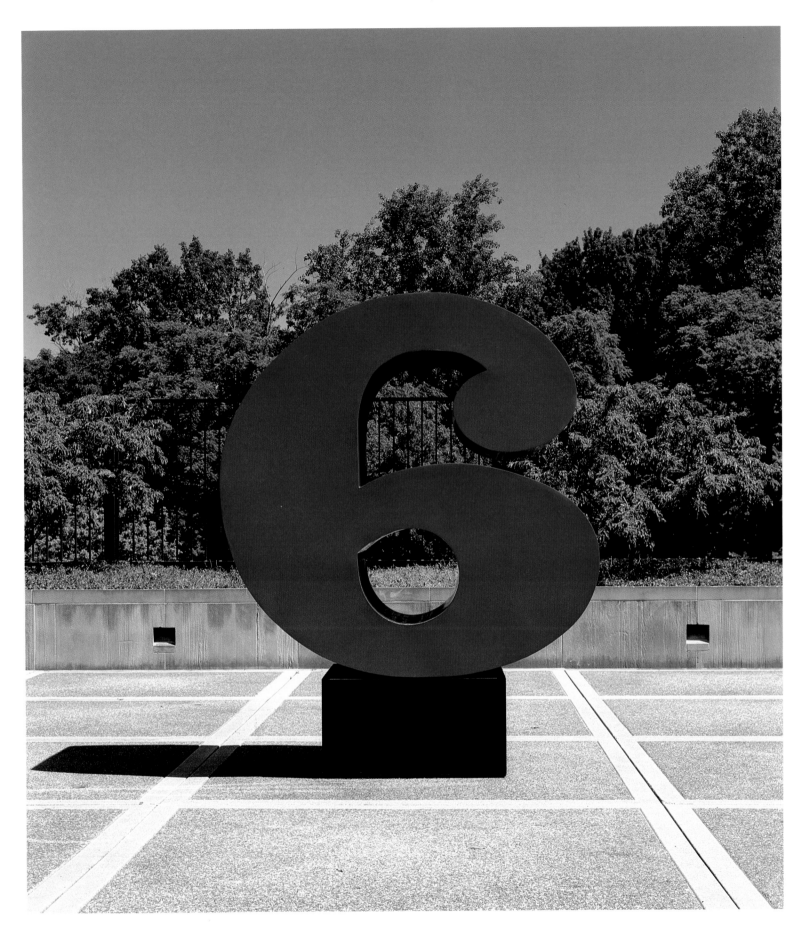

SIX. 1980–82, EXECUTED 1983. PAINTED ALUMINUM, 8′ × 8′ × 4′.

© INDIANAPOLIS MUSEUM OF ART. GIFT OF MELVIN SIMON & ASSOCIATES

ORANGES. 1969. OIL ON CANVAS, 60 × 50″

LEAVES. 1965.
OIL ON CANVAS, 60 × 50″.
COLLECTION MRS. EDGAR TOBIN,
SAN ANTONIO, TEXAS

WHAT HE HAS BEEN SAYING HE WAS ALL ALONG: "AN AMERICAN PAINTER"; A "PAINTER OF SIGNS"; "A PEOPLE'S . . . AS WELL AS A PAINTER'S PAINTER";[7] A MAN WITH "A REAL DESIRE TO BREAK THROUGH PREJUDICE"; AN ARTIST WHO TRIES "TO DO BOTH"[8] THINGS AT ONCE—TALK TO HIMSELF AND COMMUNICATE WITH OTHER PEOPLE; "FASCINATED WITH NUMBERS . . . THE UNPREMEDITATED CIRCLE OF NUMERICAL COINCIDENCE";[9] A POET WHO, IN 1955, "DECIDED AGAINST THE LITERARY LIFE"[10] BUT CARRIED HIS LOVE FOR POETRY BOTH LITERALLY AND FIGURATIVELY INTO HIS PAINTING WITHOUT GIVING UP HIS WRITING OF CRITICISM, AUTOBIOGRAPHY, AND POETRY; AND A PAINTER PERSISTENTLY "CELEBRATORY"[11] IN SPIRIT.

IF INDIANA'S WORK SEEMS STILL TO HOLD UNDISCLOSED A KERNEL OF PRIVACY, OF ULTIMATELY INCOMMUNICABLE HUMAN INDIVIDUALITY BEYOND VISUAL EXPRESSION, VERBAL ELUCIDATION, OR CRITICAL AND ART HISTORICAL SCRUTINY, THAT MAY BE SAID AS WELL OF ANY ARTIST OF SUBSTANCE OR OF ANY WORK THAT CONTINUES TO COMMAND ATTENTION AFTER IT HAS BECOME FAMILIAR.

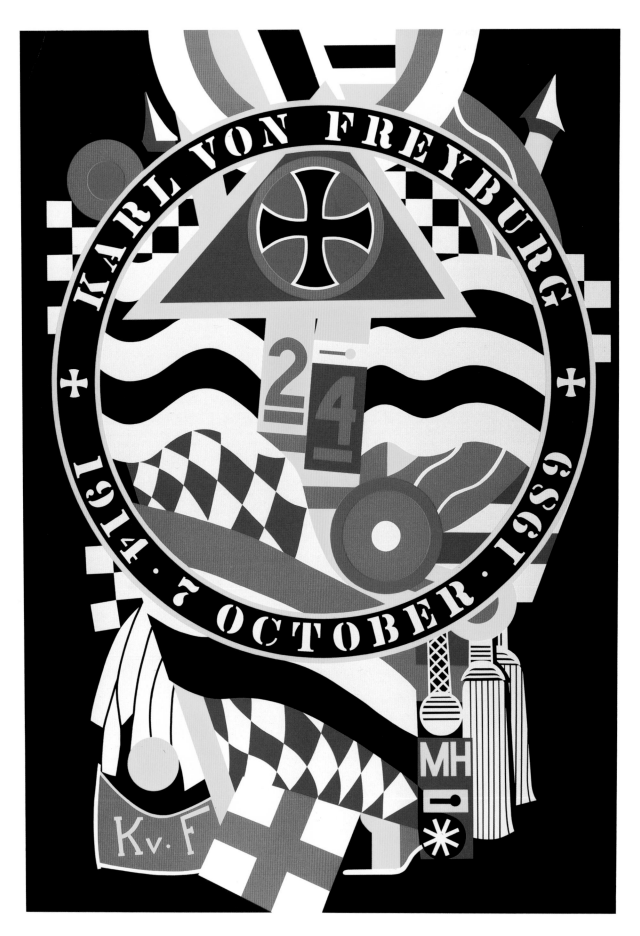

THE HARTLEY ELEGY, **THE BERLIN SERIES: KvF I**. 1990. SILKSCREEN, 76¼ × 53⅜″.

PARK GRANADA EDITIONS, TARZANA, CALIFORNIA

ROBERT INDIANA'S STUDIO, LIVING ROOM, AND STUDY/PRINT ROOM IN VINALHAVEN, MAINE

1. IN UNIVERSITY OF TEXAS AT AUSTIN, **ROBERT INDIANA** (1977), EXHIBITION CATALOGUE, P. 25.

2. ROBERT INDIANA, NOTE TO AUTHOR.

3. IN EDNA THAYER, "A VISIT WITH ROBERT INDIANA, THE 'PAINTER OF SIGNS,'" **COLUMBUS** (INDIANA) **REPUBLIC,** 22 JUNE 1981.

4, 5. ROBERT INDIANA, LETTER TO AUTHOR, APRIL 1980.

6. IN UNIVERSITY OF TEXAS AT AUSTIN, **ROBERT INDIANA,** P. 37.

7. IN INSTITUTE OF CONTEMPORARY ART OF THE UNIVERSITY OF PENNSYLVANIA, PHILADELPHIA, **ROBERT INDIANA** (1968), EXHIBITION CATALOGUE, P. 9.

8. IN UNIVERSITY OF TEXAS AT AUSTIN, **ROBERT INDIANA,** P. 26.

9. IN INSTITUTE OF CONTEMPORARY ART OF THE UNIVERSITY OF PENNSYLVANIA, **ROBERT INDIANA,** P. 27.

10. ROBERT INDIANA, "AUTOCHRONOLOGY," IN UNIVERSITY OF TEXAS AT AUSTIN, **ROBERT INDIANA,** P. 46.

11. SEE NOTE 1.

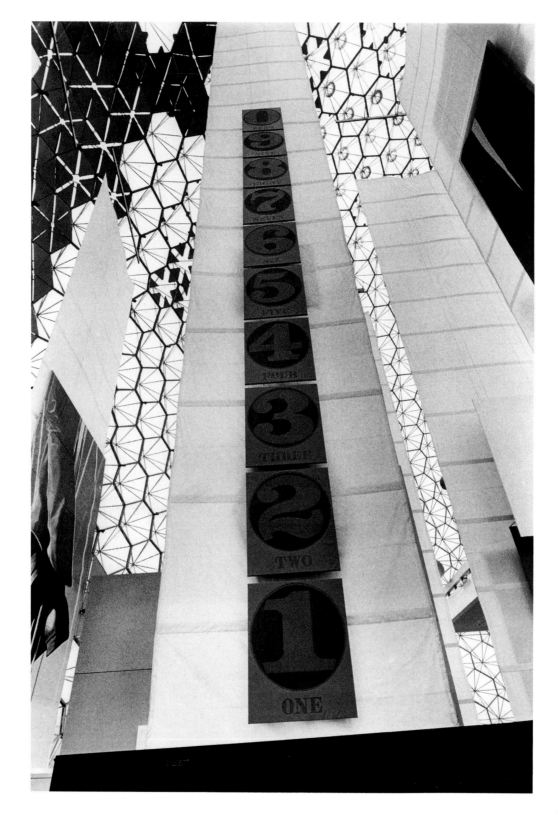

THE CARDINAL NUMBERS (PAGE 205),
DISPLAYED VERTICALLY IN THE AMERICAN PAVILION, MONTREAL EXPO '67

BIOGRAPHICAL OUTLINE

1928 BORN AT NEW CASTLE, INDIANA, SEPTEMBER 13.

1942–46 ATTENDED ARSENAL TECHNICAL HIGH SCHOOL, INDIANAPOLIS, GRADUATING IN 1946. IN 1945 ALSO TOOK SATURDAY SCHOLARSHIP CLASSES AT JOHN HERRON ART INSTITUTE.

1946 RECEIVED NATIONAL SCHOLASTIC ART AWARDS SCHOLARSHIP TO JOHN HERRON ART INSTITUTE, BUT RELINQUISHED IT TO JOIN THE UNITED STATES ARMY AIR CORPS.

1947–48 STATIONED AT ROME, NEW YORK. ATTENDED EVENING CLASSES AT SYRACUSE UNIVERSITY AND MUNSON-WILLIAMS-PROCTOR INSTITUTE IN UTICA.

1949–53 AFTER DISCHARGE FROM THE AIR CORPS, ENROLLED UNDER GI BILL AT SCHOOL OF THE ART INSTITUTE OF CHICAGO, MAJORING IN PAINTING AND GRAPHIC ARTS.

1953–54 RECEIVED SCHOLARSHIPS FOR SUMMER CLASSES AT SKOWHEGAN SCHOOL OF PAINTING AND SCULPTURE IN MAINE. ALSO WON A GEORGE BROWN TRAVELLING FELLOWSHIP AND STUDIED FOR A YEAR AT THE UNIVERSITY OF EDINBURGH TO COMPLETE THE ACADEMIC REQUIREMENTS FOR HIS BACHELOR OF FINE ARTS DEGREE FROM THE CHICAGO ART INSTITUTE. AT THE SAME TIME, WORKED ON PRINTING AND LITHOGRAPHY AT THE EDINBURGH COLLEGE OF ART. TRAVELED IN FRANCE, BELGIUM, AND ITALY.

1954 AFTER SUMMER SEMINAR AT THE UNIVERSITY OF LONDON, RETURNED TO THE UNITED STATES. SETTLED IN NEW YORK CITY, WHICH REMAINED HIS PRINCIPAL RESIDENCE UNTIL THE END OF 1978.

1958 TOOK TEMPORARY JOB AT CATHEDRAL OF SAINT JOHN THE DIVINE, WHICH INCLUDED TRANSCRIBING A MANUSCRIPT OF A BOOK ON THE CROSS. EXECUTED **STAVROSIS (CRUCIFIXION)** AND WROTE THE POEM "WHEREFORE THE PUNCTUATION OF THE HEART," WITH ITS PLAY ON THE WORD **LOVE**.

1961 REPRESENTED IN THE SHOW "THE ART OF ASSEMBLAGE," THE MUSEUM OF MODERN ART, NEW YORK.

1962 FIRST SOLO SHOW, STABLE GALLERY, NEW YORK. COMMISSIONED BY THE MAGAZINE **ART IN AMERICA** TO REDESIGN THE AMERICAN ONE-CENT PIECE; THE DESIGN WAS USED ON THE COVER AND EXHIBITED AT THE SOLOMON R. GUGGENHEIM MUSEUM, NEW YORK.

1963 FIRST COSTUME DESIGN FOR THE NEW YORK THEATER FOR THE BALLET **IN THE HALLELUJAH GARDENS,** HUNTER COLLEGE.

1964 COLLABORATED WITH ANDY WARHOL ON THE FILM **EAT,** IN WHICH INDIANA ATE A MUSHROOM IN SLOW MOTION. RECEIVED ALBERT A. LIST FOUNDATION COMMISSION FOR INAUGURAL POSTER FOR NEW YORK STATE THEATER IN LINCOLN CENTER. ALSO DID MURAL FOR NEW YORK STATE PAVILION AT NEW YORK WORLD'S FAIR.

1966 SUBJECT OF A MUSICAL PORTRAIT, **EDGES,** BY VIRGIL THOMSON.

1967 ON COMMISSION, DID COSTUMES, SETS, AND POSTER FOR THE OPERA **THE MOTHER OF US ALL** BY VIRGIL THOMSON AND GERTRUDE STEIN, PRODUCED FOR THE WALKER ART CENTER OPERA COMPANY AT THE TYRONE GUTHRIE THEATER, MINNEAPOLIS. ALSO RECEIVED COMMISSION FROM THE JEWISH MUSEUM, NEW YORK, FOR A SERIGRAPH TO CELEBRATE THE PURIM HOLIDAY.

1968 ARTIST-IN-RESIDENCE AT THE CENTER OF CONTEMPORARY ART, ASPEN, COLORADO. **NUMBERS,** SUITE OF TEN SERIGRAPHS WITH POEMS BY ROBERT CREELEY, PUBLISHED IN BOOK AND PORTFOLIO FORM BY EDITION DOMBERGER, STUTTGART, AND GALERIE SCHMELA, DÜSSELDORF.

1970 AWARDED HONORARY DOCTOR OF FINE ARTS DEGREE FROM FRANKLIN AND MARSHALL COLLEGE, LANCASTER, PENNSYLVANIA. **TRILOVE,** SUITE OF THREE LOVE POEMS, PUBLISHED BY BOUWERIE EDITIONS, NEW YORK, AND EDITION DOMBERGER, STUTTGART.

1971 SUBJECT OF A DOCUMENTARY FILM, **INDIANA PORTRAIT,** BY JOHN HUSZAR, FEATURING THE ARTIST, HIS COR-TEN **LOVE** SCULPTURE, AND THE VIRGIL THOMSON MUSICAL PORTRAIT **EDGES**. **DECADE,** SUITE OF TEN SERIGRAPHS IN PORTFOLIO FORM PUBLISHED BY MULTIPLES, INC., NEW YORK AND LOS ANGELES, AND EDITION DOMBERGER, STUTTGART.

1973 COMMISSIONED BY UNITED STATES POSTAL SERVICE TO DESIGN A "SPECIAL STAMP FOR SOMEONE SPECIAL" IN AN EIGHT-CENT DENOMINATION (THE **LOVE** STAMP). RECEIVED INDIANA ARTS COMMISSION AWARD FOR HIS CONTRIBUTION TO THE CULTURAL LIFE OF THE STATE.

1974 COMMISSIONED BY THE SMITHSONIAN INSTITUTION TO DESIGN A POSTER AND AN ORIGINAL, SIGNED EDITION OF PRINTS FOR THE OPENING OF THE HIRSHHORN MUSEUM AND SCULPTURE GARDEN IN WASHINGTON, D.C.

1975 **POLYGONS,** PORTFOLIO OF SEVEN SERIGRAPHS, WITH THE COLLABORATION OF WILLIAM KATZ, PUBLISHED BY GALERIE DENISE RENÉ, NEW YORK.

1976 COMMISSIONED BY SANTA FE OPERA COMPANY OF NEW MEXICO TO DESIGN AND SUPERVISE SETS AND COSTUMES FOR **THE MOTHER OF US ALL** TO CELEBRATE BOTH THE NATION'S BICENTENNIAL AND THE COMPANY'S TWENTIETH ANNIVERSARY. THE PRODUCTION WAS FUNDED WITH A GRANT FROM THE NATIONAL ENDOWMENT FOR THE ARTS.

1977 AWARDED HONORARY DOCTOR OF FINE ARTS DEGREE FROM THE UNIVERSITY OF INDIANA, BLOOMINGTON. DESIGNED A NEW BASKETBALL FLOOR FOR MILWAUKEE EXPOSITION CONVENTION CENTER ARENA (MECCA). CREATED **AHAVA,** A FOUR-CHARACTER EQUIVALENT OF THE LOVE SCULPTURE, FOR ISRAEL MUSEUM, JERUSALEM.

1978 LEFT NEW YORK CITY TO LIVE ON THE ISLAND OF VINALHAVEN, MAINE, HIS SUMMER RESIDENCE AND STUDIO FOR SOME YEARS.

1980 **VINALHAVEN SUITE,** SERIES OF TEN SERIGRAPHS OF THE DECADE: AUTOPORTRAIT GROUP, PUBLISHED BY MULTIPLES, INC., NEW YORK AND LOS ANGELES, AND EDITION DOMBERGER, STUTTGART.

1981 RECEIVED HONORARY DOCTORAL DEGREE FROM COLBY COLLEGE, WATERVILLE, MAINE. COMMISSIONED TO PAINT **CITY OF COLUMBUS** FOR THE NEW CITY HALL OF COLUMBUS, INDIANA, UNVEILED LATER IN THE YEAR. COMMISSIONED BY MELVIN SIMON AND ASSOCIATES (SHOPPING-PLAZA DEVELOPERS) TO DO TEN 8-FOOT-HIGH ALUMINUM NUMERAL SCULPTURES, A THREE-YEAR PROJECT, FOR EVENTUAL ACCESSION BY THE INDIANAPOLIS MUSEUM OF ART.

SOLO EXHIBITIONS

1962 STABLE GALLERY, NEW YORK

1963 WALKER ART CENTER, MINNEAPOLIS; INSTITUTE OF CONTEMPORARY ART, BOSTON

1964 STABLE GALLERY, NEW YORK

1965 ROLF NELSON GALLERY, LOS ANGELES

1966 STABLE GALLERY, NEW YORK; DAYTON'S GALLERY 12, MINNEAPOLIS; GALERIE ALFRED SCHMELA, DÜSSELDORF; STEDELIJK VAN ABBEMUSEUM, EINDHOVEN, NETHERLANDS; MUSEUM HAUS LANGE, KREFELD, WEST GERMANY; WÜRTTEMBERGISCHER KUNSTVEREIN, STUTTGART

1968 INSTITUTE OF CONTEMPORARY ART OF THE UNIVERSITY OF PENNSYLVANIA, PHILADELPHIA; MARION KOOGLER MCNAY ART INSTITUTE, SAN ANTONIO, TEXAS; HERRON MUSEUM OF ART, INDIANAPOLIS; TOLEDO MUSEUM OF ART; HUNTER GALLERY, ASPEN, COLORADO

1969 CREIGHTON UNIVERSITY, OMAHA; SAINT MARY'S COLLEGE, NOTRE DAME, INDIANA; COLBY COLLEGE MUSEUM OF ART, WATERVILLE, MAINE

1970 CURRIER GALLERY OF ART, MANCHESTER, NEW HAMPSHIRE; HOPKINS CENTER, DARTMOUTH COLLEGE, HANOVER, NEW HAMPSHIRE; BOWDOIN COLLEGE MUSEUM OF ART, BRUNSWICK, MAINE; ROSE ART MUSEUM, BRANDEIS UNIVERSITY, WALTHAM, MASSACHUSETTS

1971 GALERIE IM HAUS BEHR, HINDENBURGBAU, STUTTGART; GALERIE DE GESTLO, BREMEN; OVERBECK GESELLSCHAFT, LÜBECK; GALERIE CHRISTOPH DÜRR, MUNICH; GALERIE DRÖSCHER-FÜRNEISEN, HAMBURG; BADISCHER KUNSTVEREIN, KARLSRUHE; AMERIKA HAUS, BERLIN

1972 GALERIE DENISE RENÉ, NEW YORK; LOUISIANA MUSEUM, HUMLEBAEK, DENMARK; DIDRICHSENS KONSMUSEUM, HELSINKI

1973 SUMMIT ART CENTER, NEW JERSEY

1975–76 GALERIE DENISE RENÉ, NEW YORK

1976 SANTA FE MUSEUM OF FINE ARTS

1977 UNIVERSITY ART MUSEUM, UNIVERSITY OF TEXAS AT AUSTIN; CHRYSLER MUSEUM, NORFOLK, VIRGINIA

1978 INDIANAPOLIS MUSEUM OF ART; NEUBERGER MUSEUM, PURCHASE, NEW YORK; ART CENTER, SOUTH BEND, INDIANA

1980 MULTIPLES, NEW YORK

1982 WILLIAM A. FARNSWORTH LIBRARY AND ART MUSEUM, ROCKLAND, MAINE

1984 NATIONAL MUSEUM OF AMERICAN ART, SMITHSONIAN INSTITUTION, WASHINGTON, D.C.

1989 VIRGINIA LUST GALLERY, NEW YORK; LORENZELLI ARTE, MILAN

GROUP EXHIBITIONS

1960 **NEW FORMS/NEW MEDIA,** MARTHA JACKSON GALLERY, NEW YORK

1961 **THE ART OF ASSEMBLAGE,** MUSEUM OF MODERN ART, NEW YORK; **INDIANA/FORAKIS,** DAVID ANDERSON GALLERY, NEW YORK

1962 **NEW REALISTS,** SIDNEY JANIS GALLERY, NEW YORK

1963 **66TH ANNUAL AMERICAN EXHIBITION,** ART INSTITUTE OF CHICAGO; **AMERICANS 1963,** MUSEUM OF MODERN ART, NEW YORK; **FORMALISTS,** WASHINGTON GALLERY OF MODERN ART, WASHINGTON, D.C.; **MIXED MEDIA AND POP ART,** ALBRIGHT-KNOX ART GALLERY, BUFFALO

1964 **NEW REALISM,** GEMEENTEMUSEUM, THE HAGUE; **PAINTING AND SCULPTURE OF A DECADE,** TATE GALLERY, LONDON; NEW YORK STATE PAVILION, NEW YORK WORLD'S FAIR; **POP, ETC.,** MUSEUM DES 20. JAHRHUNDERTS, VIENNA

1965 **POP ART, NEW REALISM, ETC.,** PALAIS DES BEAUX-ARTS, BRUSSELS; **THE NEW AMERICAN REALISM,** WORCESTER ART MUSEUM, MASSACHUSETTS; **29TH BIENNIAL EXHIBITION OF AMERICAN PAINTING,** CORCORAN GALLERY OF ART, WASHINGTON, D.C.; **POP ART AND THE AMERICAN TRADITION,** MILWAUKEE ART CENTER; **WHITE HOUSE FESTIVAL OF THE ARTS,** WHITE HOUSE, WASHINGTON, D.C.; **1965 ANNUAL EXHIBITION OF AMERICAN PAINTING,** WHITNEY MUSEUM OF AMERICAN ART, NEW YORK; **WORD AND IMAGE,** SOLOMON R. GUGGENHEIM MUSEUM, NEW YORK

1966 **PAINTING AND SCULPTURE TODAY,** HERRON MUSEUM OF ART, INDIANAPOLIS; **161ST ANNUAL EXHIBITION OF AMERICAN PAINTING AND SCULPTURE,** PENNSYLVANIA ACADEMY OF THE FINE ARTS, PHILADELPHIA; **ART THAT LIGHTS UP,** INSTITUTE OF CONTEMPORARY ART, BOSTON; **KUNST-LICHT-KUNST,** STEDELIJK VAN ABBEMUSEUM, EINDHOVEN, NETHERLANDS; **1966 ANNUAL EXHIBITION OF CONTEMPORARY SCULPTURE,** WHITNEY MUSEUM OF AMERICAN ART, NEW YORK

1967 **AMERICAN PAINTING NOW,** EXPO '67, MONTREAL; **ENVIRONMENT U.S.A. 1957–1967, 9TH SÃO PAULO BIENAL,** BRAZIL; **PROTEST AND HOPE,** NEW SCHOOL FOR SOCIAL RESEARCH, NEW YORK; **PITTSBURGH INTERNATIONAL EXHIBITION OF CONTEMPORARY PAINTING AND SCULPTURE,** MUSEUM OF ART, CARNEGIE INSTITUTE, PITTSBURGH; **1967 ANNUAL EXHIBITION OF CONTEMPORARY AMERICAN PAINTING,** WHITNEY MUSEUM OF AMERICAN ART, NEW YORK

1968 **WORD AND IMAGE,** MUSEUM OF MODERN ART, NEW YORK; **EXHIBITION OF CONTEMPORARY PAINTING AND SCULPTURE,** NATIONAL INSTITUTE OF ARTS AND LETTERS, NEW YORK; **DOKUMENTA IV,** KASSEL, WEST GERMANY; **SIGNALS IN THE SIXTIES,** HONOLULU ACADEMY OF ARTS; **L'ART VIVANT,** FONDATION MAEGHT, SAINT-PAUL-DE-VENCE, FRANCE.

1969 **ART IN THE SIXTIES,** WALLRAF-RICHARTZ MUSEUM, COLOGNE; **ARS 69 HELSINKI,** FINE ARTS ACADEMY OF FINLAND, HELSINKI; **CONTEMPORARY AMERICAN SCULPTURE,** WHITNEY MUSEUM OF AMERICAN ART, NEW YORK; **SUPERLIMITED: BOOKS, BOXES AND THINGS,** JEWISH MUSEUM, NEW YORK; **SEVENTY YEARS OF AMERICAN ART,** WHITNEY MUSEUM OF AMERICAN ART, NEW YORK; **POP ART REDEFINED,** ARTS COUNCIL OF GREAT BRITAIN, LONDON

1970 **PACE EDITIONS,** PACE GALLERY, NEW YORK; **THE HIGHWAY,** INSTITUTE OF CONTEMPORARY ART OF THE UNIVERSITY OF PENNSYLVANIA, PHILADELPHIA; **MONUMENTAL AMERICAN ART,** CONTEMPORARY ARTS CENTER, CINCINNATI; **L'ART VIVANT AUX ÉTATS-UNIS,** FONDATION MAEGHT, SAINT-PAUL-DE-VENCE, FRANCE; **AMERICAN ART SINCE 1960,** THE ART MUSEUM, PRINCETON UNIVERSITY, NEW JERSEY

1971 **PRIMERA BIENAL AMERICANA DE ARTES GRAFICAS,** MUSEO DE TERTULIA, CALI, COLOMBIA; **THE ARTIST AS ADVERSARY,** MUSEUM OF MODERN ART, NEW YORK; **SEVEN OUTDOORS,** INDIANAPOLIS MUSEUM OF ART; **MONUMENTAL SCULPTURES FOR PUBLIC SPACES,** INSTITUTE OF CONTEMPORARY ART, BOSTON

1972 **PAINTING AND SCULPTURE TODAY, 1972,** INDIANAPOLIS MUSEUM OF ART; **THE MODERN IMAGE,** HIGH MUSEUM OF ART, ATLANTA

1973 **THE ZERO ROOM,** KUNSTMUSEUM, DÜSSELDORF; **GRAY IS THE COLOR,** RICE UNIVERSITY MUSEUM, HOUSTON

1974 **NINE ARTISTS/COENTIES SLIP,** WHITNEY MUSEUM OF AMERICAN ART, DOWNTOWN BRANCH, NEW YORK; **AMERICAN POP ART,** WHITNEY MUSEUM OF AMERICAN ART, NEW YORK; **PAINTING AND SCULPTURE TODAY,** INDIANAPOLIS MUSEUM OF ART AND CONTEMPORARY ARTS CENTER, CINCINNATI; **MONUMENTA,** NEWPORT, RHODE ISLAND; **TWELVE AMERICAN PAINTERS,** VIRGINIA MUSEUM OF FINE ARTS, RICHMOND; **OPENING EXHIBITION,** HIRSHHORN MUSEUM AND SCULPTURE GARDEN, WASHINGTON, D.C.

1974–75 **POETS OF THE CITIES, NEW YORK AND SAN FRANCISCO, 1950–1965,** DALLAS MUSEUM OF FINE ARTS; SOUTHERN METHODIST UNIVERSITY, DALLAS; SAN FRANCISCO MUSEUM OF ART; AND WADSWORTH ATHENEUM, HARTFORD, CONNECTICUT

1975 **34TH BIENNIAL EXHIBITION OF CONTEMPORARY AMERICAN PAINTING,** CORCORAN GALLERY OF ART, WASHINGTON, D.C.; **SCULPTURE OF THE '60'S, SELECTIONS FROM THE PERMANENT COLLECTION,** WHITNEY MUSEUM OF AMERICAN ART, DOWNTOWN BRANCH, NEW YORK; **MASTERWORKS IN WOOD: THE TWENTIETH CENTURY,** PORTLAND ART MUSEUM, OREGON

1975–77 **AMERICAN ART SINCE 1945,** TRAVELING EXHIBITION FROM THE COLLECTION OF THE MUSEUM OF MODERN ART, NEW YORK

1976 **AMERICAN POP ART AND CULTURE OF THE SIXTIES,** NEW GALLERY, CLEVELAND; **THIRTY YEARS OF AMERICAN PRINT MAKING,** THE BROOKLYN MUSEUM, NEW YORK

1977 **VISION PROCESS ENVIRONMENT,** LAFAYETTE NATURAL HISTORY MUSEUM AND PLANETARIUM, LOUISIANA

1978 **ART ABOUT ART,** WHITNEY MUSEUM OF AMERICAN ART, NEW YORK

INDEX

ILLUSTRATIONS ARE INDICATED BY PAGE NUMBERS IN **BOLD** TYPE.
ALL WORKS ARE BY INDIANA UNLESS OTHERWISE INDICATED.

PHOTOGRAPH CREDITS

WHERE NO COLLECTION CREDIT IS GIVEN, THE WORK IS IN THE COLLECTION OF THE ARTIST.

THE PUBLISHERS ARE INDEBTED TO THE ARTIST FOR THE MANY PHOTOGRAPHS HE MADE AVAILABLE FOR THIS BOOK. FOLLOWING ARE THE NAMES OF ALL THE PHOTOGRAPHERS WHO WORKED WITH HIM IN RECORDING HIS PAINTINGS AND SCULPTURES, INCLUDING SEVERAL WHO SUPPLIED LOCATION PHOTOGRAPHS.

JOHN ARDOIN: 42, 70, 116 LEFT; STEVE BALKIN: 141 RIGHT; THEODORE BECK: 170–71, 220; BARNEY BURSTEIN: 44; GEOFFREY CLEMENTS: 195 LEFT; C. EDWARD CURTIN: 213; JODY J. DOLE: 132; JONAS DOVYDENAS: 83 LEFT; ELIN ELISOFON: 221 ABOVE RIGHT, BELOW; ELIOT ELISOFON: 176; YAAKOV HARLAP: 202; KEN HOWARD: 134; BRUCE C. JONES: 18, 47, 50 ABOVE, 64, 67, 68, 69 RIGHT, 74, 129, 130, 131, 133, 135, 136, 142, 182 LEFT; THOMAS R. KONDAS: 194; LAWRENCE LANDRY: 123; BASIL LANGTON: 26, 139; ROBERT BUCK MILLER: 180; RUSTY MORRIS: 34 BELOW LEFT, 36, 37; GERARD MURRELL: 167 BELOW, 176 BELOW; HANS NAMUTH: 34 ABOVE LEFT; PETER NAMUTH: 221 ABOVE LEFT; OTTO E. NELSON: 81, 115, 197, 210; ERIC POLLITZER: 22, 34 ABOVE RIGHT, 41, 48, 50 BELOW, 52, 53, 59, 60, 72, 75, 76, 82 LEFT, 88, 92, 93, 94, 96, 97, 104, 111, 114 ABOVE LEFT AND RIGHT, 144, 145, 155, 162–63, 165, 166, 169, 177, 182 RIGHT, 188, 189, 191, 192, 204; GEORGE ROOS: 186; TOM ROMMLER: 167 ABOVE; COURTESY ALEX ROSENBERG GALLERY: 193; JOHN D. SCHIFF: 40, 49, 114 BELOW LEFT AND RIGHT.